ART & RITUAL

*A Painter's Journey
by Stephen Newton*

Stephen Newton is a painter whose work has been exhibited internationally. His academic career began with a B.A. from Leeds University and an M.A. from Nottingham Trent University. He went on to receive an M.A. (Distinction) in Art and Psychotherapy and a Ph.D. in Psychoanalysis and the Creative Process from the University of Sheffield. He is the author of *The Politics and Psychoanalysis of Primitivism* (Ziggurat Books, London, 1996) and *Painting, Psychoanalysis, and Spirituality* (Cambridge University Press, Cambridge, 2001). Stephen Newton is Visiting Professor at the University of Northumbria at Newcastle, England.

ART & RITUAL

A Painter's Journey
by Stephen Newton

Introduction
by Donald Kuspit

Series Editor
Marcus Reichert

ZIGGURAT BOOKS
International

Copyright ©2006 by Stephen J. Newton
This edition published by Ziggurat Books International 2008
Originally published as *Ritual and The Creative Process: The Psychoanalysis of Trance-Formation* by the Department of Art, Art Criticism, Vol. 21 No. 1, pp 13-239, State University of New York at Stony Brook, 2006

The Post-Modern Icon: Stephen Newton's Post-Abstract Paintings Copyright ©2002 by Donald Kuspit

All rights reserved. Except for brief passages quoted in a newspaper, magazine, radio, or television program, no part of this book may be reproduced in any form or by any means, electronic or mechanical, including photocopying and recording, or by any information storage and retrieval system, without permission in writing from the Publisher.

Front cover painting (detail): Stephen Newton, *Bedroom*, 1997
Back cover painting (detail): Stephen Newton, *Room with a Vase on a Table*, 2008

UK office: 27 St. Quentin House, Fitzhugh Grove,
London SW18 3SE, England
Editorial office: 6 rue Argenterie,
30170 St. Hippolyte du Fort, France
Enquiries: zigguratbooks@orange.fr

Printed by imprint*digital*.net Upton Pyne, Exeter. UK

Distributed by Central Books Ltd.
99 Wallis Road, London E9 5LN, England
Tel UK: 0845 458 9911
Fax UK: 0845 459 9912
Tel International: +44 20 8525 8800
Fax International: +44 20 8525 8879
email: orders@centralbooks.com

ISBN 9780956103802

LIST OF ILLUSTRATIONS

Frontispiece: *Promised Land* 1983

Fig. 1 *Nude* 1971
Fig. 2 *Woman on a Bed* 1971
Fig. 3 *Self-Portrait* 1971
Fig. 4 *Two Figures* 1973
Fig. 5 *Woman and Cat* 1975
Fig. 6 *Self-Portrait with a Model* 1976
Fig. 7 *Self-Portrait with Nude and Cat* 1976
Fig. 8 *Untitled (Dark Red)* 1982
Fig. 9 *Table with canvas strips*
Fig.10 *Untitled (White)* 1983
Fig.11 *Promised Land* 1983
Fig.12 *Untitled (Grey)* 1983
Fig.12a *Untitled (Grey)* 1983 (detail)
Fig.13 *Untitled* card collage 1989
Fig.14 *Recollection* 1985
Fig.15 *Figment* 1985
Fig.16 *Path* 1987
Fig.17 *New Horizon* 1984
Fig.18 *Armchair before a Mirror* 2003
Fig.19 *Chest of Drawers* 1995
Fig.20 *Shelter* 1997
Fig.21 *Stairway to a Door* 2001
Fig.22 *Agonli-style bocio* 19th or 20thC.
Fig.23 *Fon bocio* coll.1931
Fig.24 *Luba Stool* 19th or 20thC.
Fig.25 *Unearthed Foundations* 2002
Fig.26 *Doll's House in a Room* 2004
Fig.27 *Room with Red Carpet* 1998
Fig.28 *Announcement* 1999
Fig.29 *Room at Night* 2003
Fig.30 *The last Supper* 2004

for
CHRIS

CIX

O! NEVER say that I was false of heart,
Though absence seem'd my flame to qualify.
As easy might I from myself depart
As from my soul, which in they breast doth lie:
This is my home of love: if I have rang'd,
Like him that travels, I return again;
Just to the time, not with the time exchang'd,
So that myself bring water for my stain.
Never believe, though in my nature reign'd
All frailties that besiege all kinds of blood,
That it could so preposterously be stain'd,
To leave for nothing all thy sum of good;
For nothing this wide universe I call,
Save though, my rose; in it thou art my all.

William Shakespeare

CONTENTS

The Post-Modern Icon:
Stephen Newton's Post-Abstract Paintings
by Donald Kuspit 3

PREFACE
by Stephen Newton 15

CHAPTER ONE:
Early Years 17

CHAPTER TWO:
Abstraction and Infinity 35

CHAPTER THREE:
Encounter with Psychoanalysis 59

CHAPTER FOUR:
Mysticism and the Oceanic 79

CHAPTER FIVE:
Ritual and the Creative Process 115

CHAPTER SIX:
Ritual and Iconography: The Later Years 153

CONCLUSIONS 195

NOTES 203

BIBLIOGRAPHY 221

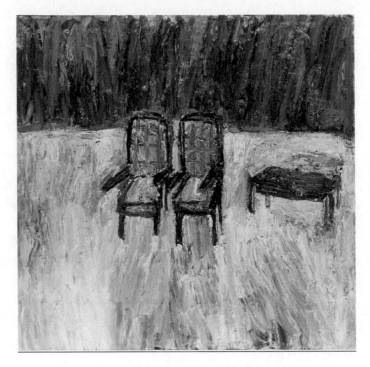

Two Chairs and a Table (73 x 73in) 1997

THE POST-MODERN ICON

Stephen Newton's Post-Abstract Paintings

by Donald Kuspit

> Stripped of its spiritual role, art quickly degenerated into
> academic illustration and 'mannerism.' 20th century abstract
> art tried to win back the lost abstract spiritual *pictorial space*
> of the icon, which as [Anton] Ehrenzweig recognised, is only
> possible through the intuitive, subliminal, 'depth perceptions'
> of unconscious creativity.

Stephen Newton (1)

Suppose, as I think, 20th century abstract art has by and large lost its creative depth and become an academic mannerism: an illustration of the idea of spiritual pictorial space rather than its ecstatic substance. Then the question art faces – at least for art eager to serve and "substantiate" the spiritual unconscious – is how to sustain spirituality without its abstract mode of articulation. (2) More simply, how can spirituality be made to seem credible when the abstract art that has been its modern vehicle has become shopworn and outworn, that is, old? (3) If familiarity breeds contempt, as the saying goes, then by becoming all too familiar and respectable – as its institutional success indicates – abstract art seems to deserve a little contempt. For out of avant-garde necessity – the avant-garde compulsion to rebel against whatever has become a tradition, however untraditional it once was – the critical spectator, along with the critical artist, must repudiate an art once it has acquired "bourgeois" credentials. Assimilated by society, abstract art – supposedly the peak modern art has been struggling to climb from the start – suddenly loses its authenticity and difficulty, and becomes, as Max Horkheimer has suggested, no more than entertaining wallpaper. (4)

Call this the question of post-modern spirituality, or, more precisely, of the post-modern possibility of spirituality, that is, the problem of how to embody the spiritual when the abstract means of its revelation developed by modern art no longer seem able to do so. They have become simply another language of art, in which the artist makes many interesting, even intriguing statements – none of which, unfortunately, evoke the spiritual or afford a spiritual experience. Or, to put this another way, abstract art no longer implies spiritual communion, that is, communion with unconscious creativity: depth perception of the creativity that permits people to transcend ordinary superficial perception, and thus experience the mystery of creativity as such – grasp its sacredness, by reason of the fact that it is the source of life, indeed, its last stand and resource in its struggle with death.

I think Stephen Newton's paintings offer an important, convincing answer to this question: they are post-modern – post-abstract-icons, that is, painterly images that reconstitute the icon – the traditional artistic means of embodying

3

spirituality – in new figurative terms. If, as Newton writes, the icon, in its "*acheiropoietic* function," seems to be a "causal emanation from the sacred personage whose image it then comes to bear," so that "the icon is worshipped as the actual sacred body of the person represented," (5) then the figurative elements in Newton's paintings – houses and their interiors and the few pieces of furniture that exist in their looming emptiness – are the attributes of an invisible spiritual personage, symbols of his sacred body, as it were. But the question is, who is this sacred personage? How did he become sacred? What does it mean to be sacred? It has to mean to discover one's own spiritual unconscious, more particularly, to make one's own unconscious creativity manifest in one's life, in defiance of the odds of doing so in a world indifferent to it, and oneself. Traditionally, a sacred person is someone who has been saved by the grace – creativity – of God, in whom he has placed his faith. In our godless world, a sacred person is someone who has been saved by his own creativity – by having faith in his own spiritual unconscious. In other words, the sacred person is an "artist" in principle.

Newton's pictures give us a view of an inhospitable, indeed, inhuman space, which diminishes whatever is in it. Everything becomes smaller in it, as it becomes too big to bear. His pictorial space it is essentially deserted – the epitome of an emotional desert. Human reciprocity is impossible in it – altogether extinguished, as though it had never existed. Indeed, the radical emptiness of the space embodies the impossibility of being intimate in it. Newton's space has an air of remoteness about it, conveying feelings of separation and isolation – radical loneliness. Crucified by the surrounding emptiness much as Christ was crucified on Golgotha, Newton conveys the martyrdom – living death – of the unloved, unwished for, abandoned child. Implicitly it must be himself. The space must be his inner space, projected into the picture – given pictorial form.

Newton's paintings are, on one level, flashbacks to childhood feelings of inner solitude – desolate instances of unhappy childhood memories of home life, or rather home death. The child itself is not portrayed – the objective correlative, as it were, of its subjective feeling of lacking a self and not being a person. Indeed, there is an impersonal air to the bleak space, however much this is contradicted by the aggressively personal way it is painted – a tension, dialectically unresolved, which I will explore later. There are in fact no people anywhere in Newton's paintings, no human presence, friendly or unfriendly, in the pseudo-home he pictures – often from the outside, turning it into a kind of toy, and seeing it from a great distance that makes it abstract – only things, sometimes living (flowers), usually dead, and all peculiarly emblematic and thus oddly unreal, or rather uncannily real. The atmosphere is one of stultifying indifference, conveying the emotional indifference with which the child was treated. Newton's pictures are clearly not of a childhood recollected in tranquillity, but in a kind of quiet – at times not so quiet as the manic painter-liness; suggests – rage.

Clearly, the modern idea that art regresses to a child's vision of reality in order to serve the troubled ego of the adult has reached an ironic climax in Newton's imagery. It is always hard to grasp the emotional reality of one's childhood environment, all the more so because one is supposed to have had a happy

childhood – a social fantasy that serves childhood amnesia – but Newton, cour-
ageously, shows that it is usually more unhappy than happy, because one's
parents were not the most facilitative environment, all the more so because
they rarely sponsored one's creativity, having none themselves.

What does the psychodynamics of Newton's paintings have to do with their
being icons? I am suggesting that they are personal icons, and that these are
the only kind of icons that can be legitimately made in this age of doubt,
indeed, of abysmal self-doubt. The self is reconsecrated in them, recovering its
sense of itself as sacred by working through its wretched past – the past in
which its growth was stunted rather than encouraged. In a sense, we all grow
ourselves, despite our emotionally impoverished childhood environments – and
there is an air of genteel poverty to Newton's rooms – and Newton is trying to
regrow himself in his pictures by exploring the miserable childhood world in
which he seemed to have no chance to grow – a world in which nothing
grows, nothing lives, except now and then a flower. Thus his self-analytic
pictures show the process by which an emotionally wounded person heals
himself with the help of his spiritual unconscious – his unconscious creativity. This
is the hidden triumph, strength, and richness of his paintings – it is hidden in their
ecstatically creative gesturalism, their relentless expressionistic dynamics –
which on the surface present such a spare, even barren environment. In other
words, Newton pictures not only his unhappy childhood, but, subliminally, and
in defiance of it and despite it, the deeply happy process of discovering that
he is creative – an artist, and thus a peculiarly sacred person – a true person or,
to use D. W. Winnicott's term, a True Self, capable of spontaneous gestures and
personal ideas. (6)

The individual pictured in the traditional icon is not born sacred or matter of
factly sacred, but someone who has become sacred by reason of his suffering
for a higher cause – for his belief that there are other possibilities in life than
those actualised by everyday life, other ways of being than the ordinary way of
being in the ordinary world. A person becomes sacred because he has wider
and higher horizons – the extraordinary horizons of heaven itself – than those
that can be found in the world, and because he is willing to sacrifice himself for
them, and actualise them through his creativity. Raw creative possibility hides in
the ominous, frequently dark sky beyond the horizon line that abruptly cuts
across the void of Newton's space. The sacred person – saint – has a vision
where profane others merely see: a vision blocked by the barriers of ordinary
consciousness, which is represented by Newton's cramped, confining domestic
space. Saints are special selves, self-realised and creatively fulfilled through their
transcendence of ordinary circumstances and ordinary consciousness, indeed,
by reason of their strong will to transcend whatever impedes their spiritual
growth – their creativity. In short, Newton's icons are in emotional affect an
account, even a kind of allegory, of his difficult ascent from inauthentic
homebound uncreative existence to authentic creative selfhood – to creative
and personal autonomy.

If the icon is a kind of mystical representation, in which the passage of the self
from the profane to the spiritual is documented, as it were – in which the
transformation of self that comes from its transcendence of the world is
encapsulated in pictorial space – then Newton's post-modern icons represent

his transcendence of his profane childhood world through his creative spirituality. The act of painting the oppressive ordinariness of his childhood world leaves it behind in the expressionistic wake of the painting. The spiritual unconscious is narcissism at its most creative but also most desperate, creative narcissism restores a self that has been destroyed by the world. Creativity dramatises this destruction, and in so doing discovers a dramatic new self. Creativity is the basic skill of survival in a world indifferent to the survival of the self. Newton's pictorial space embodies this vast indifference, which at once avoids and voids the self – treats it as though it was nothing, as though it does not exist – even as the dense painterliness which ironically embodies the emptiness, conveys the fullness of self that creativity alone makes possible, and expresses, and is the only alternative to the feeling of emptiness – the hollow, sinking feeling of nothingness – the spiritless world induces in the sensitive self.

I am suggesting that Newton's pictorial space – the heavy burden of void that is the basic substance of his paintings – embodies the paradox of spiritual trans-formation. The icon is not just the pictorial embodiment of a sacred personage, it is the embodiment of the process through which someone who experiences himself as nothing in the world's eyes rises to the occasion of his own creativity to become a person in his own eyes. He has unexpectedly found creative full-ness in what the psychoanalyst Michael Eigen calls the empty core – found the saving grace of unconscious creativity in the emptiness the world made him feel. He was able to make dead stone bring forth vital water by striking it, the right creative way. Newton's pictorial space may be the epitome of an emo-tional desert, as I have said, but it is also an epiphany of creativity at its most demanding and sustained. Indeed, it is an epiphany in which the workings of creativity are revealed.

As Viktor Frankl (another psychoanalyst) suggests, we have become intox-icated by creativity, but we no longer understand its redemptive existential significance – its spiritual character. (7) We think that it can be consciously willed, forgetting that creativity is an unconscious response to the sense of the meaninglessness of life – an unconscious attempt to overcome the feeling of the futility of it all – the intense feeling of nothingness embodied in the void of Newton's pictorial space. It is the same void we find in a good deal of 20th century abstract painting, for example, in the work of Malevich, Motherwell, Newman, Rothko, and Still. (Motherwell, it should be noted, declared that "abstract art is a form of mysticism.") (8) Newton has rescued and rehumanised this void, so that it fits the purpose of his figurative pictures. It is no longer aesthetically reified as pure spiritual space, undermining its existential import, but rendered in a more down to earth, gutsy way – made existentially real. Newton pictures not the sublime, self-certain end product of creativity, but the uncertain, primitive process that underlies the product. He demonstrates that creativity is not a process of purification, as it were – that is only the upper half of the story – but an impure existential process, in which the psyche struggles with the ugly reality of its own suffering and sense of nothingness – in which it knows itself through a crisis of faith in itself indeed, by, losing faith in itself, and with it the world. The pictorial space of Newton's post-modern icon, like that of the pre-modern icon, is immanent with suffering as well as the potential for transcendence. Newton's post-abstract space is all too human, for it is fraught with pain, even as it remains spiritually hopeful, for it recapitulates the spiritual

6

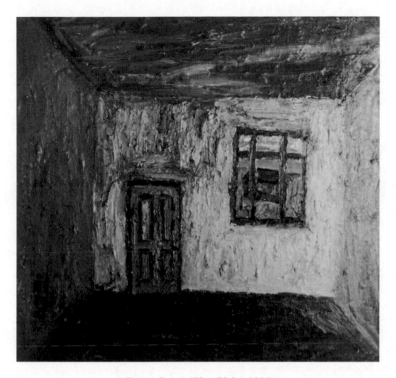

Empty Room (73 x 73 in) 1997

unconscious – the creative process that gives us a reason to live. Indeed, Newton's pictures suggest that to experience it is the basic reason for living.

In Frankl's words, Newton's post-modern icons make it clear that "human life can be fulfilled ... in suffering," (9) for suffering becomes creative – generates a new sense of being – to defend itself against the all but overwhelming feeling of not being. Newton's painterliness, embodies this new respect for being alive – for being part of the substance of life – much as the space it constitutes embodies the feeling of nothingness, of the worthlessness and meaninglessness of life. In other words Newton makes it emotionally clear that creativity is a primitive process of self-healing, dialectically incorporating the "sickness unto death" (Soren Kierkegaard) that made the self suffer in the first place. If creativity attempts to overcome the trauma of alienation – the sense of not having any spiritual home in the world, that is, a space in which one can come into one's own, and truly be oneself – by making one at home with one's own unconscious, then Newton's pictorial space is the symbol of such spiritual homelessness, but also of potential at – homeness. It is Newton's ambivalence about the home that is creatively decisive for his art. He wants a safe haven from the impingements of the external world, but then for him the home

impinges on the internal world – on unconscious creativity. Home for him is a space of betrayal, in which one can never feel emotionally safe. But to become pictorially conscious of one's alienation is to give it a new home in one's creative unconscious, making it less painful.

Newton's pictorial space, then, is the self's new as well as old home. His furniture represents both the destructive loss of selfhood and creative self-discovery – self-recovery. The insular little house that recurs again and again – like all of Newton's standing motifs, it seems naively real as well as profoundly symbolic – is both prison and sanctuary. It is clearly an image of privacy become estrangement, and the site of self-estrangement. Newton's very personal icons convey the dark night of the soul the saint must experience before he finds his salvation – recovers his sense of self – by investing his creativity – all that he has left after suffering has stripped him of every shred of selfhood – in God. Or, in Newton's case, investing in his creativity – in the spiritual unconscious, Newton's paint especially conveys what Frankl calls the "defiant power of the human spirit" (10) – the defiant power of creativity – while the poignant emptiness of his scenes conveys its defeat. The densely – aggressively – painted *Empty Room* and the empty chairs in *Two Chairs and a Table*, both 1997, say it all.

Anton Ehrenzweig, Newton's acknowledged mentor, describes creativity in terms derived from the Kleinean model of psychic development as well as, more broadly, Hegelian dialectic. There is an "initial ('schizoid' stage of projecting fragmented parts of the self into the work, unacknowledged split-off elements will then easily appear accidental, fragmented, unwanted and persecutory." (11) This moment of Hegelian negation corresponds to Melanie Klein's paranoid-schizoid position. (12) "The second ('manic') phase initiates unconscious scanning that inaugurates art's substructure, but may not necessarily heal the fragmentation of the surface gestalt." This gestalt symbolises the naive self and the naively experienced world – the prelapsarian state of affairs in which the self and the world are innocently integrated or symbiotically merged – that is, the self before it has experienced its own negation, catalysed by the frustrating, traumatic experience of the world, which it suddenly experiences as alien. In the manic phase there is the experience of what Winnicott calls "death inside," (13) that is, the destructiveness and self-destructiveness brought about by the loss of innocence that comes with the traumatic recognition of the world's indifference to one's existence – to whether or not one lives or dies. One's self has in effect collapsed – suffered the catastrophe of loss of value in the world's eyes. In revenge, one destroys the world, turning it into a kind of ruin: Newton's homes are ruined worlds, imaginatively excavated in an act of reconstruction (his visualisations are in effect a kind of archaeology). This proves, as it were, that it is a catastrophic place in which to live, indeed inherently catastrophic. For Ehrenzweig "creative dedifferentiation tends toward a manic, oceanic limit where all differentiation ceases. The inside and outside world begin to merge and even the differentiation between ego and super-ego becomes attenuated. In this manic stage all accidents come to seem right; all fragmentation is resolved," in effect re-integrating the subjective and objective worlds without denying the separateness and integrity of each. In the 3rd final phase a new gestalt is created, which embodies the autonomy of both, but also their

connection and even reciprocity. Thus what Klein calls the depressive position is reached.

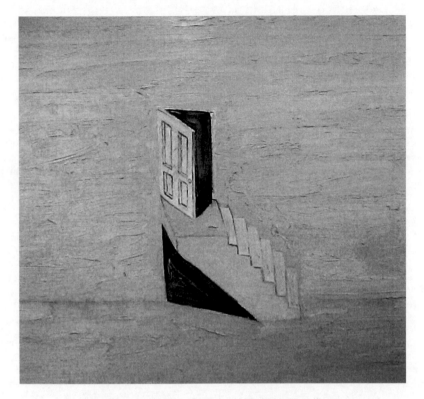

Stairway to a Door (76 x 110in) 2001 (Detail)

Ehrenzweig offers an original way of understanding the transition from the paranoid-schizoid to the depressive position. The latter becomes possible when the manic defence, against the former has the happy outcome of making all the fragments polyphonically equivalent, thus transfiguring destructive fragmentation so that it is experienced as benign all-over harmony (to play on Clement Greenberg's conception of the all-over painting). More crucially, the synthesis of opposites which occurs in the final phase heals the split within the self as well as the split that developed between the self and the world when the self suffered the devastation of the world's devaluation – total trivialisation – of it.

The interpretive issue is to show how these stages are embodied in Newton's icons. The task is complicated by the fact that every element in them does double symbolic duty. The figurative element is both a fragment of the self and of the world, that is, it represents both the isolated suffering self and the world

9

that has caused the suffering. It is also, by reason of its clarity and specificity, emblematic of the restored, integrated self and the objectively viewed world. The staircase that appears in so many of Newton's paintings goes nowhere – its subjective meaning – yet it leads upwards – its objective, transcendent meaning. (The motif of the staircase occurs in – *Stairs*, 1995, *Flight of Stairs* and *Walled Staircase*, both 1996, *Reflection* 1997, *Facade, Doorway and Staircase, White Door with Red Stairs*, all 1999). Similarly, the dense matrix of gestures – worthy of Van Gogh and Soutine, carried to a virulent extreme – that form the ground in which the figure is embedded – is undifferentiated manic-oceanic space. At the same time, it is the spiritual pictorial space in which every gesture is experienced as a spontaneous revelation of indifference, subjective and objective simultaneously. If one regards it as completely objective – descriptive of the world – one misses its subjective import, and if one regards it as completely subjective – a subtle expression of the self (a self-dramatising gesture) – one misses its objective import. The painterly unity of articulate, consciously constructed figure and inarticulate, unconsciously – radically – expressive ground epitomises this "oscillating" simultaneity. Indeed, it is the peculiar way they converge and merge – "mystically" become one – that seems the "most right" aspect of the picture. If Newton's primitive, intense gestures can be understood as what Wilfried Bion calls "beta elements," then their containment in a figurative form – their use as the mortar and building blocks of the "homely" gestalt, whether it be an interior room with its few furnishings, seen up close, or the house as a whole, seen from the transcendental distance of a bird's eye point of view – indicates that for Newton painting performs the "alpha function." (14) That is, painting makes what is painfully – unbearably – real into an emblem that one can reflect upon with affection, thus making it tolerable, memorable, and personally sacred.

I am suggesting that Newton's most important achievement is to picture the creative process itself, and, equally important, to convey its profound human import. "If we visualise the creative instinct as a river," the critic Alfred Neumeyer writes, "with its source in the ego of the artist, and as its mouth or estuary the final product – the work of art – then we realise that before the twentieth century the flow of the river remained hidden. The finished product did not show the traces of experimentation and the trial and error of the working process. Contemporary art, on the other hand, charts the river from source to sea." (15) Few contemporary artists have traced the course of the creative river with as much precision – as much scientific awareness – as Newton. To surrender to the flow of unconscious creativity without losing consciousness of its treacherous intricacies – the changing currents of dialectical interplay between resolved gestalt and unresolved gesture that constitute its drama – and with no sacrifice of self-possession is a rare feat, and it is Newton's.

NOTES

(1) Stephen Newton, "The Creative Structure of Psychoanalysis" (1996), *The Spiritual Unconscious: Stephen Newton, Paintings and Drawings 1975-1996* (London: Ziggurat Books, 1996), p.124

(2) The issue in part involves convincing the typically "spiritless" and sceptical modern spectator of the reality of the spiritual unconscious. He must be made vividly conscious of its process, so that he has a kind of "conversion" experience of it – an unexpected "peak experience," as it were, of his own unconscious spirituality and creativity. However momentary, this has a lasting effect on him, all the more so because of the novel sense of freshness of being and startling self-knowledge it affords, which remain fixed in his memory as experiential ideals.

(3) The feeling that 20th century abstract art has become bankrupt, or, more simply, a stale, flat, and unprofitable enterprise, and that art must move on to the "next step" – all the more so because the fin de siécle and even more dramatically the millennium is at hand, and abstract art has been the dominant if also controversial art of the century – may simply reflect the modern truth that, in Hans Eysenck's words, "artists ... inevitably search for novelty." "What has been done once cannot be done again. A given style in art finally collapses, and a new style ... arrives because the old style has nothing new to contribute. Artistic production is judged in terms of its 'arousal potential,' i.e. in terms of what Berlyne called 'collative properties,' such as complexity, surprisingness, incongruity, ambiguity, and variability." Hans Eysenck, *Genius: The Natural History Of Creativity* (Cambridge: Cambridge University Press, 1995), P.159

At the same time, it may be that it, 'within a given style, arousal potential is produced by what Martindale calls primordial content,' i.e. by what Kris called 'primary process thinking' (pp.159-60), then 20th century abstract art has lost its primordial content and no longer involves primary process thinking. It seems logical that, after a century of mining such content and swimming with the changing tides of primary process, abstract art has become exhausted. Of course, we may also want to hustle it out of the way because, after a century of life, it has come to seem like ancient history, and thus unconsciously reminds us of death. However, it may not be dead, but rather pausing to regroup its energies – lying fallow to renew its spirituality.

(4) As Max Horkheimer writes in *Critique of Instrumental Reason* (New York: Continuum, 1974), p.99. "total abstraction ... has become pure wall decoration and is accepted as such, at least by the wealthy who buy it ... Abstract pictures are simply one element in a purposive arrangement." Thus, the dimension of the absolute is disappearing from an art that thinks of itself as wholly free ... Works of art ... buy their future at the expense of their meaning."

(5) Newton, p.124

(6) D. W. Winnicott, "Ego Distortion In Terms of True and False Self (1960). *The Maturational Processes and the Facilitating Environment* (New York, Interna-

11

tional Universities Press, 1965), p.148 describes the True Self as "the theoretical position from which come the spontaneous gesture and the personal idea. The spontaneous gesture is the True Self in action. Only the True Self can be creative and only the True Self can feel real. Whereas a True Self feels real, the existence of a False Self results in a feeling unreal or a sense of futility." It seems clear that Newton's spontaneous and strong gestures, and his personal idea – fantasy – of the home, change it from a futile place to one in which he can feel creatively alive.

If, as Winnicott says, "the True Self comes from the aliveness of the body tissues and the working of body-functions, including the heart's actions and breathing," then Newton's gestures form a kind of bodily tissue, and their wild rhythm, as well as the generally strong pulse of his painterliness, give his imagery a kind of heartfeltness, and vital breath. And if the True Self is "closely linked with the idea of the Primary Process, and is, at the beginning, essentially not reactive to external stimuli, but primary," then Newton's primary process gestures restore a sense of the vitality in which the True Self begins, even as they are a kind of retrospective reaction to the external stimulus of a home which did little to encourage "the experience of aliveness" – a very little embodied in the few paltry flowers that sometimes enliven the grim space of the home.

(7) Viktor E. Frankl, *The Doctor and the Soul: From Psychotherapy to Logotherapy* (New York: Bantam Matrix, 1969), p.23

(8) Stephanie Terenzio, ed., *The Collected Writings of Robert Motherwell* (New York. Oxford University Press, 1992), p.86

(9) Frankl, p.85

(10) Quoted in Viktor Frankl Pioneer of the 21st Century, "*Austria Kultur*, 7/6 (1997):16
(11) Quoted in Newton, p.124

(12) Hanna Segal, *Dream. Phantasy and Art* (London and New York: Tavistock/Routledge, 1991), pp.27-28 writes that "the real battleground for the development of a mature relation to reality lies in the move from the paranoid schizoid to the depressive position. The depressive position has been described by Klein as the state of mind appearing" in the infant when he starts relating to mother as a 'whole object.' Previous to that, the infant is in the paranoid-schizoid position. This is characterised by a wholly egocentric 'part-object' relation, in which the infant perceives the object only in terms of his experiences split into good and bad objects, attributed to a good or bad respectively. Splitting, idealisation, projective identification, and fragmentation predominate. In projective identification the infant projects not only his impulses but also parts of himself into the object, thus confusing the internal and external worlds. With a gradual withdrawal of projective identification, together with a change in the content and intensity of projection, a truer perception is established of mother as a separate person with her own continuity and characteristics, good and bad, and of oneself as having contradictory impulses, loving and hating, toward that person. This allows for differentiation between oneself and the object, awareness of guilt, and fear of the loss. In the earlier state of mind one

12

could hate and wish to annihilate the bad object, and love, idealise, and keep the good one. When mother as a whole is felt to be omnipotently destroyed in hatred the needed and loved one is destroyed as well. New impulses appear – the wish to restore and regain the lost object – reparation."

Clearly it is the mother that is missing from Newton's pictures – the chairs in many of his pictures are certainly parental chairs – and clearly the sense of reality in them is ambiguous that is, on a sliding scale between the paranoid schizoid and depressive positions. Reality is at once idealised and fragmented. Newton's objects seem good and bad at once, that is, peculiarly, perfect in themselves and yet inwardly broken – strangely ideal yet perverse and hateful. He seems projectively identified with them. Nonetheless, the act of vigorously painting them is reparative – makes them whole (gestalts), which they indeed appear to be – even as it also reveals Newton's highly conflicted, impulsive, barely mastered destructive attitude to them. The remarkable intensity of Newton's paint competes with the eerily static objects to unusually uncanny effect. The contradictoriness of Newton's paintings is an astonishing triumph of expressionism – a genuine tour de force of personal vision and self-objectif-ication, in objects that nonetheless speak of the loss of self.

(13) D. W. Winnicott, "The Manic Defence" (1935), *Through Paediatrics To Psycho-Analysis* (New York: Basic Books, 1975), p.131 suggests that "the main point" of the manic performance is "a denial of deadness a defence against depressive 'death inside' ideas, the sexualisation being secondary."

(14) Segal, p.51 writes that "Beta elements are raw, concretely felt experiences which can only be dealt with by expulsion ... When those beta elements are projected into the breast they are modified by the mother's understanding and converted into what Bion calls 'alpha elements' ... (which) lend themselves to storage in memory, understanding, symbolisation, and further development ... the container – breast ... perform(s) the alpha function." One might say that for Newton painting is both a way of articulating raw, concretely felt experiences through spontaneous, primitive gestures and containing, symbolising, and storing them in gestalt images.

(15) Alfred Neumeyer, *The Search for Meaning in Modern Art* (Englewood Cliffs, NJ: Prentice – Hall, 1964), p.64.

Promised Land (60 x 58in) 1983

PREFACE

Originally, this book had the subtitle: *a personal testament.* Perhaps in this I had in mind the title of Romain Rolland's autobiography *Journey Within.* Certainly the more I read of Rolland and his correspondence with Freud, the more I felt an empathy and even a kinship with a man similarly caught up in problematic attempts to elucidate personal mystical experience; the depth of the oceanic feeling and the conversion of *trance-formation.*

It is not an easy thing to embark upon any analysis of subjective psychic experiences and there is, in truth, little encouragement to do so. Of course, people can be embarrassed by and suspicious of such claims, probably not without good reason. There is also the added complication, as I think Rolland would have acknowledged, that in order to explicate such personal psychic phenomena, autobiographical details at some point need to be addressed. I have done this here very reluctantly indeed and hopefully to a minimum. Some things are better staying private. But I also think that it is essential to explain how the individual is driven to navigate the uncertain currents of the creative process in its manifestation as rite of passage, in an urgent need to reformulate and chart a new developmental course.

I hope that in no sense would I fall into the 'my father was a tyrant – my mother didn't love me' cliché. Although I have felt it necessary to the *theoretical* case to mention briefly my dysfunctional early family life, I also want to emphasise here the harsh realities undergone by both my parents. My mother was orphaned into an orphanage whilst very young and has had much tragedy in her life. I hope in some small measure that I have lightened her load in later years. My father similarly endured extreme hardship as a boy: in his family, the old cliché 'first up, best dressed' was actually the case. It is also inevitably the eventuality, that as a father of three adult children myself, I am now far more inclined to see things from my parents' point of view than ever was the case in my youth.

Apart from the problems posed by references to a personal history, there is also the real question of credibility. When I had a sense of quite profound psychic experience, or encountered altered states of consciousness, I was relatively young and had absolutely no real knowledge of theology or psychoanalysis. I certainly didn't feel it appropriate at that time to broadcast the idea that I was having 'out of body' experiences. It undoubtedly helps to have the credibility of a deeper understanding of the phenomenon being described, but it wasn't for this reason that I embarked some years ago upon two masters degrees and a doctorate on research into the psychoanalysis of the creative process. It was rather in a desperate inner need to come to terms with this phenomenon of *ekstasis*, the foundation of all personal mystical experience, that I encountered whilst painting abstract monochromatic canvas collages.

I subsequently argue here that the trance experience at the heart of the creative process and of the initiation rite or rite of passage, is fixed or embodied within the materiality or substance of the painting or tribal artefact and in effect encoded. In other words, the trance phenomenon is substantiated at the core of the process in a *trance-substantiation.* In the context of religion, like Rolland I subscribe to the

15

proposition that it is this personal mystical transformative experience that is the original source for the various sacraments and ceremonials that come to represent it in liturgical terms. In other words, I would argue that it is archaic and primitive ritual procedures, in which the individual has the potential for a *trance-formation*, that form the nucleus of later religious institution.

Again, I argue that it has always been the function of art to mediate and to register these seminal ritual processes, so central to human evolution. It follows that I am not claiming to have had special religious experiences, but rather to have encountered the universal personal conversion experience that ultimately becomes translated into religious narratives.

Stephen Newton
London, August 2004

CHAPTER 1

EARLY YEARS

In retrospect, my life as a painter seems to fall conveniently into three general periods. Firstly, there are the years of early infancy, through to a point around my late twenties; secondly, a middle period predominantly centred on the decade of my thirties; and lastly, the years of the early forties into middle age. Basically, these three chapters of life chart the early struggle to become a painter, whatever that may ultimately mean, through to a position where an access to painting is opened up, and a subsequent, later period, where that access is developed and evolves into a personal, painterly language.

From this perspective, it can be clearly seen that painting is very much a parallel universe, where life is not only re-enacted and renegotiated, but also is form-ulated and in some important ways even determined. In the early years of a painter's development, for example, the difficulties experienced in coming to terms with the paint medium mirrors the difficult struggle inevitably encountered in these years to come to terms with life itself. There can be detected a near exact emotional cor-respondence between the experience of 'real life' and of its parallel doppelganger in the plastic medium of paint. It was Picasso who commented that: 'I deal with painting as I deal with things; I paint a window just as I look out of a window. If an open win-dow looks wrong in a picture, I shut it and draw the curtain, just as I would in my own room.' (1)

At all stages in life, painting can reflect on and mediate its vicissitudes, ini-tially on a purely personal level, but potentially also on a more general, cultural, or even universal level. In the power to evoke a parallel dimension, the painter can fulfil the key shamanist role in the culture, which again Picasso described as that of an 'in-tercessor.' (2) However, with reference to my own painting over a number of years, I will endeavour to elucidate on a key factor in this process: that this parallel dimension can only be accessed through the *materiality* of the paint substance; through the very abstract core of the creative process, way beyond narratives and imagery.

To have recourse throughout life to another dimension, a creative dimension, implies a lifelong engagement with art. Of course, most people were painters of one sort or another in childhood, but adult or mature painters are often those people, who for one reason or another didn't stop painting. Such a lifelong engagement as a painter must inevitably have a deep connection with childhood formative experiences in relation to both life and art. The future can be signalled and determined by key events which plant seeds in the impressionable mind.

In my own case, I have the vivid recollection of receiving an *A B C* book on what must have been my third or perhaps fourth birthday, and of being absolutely mesmerised by the huge red double-decker bus on the page representing the letter *B*. For this bus looked just like a real three-dimensional bus with its front seemingly advancing out of the page and its back receding into it. But how could this magical

depth take place on a flat two-dimensional piece of paper? I recall looking behind the page to see if the bus possibly came out at the back. Then I took some tracing paper (actually from the upstairs bathroom) and traced the lines at the top and bottom edges of the bus, lines that naturally met at their distant vanishing point. I remember many years later at the local grammar school being taught perspective in the art classes, but with the vivid memory of having worked this out for myself, before I could read or write.

Probably not such a rare experience, but somehow an indication of a future lifelong interest. In a way, I have spent my subsequent years as a painter trying to unlearn that very early understanding of perspectival vanishing point in the attempts to create a more resonant deep space in the sense of medieval imagery or religious icon painting. Nevertheless, it is this type of conspicuous early revelation that can leave a permanent imprint on the nascent mind and in some key ways defines the future. Again, in a similar manner, at my infant school we were often required to draw an image in wax crayon, and to write a short text below to describe it. I recall my crayon drawings getting progressively bigger forcing the text into an ever-decreasing channel along the bottom of the page. I am sure that such a ploy would not of course be exclusive to me. But it is interesting that some of my painting many years later would progressively squeeze the sparse elements of my personal iconography and narrative into an ever thinner channel along the bottom of the canvas edge.

So, as a painter, the threads that connect life and memory can be found woven in the fabric of the painting. In themselves, such small anecdotal experiences are not life-changing or visionary experiences. However, I will claim that at a deeper material and psychic level, painting *can* offer transcendental and transformative experience, which can unalterably change life's direction.

Subsequent to these early experiences with vanishing point and perspective, as with most other children, I entered that phase of vibrant and effortless art characteristic of the early years. One viable reason for the vitality of children's art is the fact that it is not concerned in any way with an analysis of the formal properties of depicted objects. Instead there is a more all-embracing, general representation of things through a child's subjective emotional response to them. In general, children have an innate empathy with objects, not clouded by concern with their actual appearance in the real world.

It has been claimed that modern painters such as Picasso, Miro, Klee or Dubuffet, for example, somehow retained or reclaimed in adulthood some of that energy and life so evident in painting during infancy. Commenting on Picasso's early painting, Patrick O'Brian recounts that when he was around ten years old his work was already relatively adult and academic, saying that his surviving pictures from this time:

> ...rarely show anything of that most impersonal genius which inhabits some children until the age of about seven or eight, then leaves them forever. Picasso's beginnings were sometimes childish, but they were the beginnings of a child who from the start was moving towards an adult expression: and perhaps because of this the drawings are often dull. It may be that his astonishingly precocious academic skill did not so much stifle the childish genius as overlay it for the time so that it remained dormant, to come to life again after his adolescence and to live on for the rest of his career − an almost unique case of

survival. Certainly during many of his later periods he produced pictures that might well have been painted by a possessed child – a child whose "innocent," fresh, unhistoric, wholly individual genius had never died and that could now express itself through a hand capable of the most fantastic virtuosity. (3)

Again, as in the normal course of events, my own early work in turn gave way to the typical representations produced up to and around puberty. Here there is a concentration on the details of the formal characteristics, which go to make up the appearance of objects in a more objective and emotionally detached perspective. It is probably no coincidence that this development occurs during a period of sexual latency, for just as there would appear to be a hiatus in sexual drive, so does there appear to be a proscription on lively and exuberant artwork during these years. There are certainly biologically adaptive and physiological reasons for this, and psychoanalytical theory has offered some interesting and plausible hypotheses. (4) It is the case that the acquisition and articulation of language at this stage of development demands a more detached and abstract mode of thought and reasoning, a mode of thought that could well be reflected in a comparable attitude in respect of art. (5)

However, it was also true in my own development that the childish, precocious element in my art remained much later than usual, and although I entered the expected phase of dull academic realism, my drawings and paintings retained a free and powerful style until a much later stage than is normally to be expected. So it may well be possible that the painter able to keep touch with the attitude of mind prevailing in these effervescent outpourings typical of the childhood years finds it easier to rekindle that strength and spontaneity in adulthood.

Fig.1 *Nude*
(48 x 40in) c. 1971

Fig.2 *Woman on a Bed*
(50 x 40in) c. 1971

Like many painters in the teenage years and the early twenties, I absorbed all styles and emulated those artists whom I admired greatly. *Nude* (Fig.1) and *Woman on a Bed* (Fig.2) are examples of my painting at this time. Painted sometime in the early 1970's, they both display the influence of Matisse and Picasso, with a strong sense of design and composition and bright, vivid colours. Through the window behind the nude there appears to be a row of pointillist trees paying homage to Seurat. Although reasonably proficient, both paintings exhibit the rigid control and organisation, which can sometimes reflect an inner reluctance to let go and open up a real dialogue with the painting. Many twentieth century modern painters felt the instinctive need to break free from this type of formal constraint.

Self-Portrait (Fig.3) is also symptomatic of this phase, being painted when I was 22 or 23 years old. It similarly shows a keen design, but again displays a rigid execution and I stare out from the canvas with an intensity that appears to insist upon a greater freedom. As with so many odd self-portraits painted around this time, the ever-present, stiff and constricting collar and tie, would appear to represent the constraints of strangulating convention, whilst the colourful design of the background elements seems to hold out the possibility of another direction in life. At its most elemental, painting is about nothing if not hope.

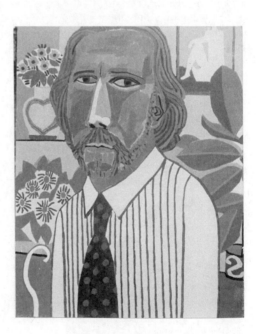

Fig.3 *Self-Portrait*
(50 x 40 in)
c. 1971

The compartmentalisation of areas in this painting and the rigid control brought to bear on its organisation can often reflect, I think, an inability to achieve an order and control in personal reality. As a result, an overbearing order is stamped on the image.

20

Paradoxically, this is coexistent with a need for personal freedom, but rules can only be broken when they are fully understood and have been fully absorbed. Despite this, the self-portrait does seem to be an early precursor of my later interest in the religious icon painting. The direct gaze out of the canvas at the viewer can symbolise the power of painting to act as mirror of the soul. In the original *mandylion* icon, the prototypical image of Christ stares out of the canvas in this manner. (6) Inevitably, the somewhat plaintiff pose of this self-portrait reflects the emotions encountered at this stage of life. In my case, that is the university years and their aftermath.

The apparently unending succession of dismal bedsitters and flats in an alien and hostile environment; the insecurity and futility of an unknown future; the struggle to gain self-confidence and a sense of self-worth in the face of the myriad challenges of life faced at this time, can give a literal edge to Melanie Klein's whole notion of the 'depressive position' in coming to terms with the real world. (7) It is this confrontation with the first real recognition of the infinite loneliness and absolute isolation that is everyone's ultimate condition, which can induce a real depression. As we shall see, painting, and the elemental creative process is, in its very essence, a template of these conditions.

The need for a greater confidence and with it a greater freedom in life, is inexorably linked to the innate compulsion to achieve a concomitant freedom within the materiality of the paint substance. Here is a crucial point that I have elaborated at length in many of my other essays: a real freedom through creative liberation can only be attained through a deep engagement with the plastic material medium of paint, and not, as is often supposed, through the imagery, symbols and narratives of painting. This key factor has been overlooked in many different contexts, including those of art criticism and of classical psychoanalytical criticism and theory. This is why art that *illustrates* ideas of liberation and transformation can only ever be just illustrative, and will not be able to actually engage with, or really effect any real liberation or trans-formation, either for the artist, or for the viewer.

I have discussed this in far greater detail in *Painting, Psychoanalysis, and Spirituality* (2001), not only in relation to modern painters, such as the American painter Philip Guston, but also to Renaissance artists such as Leonardo. I describe how the younger Philip Guston became frustrated and dissatisfied with his earlier socially committed murals and paintings, encountering the innate compulsion to engage the painterly creative process at its most essential dialectical core, where an absolute psychic liberation and transformation is truly possible. That is to say, he moved from painting where he *illustrated* the narratives of political and social freedoms, to a position where he had the power to actually effect a real psychological liberation, both within himself, and potentially with the receptive audience, saying: 'I would rather be a poet than a pamphleteer.' (8)

A factor that I stress in relation to Guston's evolution as a painter is that his early narrative paintings were illustrative both in terms of their content and of their form. That is, painterly form was constrained exclusively to describe and represent the narrative, and so was inevitably preconceived, controlled and relatively stilted by comparison with his remarkably ecstatic and transcendental abstract paintings which open up an exclusive dialogue with painting's intrinsic formal language of gesture and substance. It was here that Guston was to discover an authentic mirror of his emotions

and a plastic imprint of his deepest psychic processes. It is here that the painter encounters that timeless parallel universe where ultimate redemption awaits.

What is it that propels the painter towards this instinctively sensed position of total liberation? This is a question that to some degree I feel qualified to tackle in the course of this work, for I can recognise a clear correspondence between Guston's development as a painter and my own progress, however long and difficult that progress may have been. I unquestionably experienced the powerful inner directive for painterly freedom and for its reciprocal psychological liberation, a directive which I also came to understand could only be complied with in the boundless and infinite space of monochromatic abstraction. But, as with Guston, the transition had to be negotiated through varying stages of figurative imagery.

Recognising the limitations of my early works, works which rigidly clung to organised design and shape on the canvas surface, and which avoided the unconscious depth that painterly formal language can open up, I strove to find ways towards a greater freedom of expression. My attempts to set free my painterly style reflect the influence on my painting at that time of Expressionism.

Two Figures (Fig. 4) painted in 1973, shows the powerful influence exerted by Ernst Kirchner and German Expressionism. The garish purples, lavenders and reds against an acid yellow table certainly acknowledge the basic tenet of Expressionism: that subjective inner emotion is projected on to the painting and expressed through the vehicle of its formal and painterly qualities. Objects and figurative aspects are not so much depicted as they might seem to appear in external 'reality,' but are rather bent by the painter's subjective will into elements expressive of inner emotion.

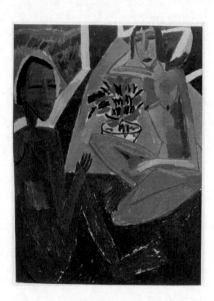

Fig.4 *Two Figures*
(43 x 38in)
1973

The couple shown in this painting sit in a pose reminiscent of Kirchner's paintings of himself and his muse Erna. The spiky, angular, brittle and contorted

22

figures are set in a sharp, pointed space where the whole floor and environment are tilted precariously forward threatening to dislodge the pictures unstable contents and eject them through the planar surface. Such a space echoes some of Kirchner's volatile and insecure environs depicted in his work. For Kirchner, the spontaneous and violent power of Expressionism articulated the instability and neurosis of modernity, where the pace of change had quickened alarmingly plunging headlong into an uncertain and unknown future.

In this way, Kirchner and other Expressionist painters made a wider cultural statement about the human condition and the alienation implicit in the modern world. For my own part, of course, at this time I was dealing with the personal concerns surrounding the evolving character of my own painting. I think that to appropriate an earlier style, in which a radical freedom is detected, can inevitably be useful in acquiring a deeper understanding of the painterly language. Painters have always undergone this process of learning and re-evaluation. But to use the cloak of a free style is no guarantee of access to a real engagement with painterly freedom. Although the painting *Two Figures* (Fig. 4) represents the surface style of freedom, both in terms of a much more spontaneous and freely painted style, and of an edgy and atmospheric composition, such works could not satisfy my inner craving and compulsion for an unknown state that I could only instinctively sense could ever exist.

Again the question surfaces: Why the irrevocable drive towards an intangible condition that cannot be visualised or rationalised? As I have already intimated, this question is central to the theme of this work and I will address it in greater detail when I analyse my descent into the unconscious dimension of pure abstract painting. But at this point it has to be made clear that this inner need demands a resolution and a satisfaction; that it is a force that will not be denied. In fact all my paintings at this time exhibit in one form or another this underlying force and the inner need to fragment and penetrate the surface conventions represented in painterly composition, shape and form, which are analogous of social and personal inherited convention.

As the conventional forms disintegrate within the parallel universe of painting, so the reciprocal restraints within the psyche of the individual artist will also dissolve. The stripping away of the congealed surface layers of constructed and often false realities and formal conventions represented in the painterly language at any given time excavates the underlying framework of the creative process. This process of distillation, of extracting the essence of the creative matrix, mirrors the inner psychic necessity to contact the earliest human developmental template and sequence of the first few months of life, which in all its essentials has the same characteristics as the structure of the creative process.

It is this parallel with the earliest psychic development which gives art and creativity its therapeutic and healing foundations. The painter who experiences that almost obsessive compulsion to commune with the creative process at its most elemental, is in fact experiencing the congenital necessity to re-engage with earlier formative periods of life and to effect a change, or a re-creation of a transformed self; a transformation effected through an alteration or reprogramming of those embryonic psychic developments.

My own need to decompose and dissolve those surface forms and what they stand for reflected the desire to redevelop the self. The painting *Two Figures* (Fig. 4)

23

that I have discussed represents the tentative steps to dislocate my painting's figurative and formal characteristics in order to engage with a deeper dimension. At this stage the disintegration of formal rigidity extends to a greater rawness in paint application and gesture, with areas of white canvas left exposed, alongside a disruption of figurative convention on Expressionist lines. But as I have suggested, such surface effects fell well short of attaining the degree of liberation that I aspired to reach.

I came to realise some years later that this innate desire to redevelop the self and to reconnect with the deeper dimension that I refer to, was my own compelling demand to address a long forgotten anomaly; to redress some archaic imbalance; to again make contact with something unknown that had been beyond reach for a long time; the mythical search for the lost half of the self. But the only way I could go back in time to the first few months of existence in order to relive that period of loss and to effect some kind of reparation, was through the creative process and the chance of a rebirth that it held out. I was also to discover in time that it was only through the portal of the abstract essence of this process that this could be accomplished.

The instinctive struggle to pierce painting's surface and to get beneath it, was not, as I have suggested, to be resolved in paintings with an Expressionist style. They could not offer the formal qualities essential to disrupt conscious faculties up to a point of absolute breakdown, which is an indispensable prerequisite necessary to bring into force a fundamental change. I had yet to recognise that a only a radical communion with abstraction could enable me to reach this point of complete negation of consciousness. I instead tended to rely on the disruption of figurative components and of the general iconography of my imagery.

This quest led me into a series of rather odd paintings that I have since tended to refer to as a 'psychotic phase.' Painted over a period of some three or four years in my twenties, I think that they not only reflect my clear need to dislocate my own surface conscious restrictions through a type of 'dissemblance' or contrived naivety, but are also undeniably indicative of my state of mind at this time. (9) For it must be the case that any individual willing to undertake the drastic measures of eradicating all of those conventionally accepted norms of perception and representation and to recklessly 'wipe the slate of reality clean,' has compelling reasons so to do. Bearing in mind that within the parallel universe of painting the shapes and forms can come to build a type of ultra-reality for the painter, a dimension potentially more real in many ways than 'reality' itself, there is in this dangerous pursuit an inevitable 'death' to be experienced: The death of the reality constructed over a number of years of life's development, and along with it of the conscious self.

The paintings in this psychotic phase, for example, *Woman with a Cat* (Fig. 5), were therefore both a *conscious* and deliberate attempt to radically reorder my own personal painterly traditions, and an *unconscious* reflection of my state of mind. I have touched briefly on the difficulties most people can experience at this stage of life in terms of the inherent insecurities so often attendant to these years. In order to consider why my painting took the direction it did, I need to tentatively explore the psychology that shaped them.

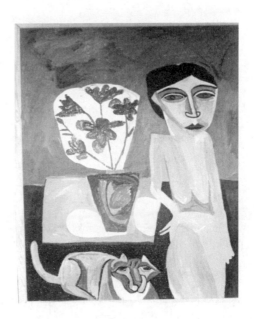

Fig.5 *Woman and Cat*
(65 x 48in)
1975

Any detour into self-analysis is fraught with problems and pitfalls, and it is not my intention here to attempt this in any great degree. After all, can it be possible to be objective about one's own psychology? I do not think it is really feasible and probably not even desirable. As a painter I have had occasion to baulk at attempts to critique artworks through a psychobiographical analysis of the artist. Psychoanalytical critiques of art have, of course, been notorious in this respect from Freud onwards. It was Freud who deciphered elements of Leonardo's painterly iconography to justify assertions about the artist's latent homosexuality. (10)

Some years ago, when embarking upon a doctorate in the psychoanalysis of creativity, I was told that I would be expected to undergo a course of clinical analysis in respect of training. My response at that time was that through the intensive self-dialogue within the dynamics of the painterly creative process, I had already undergone a course of analysis. Whether or not such a claim can be substantiated, there is nevertheless a distinct correlation between the creative process and the operation of psychoanalysis. Both can basically involve a type of exorcism in which parts of the personality, which may for some reason be problematic, are projected externally. In the case of the painter the excised aspects are projected on to the canvas, whereas in the case of the analysand, they are projected on to the therapist. At this very rudimentary level of the creative process, the painting equates with the analyst in making sense of alien exorcisms, just as the analyst can make sense of the patient's hidden motivations and alienated aspects of personality. (11)

In this light, therefore, the paintings can stand and speak for themselves, because ultimately, within their own dynamic, my own psychoanalysis is embedded. I think that this is very much the case in my later work. But my reference to the psycho-

logical motivation for these early paintings, with their psychotic-like character, assists in an understanding of those original factors driving the painter's Sisyphean task, along with my own long addiction to the process.

Without being too invasive of the privacy of both myself and of some relatives, it would be fair to say, I think, that from the earliest recollections my family background was dysfunctional. Today, dysfunctional families are a common phenomenon and I am not claiming that my situation was unique, although I think my environment was certainly eccentric and in some ways threatening. It is rather that I want to show how painting and the creative process can for some individuals act as a vehicle to deal with such issues. It is this function of painterly creativity that I shall elaborate on in this work.

Perhaps not surprisingly, my father was a very powerful and dominating character. He was a feared trawler captain during the 1950s and 60s, times of an extremely harsh and unremitting environment where severe weather in the Arctic hemisphere around Iceland and Greenland, combined with cutthroat crews, could conspire to break the spirit of all but the strongest. He was nicknamed 'the beast' and was both feared and respected by the men who sailed under him, few daring to question his authority or challenge his rule.

He played a prominent role in the fishing 'Cod War' disputes with the Icelanders in the 1960s Arrested by Icelandic gunboats on more than one occasion for fishing inside Iceland's declared coastal limits, he was imprisoned in the capital, Reykjavik. He made international headlines when with his crew he broke out of Reykjavik harbour with his impounded vessel along with the Icelandic guards still on board, and sailed out to sea, only to be recaptured days later. He had also been arrested and imprisoned in the Soviet Union in the late 50s, a state very forbidding with the Stalinist machinery of control still in place. I was only 8 or 9 years old at the time and believed, along with the rest of my family, that my father had been lost at sea.

It is probably inevitable that family frictions will be generated in an environment dominated by such an autocratic patriarch. The situation was to end in final tragedy when my only sibling and elder brother killed my father with a shotgun. Charged with murder he hired the brilliant Queen's Council George Carman, who is recently deceased. It was Carman's skill that managed to get the charge commuted to manslaughter, despite the fact that the final shots were discharged into the back of my father's head as he lay helpless on the ground in an act more akin to an execution than of self-defence. However, my brother's case was helped enormously by the fact that not one statement in police hands was supportive of my father.

The salient point about all this is that *I* 'murdered' my father in the dynamics of the creative process of painting, whereas my brother killed him in reality. I will give a clearer exposition of this in subsequent chapters, but it remains the case that within the simulated space of painting, the parent, in the guise of those formal elements representing formal control, can be obliterated. This is, of course, the whole basis of the Oedipal myth, and of *Oedipus Rex* by Sophocles, upon which so much psychoanalytical thought and procedure are founded. In actuality, they are both representations of the fundamental nature of the creative process at its core.

This unfortunate state of affairs surrounding my family does need some further comment in order to clarify the connection with the dimension of painting. I think it is

reasonable to argue in the light of my knowledge of psychoanalytic thought, however inadequate this may be, that my brother does have a psychotic personality, at least to a degree. As an infant my brother witnessed physical violence on a number of occasions. In one instance my mother was violently attacked and escaped through a window in order to stop an oncoming car, which took her to hospital.

It is hardly surprising that such an environment had a profound effect on my brother; the headmaster of our local junior school advised my mother to take him for treatment to a psychiatrist, which she unfortunately failed to do. This advice was given in the early 1950s when a greater stigma was attached to such events which were consequently relatively rare. Apart from the predictable neurotic symptoms of bed-wetting late in adolescence, nail biting and compulsive stealing, for many years throughout infancy my brother refused to defecate. Despite much coaxing and bribery, I remember that he would walk around for hours on tiptoes defying the desperate need to evacuate the bowels. In adulthood, his obsession with cleanliness has certainly led to the failure of more than one of his emotional relationships. I think it is highly significant that at the end of his trial the presiding judge described him as 'emotionally arrested.'

In this violent and threatening environment I was to a degree protected by my elder brother, who was inevitably in the forefront in his infantile attempts to protect my mother. In classical Oedipal fashion, he had an intensely close relationship with our mother, possibly even to an unhealthy degree. On the other hand, I cannot say that I was ever close to my mother, who openly admitted that she disdained me at birth. Similarly, my father was very distant and aloof and I never developed a relationship with him. My own response to this somewhat derelict household was rather to retreat into a private creative environment sustained by my inner world.

I do not think it can ever be possible to experience such a childhood environment and come through unscathed. We all carry our childhoods within us throughout our whole life. I was scarred in ways that were not evident to me for some time. In my twenties I suffered a deep clinical depression fuelled by periods of alcoholism. However, as I have already mentioned, through painting I was in time able to return to the key developmental stages of infancy, effect a psychological reconstitution, and return 'reborn.'

As a type of postscript to my resume of what are understandably highly sensitive and personal issues, I should just point out that my father was in many ways a generous, intelligent and cultured man. My brother, though wounded by these abnormal surroundings, has many excellent and positive characteristics. Nevertheless, the nightmarish scenario that my home life often degenerated into cannot really be conveyed by the written word.

The series of paintings that I have designated as being representative of a 'psychotic phase' were, therefore, symptomatic of both childhood trauma and a later depression. I am not suggesting they could be classed as actual psychotic art, a category of art analysed and defined by theorists since the early nineteenth century. (12) Neither do I wish to give the impression that my own personality was psychotic. Neurotic symptoms such as claustrophobia and depression, from which I did suffer, can be extremely debilitating, but are far removed from the severity of psychosis, where there is

27

a complete negation of reality in favour of what has been referred to as 'delusional systems.' Nevertheless, such neuroses can engender a degree of what psychoanalysis has termed 'dissociation' causing a split in the personality.

Psychoanalytical theory has generally favoured the idea that the healthier individual has managed to a greater degree to integrate the whole of the personality. On the other hand, the 'split personality' with evidence of dissociation, is one where unpalatable truths and aspects of character can be ignored or buried, dissociated or 'repressed' beyond the reach of the conscious self. Such a psychic defence aims to ward off and banish parts of the self, which for various reasons, perhaps the risk of loss of love or self-esteem, could threaten the emotional balance or psychic stability of the individual. Such aspects can include childhood abuse and trauma, which psychoanalytical theory argues can be repressed without trace, perhaps only to resurface many years later. Repression is a defence mechanism essential to the healthy ego, but is more severe in the psychotic or schizophrenic.

The basic point here, however, is that in dissociative states parts of the personality can be denied. These elements are exiled to unconsciousness. In the most severe states of dissociation, such as those experienced in schizophrenia or psychosis, the unconscious itself may be rejected and even feared as being the site of a kind of 'death.' I have argued that this rejection of exorcised parts of the personality can be detected and traced within the formal characteristics of psychotic art.

I have analysed these issues in greater depth elsewhere and drawn some tentative and speculative conclusions about the general formal or aesthetic characteristics of psychotic painting. (13) To a degree such generalisations must by their very nature be subjective and tainted by value judgements. It is also the case that others have made far deeper and extensive analyses of the characteristics of psychotic art. Perhaps most prominent amongst these is Hans Prinzhorn who assembled a vast collection of psychotic art and carried out a life long research, recording his analysis in the seminal study: *The Artistry of the Mentally Ill.* (14)

Although aware of the pitfalls of such an approach, I am suggesting that certain formal characteristics are more likely to be in evidence in psychotic painting than in other categories of art. For instance if we look very broadly at psychotic art in its authentic 'golden era' of the later nineteenth and early twentieth centuries, I think there can be detected an overall predominance of works which rely for their effect on one layer of surface forms and facture to delineate their figurations and imagery. That is to say, there is less evidence of superimposition of forms, of erasure, of traces of struggle within the process towards resolutions, traces that can be so prominent in the techniques and processes of modern painters. Many would disagree with such a sweeping judgement, but I think that it is true that psychotic painting would tend to have this characteristic in common with children's art, which so often involves one execution in one surface level of form and shape.

There are plausible reasons for this. As I have said, the psychotic is more likely to deny those unpalatable and untenable truths that perhaps need to be worked through and faced if the individual is to acknowledge the whole self. There can be a parallel denial in psychotic painting in a tendency to cling on to the clarity and safety of surface shapes and forms which are representations of deliberation and conscious

control, at the expense of those accidental, informal textures and anomalies which are discordant, dissonant and disruptive of formal convention and so of consciousness.

Such elements of the formal language of painting, of its plasticity and substance, have been described as 'inarticulate' in that they are really beyond the control of the painter and creep in unawares. (15) They would include the scratches and striations within the painterly brush marks and gesture; the 'bleeding' and drips of paint; the unplanned distortions of colour and tone; the fissures and rivulets within impasto and texture. The artist may be subconsciously aware of such aspects but cannot preconceive them or control them during the creative process. Such elements in the artwork carry the most forceful emotional loading and give art its vitality and punch. The reasons for this are rather complex but I have offered an explanation in other works. (16)

However, if we can subscribe to the idea that unconsciousness can be embedded within the texture and materiality of the paint substance, it can then be seen how modern painters could use heavy impasto and texture to demonstrate feats of integration of the whole psyche. Modern artists such as Jean Dubuffet, Nicholas de Stael, Frank Auerbach, Jasper Johns, Georg Baselitz, to name but a disparate few, are far more likely to engage with a much deeper material and tactile dimension, with richer and heavier impasto, and so potentially with deeper parallel levels of unconsciousness.

Although psychotic art would often involve an ambiguity of surface shape and figuration and strange, disconcerting imagery, it is rare to encounter this deeper dimension of material depth, a depth which can present the most radical, challenging and confrontational aspects of the creative process. At this level there can be a type of denial of conscious organisation that the psychotic may register as overwhelming, threatening to the point of an experienced 'death.' The relatively surface distortions of psychotic painting, therefore, tend to be restricted to curious dislocations of figurative elements similar in style to dream imagery.

In my own paintings in what I have called a 'psychotic phase,' I sensed similar factors at work; the need to liberate and exorcise the demons that haunted me, but being unable to make contact with the level necessary to release them. That is to say, I felt the frustration of the psychotic in the 'spontaneous creative phase' desperately attempting to heal the self, and being blindly propelled towards that elemental creative connection at its core, but unable to disrupt those conscious barriers preventing access to it.

In the painting: *Self-Portrait with Model* (Fig.6), I sit in the foreground forced into the glare of the viewer, tightly clenched and set apart from the model on the bed and the canvas on the easel which depicts her, two elements that must provide the only real hope of release and freedom. I think that this psychological limitation is reflected in the formal properties and painterly language of the painting. Although there is a surface, superficial attempt to free the formal conventions, it is only in effect 'skin deep.' The free brushwork introduced in limited areas of the painting are in a way afterthoughts, or gratuitous and do not really breakdown the rigid and tightly controlled composition, which is symptomatic of the repressed and confused figure, stifled in the ever-present suit and tie.

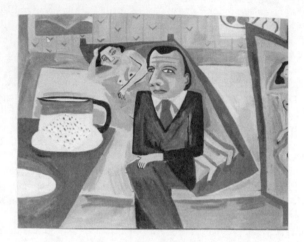

Fig.6 *Self-Portrait*
With a Model
(38 x 42in)
1976

Looking back at this picture painted now nearly thirty years ago, I see a basically proficient and well painted work. It is an interesting image, interesting for its curiously eccentric contrived naivety, which does lend it an air of the neurotic. Ironically, such a painting would probably be more acceptable in the contemporary post-modern climate, where notions of the authentic gesture are viewed critically along with ideas of painterly expression, in favour of the stilted and emotionally barren. No doubt the recent phenomenon of the 'Neurotic Realism' school would have whole-heartedly embraced such imagery.

At the time, however, this series of paintings were profoundly unsatisfying for the very reason that they did not engage with a deeper emotional reality. It is true that the figurative imagery was exactly what I was aiming for in its stilted, faux-naif style, and was very symptomatic of my state of mind. Underneath, however, remained the innate compulsion to form a nexus with the dialectic at the core of creativity.

The painting: *Self-Portrait with Nude and Cat* (Fig.7) is very representative of this phase of my painting. It demonstrates a further stage in the ambition to free my painterly style and to dislocate the figurative imagery, a figuration that has become oddly neurotic and peculiar to my situation. The execution of this work involved a far greater degree of spontaneity and freedom of approach in which I attempt to reduce the constraints imposed by the need to describe the figurative elements. There is less deliberation and control of the imagery and a more primitive and simplistic feel that is registered in the distinctly strange facial features. In one sense this is a move towards abstraction and a freer aesthetic and to a subordination of figuration in favour of a greater freedom in the painterly language. To this end I would rehearse the painting in my mind's eye to a point where I knew it so well that I could immediately execute the image without thought or consideration for the manner in which it was painted, or the expression of the figures, or aspect of the other objects. I would even paint these images without really looking at the canvas; that is, obliquely, almost blindly. I would certainly not deliberate at any stage on factors such as colour, composition, line, tonal

30

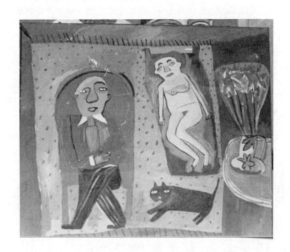

Fig.7 *Self-Portrait with Nude and Cat* (38 x 42in) 1976

relationships and so on, aspects which I had sorted out to the rudimentary point required prior to starting the work. I would even go to the lengths of painting these pictures with the canvas turned upside down, to deflect and subvert any inclination to engage with these painterly formal factors. I needed to defy the normal reactions to surface painterly forms in order to dissolve those representations of consciousness that form a barrier against a more arcane compact with the creative process.

The rehearsal of a painting prior to its execution in one sitting in a type of performance, has to one degree or another, been a key ingredient in my method of painting throughout my life. It is not easy to explain why this should have been the case, but I will comment on this further in the context of my later painting. At this point in my development as a painter, such a device served to strengthen the spontaneous and uncontrolled range of the painting, even if it was for only a short time. It takes determination, ego strength and the capacity to hold a distinct frame of mind, to maintain a free and spontaneous approach throughout the whole execution of a work taking much longer, with a more profound material dimension, and paradoxically demanding more of a type of control which can coexist with the spontaneous and not impede it any way. In this sense, I think, paintings such as *Self-Portrait with Nude and Cat* again reveal those similar characteristics to psychotic art, in the reliance on one surface film of facture, in the absence of freedom in any depth, within the very material substance of the painting.

As with many other examples of works in this series, the figure representing myself was often encased in a strange somewhat old-fashioned chair, which closes me off from the other elements in the picture. It is a chair which confines but also secures. The nude on the bed looks awkward, self-conscious and vulnerable, being precariously tilted upwards in the full gaze of the viewer. This is a vividly coloured painting in pinks, oranges, violets and browns, with a designed composition adding to the charged

31

atmosphere. It would seem that the aesthetics of this work again hold out the ultimate hope of a brighter tomorrow and the redemption that can reside in the creative process.

As with most painters generally, elements of personal iconography can be traced throughout work extending over many years. The chair, which encases me in *Self-Portrait with Nude and Cat*, was to appear many times over the years in my painterly vocabulary, always seemingly representative of a figure, whether parental or personal. In my paintings many years later the figures will totally disappear from view, although all the inanimate objects remain untouched and in place, as if a neutron bomb had been dropped on my painterly world.

It was at this time in my late twenties that I was to have the first profound psychological experience powerful enough to affect the course of life and to map my way forward as a painter. My problems then, both on a personal and on a social level, were at a critical point. My depression was very fierce, disabling any chance of leading a normal existence. Preposterous though it may seem with hindsight, with all seriousness for a short period I actually believed that blinding myself would solve my seemingly intractable hypersensitivity and vulnerability. It seems uncanny at times how my family situation seemed to be a monstrous incarnation of the Oedipus myth. Blindness seemed to offer escape into anonymity and freedom from guilt and the hell that was the intrusiveness of others determined to pierce and invade my inner world.

To be trapped in your own body, with a critical hyper-consciousness of the remorseless thumping and banging of your own heartbeat against your ribs is a kind of hellish wilderness where the concept of rest and peace never existed. There can be no respite when the body you live in has lost its mechanism for relaxation, a nightmarish scenario that alienates you from the real world. I am sure that my partner of long standing would in truth testify to the many nights when she must have been disturbed by the incessant vibration of the brass bed as I thumped and shuddered my way through the long night.

Such depressions are very common, but as is usually the case in these matters, you have to experience them yourself to get a real idea of the terror they can generate. I mention such a private state of affairs with great reservation and only because I need to in order to explain why I had to journey to the very depths of my being to affect a cure.

Fortunately for me at this period I visited an exhibition of contemporary painting that included some very large abstract works. Without wishing to sound melodramatic, I can say that I had a peculiar experience which left an indelible mark upon me. Whilst standing in front of a large abstract painting, placed quite high up on the gallery wall as I recall, I was momentarily lifted off my feet, swallowed completely up by the work itself, then placed back down upon the ground again! Sounds highly implausible, I know. Could it have been hallucination, autosuggestion or momentary light-headedness? Whatever, it was quite real.

I think that this was an ecstatic experience in the original archaic sense of *ekstasis* meaning 'out of body.' It was also an experience of the elation and all-embracing momentary 'high' or 'kick' that art can transiently convey to the viewer as it eliminates consciousness. I was to read much later how thinkers such as Adrian

32

Stokes and Anton Ehrenzweig had described this experience as 'envelopment' or 'engulfment.' (17)

I left the gallery, enthusiastically seeing works of abstraction on every door and wall surface and with a determination to recreate this psychological experience for myself within my own painting. I recognised that the instinctive craving that I had sensed for such a long time could be satisfied here, in the infinite and timeless dimension of abstract creativity. It was not possible for me at this time to know how or why this was the case, only that I must follow blindly.

It took quite a long time, probably 3 or 4 years, to recreate within the 'laboratory' of my own studio the conditions to once again experience this momentary trance state. For these to be met I needed to find a way to somehow disengage from all formal consideration in painting; with all consideration of those aspects which supposedly make painting what it is: with shape, line, colour, composition, tone, figuration; in fact with all of those elements which actually serve to construct what we perceive as 'reality.' It is only when all of these representations and surrogates of the real are eliminated that the painter can enter the transcendental void where the soul leaves the body and floats free.

CHAPTER 2

ABSTRACTION and INFINITY

In the opening chapter I began by suggesting that my life as a painter could be simply divided into three basic phases or stages. I went on to describe the salient characteristics of the work of my earliest period and what gave rise to it at that time. I also indicated those factors that propelled me towards a personal encounter with the infinite dimension of abstraction. This middle period of abstract painting was of relatively short duration and occurred in my thirties.

Early in Chapter 1 I also stated that in order to effect a penetrating contact with the very constitution of painting as a parallel universe and with the access it can provide to another dimension, the materiality and substance of the medium has to be exclusively engaged. The figurative works that I had painted into my late twenties basically relied upon the distortion of surface imagery to dislocate conscious faculty and to figure some of the complexities encountered in the emotional engagement with the painterly process, complexities which are in truth really beyond figurative representation. These works, especially in what I described as a 'psychotic phase,' only extended to a superficial level of facture and texture. In effect, they were quirky distortions of articulate surface imagery, devoid of substantial depth. (1)

I labelled these paintings as being part of a 'psychotic phase' because I detected parallels in their aesthetic formal characteristics with those of psychotic painting, especially in respect of the lack of reworking in paintings that were 'one-off' in execution and relied for their spontaneity on speed of working and a denial of a deeper contact with the work. Such a denial reflected a lack of ego strength, which ultimately only the creative process can generate. (2) I came to understand that only entry into an exclusive dialogue with painting's formal dimension could activate the psychological conversion that I instinctively demanded.

So as suggested in the first chapter, these paintings in their way were attempts to deform the *figurative* conventions of painting, but functioned at a level where they could not deal with the *formal* conventions of painting, as I perceived them. In fact I needed to strip away the accumulated layers of false realities and excavate the essence of the creative network, an essence that can radically reawaken some of the most formative experiences of human existence.

From the date of my powerful psychological encounter with abstract painting, a sort of vision on the Road to Damascus, the move towards abstraction was a gradual one, during which time many of my figurative paintings were dismembered and cannibalised to feed the demands of the abstract canvas collages that were developing. This was to be a defining feature of the middle phase of abstraction, that painted canvasses were continually cut up and recycled into further canvas collages. The same held true for the series of card collages executed at this time. Maybe the word 'execute' here takes on its true sense and betrays an essential constituent of the creative process in its often ruthless elimination of what has gone before. In the card

35

collages I built up actual libraries of marks and whole areas of marks, which could be immediately and spontaneously inserted into a collage, so circumventing the need to actually develop a discordant element.

However, before such collaged works could resonate with the same frequency as the deepest levels of unconsciousness, I discovered that over a period of time I had to work consciousness to 'death,' another dimension of 'execution.' That is to say, I felt the need to press the aspects of conscious control and deliberation to a point of exhaustion so that their resistance was broken and I could access and traverse the threshold of consciousness itself. It was in a series of abstract, monochromatic canvas collage paintings, made up of painstaking strips of canvas, that I was able to grind the fundamental components of conscious representation down to a critical breaking point prior to complete dissolution. *Untitled (Dark Red)*, 1982, (Fig. 8) is a relatively small example of these works, chosen for its clarity. Some were on a larger scale, demanding a greater conscious effort in preparation.

One clear objective evident throughout the whole series of monochromatic collaged paintings was to create a set of circumstances in which any considerations whatsoever of the conscious, deliberate organisational elements in the painting process could be totally obliterated. That is, I devised a *modus operandi* whereby those aspects within the creative dialogue, requiring any degree of awareness and controlled engagement, were self-evident within the work before the act of painting even began. The organisation of any composition and arrangement of shape; any consideration of colour relationships or light and dark; any evidence of deliberate line or contours, all were dealt with in the initial structure of the canvas collage.

This central tenet of these works held true for the earlier minimalist strip abstractions that I am describing, as well as for the collages developing at a slightly later date. I should perhaps make it clear also at this point that I had no idea whatsoever at the time why such issues were of such overriding importance to me. I was only motivated by blind instinct and it was only many years later that I achieved a greater insight into what was really going on in these works. But certainly at the time I sensed that those representations of consciousness within a painting had to be overworked, weakened and finally eliminated.

Fig. 8 *Untited (Dark Red)*
(20 x 26in)
1982

Powerful resistances are inevitably put in the way of any forces threatening to breach our conscious hold on reality. This is the case both in terms of the way we see or build up a picture of our reality, or in terms of our psychological reality. Inevitably this state of affairs is up to a point biologically adaptive. Elsewhere I have dealt with this subject in some detail, because I felt it was of paramount importance to explain that the real painter doesn't just produce a rendition or illustration of external reality, but in effect mimics and manipulates the very dynamic perceptual and psychological processes through which we construct our inner picture of that reality. (3)

In processes of human vision, the clearest most simplified image is distilled automatically from the myriad complexities that exist out of reach of our conscious awareness. Again, this is obviously necessary in an adaptive sense and fulfils an important function in maintaining the supremacy of consciousness. It can be shown that this state of affairs is also predominant in psychology where a healthy mental function needs to some extent to protect itself from unconscious aspects that could threaten psychic stability.

The point of all this is that the painter who wishes for whatever reason to circumvent these powerful psychological imperatives, must find ways to undermine the tough resistances forming a barrier. In the strip collages I made a move towards this through a laborious process of slicing up hundreds of strips of canvas that were actually all individually numbered and affixed to the canvas in the correct order, which had to correspond to the order in which they were cut. This can be seen here, where hundreds of meticulously cut strips of white primed canvas, all carefully numbered, wait to be glued on to the stretched canvas. (Fig. 9)

Fig. 9

Considering the apparently rigidly controlled format of these strip collages, it is something of a paradox that they were really a considerable move towards a total liberation of painterly form, and so towards a reciprocal psychic liberation as the two elements come to resonate on the same frequency in a type of mirrored reflection. The lengthy preparatory exercise in detailed control in fact served to weaken and dilute aspects of conscious deliberation by getting them out of the system. By contrast, the

relatively short-lived moment of free painting entailed in these collages seemed all the more liberating. It is as if the painter has to do a period of penance to earn the moment of freedom. To put it another way, the innate aspects of human psychology that inhibit freedom through devices such as guilt, conscience, repression and so on, first have to be appeased.

I have mentioned that a basic premise of these works was the elimination of those aspects that should constitute the fundamentals of painting, such as line, composition, colour, tonal contrasts, or gesture and texture. In effect, the removal of those aspects, which to all intents and purposes are supposed to be central to the very make-up of painting. However, in these strip collages, line was formed by the cut edges of the canvas strips; colour was a pre-selected monochrome, composition was 'all-over.' So in the actual act of painting none of these important factors needed any consideration. They were incorporated into the canvas structure beforehand.

In effect there was no painted line, or arranged composition, or selected colour arrangements or texture and absolutely no consideration of such things in the act of painting. They may have been evident to some degree, but as far as I was concerned they were far removed from my real objective, which was to isolate the inner core of the creative process when it is stripped bare of the factors of which it would appear to be comprised. It is only then that the elemental dynamics of the creative structure can be discerned and key human developmental sequences can be detected, along with other evidence for far-reaching possibilities in the psychological responses of artist or viewer.

Discussing these issues during a seminar some years ago I was explaining that these works were devoid of any consideration of such elements when someone commented: 'but these factors are all there, in the work.' I replied, 'Yes, but *I* didn't put them there,' to which someone else retorted, 'then who did?' In the end, I suppose that this is a very interesting question and one that is never easy to answer.

Although basically monochromatic, these collages did have slight tonal variations within the piece and so light could be intrinsically reflected, which I feel is an important function of the painterly surface. But this slight tonal variation did not interfere with the freedom of execution, being also considered prior to the creative act itself. The strips of canvas collage would be painted firstly, so that the channels around them, when painted, would automatically form the lines and the tonal variation. The format was really designed so that the painting could be effortless and free from any reflection on compositional balance, colour arrangement, or fineness of line. Such factors can cause enormous headaches for the aspiring painter.

In effect these works formed a rudimentary template upon which the act of painting could be practiced free from any problem or threat that the painting could 'fail' in any way at all. The composition could never appear unbalanced, or colour discordant, or line crude. Here was a basic grid in which all such conventions were taken care of and the act of painting in the creative process could be liberated from the need to serve such demands. In this sense such works had no connection with minimalism or post-painterly abstraction as cultural movements, but were personal creative exercises. But whilst appearing to a degree 'beautiful' and fine in their subtlety and delicacy of light, line and colour, for me these works were really the harbingers

of a complete break with the conventional ramifications of organised form, and of a future rawness and dislocation as positive expressions of discordance capable of challenging inner convention and developing a personal originality.

So the whole point of this exercise was to move towards a greater freedom in painting and towards a position of omnipotence, a position that analysis of the creative process reveals to have a key role. (4) However, in these works the duration of freedom and omnipotence was relatively short-lived. It was in the subsequent set of painted canvas collages that I was to recreate the deep psychological and ecstatic encounter with abstract painting that I had experienced a number of years previously.

The canvas collages were a development from earlier exercises and were still basically monochromatic and painted in 'all-over' style, but were far more complex than the strip monochromes preceding them. They were created from an ever-increasing resource of cannibalised and recycled works within which was incorporated a greater variety of painterly marks and textures. The strip monochromes had been created exclusively from pure primed canvas, whereas the collages now were built using other painted abstractions and so became more complex in the degree of their painterly vocabulary.

Untitled (White), 1983, (Fig.10) reveals a greater depth of painterly mark in terms of collaged elements of line, contrast and variety of shape, and range of colour and tone within a basically monochromatic spectrum. But the principle remained exactly the same as for the strip collages. That is to say, all of these elements were incorporated into the structure of the collage prior to the final act of painting, an act that ultimately integrates the polyphonic diversity into a coherent piece. There is still the same ambition for a complete freedom of painterly expression, again facilitated by the fact that these painterly elements were dealt with and included before the real painting process was initiated. But the greater complexity and fragmentation within these pieces inevitably precipitated a more critical position in respect to the ultimate breakdown of the conscious, rational and organisational facilities in their inability to negotiate the serial superimpositions that such collages developed.

So a pivotal objective of these instinctive abstractions was to precipitate a position of free painting, where conscious reflection and organisation was neutralised. Conscious organisation appears to malfunction or overload when confronted with a degree of complication beyond its capacity. Paintings such as *Untitled (White)* (Fig. 10) search out and trigger this critical point of breakdown, automatically initiating the engagement of a deeper, subliminal mode of psychic functioning. Strange though it may seem, and apparently against any reasoned judgement, this unconscious mode of operation, devoid of the reflection and contemplation of more rational consciousness, has a far greater capacity to cope with and organise a complex scenario appearing incomprehensible to the conscious mind.

Why this should be so is a difficult question and I have said that there must be some adaptive reasons for such an unconscious capability in human development. However, it is probably in art, whether in painting, music or poetry, that there is the most compelling evidence for this. Often in the artwork what at first sight appears as fragmentation, incoherence, disorder and even nonsense, seems uncannily to have some sort of sense and order to it. It is the nature of consciousness to react to an

unconsciously created mode of organisation as if it were chaos. This is one reason why it is impossible to consciously recreate or copy something which was spontaneously and unconsciously produced. (5)

Fig. 10 *Untitled (White)*
(42 x 44in)
1983

In *Untitled (White)* it can be seen that there is a diversity and fragmentation of line and shape and a much greater confusion of superimposition and depth within the overall pictorial space. Many of the collaged elements incorporate remnants of textures and painted areas of colours and fragments of line from earlier paintings. Superimposed over these shapes in some areas are collaged lines, sometimes collaged from pieces of canvas painted black, which have been partly suppressed and integrated by white over-painting.

This sort of action can develop anomalies that create insurmountable problems for conscious reflection in the very act of painting, and the painter's mind is compelled to switch over to a wider sweep and deeper unconscious mode of creative functioning and perception in order to process the elaborate network with which it is confronted. It is then that the unconscious creative process seems to mysteriously and spontaneously develop links and connections that can resonate in an almost uniform depth and integration throughout the whole of the piece, that shortly beforehand had seemed to be an impenetrable mass.

A legible example of the kind of circumstance that I am talking about can be detected within the collaged shape looking something like an inverted trapezium, seen at the bottom left of the painting and directly below the point of a shape that seems to balance on top of it. There is a partly obscured line of black paint running vertically across the left of centre of this collaged piece; a horizontal band of knifed paint dissecting it in the centre and running under an odd shape to the right. This relatively

40

vacuous line appears to exist in the deeper recesses of the painterly depth and certainly would appear to be far further beneath the surface than the collaged piece of horizontal line extending upwards from the top left corner of the shape in question. This immediately sets up a contradiction in that the fainter central horizontal line is in actuality painted on the surface of the trapezium that is collaged on the same plane as the darker line meeting the top left-hand point.

This is but one relatively conspicuous example of what close examination reveals to be a myriad complexity of such anomalies. Some of the collaged shapes and lines on the surface appear to exist on deeper planes, whilst other elements actually incorporated within the earlier levels seem to oddly sit on the surface. Lines which are perceived to logically run on with others on surfaced collaged shapes are revealed to travel underneath; lines which should meet up and continue as one do not do so, and there is an overall confusion about where lines actually exist within the planar depth of the work.

Some of the collaged elements are completely embedded within thick layers of paint in the apparent void behind the surface and others are plastered into place by swathes of paint applied with a palette knife. In a kind of paradoxical inversion, some of the surface shapes are pieces of primed canvas virtually unpainted, whilst the deeper recesses enclose thicker more opaque areas of paint in which collage is submerged. This is a subversion of what might be rationally interpreted; a subversion potentially confusing and even disabling to the expectations of the faculties of conscious perception. All this coexists with a range of inarticulate residue of acidic, rust-like toxic glue, canvas folds and tears, scratches and striations of painterly marks and distortions of colour and paint, which further disorientate a conscious reading of such a network.

It is important to bear in mind that these anomalies and irregularities were set up largely during the final and relatively short act of unconscious painting in which some of the surface elements are suppressed in favour of other elements originally in recession; where continuous passages can be dislocated and where continuity and connections or linkages may be set up between disconnected constituents apparently unrelated. This act of painterly integration was carried out wholly in subtle off-whites ranging from white to faint greenish hues and greys, but which are basically related to the original off-white of the pristine primed canvas itself. White paint is used to suppress some surface areas, highlight backgrounds, or perhaps in other areas to leak one into the other where the tones become one, in an act of orchestration where the serial diversity is transformed through an overall set of linkages and resonating levels of depth which strangely install an inner sense of order and uniformity.

This painting was actually the first one in which I was able to recreate within the laboratory of my own studio, the ecstatic experience I had first encountered whilst standing in front of an abstract painting some years before. As I began to enter into and engage with this labyrinthine matrix of superimposed infinities, armed with a paintbrush loaded with white and off-white paint, my cognitive, conscious faculty to direct events curiously deserted me. Absurd though it may seem, I found myself floating within the rafters of my studio ceiling watching myself paint the picture. The studio roof, perhaps fortuitously, contained my floating 'soul,' which might otherwise have continued on its upward drift towards infinity and oblivion. When I eventually returned to my own body, the painting was miraculously complete. My initial loud

41

exclamation 'I've done it, I've done it!' was soon superseded by the consequential question: 'done what exactly?'

It can be seductive to search out simple answers to this question and many have done. In my own case investigations began to disclose the wide-ranging ramifications of such a question, which extend to arcane and esoteric theological argument, metaphysics, mysticism and the more contemporary concerns of psychoanalysis. Conflated with this diversity of discourse and debate stretching as far back as human cultural development, are questions surrounding autosuggestion, self-hypnosis, hallucination, daydreaming, sensory deprivation and so forth. There is also the whole question of the relationship of this type of experience to sexual activity of one sort or another, a relationship discussed in significant theses. (6) It has even been suggested that the collage artist is susceptible to intoxication by the inhaled toxins of glue.

At this point I should perhaps point out that, for the most part, I think that I am a rational human being. I don't spend my time searching for UFOs or trying to make contact with spirits on the other side. I do not have any sort of religious background and I am not a practising religious person; I do not attend church and I do not pray, for example. In my research into this phenomenon I have rather tried to give rational, theoretical explanations in place of the relatively abstruse dialogue of mysticism and theology. There is no doubt, however, that these issues overlap and stray into different discourses that generate their own analogies and metaphors for such experience. In subsequent chapters I will try to give a clearer idea of these theoretical connections. Suffice it at this point, however, to say that the 'out of body' experience that I have briefly described, is the essence of the Greek *ekstasis*, the Greek word for ecstasy meaning 'to stand outside of or transcend oneself.' I think it is fair to claim that *ekstasis* is the foundation of all religious and mystical experience.

Again I think it is important to stress that at the time I was painting these works, I had absolutely no idea of any parallels or connections with psychoanalytical theory, theological discourse or mysticism. An abstract canvas collage that I painted at this time was actually given the title *Promised Land*, not because I perceived any religious connection, but simply because I had struggled instinctively for such a long time to reach this point, a point of infinity that I could not have known existed or had any clear idea how to get to.

The painting *Promised Land*, (Fig. 11) was a very important piece of work for me personally. Not just as a painter or as a researcher into the mysteries of the creative process, but actually in my development as a human being, for this was a work in which so much psychoanalytic theory that I was to read subsequently, made sense. I think that this is as it should be, for as Nietzsche argued, 'art is a re-enactment of life in another medium,' and he didn't mean simply in the sense of some sort of illustrative rendition of external life. (7) Rather he was referring to that ultimate potential of art to fundamentally recreate and re-enact life in its very essence. That is, as I have suggested, to access and reconnect the earliest developmental sequences which are universal in human maturational processes and which form a type of creative template through which radical transformation can be effected. In the painting *Promised Land* this for me was achieved and so the title instinctively suggested itself.

42

I will say more about the theoretical and dynamic implications of these works in subsequent chapters. At this point I will describe the process of their manufacture and distil some of the emotions that accompanied it.

Fig. 11 *Promised Land*
(58 x 60in)
1983

I have said that both in terms of my evolution as a painter and as a human being, this painting was pivotal. A key feature here is that through the use of canvas collage I could lift the apparent surface of the canvas in order to create an underneath, or another subterranean dimension beneath the surface. That is to say, elements and fragmented pieces of collage initially affixed to the original canvas surface on the stretcher, were then overlaid with larger sheets of canvas which created an apparent surface. Through gaps, cracks, holes and fissures in between these sheets, the earlier, deeper fragmentation can be glimpsed. In describing the process, I will make this point clearer.

Promised Land is a canvas collage painted in a monochromatic dark red colour. Originally I was searching for a colour which would serve my essential objective to isolate the painting process, and hence the creative process, by eliminating all other concerns. So the colour was not to be a colour that was obvious or clear-cut, but ill defined and ambiguous. In this way the conscious mind is deflected from locking into a clearly recognisable label or format inevitably bringing its constraining influence into play. Later I could recognise that this deep plum colour is also very much a psychological colour, a colour that evokes associations with the inner mind. In this sense it was absolutely apposite in its very depiction of inner mental dynamics.

I began this painting by placing the primed white stretched canvas of about 6 feet square on the floor of my studio. I covered the whole surface with glue. The first stage then involved the more or less random selection of those torn and fragmented

43

pieces, and collaged clusters of canvas, in the dark red colour, which were glued and dropped onto the surface of the stretched canvas. The glue on the canvas surface was slowly drying and so became very adhesive and securely held the fragments.

This dark red colour was being used in a whole series of paintings at this time, many of which had been cannibalised and recycled into further works. So canvas fragments and ripped elements in this colour would have been available in abundance and would often be scattered on the studio floor. Inevitably they would pick up some dust and become tainted with alien remnants of other paint, glue and dirt. However, this understandable and expected condition could in no way explain the peculiar reaction that these fragments induced within myself. In fact I experienced a deep revulsion and disgust to such a degree that I could hardly bring myself to pick the pieces up and it took a real effort to glue them as quickly as possible and to eject them on to the canvas surface. How can mere pieces of canvas arouse such hostile emotions?

Again, such questions may seem straightforward and relatively simple. However, it soon becomes apparent that in the effort to unravel such a question, complex sets of propositions are encountered. But one thing seems immediately apparent even at such a rudimentary stage of the creative process: its unique power to set up parallels and analogies that can provoke reactions from our deepest instincts. The apparently poisonous and toxic characteristics of these elementary and raw projections in the creative process can generate feelings of intolerable anxiety and apprehension within the susceptible artist or viewer, as some early and fundamental developmental processes and all that they can entail are once again activated and have to be faced.

It is perhaps incongruous that it is at these most preliminary stages of the painterly creative process that the fiercest reactions can be experienced. In fact it is at this radical level of formal dynamics that the creative template in its essence is exposed and it functions at a far deeper unconscious level than that of visual imagery and representation. This potential of the creative format to re-engage with essential maturational processes has often been misunderstood. Even psychoanalytic theory, which offers some of the most plausible hypotheses to explain such strange phenomena, at times falls prey to the literalised explanation. The toxicity of initial painterly projections lured some into the somewhat banal and simplistic conclusions in respect of their origins.

It is the case, however, that through the creative process we can access the very earliest processes of development. Inevitably, in such a deep regression we must encounter and re-engage with some of the most formative experiences in early human life, including the acquisition of feelings of disgust, which in the very young infant are usually non-existent. However, this led some schools of psychoanalysis and psychotherapy to literalise this possibility through a type of therapy in which patients were encouraged to act as infants again and to regress to infantile behaviour and to accept noxious products. A good example of this is to be found in the case of Dr. Grace Pailthorpe and Reuben Mednikoff. (8)

It is true that on one very rudimentary level in the painting *Promised Land* the fragmented projections acquired the characteristics of noxious substances and the inclination to bury them under layers of canvas sheets perhaps further underlines their more regressive associations. However, I think that it is really the psychological or

internalised psychic representations of these processes that are really at stake in the creative process. At least one prominent school of psychoanalytic thought, the 'Object-Relations' school, recognises that for every external experience we have, we automatically internalise a psychic counterpart or corresponding internal memory of it. *Promised Land* is not a painting in the accepted sense of an artwork, but rather a personal psychic framework in which this absolute duality is exposed.

I want to say more about how I came to apply psychoanalytical models to these works later in this book. But I should perhaps indicate at this point that psychoanalytical theory recognises the dense and entangled relationship between feelings of disgust and of uncanniness, and between feelings of ugliness, disgust and art and aesthetics which seem to function on one level as a mediator and container or counterweight for the poisonous and toxic threat that such elements can be perceived to carry. As I said earlier, the excavation of the creative process undertaken in such works as *Promised Land* reveals its inner mechanism much like removing the back off a timepiece.

The tendency to literalise the psychic representations actually making up the creative process has lead not only to much crass therapy, but also to much bad art. More knowing artists may well ironise this tendency towards the literal banalisation of art. We can see references to these issues in the work of the Italian conceptual artist Piero Manzoni, who canned his own faeces in his 'canned shit' pieces of the 1960's (one apparently recently exploded); in the elephant dung paintings of the contemporary painter Chris Ofili; or in the semen and urine paintings of the first post-modern artist Andy Warhol. I have discussed this at greater length in a recently published paper. (9) Such literalisation can miss the key psychic representations that in the final analysis form the basis of mental life. Even the brain, as the thinker W.R. Bion acknowledged, is a parallel digestive system, a correspondence embedded of course in the word anal-ysis. (10)

So even at the most elementary stages of the creative process attempts at understanding can already encounter deeper implications than would have been foreseen. In the execution of *Promised Land* these processes were automatic and instinctive and free from the analysis that I subsequently undertook for various reasons. In these first stages I could only recognise that there was an associated anxiety, discomfort and even threat, and a consequent need to expel and inter these projections as quickly as possible.

The basic process of manufacture of *Promised Land* was initiated, therefore, by the random selection of discarded and cannibalised fragments of canvas collage, some of which were conglomerates with embedded canvas elements from earlier cannibalised pieces, being expelled on to the prepared canvas surface and pressed into the glue. These included remnants of canvas strips, nodules, previously glued clusters and torn fragments. These were then overlaid by large rectangular sheets of canvas, already painted in the dark red colour, in such a way that long thin vertical channels separated them. In Fig. 11 we can see that there are four main large rectangular sheets vertically placed, running from top to bottom, which form three narrow vertical channels running nearly the whole length of the canvas. There is also a much thinner sheet of canvas on the extreme right hand side of the painting creating a smaller channel to its left.

So the first stage in the process of this work exclusively involved the application of canvas collage on to the glued surface. No painting was involved; virtually all of the elements had been coloured at some prior stage, although some white primed canvas would also have been in evidence. The overlaid canvas sheets form a new canvas surface above the original surface of the canvas mounted on the stretcher. They are applied in such a way that gaps or fissures are formed where they fail to join up and they also have holes, cracks and cuts in them which also allow a glimpse of what is going on underneath. This apparently submerged depth is made up of a conglomeration of collaged elements; strips of canvas embedded in paint and collage; jagged corners of bent and folded canvas; lumps of dried oil paint; areas of thickly impastoed knifed paint superimposed with thinly painted pieces of canvas clearly displaying the canvas weave.

The canvas sheet overlaid just to the left of the most central vertical channel; that is, in effect the canvas sheet second from the left of the painting, shows clearly in its upper areas the nodules, bumps and undulations formed by the pressure of the elements underneath. The relatively thinner canvas surface of this sheet is clearly deformed and prised upwards by the underlying eruption. These eruptions are echoed down the ripples of its right hand edge, that is effectively the selvedge of that canvas piece. There is a circular area to the right centre of this sheet which exposes a ridge of canvas collage embedded beneath. To the extreme right of this circular shape are two swathes of greenish paint applied with a knife and exposed within the channel formed between the two sheets. Extending horizontally on to the next canvas sheet is a prominent ridge forming a sort of counterweight to the horizontal slices in the far left canvas sheet. On the same central level as the circular shape on the second sheet, but on its left edge, is a small square shape. This square has been effectively patched up.

This is a recurrent feature throughout this collage: that areas ripped or cut open have been patched up or repaired. Not repaired in the sense that there is a seamless join, but in the sense that the mechanics of the repair are clearly discernible. To this end, slight discolorations of the basic monochromatic colouring are used to expose the inserted piece, which might also be of a different kind of canvas material. In other words, this is not invisible mending; the join can be seen and the crucial relationship between the attempt to heal the split and the degree of repair is laid bare. In this way the mechanism of the inner painting is excavated and not only the artist, but also the sensitive viewer can be embroiled in and conjoined with the creative process and can access fundamental and universal formative experiences.

The basic premise of this first creative stage is indeed part of universal human experience and is well represented in mythology, not least in the archetypal figure of Dionysius. (11) The initial dismemberment with the associated ripping and tearing, fragmentation and loss, is to be followed by a repair, or what psychoanalytic theory tends to refer to as a 'reparation,' a reintegration and a new cohesion formed from the chaotic destructiveness of early creativity. This idea, that art has so often been essentially about a destruction followed by a restitution, goes back far in human history. Many object-relations theorists, most importantly Melanie Klein, Anton Ehrenzweig, Adrian Stokes, D.W. Winnicott and Hanna Segal, have tried to define exactly what this reparation actually consists of and what exactly is being repaired.

An early memory was brought back into focus by my efforts to understand the painting *Promised Land.* I have said that my choice of colour in this work was prompted by the need for a degree of ambiguity and because the colour instinctively evoked subconscious references: it seems the colour of the unconscious mind and so was ideal to parallel its inner processes. However, I also have a very distinctive memory in relation to this colour from the age of about 4 years. I know for certain that I must have been either 3 or 4 years old because my family moved house when I turned 5 years old. My mother had bought me a toy lorry, which as I remember, was a sort of removal truck. It was coloured dark plum red. I had been shopping with my mother and we then visited a friend who lived opposite.

Whilst my mother and the friend gossiped, I dismantled this toy vehicle, in effect taking it to bits, removing the wheels and rubber tyres along with anything else I could get off, leaving just a shell. I was greatly excited and pleased with the present and so to this day, so many years after the event, I can still recall the extreme pain of loss that shot through me when it dawned upon my young self that neither me, nor anyone else, would ever succeed in putting back together that dark red toy lorry. I think that the series of red monochromes that I executed many years later in my thirties, with their ongoing process of dismemberment, recycling and reparation, were at least on one fundamental formative level, a belated attempt to put back together that toy lorry, and with it, all that it represented in the infantile mind.

The second stage of the creative process in *Promised Land*, which is structured basically in the same way as the other painted monochromes, involved the actual painting process, which effectively completed the reintegration of the superimpositions, distortions, textural anomalies and the whole range of polyphonic diversity. Most of the original canvas on the stretcher would still be primed white. Although covered with a diversity of fragments and overlaid with the painted canvas sheets, the channels, holes and cracks would still be predominantly white, although a white discoloured by yellowish glue, remnants of oil colour, scratches and other marks. The act of painting, which is a short-lived process here, perhaps only lasting minutes, applies a similar dark red colour to quickly cover the whites, the glue and so on in a spontaneous act of unification and reparation. Inevitably some of these discolorations will not be completely covered and will show through the red paint.

Again, it is at this second and central creative stage, that whilst painting quickly in an attempt to encompass the infinite disposition of the apparent chaos, the conscious determining faculty loses its way, and the brush, like the broom of the sorcerer's apprentice, takes over and unconsciously completes the work. (12) As I became enmeshed and submerged in this unconscious creative act, I again experienced the peculiar sensation of envelopment, the same sensation that I had encountered some years before. It is as if momentarily, the whole womb of the painting draws you into itself in a total engulfment. The loss of the self in this mystical union can be found in the core beliefs of mysticism and religion, particularly those of the Eastern world. Many others have attempted to come to terms with this uncanny experience, an experience that words alone cannot possibly hope to convey.

I am writing, of course, from the perspective of a painter evolving at that time through a phase of developmental abstraction and inner research. My analysis and

description, therefore, is of the pure essence of the creative process at a level that has been described as 'the minimum content of art.' (13) Such apparently reductive and formalist terms are not very popular in contemporary cultural debate where the emphasis tends to be on the extension of categories of art and on the dismantling of formalist barriers. However, I have to say that I do believe that at this level of the creative process an irreducible essence is encountered, a minimum content that reveals the creative template in its most essential format.

I have tried to understand this phenomenon, therefore, in the context of the essential creative act, an act that is fundamentally identical to the essential tribal ritual performance stretching back through human evolution. I recognised that during an unconscious creative engagement where deliberation and control is critically diminished along with those representations in painting through which they exert influence, evidences and traces of unconscious activity are inevitably imprinted into the painterly surface. In effect, elemental aspects of psychic functioning and processes are externalised. When the artist or viewer looks at the work there can be a sort of recognition of a psychic mirror image and this fleeting glimpse of a reciprocal psychic structure can lead to the momentary experience of envelopment.

This, of course, can happen on a more conscious level when we inadvertently catch a glimpse of our image in a mirror. I think that at some point the whole experience is related to the so-called 'mirror stage' in human development, when the infant first recognises his or her own image in a mirror. This mirroring of psychic operation was referred to by Adrian Stokes as a 'parallel amalgam,' whilst the French psychoanalyst Jacques Lacan recognised the critical nature of the mirror stage. (14) I have also discussed this phenomenon in a more theoretical context elsewhere. (15)

In effect, in the painting *Promised Land* I set up a series of surface conditions that ultimately could only be processed by the wider serial scope of unconscious creativity and in such a way that unconscious processes are substantiated in an essential relation to consciousness in a minimal model of the creative process.

The phenomenon of envelopment, along with the out of body experience I discussed earlier in relation to *Untitled (White)*, (Fig. 10), are not, however, the whole story. In the grey painting *Untitled (Grey)*, (Fig. 12), I was to encounter what can only be described as the full 'oceanic' experience. Again, the oceanic experience has been well documented and crops up in many different contexts and I will in due course make further reference to the observations of some of the important thinkers on the subject.

In the abstract canvas collage *Untitled (Grey)*, (Fig. 12) I was to engage with the most forceful exposure to the oceanic experience. However, the basic format of this monochromatic collage was once again simplicity itself, involving only two main stages. As with the other monochromes in this series, fragmented elements garnered from other grey canvasses were glued all over the stretched canvas surface.The collage was subsequently painted over randomly in a grey colour, a process that submerged some elements, surrounded and embedded others whilst leaving them relatively untouched, or partly covered in.

In this case I had pre-prepared two or three canvasses as raw material for the collage. It is possible in this case, therefore, that the cannibalised pieces of scratched

and black line ultimately had more of a genetic correspondence, which may have resulted in a greater sense of integration and so to a deeper oceanic experience.

Fig. 12 *Untitled (Grey)*
(47 x 52in)
1983

Some of the fragmented elements appear to have fragile white lines incised into a single coat of grey paint; some have both scratched lines and painted black lines on grey; other pieces of collage are simply white primed canvas with perhaps the odd scrap of black line or cluster of dots; some have the black line extinguished by grey paint; sometimes the lines and scratches suggest that they belong in line with others, but might not meet up properly and so on. As with the other monochromes, the essential proposition held true: that the disorganisation, dislocation and disjunctions could not be rationalised or ordered logically. Any synthesis or integration could only be decided intuitively.

I think that it is appropriate to claim that such abstract paintings expose the vital nucleus of this complex creative process. That is to say, in their minimalism a relatively simple model of the inner workings of creativity is developed. Within this apparently elementary construction, the myriad confusion of the unconscious creative process can be detected and to a point manipulated. The vacuous and infinite edges where fragments are practically totally submerged; the fragmented lines, some existing over, or under, or within paint and collage; the lost scratched line in areas painted over, but discernible in other places rising to the surface, are all factors contributing to this delicate and fragile web. Within this construction, crude and brutal line, incongruous and disparate areas of texture and glue, collaged fragments some of which are virtually white with only a residual thin covering of grey and so on, all seem to find appropriate levels of coexistence way beyond any conscious scope of perception or representation. (Fig. 12a)

Fig. 12a *Untitled (Grey)*
1983 (detail)

Although painted over twenty years ago, I can still remember the action vividly. Shortly after I began the crucial second, or central painterly stage, a truly surreal and fantastic thing occurred. I began to paint at the top right hand corner of the canvas to quickly integrate the disparate vestiges, shapes, raw black line, exposed white canvas and glue, scratched line, and was moving downwards when the vertical canvas seemed to slide down to a horizontal position. Suddenly and inexplicably, I found myself at the centre of an endless grey sea, with its surface covered as far as the eye could see with floating fragments or flotsam of canvas collage, scraps of line, painted and glued canvas, all rising and falling around my person half submerged at the centre of its infinity. I was not in any way fearful of drowning, being overwhelmed or lost; rather the experience was to be expected and welcomed and, at that time, didn't take me by surprise. When I was once again deposited on dry land, the painting had been completed.

Naturally, after such and intense encounter, the term 'oceanic' seemed all the more appropriate to describe the experience. There are, of course, many allusions to such transcendental creative engagement by other writers and painters, such as Herman Melville and William Blake, and by noted mystics. Nevertheless, imagine my absolute astonishment when only this last year, over twenty years since I painted this collage, I read an account of an identical experience described by the Indian mystic Ramakrishna, who lived from 1836-1886:

> One day I was torn with intolerable anguish. My heart seemed to be wrung as a damp cloth might be wrung…I was racked with pain. A terrible frenzy seized me at the thought that I might never be granted the blessing of this Divine vision. I thought if that were so, then enough of this life! A sword was hanging in the sanctuary of Kali. My eyes fell upon it and an idea flashed through my brain like a flash of lightning. "The sword! It will help me to end it." I rushed up to it, and seized it like a madman…And lo! The whole scene, doors, windows, the temple itself vanished…It seemed as if nothing existed anymore. Instead I saw an ocean of the Spirit, boundless, dazzling…In whatever direction I turned, great luminous waves were rising. They bore down upon me with a loud roar, as if to swallow me

50

up. In an instant they were upon me. They broke over me, they engulfed me. I was suffocated. I lost consciousness and fell...How I passed that day and the next I know not. Round me rolled an ocean of ineffable joy. And in the depths of my being I was conscious of the presence of the Divine Mother. (16)

This account is given in Romain Rolland's Biography *The Life of Rama-krishna* first published in 1929. Rolland, a French philosopher and thinker, said: 'I am bringing to Europe, as yet unaware of it, the fruit of a new autumn, a new message of the Soul, the symphony of India, bearing the name of Ramakrishna.' The publisher comments that: 'he obviously thought Ramakrishna had something extraordinary to say to humanity as a whole.' (17)

It is evident from Rolland's text that for Ramakrishna this was the ultimate vision that he had long sought and had long suffered to access. He endured humiliation, debasement, complete loss of control, a body racked with pain and shaken with spasms in order to reach that point of no return, 'the very edge of the abyss,' where 'there is nothing but descent into the darkness of apoplexy – or vision.' Rolland also notes that Ramakrishna 'knew nothing of the science of directed ecstasy, as minutely noted and codified by religious India for centuries past with all the minutiae of a double Faculty of Medicine and Theology; and so he wandered haphazard, driven by a blind delirium.' (18)

I have referred to this account of Ramakrishna's mystical experience at this point because it so closely parallels my own creative experience. I was astounded because years before I had myself described this phenomenon in such similar terms stating on more than one occasion that in the midst of it as far as the eye could see I was surrounded by huge grey waves rising and falling about me. I also want to draw attention to Rolland's reference to the fact that Ramakrishna was 'driven by a blind delirium.' I have described the blind instinct that propelled me towards an encounter that I could only instinctively sense. Progress towards this radical state, as Ramakrishna relates, can be extraordinarily painful and slow to remove that 'thin partition' which can seem so impossible to break down.

I certainly found that the removal of that thin partition in painting took some years of painstaking progress. It can be all too easy to deal only with that thin veneer of reality in surface representational painting which merely illustrates our existence. I had to resort to the metaphor of the fragmentation and destruction of those vestiges of representational surface; those islands of consciousness, which when subsumed in the unconscious creative process, also served to subsume the reciprocal conscious functions within my own psyche. As I have described, I also resorted to the somewhat extreme metaphor of a false surface ripped and torn to reveal glimpses of a subterranean stratum beneath. Again, a visual metaphor that further invokes a reciprocal reaction within the real mind.

I also mentioned Ramakrishna at this point in order to underline the fact that the process can be a long and painful one. I am not suggesting that the painter experiences 'the limit of physical endurance,' the 'face and breast reddened by the afflux of blood,' the 'eyes filled with tears.' (19) But the slow progress towards an oceanic transcendence can be fraught with deep frustration and longing. Because the ultimate goal is vague and indefinable before the event, there can be no guarantee in attaining

it, and the metaphors of threat and anxiety that the painter may deal with, innocuous though they may appear to some, can be overwhelming and disabling. On more than one occasion I have come across painters who were utterly paralysed and unable to make even the most rudimentary of painterly marks.

As I have said in reference to my own development and background, this process can often be associated with some form of neurosis or depression; with a dysfunctional background and resulting social inadequacy and alienation. This is why it is such a long process and the innate sense of dissatisfaction and lack is usually rooted way back in a failure to properly engage with and to negotiate the original developmental sequences in the early months of life. This defect dogs the individual who is always aware of the maladjustment. Depression and alcoholism are just two symptoms of this psychological hiatus.

In religious narratives, which are really describing the human individual's maturational development, this alienated condition is symbolised by the idea of the 'wilderness.' Again, as I indicated earlier in the first chapter, access to this creative core actually gives renewed access to this formative developmental sequence. So the artist who is able to penetrate this essence can reformulate development and, in effect, can redress an imbalance and rectify a failure suffered in infancy. In this light, the foundations of art are indeed therapeutic, as are also the foundations of religion and religious ceremony, which is predicated on ritual. Again, ritual has the same basic structure as the creative framework and can also access key maturational phases. At some stage the individual must engage properly with these processes in order to deal with external reality, to mediate conscience and guilt, or aggression; to effect reparation and restitution and to respect the autonomy and individuality of others.

At the time I was painting the canvas collages, I also executed a long series of collages constructed from card. These card collages are probably even more definitive of the creative matrix than the canvas monochromes. In their exclusive use of off-white card, drawn pencil line and glue, they present a clearer model of the inner workings of creativity. They seem to expose the underlying relationships that form the essential dialectical core at the level of the 'minimum content of art.' I remember instinctively describing these collages as 'blueprints' for the creative process – or at least for my own take on the creative process. In fact throughout my life as a painter I have returned to this essential creative diagram in order to regenerate and revitalise my own creativity.

Some of the earliest card collages in this series had titles such as *The Escape*. Indeed, I did experience a very profound sense of creative liberation in these pieces. Again, I want to stress that at this purely formal level, a parallel psychic universe is set up, where there is a direct consonance acting like a mirrored reflection. Actions in this parallel dimension automatically induce a reciprocal and identical psychic response. So a creative liberation enacted in those plastic artistic analogues, invokes a psychological liberation.

How this sense of liberation is generated psychologically will be explored later from a theoretical perspective. I have already mentioned the object-relations school of psychoanalytic thought which provides some useful models to explain how these corresponding internal and external processes intrinsically converge. But in the

discussion of the construction of these pieces I will again restrict my comments largely to the practical processes involved and I want to look briefly at the card collage illustrated, (Fig. 13), because it is such a good exemplar of the theory of creativity and clearly validates some of the psychoanalytic developmental models of the creative process.

Fig, 13 *Untitled*
(18 x 30in)
Card Collage
1989

The card collages comprised the same basic processes and stages as the painted monochromes. In the *Untitled* collage (Fig. 13), the initial stages centred on the development of raw and spontaneous elements and fragments of pencil line, some hatched aggressively or scribbled inchoately; some fine and delicate, some black and crudely forceful; some appearing deliberately executed, whereas some appear totally random. In fact, a wide variety of line freely drawn on sections of card, then compounded with others, some obliterated, cut short or ripped and torn leaving only vestigial traces. Some pieces would have been extracted from earlier examples, but the majority of the marks would have been produced for this collage. However, they would still be made completely arbitrarily and compounded and isolated into related conglomerates.

These compounds incorporated levels of superimposed card leaving traces of earlier workings exposed beneath. In this collage it can be seen that there are five basic sections placed alongside one another, each carrying related marks and textures. At their edges and margins remnants of lines and marks can be detected underneath forming apparent earlier traces of process. The underlying line, almost completely obliterated apart from this tentative marginalized evidence, seems to set up analogues of unconscious linkages crucial to the creative process. These fragments of line inevitably appear in deeper recesses of the pictorial space and set up a dynamic evolutionary process of drawing together earlier spontaneously projected elements into a synthesis or cohesion nearer to the surface, a surface at the same time material and psychical.

In most of the card collages that I carried out in this series these disparate sections would have been integrated in the second stage of the creative process both by their relative placement and ultimately by a final painting process in which off-white paint colour would sensitively resonate between the levels and density of the space. This final act of applying white paint would also reflect and enhance the very subtle

hues of off-whites presented by different pieces of card. Some would be closer to a pinkish white, some to a greenish white. These variations would be intuitively sensed and made to resonate against one another in the overall orchestration of a vibrant pictorial space.

However, in this particular collage, there was no painting whatsoever. The integration of the piece is implied rather than carried out. Its cohesion depends upon the relationship of the various conglomerates and the generic correspondence of the marks. The violently torn and ripped card of a collage which has been virtually attacked, exposes slight variations of tone again providing linkages and threads throughout the structure of the collage. Hence the radical contradiction central to the creative process between incongruous, untenable remnants, fractured and dislocated, and the uncanny power of unconscious creativity to somehow confer an overall cohesion, is heightened to a more critical point.

In this manner, this type of blueprint in its testing of critical levels and the capacity to provoke them to a point of breakdown, is actually researching and examining the potential of the inner creative balancing act to make an accommodation. At the same time what is also being tested and arguably ultimately strengthened is my own personal toleration to the invasive nature of aggressive and toxic psychological analogues. In the process, a dialectical model of the creativity is constructed, a model in which the presence of yellow toxic glue takes the analogy on to a more literal level.

The fact that in these later collage pieces the degree of integration carried out in the so-called 'manic-oceanic' stage was implied rather than actively engaged with, is an important point both from a developmental point of view and in respect of the psychoanalytic theory which aspires to understand the whole process. I stress this point here because it does have a bearing upon the comments I will further make on the subject. Suffice it to say at this point that in jettisoning the oceanic stage, a developmental defence mechanism has been dispensed with, at least for the time being.

Two of the last abstract collages painted late in this series display more distinct evidence of this trend. (Figs. 14&15) The vague, ambiguous and diaphanous quality of the earlier collages, such as *Untitled (White)*, (Fig. 10), with the invitation to partake in an experience of infinity, have given way in *Recollection* (Fig. 14) to a far more solid pictorial space and distinctive organisation of the picture plane.
In line with the earlier collages in the series, *Recollection* was formed from recycled and cannibalised canvas pieces from other works, but here they have become condensed into more definite and prominent clusters of thick, painted coloured line, canvas, wax and glue. That is to say, the painted line was created on the elements prior to assembly, so bypassing the oceanic stage of total integration. However, I think that this collage makes a more powerful reference to another central factor in the creative process. That is its role in the precipitation of clarified aspects out from a vacuous matrix, or what might be described as a primordial psychic 'soup.' In its replication of fundamental psychological processes, the abstract painting exposing the essence of creativity will clearly depict this process of psychic development in which the perceptions of the object and ultimately of the symbol are distilled and extracted from the amorphous unconscious.

Fig. 14 *Recollection* (62 x 84in) Fig. 15 *Figment* (36 x 48in)
1985 1985

 This is why in so much painting, whether in the context of modernist abstraction and figurative painting, some contemporary painting, and in painting stretching back to the Renaissance and beyond, there is the tendency to leave evidence of earlier traces of the artist's creative process, through to later resolutions and closures. In this way the viewer can be carried vicariously and intuitively through a swift engagement with the whole creative process of the artist. It is this immediate envelopment into the developmental structure of the creative process that is such a powerful contributory factor to the instantaneous sense of liberation and release that painting can offer. Again, this is something that I have discussed elsewhere, especially in relation to the modernist abstract painting of the American painter Philip Guston, whose empty, vacuous and infinite edges continuously gave rise to more definite and clarified shapes which putatively evolved from the unconscious vacuum. In his later paintings, before he moved back completely into a figurative idiom, actual figures, vague but discernible, were precipitated from the matrix. (20)

 This process of the evolving pictorial space is strengthened in *Recollection* (Fig. 14) and as can be clearly seen right of centre, there is a section actually lifted out of its background, made up of the same background material. The connections remain and are reinforced by the fact that the areas of collaged marks from the background matrix are repeated as echoes, or 're-collections,' in the sectioned out raised area. There is the sense that painting should lift something from infinity and condense its existence.

 Figment (Fig. 15), painted around the same time, was the last abstract collage in the series and brought to an end this middle phase of my painterly life, a phase which was pivotal to my existence in all aspects. *Recollection* and *Figment* are obviously related and both evidence a petrification of the creative cycle, a feeling of deliberation and recognition which often heralds the closure of the experimentation and spontaneity of the creative research in that particular mode. However, *Figment* does have an air of resignation and recognition of an ending.

 The execution of *Figment* was relatively effortless and immediate. The collaged elements all came from one work made just prior to the finished piece. This

preceding collage was sliced and dismembered whilst the paint was still wet and the collaged clusters were applied without preconception to a canvas whose surface was covered in wet glue. Any organisation was really rendered unnecessary because of the related characteristics of each nodule of canvas, which, all being extracted from the same earlier work, had an inherent connection.

Oddly enough, this collage suggests that the whole series has come full circle. Here the projected fragments, still toxic and threatening, are not buried under sheets of canvas or integrated in an act of painterly orchestration. If anything the fragmentation is more toxic because the aspects of red paint, originally applied to the prior collage assembled to feed the work, take on the character of blood. This is compounded by the fact that the red oil paint was still wet when the collage was cut up and the fragments attached to the finished piece. Areas of the primed canvas seem therefore to be blood spattered and the canvas collage takes on the appearance of bandages. The glue and superimposed wax looks like skin. If a body has been dismembered and then repaired here, the reparation is a tentative and fragile one. The constituents are held together not by design, but by an unconscious tenuous association. It is a relic – a 'figment' of the process.

So these last two collages brought to a conclusion the middle phase of abstraction that I have discussed in this chapter. The abstract card collages were to continue on for some time, and as I have indicated, I will probably always have recourse to these personal creative blueprints in order to revitalise my own artistic process. In respect of painting, I was to move into a figurative idiom. However, this was not to be figuration in the sense of paintings of subject matter or illustrative representations, but rather the objects depicted came to be seen as icons distilled as symbols of more arcane forces.

The painting *Path* (Fig. 16) is representative of a group of paintings that formed a transitional phase or bridge between the abstract canvas collages and full-blown figuration carried out purely in oil paint. *Path* still has some canvas collage. In the vertical section just left of centre, running from the top edge to the bottom edge of the canvas, sheets of superimposed canvas collage were overlaid to build the area outwards from the stretched canvas ground. In this way, both literally and metaphorically, there is the extraction and distillation of the figurative symbol from the depths of the pictorial space. In fact, in this painting the background looks drained of colour and any vitality leaving a grey desert. It is as if the collages section has drawn the life's blood from the rest of the canvas in order to feed its own vibrancy and colour. Again, I think that this elucidation of the evolutionary creative process can embroil the viewer vicariously in the whole developmental process.

It is interesting to look back at this painting because the path now seems to me to represent a route through the grey amorphousness of oceanic creativity, perhaps now drained of meaning, towards a more secure footing on the dry land of reality. Prior to the period of the abstract monochrome works, my earlier figurative paintings that I discussed in chapter one had in the end narrowed down to a lifeless grey palette. In fact, in a phase of depression, the real world for a time actually registered exclusively in grey tones. Subsequently, the abstract collages were painted in virtual non-colours, in greys, dark rusts, or off-whites. But it was in the cracks and fissures of

these collages that colours began to return; small areas of thick coloured paint left exposed behind and within the collage. I would have to say that it was through painting, in its therapeutic role, that I once again learned how to perceive colour, not just in the painting, but in the real world. This is how abstraction, in its mimicry of dynamic psychological processes can somehow serve to reactivate them and renew connections unexpectedly lost.

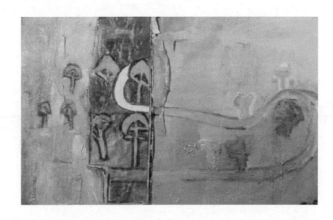

Fig. 16 *Path*
(55 x 78in)
1987

This middle phase of abstraction was a transitional phase; a recourse to the oceanic with its mysterious power to regenerate the psyche. After such a deep engagement there is a new perspective; a new confidence to hold on to reality and to see again its vibrant colour and vitality of life. As I have said, the parallel universe accessible at the core of the painterly creative process provides a template of a dimension through which a new engagement with reality can be effected.

I have since considered myself fortunate in having these unusual experiences, despite the fact that they could be accompanied by pain and frustration. My subsequent interest in psychoanalytic theory was driven by a need to gain a better understanding of such psychological experience. I found that not only did psychoanalysis help to understand and describe such peculiar events, but also that painterly creativity validated much of the theory. In my research I discovered that my constant references to my own inner creative experience nearly always served to provide living examples of theoretical models.

CHAPTER 3

ENCOUNTER with PSYCHOANALYSIS

Up to this point I have given an outline of my progress as a painter through the two general periods of development in which the paintings, for the reasons I have suggested, could be conveniently compartmentalised into each group. This method of proceeding can appear to be inordinately reductive and over-simplified and some of the phrases that I have used could also fuel criticism along these lines. To talk of a 'creative core,' of 'creative essence' and minimal stages in the creative process, may well appear reductive and to be dealing with a creative process that is essentially out-moded and regressive.

Considering that in this chapter I will make reference, among other things, to Anton Ehrenzweig's 'three phases of creativity,' I want to emphasise now that I am in no way a 'formalist' or 'minimalist' obsessed by reducing everything down to numer-ical sequences, even if at times it might seem like that. At this stage I can only point out that my later work as an artist and writer endorses my belief that diversity and variety in art are intrinsic to its liberating and critical potential. The opening up of new categories and the inventive transgressions of much contemporary art has the potential to represent positive and radical developments.

The abstract collages that I discussed in the last chapter might appear to be minimalist, but in fact they make no reference whatsoever to the cultural minimalist movements of the 1960s and the 1970s, being purely introspective and subjective creative experiments. It's just that in my own personal practice, when I had system-atically demolished the edifice of what purports to be the constitution of painting, I hit the bedrock of the creative process beyond which it did not seem possible to progress and continue to engage creatively.

It is perhaps a little unfortunate that this apparently irreducible creative foundation does seem to involve only two or three basic sequences and I am certainly sensitive to the somewhat ludicrous efforts of some to project whatever essential formation they have hit on into all natural or unnatural manifestations. Herbert Read fell foul of this in his famous book *Education Through Art*, where he seems at times to be overly concerned with arrangements in groups of four. (1) Under the influence of the ideas of structuralism it has at times been popular to detect underlying structural relationships and templates within diverse and apparently unrelated categories. Such methodology is reminiscent of mediaeval preoccupation with a harmonious universe of numbers and geometry and more widely, man's concern to impose rational order on random nature. (2)

Having said all of this and with these considerations in mind, however, I will in the course of this work be drawing attention to some uncanny parallels between the dynamics of the creative process and those of ritual; for example, in the parallel between Ehrenzweig's 'three phases' and the anthropologist Arnold van Gennep's tri-partite structure of ritual and *rites de passage*.

In respect of the regressive disposition of the creative process, I think that it is important to point out that these inevitable regressive tendencies which must accompany the disintegration of acquired modes of conscious existence during the process of ritual or art practice, are counterbalanced by the potential within this universal human dynamic to recreate a new and transformed apprehension of reality. As I briefly indicated in chapter 2, if the creative process, as I am claiming, can offer access to the earliest developmental sequences, then there will be an unavoidable collision with those primitive and barbaric infantile emotions and sensations. But it would be a mistake to dismiss art and ritual capable of actually realising this authentic link as simply regressive. It is rather, as with Ernst Kris' 'regression in service of the ego' that the reorganisation and reprogramming of those earliest impressions can effect fundamental change, even in the mature adult. (3)

The term 'regression' is now, of course, a term that is predominantly associated with psychoanalytic theory. I have mentioned that my frequent recourse to psychoanalytic theoretical models is a direct result of the uncanny parallels that I detected between my own empirical creative experiments and psychoanalytic theory, which I stress again, was encountered after the event. In psychoanalysis, regression can take on derogatory overtones and I again make it clear that psychoanalysis has often displayed a less than sympathetic understanding of art. Freud has been widely criticised for his somewhat reductive approach to some art and I have discussed this in greater depth elsewhere. (4)

One of the principal problems with classical Freudian psychoanalysis is in its inclination to be concerned almost exclusively with the Oedipal level of narrative and symbolism. In fact, such narrative and symbolism really only serve to represent and filter much deeper emotions often beyond the reach of consciousness. *Oedipus Rex* by Sophocles, which forms the basis of Freudian Oedipal theory, is surely a narrative version of fundamental universal creative and formative processes underpinning the play. (5) Modern abstract art often appeared beyond the reach of psychoanalytic interpretation because it was devoid of such 'mature' narrative and symbols. It was all too easy, therefore, to dismiss it as 'regressive.'

The type of monochromatic abstract canvas collages that I have discussed in relation to my own practice as a painter, would, therefore, be something of a mystery to the classical psychoanalyst. Paradoxically, it was only those theorists in the area of paediatrics, such as D.W.Winnicott or Melanie Klein, responsible for charting the paradigms of developmental sequences and original creative engagement, who could offer the possibility of unlocking the secrets of modern abstract painting. But even here, because of the obvious associations with infancy and with the earliest mechanisms of developmental relationships, abstract painting was again associated with the regressive.

Few recognised that in order to reformulate a transformed psychological disposition through the medium of abstract art or ritual and the immediate access to a creative dynamic they can provide, the artist or initiate had to have recourse to the original prototype of their developmental psychology. For it is only at this formative point, way beyond the reach of narrative, dialogue or symbolism, that a radical reconstruction of the psychology could take place.

D.W.Winnicott, along with Klein, made brilliant contributions to the under-standing of infantile development. In note 2 of chapter 3 I have already briefly referred to his realisation, so relevant to my arguments here, that it is only through being creative that the individual can discover the self. He positively espouses creativity as a 'feature of life and total living' (6) and of a vital and creative existence, suggesting that: 'It is creative apperception more than anything else that makes the individual feel that life is worth living.' (7)

However, it does not necessarily follow from this that Winnicott is uncri-tically positive about creativity in the context of art. As the title of his seminal work *Playing and Reality* would indicate, he does inextricably link creativity and the discovery of the self, with play. He says that the individual can only find the self through creativity, but then claims that: 'It is in playing and only in playing that the individual child or adult is able to be creative and to use the whole personality...' (8) Furthermore, in respect of art, Winnicott makes this significant statement:

> In a search for the self the person concerned may have produced some-thing valuable in terms of art, but a successful artist may be universally acclaimed and yet have failed to find the self that he or she is looking for. The self is not really to be found in what is made out of products of body or mind, however valuable these constructs may be in terms of beauty, skill and impact. If the artist (in whatever medium) is searching for the self, then it can be said that in all prob-ability there is already some failure for that artist in the field of general creative living. The finished creation never heals the underlying lack of sense of self. (9)

Winnicott's emphasis on the role of play in the creative process is remini-scent of Freud's emphasis on the role of daydreaming and fantasy in art. (10) Both involve essentially subjective experience and escapist wish-fulfilment more usually employed to deny reality. It is inevitable that such experience can be implicated in the creative process, but undue stress on such factors can risk overlooking art's potentially critical role in formulating new perspectives and interpretations with respect to reality, whether in the individual or wider cultural context. Such theoretical approaches betray a tendency to reduce art exclusively to psychoanalytic models of experience.

It is, of course, important to acknowledge that the case I am making here for the metamorphic potential of the creative essence, whether in its manifestations of art or ritual, would have its detractors. Again, the further claim in my argument, that the transformative creative core of the painterly process is in all of its essentials the same as the transformative core of the ritual embodied in rites of passage, might further be contested.

From the quotation of Winnicott above, it would not appear that he sub-scribes to the idea that art can heal the artist who already has some 'failure' in 'general creative living.' In addition, he relates how the analyst often comes into contact with individuals who are searching for the self in the 'products of their creative exper-iences.' He compares this to the infant's early tendency to try and create something from 'faeces or some substance with the texture of faeces and tries to make something out of the substance.' He says: 'I am suggesting that the search for the self in terms of what can be done with waste products is a search that is doomed to be never-ending and essentially unsuccessful.' (11)

So although Winnicott does differentiate between this early infantile creativity which is 'valid and well understood,' from creativity as a feature of life and in the context of universal acclaim, neither in his view can truly create a real sense of self, which is 'not really to be found in what is made out of products of body or mind...' Winnicott prefers to put his faith largely in the creative and imaginative potential of play.

These factors are highly relevant in relation to my whole discussion of the abstract collage paintings and to my assertion that such works are capable of transporting the artist back to the earliest points of developmental history. In chapter 2 I described in detail the creative process involved in the production of these works. In the case of the painting called *Promised Land* (Fig. 11) I explained how some of the fragmented collaged elements inexplicably attracted a toxic aura. Such a circumstance is all the more peculiar and unlikely as the collaged pieces were comprised exclusively of pure canvas, a material in this context clearly not alien to the stretched canvas ground. But as I have suggested, the apparently poisonous nature engendered by this intrinsically benign material, must in some part be associated with the early developmental sequences that such skeletal frames of the creative process can key into.

D.W.Winnicott's deep understanding and recognition of the role of play in development and that some of the infant's earliest creative experiences may be associated with 'waste products,' no doubt unwittingly contributed to the notion that took hold in the 1960s that paint really only substituted for this. Although this perhaps had a grain of truth in it, as I indicated briefly in chapter 2 I have in my own writings tried to explain how this connection is really more to do with the internalisation of a psychic mechanism for repression, a mechanism essential to the individual's development. (12) I will also show later in this work that the alienated and persecutory nature of such elements can be connected to other deeper factors encountered in early infantile development.

Again, it is important to reiterate that the human animal is never free from infantile experience. We carry the experience and trauma of infancy with us throughout our lives, from cradle to grave. We may well build subtle, judicious, balanced and mature layers of experience in our relationship with reality, but underneath lurks the core of our being, a core which psychoanalytic practice knows all too well. The same is true of art and painting. Painting, of course, is not just about the abstract elemental framework and the somewhat primitive associations it can provoke. I hope to show in the course of this work how art can assist the individual to build layers of understanding both internally and externally.

It is understandable that Winnicott, or Melanie Klein, engaged as they were in the area of paediatrics, tended to emphasise those aspects of creativity which were formative. However, it was another Kleinian object-relations theorist, Anton Ehrenzweig, who was to offer far deeper insights in his application of developmental theory to art practice and the creative process. It is to his work that the title of this chapter makes central reference.

Back in the 1980s, shortly after completing the series of abstract collages that I have described and in which I had the deepest psychological experience, (Figs. 10-12), I inadvertently encountered Ehrenzweig's work. Browsing in a London book-

shop, purely by chance I came across his *Hidden Order of Art* (1967) and happened to glance at the page in which he outlines 'the three phases of creativity.' (p.102) I was more than a little astounded to read an exact account of the creative process that formed the infrastructure of the abstract monochromes. Perhaps in a more objective appraisal, I was not the only one to make this clear connection. (13) Bearing in mind that my own process seemed to me to have stripped the creative act to its very core, Ehrenzweig's argument about the 'three phases' being the 'minimum content of art' took on real significance.

In my opinion, Ehrenzweig's crucial contribution to the whole debate really centred on his realisation that the prototypical developmental sequence revealed in the seminal research of Klein and Winnicott, also formed the core of the creative process. Although it should be stressed that for Ehrenzweig access to this sequence was in no way regressive. He argued that a creative engagement at this formative level actually opened up a different and more complex mode of perception operating at a psychic structural level below normal consciousness. (14) In other words, a creative communion in the oceanic experience that I outlined in reference to my own collages, a communion forming the core of mysticism, is not simply infantile or regressive, but results from a positive and to a degree controlled and mature creative process which can dissolve the normal boundaries of individual existence.

The creative process according to Ehrenzweig is divided into three stages: an 'initial ("schizoid") stage of projecting fragmented parts of the self into the work'; a 'second ("manic") stage initiating 'unconscious scanning that integrates art's substructure'; and a third stage of 're-introjection' in which 'part of the work's hidden substructure is taken back into the artist's ego on a higher mental level.' (15) At first sight this may appear to have little real relevance to my own creative process in the collages, but I want to show why this struck such a deep and resonant chord within me and why I think that it is so important in relation to other dynamic processes such as ritual and shamanic practice.

As I have mentioned, this basic schema is drawn from Klein's account of the early stages of infantile development experienced in the first few months of life. She defines two key stages in the infant's progress: the initial 'paranoid-schizoid' position, followed by the 'depressive' position. In between the two she also sites an 'omnipotent' phase, which in Klein's analysis acts as a kind of intermediary connecting corridor. (16) There is a clear correspondence between Ehrenzweig's 'three phases of creativity' and Klein's developmental framework.

For Melanie Klein, the first transitional stage in the infant's development was inevitably and naturally 'paranoid' and 'schizoid.' The helpless infant, devoid of controllable motor functions, is inescapably at the mercy of this huge all-powerful entity that is perceived as the mother's body. Klein elaborates how this inaugural relationship is by nature laden with anxiety, feelings of persecution and fragmented, dislocated and dissociative states. In these first few months of life the powerless infant, being at the mercy of events rather than in control of them, can harbour murderous resentments and hatred towards the object apparently able at will to withhold or grant gratification. As a result of these barbarous feelings, the infant naturally fears retaliation and retribution and so experiences feelings of insecurity and persecutory anxiety.

The maternal function at this stage is to create a nurturing space where the infant can come to terms with the stress and anxiety generated by its innate condition. The mother undertakes the role of conductor to guide the infant through to what Klein describes as the 'depressive position.' At this point the infant should begin to realise that he or she is not the centre of the universe and that in reality the mother is an independent, autonomous being with her own needs and foibles. This general recognition of its true nature in the real scheme of things can be depressing. Hence the nomenclature: 'depressive position.'

As I have also mentioned, these two basic stages in both Klein's schema and in Ehrenzweig's related 'three phases of creativity,' are separated and linked by a short period during which the infant has recourse to feelings of absolute omnipotence and control. This omnipotent phase can serve both to help offset the frustrations and helplessness of the paranoid-schizoid phase and to assist in the transition through to an acknowledgement of the real world with all of its depressive undertones.

So feelings of omnipotence face both ways: they both help to cope with and to integrate the initial fragmentation and paranoid threat; they further bolster the infantile ego in the face of the impingement of reality. Early omnipotence is manifested when the infant hallucinates the gratification of needs and desires, through an organisation and integration of apparently chaotic and threatening forces and to provide a 'fallback' position against a potentially overwhelming reality. Feelings of omnipotence and their relation to the 'oceanic feeling' will be dealt with at greater length in the context of mysticism.

This cursory reference to Klein's object-relations framework is simply to give an idea of how such strong emotions and reactions can arise in the infant-mother relationship, a relationship serving as a blueprint for all subsequent ones. The important point that I wish to emphasise in reference to Klein's developmental template is that the barbaric and primitive stew of emotions evident during these infantile transitions are inevitably accompanied by persecutory paranoia and schizoid splits in personality and that these nascent psychotic states in fact form the embryonic patterns for full-blown adult psychosis in later life.

The implication of Kleinian thought is clear: that unless this developmental sequence is negotiated sensitively and brought to a satisfactory and positive conclusion, the seeds of adult neurosis and psychosis are sown. What Ehrenzweig's extension of this idea shows is that the creative process in its essence reconstitutes this fundamental and universal dynamic and that through it the adult at any stage of maturity can have recourse to this sequence. An authentic psychological transformation can only be effected through a reconstruction of this embryonic pattern. Ehrenzweig recognised the relevance of developmental theory to the structure of the creative process. In my personal experience, innocently executed creative experiments certainly validate Ehrenzweig's analytic creative dynamic and the object-relations theory it draws from.

If we again look back at the abstract paintings I defined in chapter 2, the irreducible nature of their construction presents an uncanny parallel with Ehrenzweig's three-phased 'minimum content of art.' In the initial phase of all of these works, dislocated and torn fragments were projected on to the canvas surface. These remnants unquestionably invoked anxiety with a persecutory and paranoid flavour. The raw and

empty nature of the early stages is an inevitable concomitant of all painting. In the canvas collages, however, the idea of projection takes on a far deeper significance. Here the initial marks were not simply painted on the canvas, but were literally 'split off' from cannibalised canvasses and projected – literally thrown – on to the canvas surface.

The concepts of 'splitting,' 'projection' and a subsequent 'introjection' are fundamental tenets of object-relations theory and I think it is fair to claim that my very rudimentary collages absolutely verify their credibility. Ehrenzweig realised that during the initial phase of the creative process, a phase he designates as 'schizoid,' 'fragmented parts of the self' are projected into the artwork. (17) This is the real reason why these isolated, disjointed shards can resonate so deeply within the artist and arouse a psychological response seemingly out of all proportion with their relatively insignificant presence. This key fact surfaces in the old cliché that 'every brushstroke is torn from the artist's body.' If such aphorisms are actually founded upon a degree of truth, then how can such a proposition be plausible?

It is clear that my intense relationship through the dialogue opened up with the painting *Promised Land* in fact resurrects the earliest and seminal developmental relationship with my own mother, a relationship ultimately serving as a blueprint for all others. I think it was highly perceptive and astute of the New York critic and theorist Donald Kuspit to have commented on my more recent paintings that: 'Clearly it is the mother that is missing from Newton's pictures...' (18)

This evident lacuna in paintings completed some twenty years after the abstract monochromes might seem paradoxical in that the apparent objective of these collages was to reconvene the infant-maternal relationship. I don't want at this point to pre-empt my later discussion of the figurative paintings forming the third phase in my development as a painter. However, it is useful to indicate here that my subsequent capacity to accept that my mother *had* been absent in many key developmental senses was a direct result of my renegotiation of the original maternal space which was of course conducted in the purely abstract formal aesthetic of painting prior to the arrival of symbolism and narrative. (19)

The projection of fragmented parts of the self within this painterly discourse parallels the same discourse held with the mother as depicted by object-relations theory. The mother should naturally set up a protective space within which the infant can freely expel and project those extreme angers, resentments and anxieties inherent within such a hapless condition. The venomous screams and violent kicks of the child are absorbed and neutralised by the mother's sympathetic and caring responses. For instance, screams can be transformed by the mother and returned to the infant as a delicately hummed melody and state of reverie; a kick returned as a gentle caress. Through an infinite and complex web of subtle reactions involving sounds and touch as well as mirroring of body language and so on, the mother returns the infant's fragmented and caustic projections as integrated and coordinated responses which can be acquired and internalised free from the implicit threat they carried earlier.

In this ongoing dialogue of 'projection' and 'introjection' the infant internalises the developing nurturing space as its own inner psychic structure. The mother senses the infant's *unconscious* needs. W.R.Bion suggests that '...the mother can discern a state of mind in her infant before the infant can be conscious of it...' (20)

Her reflection of these needs begins to build an unconscious structure in the infant's mind. In object-relations theory, projection exorcises feelings and aspects within the self that are untenable, demeaning or threatening and which may undermine self-esteem or even mental stability. There may be a refusal to recognise or countenance such susceptibilities and they must therefore be rejected, expelled from the self and located in another person or object.

It is significant in this respect that the idea of projection in psychoanalytic theory originates in paranoia and phobia. The paranoid personality expels intolerable ideas outwards only for them to return in the form of reproaches or retaliation. Melanie Klein extended the mechanism of projection into the concept of 'projective identi-fication,' which is closely associated with the paranoid-schizoid position in her developmental schema. Projective identification is a more extreme form of projection in which fragments of the self, or perhaps the whole self, are projected into another object in order to control, possess or destroy it. Klein developed this severe form of projection through her recognition of the desire of the infant to enter into the mother's body so as to injure or control her from within. There then follows the threat of a violent retribution involving a forcible entry of the infant, a state of affairs not un-naturally leading to a paranoid persecution complex.

The intolerable and persecutory nature of the initial projected fragments in the collage *Promised Land*, (Fig. 11) must be seen in these terms. At the time of its execution, I was confounded as to why these scraps carried such an apparent threat. Bearing in mind my relatively dysfunctional family background, which I have briefly outlined earlier, and the certain lack of what Winnicott has described as 'good enough mothering,' it is understandable that I was ultimately compelled to fall back on my own devices to again work through all of these elemental mechanisms that should have been brought to a satisfactory conclusion years before.

A strong case could be put forward to argue that the creative process at this dynamic level of painting is the model *par excellence* to re-enact this interactive dialogue. In my varied experience as a painting tutor, I have on occasion been greatly surprised by the art student unable to make even the most rudimentary of marks on the canvas surface. How can such seemingly innocuous paint marks elicit this degree of paranoid anxiety? In the light of the developmental theory I have touched upon, it can be seen now that the reasons for this may be related to the fact that these projected marks can represent split-off fragments of the artist's own self. As in the case of the infant, such projections can engender the perceived threat of retaliation. They can weaken and dilute the painter's ego; undermine a sense of balance and cohesion and induce feelings of guilt and remorse.

The painterly dynamic can serve to rehearse and restructure all such aspects and the initial phase of projection deals with levels of aggression and anxiety and isolates the means to develop a greater tolerance and ability to cope with the frustrations that accompany such emotions. In reference to *Promised Land* I have described the forceful projection of torn compounded fragments and my innate compulsion to bury them beneath canvas sheets. This has a resonance with Klein's extreme form of projection: projective identification and reflects my objective to enter the body of the work as a maternal metaphor, in order to gain control and to possess it. Similarly in the untitled card collage (Fig. 14) the aggressive and unrestrained attack on the work's

surface, including scratching, tearing and violent markings constitute a form of projective identification. In this case the attack is contained only within a very tenuous thread of reparation formed by a fragile and tacit organisation. However, the subsequent phases in the creative process do provide an opportunity to ameliorate the severity of these paranoid projections and to develop a balance and an understanding.

It is during the second phase of Ehrenzweig's three phases that the creative process is taken over by unconscious forces beyond the control or understanding of our normal everyday cognitive processes. This is quite a complex process and I went to some length in *Painting, Psychoanalysis, and Spirituality* to analyse what was actually going on here and to give a theoretical account of it. (21) It is a complex process because a number of 'neurophilosophical' issues become compounded within the action.

Ehrenzweig had a deep empathy with artistic creativity and he understood that this intermediate phase in the process engaged an unconscious, intuitive mode of synthesis and perception 'in order to integrate the total structure through the countless unconscious cross-ties that bind every element of the work to any other element.' Whereas he designated the first phase as 'schizoid,' he labels this second phase — a phase that 'integrates art's substructure' – as 'manic.' This creates a unity and a cohesion throughout the work and an 'unbroken pictorial space emerges as the conscious signal of unconscious integration.' He further says that this creative stage 'tends towards a "manic" oceanic limit where all differentiation ceases. The inside and outside world begin to merge...all accidents seem to come right; all fragmentation is resolved.' (22)

Again, I think that the parallel between this theoretical exposition and the account I have given of my own creative process in the collages is self-evident. In its most basic manifestation the creative template excavated in the abstract collages does form a nurturing, maternal space. Just as I have described how the mother's generation of a psychological womb and a state of poetic reverie serves to anaesthetise the destructive infantile projections and to reflect them back in an idealised form suitable for 'reintrojection,' so in the oceanic painterly dimension, developed to contain incoherent, harmful projections of the early creative process, '...all accidents seem to come right; all fragmentation is resolved.'

I detailed the same process in relation to the collage *Untitled (Grey)*, (Fig. 12). I recounted the intermediate or second phase of this monochromatic grey painting in which I spontaneously integrated all remnant 'disparate vestiges' into a miraculously amalgamated and coherent pictorial space. As I have described, this process was accompanied by the eerie experience of *ekstasis*, an out-of-body, a-temporal episode, a-temporal because in this encounter with the oceanic time seems to stand still. I quoted the Indian mystic Ramakrishna in this context so that I might draw attention to the uncanny parallels between creative transcendence and mystical experience.

I stress again that I am not seeking canonisation and Donald Kuspit's brilliant essay on my painting explains how the idea of sainthood gets conflated with the artist attempting to come to terms with a world often oblivious to individual creative endeavour. (appendix 1) It is rather from a psychoanalytical and theoretical ground that I have tried to make sense of such deep conversion experience and to grasp what really occurs during these arcane transformative events.

It might not be self-evident to the casual observer, but in fact every single aspect of a painting's intrinsic formal and material qualities, including painterly gesture, marks and striations within the brushstroke, impasto and textural features and so on, all present analogies and representations of inner psychic events and projections. In the natural order of things and in the way the human psyche evolves, those elements embedded within this formal language of painting which appear to be distinctive, clearly demarcated, to some degree composed and deliberately ordered or refined, come to represent those factors in the mind upholding regulation, conscious organisation and ultimately inner laws and conscience.

By contrast, the elements which fall foul of such formulations, like scratches, drips, random marks, distortions of intention, dislocated line and other complex anomalies, can appear to threaten the rational and law-like directives of composed and ordered factions. Such constituents of facture are altogether 'inarticulate,' inchoate, raw and spontaneous, although they can be intuitively and subliminally monitored and even actively procured by the sensitive painter. It is this inarticulate form, in its radically exorcising and transgressive nature, that carries the emotional charge and vitality giving painterly form expressive power.

In a paper written in 1998 entitled *Guilt in Painting*, I examine inter-reaction between these two types of form within the crucible of the creative process. Again I describe the two opposing types of form: the formal representations of order and cohesion as basically the product of a deliberate, perceptual engagement and the informal representatives of disorder and dislocation beyond predetermination or control in any normal sense. I argue that an alleviation of guilt and even a potential redemption can be achieved within the dialectic between these two categories:

> It is in the dialectical core of the relationship between these two types of form that guilt is determined. The consciously organised formal aspects of deliberate engagement that I have described, are also employed by agencies in the mind which act to ensure that conscious rational order and perception maintain dominance, an objective which in part is biologically adaptive. Psychoanalytic theory might describe such agencies as "repressive," and perhaps as being the residue in the mind of early parental discipline and social controls. In order to assert the supremacy of conscious organisation, they enlist the assistance of guilt feelings. That is to say, feelings of guilt are induced in the mind if the surface cohesive organisation is threatened in any way by the disruptive and transgressive forces of unconscious inarticulate form. Inarticulate form in its own basic characteristics as the language of the archaic unconscious psyche also carries a loading of guilt and anxiety associated with the savage earlier stages of infancy, and embryonic symbolisation.

Now it is possible to enter a central phase in the creative process, where the dialectic between these two different types of form in the painterly structure is mediated or resolved. In this phase those formal elements of definite cohesion, representing conscious deliberate determination and perception, can be painted out, obliterated, dissolved and subsumed within the unconscious painterly matrix. At one and the same time, elements of fragmented inarticulate forms and their compounds with more definite configurations will be joined and integrated within the whole. Now the removal from the scene of those representatives of conscious

rational order and perception also means that they can no longer fulfil their func-
tion to keep order by arousing guilt and anxiety often through enlisting feelings of
disgust. Simultaneously, inarticulate fragmented forms along with their associated
guilt and anxiety are integrated and become an acceptable part of the whole.

In effect, therefore, the repressive psychic forces are neutralised, their a-
gencies in organised forms are dissolved, and guilt is completely vanquished. The
painter can fleetingly experience a feeling of total omnipotence and unchallenged
control of all forms and what they represent in the mind. In Oscar Wilde's *The
Picture of Dorian Gray*, it is the painted portrait image which takes upon itself the
anxiety and guilt of a dissolute lifestyle, whilst the subject, as a metaphor for the
artist, acquires an omnipotent, guilt-free lifestyle and the ability to forever
resurrect a new psychic self. (23)

I think that this description of what goes on at the core of the creative process
goes some way to explain how the resolution of the innate dialectic here can lead not
only to feelings of omnipotence as all forms are integrated, but also to a momentary
trance state as the representations of consciousness are dissolved within the matrix. In
fact, as I have explained elsewhere, in essence these forms actively represent our con-
scious mode of constructing reality. (24) They are representations not only of our
psychological process of perception, but also of concept-formation and symbolisation.
So as these forms disappear, so does the very embodiment of all that symbolises a
sense of self. It is this progressive neutralisation of ordered representations that is
responsible for the potential trance 'death' that forms the core of ritual experience and
creates the conditions for a reorientation of psychic structure.

The description is also very apt in respect of the abstract collages. Again, in
Untitled (Grey), Fig. 12, the traces and apparently receding after-images of vaguely
organised shapes seem to be dispersing into a grey flux. They are intermingled with
other components of organised and disorganised forms, (Fig. 13), elements with dis-
tinct shapes perhaps embedded with a multiplicity of raw scraps of painted or scratch-
ed line or ragged collaged edges and so forth. The intense manic-oceanic trance ex-
perience that I detailed in respect of this collage was further a direct result of the
conscious confrontation with the 'polyphonic diversity' and complexity of the creative
process. The conscious cognitive processes become 'overloaded' in the face of such
diversity and breakdown or become immobilised as the more all-embracing intuitive
and subliminal process of unconsciousness are forced to take over.

So consciousness is not only dissolved and negated as its representations are
obliterated, but is also simultaneously disabled in the face of an overwhelming com-
plexity beyond its scope. Hence a transitory trance state and *ekstasis* are engaged as
consciousness shuts down and the unconscious structure of the mind is reorganised in
a *trance-formation*. There is, therefore, a plastic analogy in the death of consciousness
within the materiality of the collage, an analogy simultaneously provoking a parallel,
reciprocal psychic trance 'death' within the mind.

It can be seen that within this apparently innocuous and unrepresentative
space, a whole range of developmental issues can be renegotiated. In the ongoing
dialogue with the painterly matrix, all of the original formative reactions that seem to
define the inner mind are again engaged. Toleration of frustration and anxiety, the

rehearsal of positive and adaptive levels of aggression, guilt, conscience, projective identification: all can be encountered within a scenario free of real threat, but with the real potential to greatly toughen the ego and effect a metamorphosis into a new self.

Such an intense and elementary transformation is made possible because this creative encounter is prior to the development of any representative or figurative imagery, narrative or fully formed symbolism. These factors, of course, represent and embody earlier turmoil, but they are once removed and so to a degree anaesthetised for the accession of consciousness. By its nature, the conscious mind is not equipped to deal with the flux of powerful emotions at the formative dynamic levels. This is why unconscious, or 'inarticulate' form can appear to be so transgressive and radical and pose such a threat to the conscious mind. Such form carries all of the force of the *original* dynamic experiences, often traumatic in nature and all the more powerful because they are original.

To put it another way, powerful emotions capable of overwhelming the stability of consciousness are couched in abstract, indecipherable forms that cannot be reconceived by a conscious mind unable to cope. Again, this is why the emotional power of artistic form resides in its intrinsic formal language.

When I gave the red monochrome collage the title *Promised Land*, (Fig. 11), it was done after completion of the work and entirely innocently and instinctively chosen. I recognised intuitively that I had reached a place that I needed to reach for my own survival and wellbeing. I understood that it was a dimension where all of these developmental issues could again be confronted. The dimension is prior to the acquisition of language or symbolism and beyond representation. This is why the primeval *Promised Land* held out the promise of a radically emotional encounter. It goes beyond the original formulations of psychic organisation and so presents the unique potential for a psychic rebirth and the creation of a new self.

Looking back with hindsight at this painting, I can now detect the duality between the 'death' of consciousness within the materiality of the work and the reciprocal trance, momentary loss of consciousness and consequent rebirth in the actual mind. In its complete obliteration of conventional line, colour, representative shape and organised composition, conscious points of reference are reduced to an absolute minimum. However, within the excoriated terrain of this collage there can be detected the fragmented remnants of limbs and organs which psychoanalytic theory shows to be associated with these primal developmental stages. There is certainly the hint of a vaginal triangle and I would have to say now that the whole aura of the unconscious colouring is inter-uterine. So there is the clear duality and parallel of form and content. *Promised Land* creates the conditions for a psychic rebirth alongside the plastic metaphor of an actual rebirth through the inter-uterine experience of the body of the work.

I have quoted Ehrenzweig's description of this central phase as one in which all differences are negated; where inside and outside worlds merge into union; where there is integration and a resolution of all fragmentation. To the uninitiated artist this can appear to be a somewhat miraculous turn of events, as if the work somehow completed itself. It was said of the prototypical, authentic religious icon painting, that it was completed 'without the agency of human hands.' It is the case that the convergence of inner and outer worlds coupled with an apparently spontaneous and unguided

organisation and serialisation of a complexity overwhelming to consciousness, has often been interpreted by artists and others as some sort of divine intervention. Ehrenzweig comments that 'It is astonishing to see how artists after finishing their work may begin to study it in great detail as though it were the work of somebody else.' (25)

In fact, it is the installation of an unconscious 'psychic mirror' during the oceanic stage that creates the illusion of merging or 'envelopment.' The unconscious mind of the artist, or indeed the receptive spectator, reorganises the parallel plastic analogy of its own processes as in a mirrored reflection and becomes united with it. It is during this complete communion that the restructured developmental sequences within the materiality of the artwork are imprinted upon the reprogrammed mind. I should again indicate here that this exact same process holds true for the initiation ritual and for rites of passage, where during a central 'liminal' phase conscious factors disintegrate and the initiate or 'neophyte is reshaped or moulded physically and psychologically so that society's values can be inscribed on his or her body and mind.' (26)

So it is during this 'mirror stage' of the creative process that a reintegrated, unconscious structure is imprinted with the new resolution of those developmental issues perhaps unresolved since the first few months of existence. However, as Ehrenzweig points out, it is in the third and final stage of 'reintrojection' that this newly developed 'hidden substructure is taken back into the artist's ego on a higher mental level.' (27) He explains that this 'undifferentiated substructure' developed during the unconscious engagement in the 'manic-oceanic' phase will still appear 'chaotic to conscious analysis' and so will still arouse anxiety.

This residue of anxiety certainly contributes to the 'depressive' character of the third creative phase. I have already suggested why in Klein's embryonic developmental schema, the 'depressive position' is so characterised. That is, because the infant at a very early age is forced to recognise the true nature of existence in an uncertain and threatening reality. The growth of a more mature relationship with reality is tentative and risky, but is necessary and biologically adaptive. I have also indicated how the infant, engaged in the evolving dialogue with new realities, has a safety net in the form of recourse to the central manic-oceanic phase. A defensive fallback to the oceanic can again confer a sense of omnipotence and control that can revitalise and strengthen the infant ego for a renewed assault upon the depressive.

Again, the creative process provides an authentic template for this key defence mechanism, which is so important to the infant's progress and also potentially for the regeneration of the mature adult. I think that it is also important to bear in mind that this sequence, which allows for movement both backwards and forwards, is not only central within an individual context, but also in a cultural context. American Abstract Expressionist painting by such artists as Jackson Pollock or Willem de Kooning forms a seminal cultural example of the manic-oceanic omnipotent creative phase. I have argued that cultural recourse to this dimension of 'all-over' manic abstraction occurs during periods of cultural crisis, in which the general culture, as with the individual, needs to reconnect with unconscious roots in order to regenerate a cultural confidence and vitality. (28)

In his writings, Ehrenzweig recognised that resort to abstraction very often corresponded with periods of crisis and turmoil. The etymological root of the word

'crisis' is to be found in the Greek *krisis* meaning separation. It is clear that abstract paintings in the mould of my *Promised Land* re-enact the resolution of original traumatic separation and birth within their intrinsic formal dynamic. Although Ehrenzweig understood that some of the residue of this primal anxiety would be carried over into the third phase and the depressive position, he also argued that: '…if all goes well, anxiety is no longer persecutory (paranoid-schizoid) as it was in the first stage of fragmented projection. It tends to be depressive, mixed with a sober acceptance of imperfection and hope for future integration.' (29)

Ehrenzweig further states that: 'Because of the manic quality of the second stage, the following "depressive" stage is all the more difficult to bear. Who has not experienced the grey feeling of the "morning after" when having to face the work done on the day before?' He further points out that it is the residual surface fragmentation, fissures and apparent chaos of the oceanic stage, now pushing into consciousness, that can induce reactions of anxiety and even disgust. Such aspects were lost to consciousness during the ascendancy of the subliminal unconscious in the oceanic stage, where all was integrated into an overall cohesion. Only the force of unconsciousness can complete this work and it can never be seen in the same light by the conscious mind. I have indicated in relation to the collage *Untitled (White)*, Fig. 10, how as unconsciousness completed the integration of the collaged fragments, I viewed the proceedings as a consciousness floating in the roof space.

If the conscious mind inevitably perceives the work of unconscious instinct and intuition from a more restricted and narrow viewpoint, then a key aspect of the 'creative capacity' as Ehrenzweig points out, is 'the strength to resist' the depressive feelings of disappointment and distaste that can provoke the artist to discard or destroy the whole work. It is in this ongoing dialogue with the artwork that the painter can build greater toleration of such frustrations and hence greater ego strength as an ever-increasing degree of fragmentation can be processed through unconscious creativity to enrich the conscious mind and extend its boundaries. The raw and fragmented element of painterly form in this context acts as a cipher for all other untenable and alienated emotions that the individual needs to come to terms with. The development of a capacity to tolerate and to cope with the analogy in creative form engenders a reciprocal psychic capacity within the realm of real relationships, feelings and emotions.

In this third creative phase, therefore, the painter 'reintrojects' the work of unconscious creativity on a higher level of consciousness, so enriching and strengthening the ego. Ehrenzweig points out: 'In this manner a full exchange occurs between the conscious and unconscious components of the work as well as between the artist's conscious and unconscious levels of perception. His own unconscious also serves as a "womb" to receive split-off and repressed parts of his conscious self. The external and internal processes of integration are different aspects of the same indivisible process of creativity.' (30)

This is the creative stage in which the autonomy and independence of the artwork is recognised, along with all of its residual and unresolved and disjointed characteristics. Just as the infant in the depressive position learns to acknowledge the mother as an autonomous, if imperfect being, so too does the mature artist accept the autonomy and fallibility of creative products. As the original dynamic in the infant-

maternal relationship is the blueprint for all others, so too does this creative dialogue parallel subsequent real relationships. Ehrenzweig says:

> If a neurotic person has to dominate and control another person in order to love him, he can only take back from him what he himself had deliberately put into him. An immature artist who is hell-bent on exerting full control over his work is incapable of accepting that a work of art contains more than what he had (consciously) put into it. To accept the work's independent life requires a humility that is an essential part of creativity; it also presupposes a lessening of the persecutory fears of taking back into oneself split-off parts of one's personality. (31)

These were the issues that I mediated in the empirical experimentation of the abstract collages. The canvas 'strip' collages such as *Untitled (Dark Red)*, Fig. 8, discussed in chapter 2, tended to be over-refined and severely controlled even if their ultimate objective was to deconstruct consciousness by 'working it to death.' In such highly regulated exercises, it is, as Ehrenzweig states, hard to accept that the work of art has its own life and contains more than the artist determines it should contain. The subsequent series became more open in their toleration of apparent deformed and ragged fragmentation and so develop a more profound oceanic engagement with its associated greater potential for psychic regeneration. The artist needs to engender a mature understanding of the creative process in order to allow the artwork its own apparently chaotic and vital existence and in so doing generate a real and dynamic dialogue.

Shortly after completing the abstract collage series some twenty or so years ago, I remember making the casual remark along the lines that all I needed to know about art could be found in those works. Not necessarily the sort of self-opinionated comment that I would make in front of a critical academic audience, but nevertheless it had real meaning for me. If we subscribe to the view that somewhere in its essence the creative process *does* have a healing and therapeutic function, then this claim of mine would, I believe, carry some weight.

Through the vehicle of a work such as *Promised Land*, I was able to confront and deal with the paralysing neuroses that held me in their grip. Deep agoraphobia and an inability to even be in the company of others, aggravated by an ever-intensifying depression in turn fuelled by a dependence on alcohol were symptoms ultimately overcome in the creative process of the canvas collages. In the first two creative stages hostile and destructive mental attitudes were revisited: frustrations, fears and anxieties confronted and appropriate tenable levels rehearsed; simulation of psychic integration and the formation of creative models whereby the mind can relearn how to accommodate exorcised constituents of the personality hitherto deemed utterly untenable; through omnipotence and liberation from guilt, conscience and repression, the understanding of control and a 'flexibility of repression'; through the third stage, the negotiation of depression and the representation of a means to deal with depressive feelings, so crucial in a personality 'seized-up' by their overpowering force. Such claims for art and the creative process may seem overblown and far-fetched, but I would argue that they are justified and validate Donald Kuspit's key insight that: 'The artist is a natural therapist…the work of art a natural medium of healing.' (32)

73

It is in the final depressive phase of the creative process that a deeper understanding is developed along with a greater toleration of the persecutory fear associated with the 'reintrojection' and re-internalisation of split-off parts of one's own personality.

I have already briefly indicated that the abstract stencil, patterned in the abstract collage, not only serves as a psychic imprint of a newly created developmental sequence, but also within its arrangement inevitably sows the seeds of a new relationship with reality. It is clear that the first two creative phases redesign the original sequential phases and subsequently present them for conscious assimilation in a depressive reintrojection. In effect, the depressive phase is one of reality testing, for the mind cannot productively 'test the waters' of reality before this developmental sequence is properly determined. In its potential to recreate the conditions necessary to a reappraisal of reality, the creative process can alleviate the element of denial in neurosis and even the more serious fracture in the delusional systems of psychosis and schizophrenia.

In keeping with the claims I have put forward with respect to the 'parallel universe' of the creative process, my painting not only sowed the seeds of a new reality in the abstract collages, but also paralleled their maturation in a painterly dimension of new figuration. So the depressive position in the abstract creative structure, is not only embedded *synchronically* within the tripartite structure of the individual collage, but also *diachronically* in the historic painterly evolution.

The abstract collages synchronically incorporate the three phases of creativity: the paranoid-schizoid stage, the manic-oceanic stage and the depressive position. Although the depressive phase does initiate reality testing, it is nevertheless in a pre-symbolic, abstract state prior to the emergence of new perspectives on reality. As I have suggested, the depressive element here is felt in the acknowledgement of discord, fragmentation and ultimately autonomy of the artwork. Such features in the context of art's language of form, can act as analogies for the whole range of states to be encountered during Kleinian projection and introjection. Infantile conflicts and anxieties and primitive defences whether of child or adult, evidenced in depressive states, persecutory expectation, hypochondria and delusions of persecution, obsessional defences and so forth, can all be represented in this manner.

The ultimate recognition of the autonomy and inherent life of the artwork also implies 'reparation' and 'restitution' as the persecutory guilt induced through the aggressive attacks projected on the artwork (or mother) are dealt with and rationalised. Winnicott comments that:

> 'Working along Kleinian lines one came to an understanding of the complex stage of development that Klein called the depressive position.' I think …it is true that clinically, in psycho-analytic treatments, arrival at this position involves the patient in being depressed. Here being depressed is an achievement, and implies a high degree of personal integration, and an acceptance of responsibility for all the destructiveness that is bound up with living, with the instinctual life, and with anger at frustration.' (33)

This is what the three phases of the creative process within the most funda-
mental format can also restage. However, there are also more tangible ways in which
embryonic depressive position functions as I indicated in chapter 2.

It is clear that the collages are virtually colourless and wholly monochrom-
atic. Although as I have argued this device played its part in the denial of conscious-
ness, it also had a deeper significance. Prior to the start of the collage series, my last
few figurative paintings from what I have described as the 'psychotic phase,' were
losing all colour. Houses, trees, fields and gardens, in fact everything in these repre-
sentational works, became a shade of grey. With hindsight I recognise that it wasn't
only the paintings at this stage that were grey. I recall literally seeing reality as grey. I
was losing all colour both in my real world and in my painterly world, a phenomenon
often associated with depression. However, colour returned to me in both dimensions
through the cracks and fissures of the canvas collages. It sneaked back unheralded.

Fig. 17 *New Horizon*
(64 x 42in)
1984

Incredibly, the fact that I could once again view colours in the parallel
dimension of painting reawakened my dormant sense of colour in my real world. In
the painting *Promised Land*, (Fig. 11), slivers of green paint can be detected erupting
in the channel left of centre between the two central canvas sheets and flecks of red
paint appear along the bottom edge. In the canvas collage *New Horizon*, (Fig. 17),
painted a little later in 1984, the dark red colour of the earlier monochromes remains
predominant but much brighter colours have encroached on its territory. The patches
of green in the fissure between the collage sheets of *Promised Land* have now
metamorphosed into two distinctive shapes along the bottom. The cream, grey and
light blue, seem to delineate a new reality, one with a coastline and a 'new horizon.'

So there is this duality in painting in its role as 'transitional object': inner
recollections of colour re-emerge in unconscious creativity and are ultimately rejoined
with colours from external reality. The 'transitional object,' as Winnicott designates, is

neither exclusively representative of inner reality nor of outer reality, but is a composite of both. Once it is possible to 'see' something symbolically, it then becomes possible to 'see' it in reality.

It must surely seem an extraordinary state of affairs to anyone not having been in this position that an individual can actually look out on the real world and fail to sense any colour. Looking back now I realise that this state creeps up on the individual gradually and so is not disturbing or particularly noticeable. It's as if the grey blanket of depression like a type of volcanic dust, slowly smothers and suffocates everything. In my own personal circumstance only painting could provide a window through which I could again learn to 'see.' The inner mechanism to see somehow got lost or neglected and in such a case the individual must find a means to replicate it and make a connection once again.

I think that this is also the case in respect of the means to relax and experience normal existence. When I was younger and going through the utterly nightmarish period of debilitating anxiety and agitation described in chapter 1, I literally lost the physical and psychological know-how of relaxation. I have said that this is tantamount to an absolute living hell and it was only the depth of the creative oceanic process that could furnish the momentary respite in trance experience to enable the mind to re-experience and so relearn the possibility of tranquillity. In truth, tranquilliser antidepressant drugs really serve a similar function. They don't really 'cure' depression, but trigger the mechanism for calming and relaxation that is again recognised by the mind and assimilated (in a 'reintrojection').

It is interesting that when I gave a talk on such matters about 10 years ago in the department of psychiatry at the University of Sheffield, during which I showed slides of the canvas collages, I was actually asked by Professor Geraldine Shipton if I had suffered a nervous breakdown. The question took me aback because I hadn't hitherto seen my situation in such extreme terms. But in a sense this radical creative experience *is* a type of nervous breakdown as consciousness is obliterated alongside those representations of conscious functioning. What the artist is doing here is really a re-enactment of the mechanics of a nervous breakdown. In my personal context it is as though I deliberately procured the semblance and replication of the mechanism of a nervous breakdown, through the creative deconstruction of consciousness, in order to investigate its operation and to head off the possibility in reality. In this way I could deal with all of the ramifications of a nervous breakdown within the confines of the 'transitional object' of the artwork.

The monochrome collages embody synchronically the process through which such issues can be tackled. On the other hand, the paintings from the first 'psychotic phase' of my development only incorporate the paranoid-schizoid phase. They lack the unconscious depth of oceanic experience and the central creative phase, a factor reflected in the very manner of their painterly execution. By contrast, the paintings from the third phase, yet to be discussed, retain within their dynamic the three phases of the creative process, although not in such a clear cut and isolated manner as occurs in the collages. These extend the embryonic depressive element of the monochromes into the development of a new reality and the precipitation of a new figuration.

It can be seen though, as I have indicated, that the creative process can inhabit both synchronic and diachronic dimensions. In historical terms my paintings represent the diachronic dimension of creativity, whilst the abstract monochrome collages represent the phases of the creative process synchronically. This general situation also pertains to the ritual process.

At the beginning of this chapter I briefly mentioned Arnold van Gennep's division of rites of passage and the ritual process into three basic phases. Rites of passage usually incorporate a change of status in the lives of individuals or groups. Rituals of birth, initiation and death are typical 'life crisis' events. In *The Anthropology of Religion* Fiona Bowie succinctly defines van Gennep's contribution to anthropology and ethnography. She says that van Gennep:

> ...thought of rites of passage in much broader terms, as a universal structuring device in human societies. He included seasonal festivals, territorial rituals, sacrifice, pilgrimage, and indeed any behaviour, religious or secular, that displayed the same basic threefold pattern of separation, transition, and incorporation. (34)

It is also useful to point out here that within van Gennep's 'threefold structure of a rite of passage' he employs two parallel sets of terms: separation-transition-incorporation or reaggregation, and preliminal-liminal-postliminal. I will be dealing with this in greater detail when I compare the structure of ritual to that of the creative process. However, I think that it is useful here to quote Bowie again when she states that the first stage of ritual is marked by 'cutting or separating in some way'; the second stage is of 'transition or marginality' with a sense of 'ambiguity and confusion or disequilibrium'; the third and final stage is one of 'incorporation or reaggregation, when the individual, in a life cycle ritual for instance, is reintegrated into society, but in a transformed state.' (35)

I relate these points at this juncture to draw attention to the very clear parallels between the phases of the creative process and those of the universal structures of ritual. It is also the case that just as the creative process in the context of an individual's maturational process incorporates a synchronic as well as a diachronic dimension, so too does the ritual process embody both dimensions.

The tripartite ritual process of separation, transition and reaggregation, is embodied in the ritual both synchronically and diachronically. The three phases can be spread over a considerable length of time in a prolonged ritual development whilst at the same time being intrinsically configured within the unique ritual performance and process. Each stage of the evolving ritual process may well re-enact the three phases, but I think that it is of key interest here that the central ritual performance in any overall process is a pivotal event. It is during the liminal or 'threshold' stage that the incessant beating of drums and prolonged dances to physical exhaustion and perhaps sensory deprivation can give rise to a trance state equivalent to the manic-oceanic trance at the core of the creative process. Both fundamentally reconvene the original dynamics of developmental sequences and create the conditions for their realignment.

It has always puzzled me, as an outside observer of the fieldwork and re-search of anthropologists and ethnographers, that in general this inner dimension of the liminal, of the trance phenomenon in the manic-oceanic dissolution of conscious convention, is so often neglected in favour of prolonged and detailed narratives of ritual events. The great majority of works on African exploration and investigation of ritual, for example, only make passing reference to the centrality of dance and drums in their key function to induce trance and a *trance-formation*.

The same has also been generally true in respect of research into aesthetics and creativity. Any analysis is most likely to concentrate on the narratives and symbolism of artworks rather than on the potential of their innate material qualities to radically affect the mind. Even when painting's intrinsic language and facture is dealt with it has tended to be in terms of those clear and deliberate colours and shapes re-presentative of the conscious mind. Even psychoanalytic interpretation, which on the face of it would seem more likely than any other hermeneutic approach to disinter un-conscious motivations, still usually prefers to deal with the narratives and symbolism developed during and beyond the Oedipal complex.

Such a state of affairs is all the more surprising in light of the fact that it is only at the very abstract core of the creative or ritual process that a real psychic thera-peutic transformation can be activated. I hope that the references I have made so far to the inner workings of my own abstract canvas collages might have thrown some light on this arcane and little understood process.

CHAPTER 4

MYSTICISM and the OCEANIC

In my closing remarks at the end of the last chapter, I again drew attention to what is a key factor here: the correspondence between ritual process and the creative process. I referred to Fiona Bowie's summation of van Gennep's analysis of rites of passage in *The Anthropology of Religion*. I mention this again because, of course, this title does allude to the essential relationship between ritual and religion. Indeed it has been argued – and I think with good reason – that the oceanic experience, which forms the central core of both ritual and creative processes, is the foundation of all religious experience and of the whole range of religious categories designated generally under 'mysticism.'

My arguments in the preceding chapters have been set against the yardstick of the relatively short series of canvas collage abstracts. Although small in number, I have stressed that for me these abstracts were absolutely fundamental in their influences and consequences. In terms of my earlier 'encounter with psychoanalysis,' I could recognise how the pure creative engagement isolated in these works reflected and endorsed so much psychoanalytic theory. In effect, they also freeze in time early oceanic experiences that are in essence mystic states. It is for this reason that I want at this point to look at the relationship between the oceanic and mysticism, before I examine the parallels with the ritual process in the next chapter.

It is true that the abstract monochromes petrify in time the momentary ecstatic trance state and mystical oceanic experience. Furthermore, they also create a portal through which we can look backwards in time to the earliest moments of personal existence, even as far back as the intrauterine, as I have indicated with respect to the red monochrome *Promised Land*. (Fig. 11) A painting such as *Untitled (Grey)*, (Fig. 12), represents a frozen moment in oceanic and developmental time.

Perhaps such maps of early existence and experience are comparable to digital reconfigurations of light constellations in deep space, made possible by ever more powerful electronic telescopes. These can be read backwards to represent the earliest moments of the birth of the universe. Just as when we look at the light from a star millions of light years away we are really looking at that star as it was millions of years ago, so can we look back through recreated psychic representations and constellations at earlier events.

It is this potential within the dynamic creative process to move backwards in time that gives it mystical and religious overtones. To reconfigure a prehistoric oceanic moment and through engagement with it to resurrect a new psychic self, is a creative transformation underpinning not only ritual processes, but the whole notion in religious symbolism of death and resurrection.

In time, retrospectively, I came to realise that the intense psychological experiences induced through the creative process of the abstract monochromes, were in actuality naïve and empirical manifestations of the central tenets and ceremonials of

most religions. Again I stress that these psychic events were confronted absolutely innocently and were devoid of any preconceptions, prior understanding or recognition of religious belief. It is the naïve character of these works that inevitably makes the correspondence between the psychological experience they generated and religious ceremonies uncannily appearing to symbolise them, such a surprising and unexpected coincidence.

The *ekstasis* that I experienced in *Untitled (White)*, (Fig. 10), during which time my 'soul' left my body and apparently floated upwards in my studio, is represented in religious narratives as an 'ascension'; the absolute unity and envelopment encountered in *Promised Land*, (Fig. 11), has its religious counterpart in the ideas and ceremony of 'communion'; the infinite oceanic experience of *Untitled (Grey)*, (Fig. 12), as a 'baptism.' It's interesting that after I gave a paper at the University of Edinburgh in 1996, entitled *The Spirituality of Abstraction*, a young woman clearly of deep religious conviction offered to have me baptised the following day. I immediately responded that in fact I had already been baptised – in the painting. I am not here subscribing to the idea that such psychological experience constitutes a union with the divine or a visitation from a deity. I think that it is more likely the case that the ceremonials of religion try to capture and imprison free creative experience.

Some of the propositions I am putting forward are no doubt provocative and apparently sweeping in their claims. To base any hypothesis on personal mystical experience is problematic from the point of view of 'reasoned' or academic argument and can expose it to imputations of idiosyncrasy and insubstantial subjective and egocentric opinion. The parallels I am drawing between creative and ritual process and their connections with wider mystical and religious experience seem very diverse and far-reaching in scope. Compounded with the fact that these wide-ranging ideas would appear to be extrapolated from subjective transcendental moments, it would not be surprising if they aroused a degree of scepticism. In recognition of these factors, however, I think it is important to acknowledge that many other analysts of mysticism have concluded that the whole edifice of religion is fundamentally predicated on personal mystical experience.

The renowned French writer and mystic, Romain Rolland (1866-1944), considered that 'true religion arose from the mystical experience of oneness with the world (*la sensation oceanique*).' (1) In a letter to Sigmund Freud dated December 5, 1927, Rolland argues that the subjective and spontaneous oceanic sensation is ultimately the 'true subterranean source of *religious energy* which, subsequently, has been collected, canalised and *dried up by the Churches*, to the extent that one could say that it is inside the Churches (whichever they may be) that true religious sentiment is least available.' (2)

William B.Parsons, in his superb overview of mysticism: *The Enigma of the Oceanic Feeling – Revisioning the Psychoanalytic Theory of Mysticism*, says that in this letter Rolland in fact makes a claim: 'The claim was that "mysticism," that is to say, the "oceanic feeling," was the true source of religion.' (3) Parsons points out that in making this claim Rolland drew on his personal religious experience and also on 'scholarly evidence' he had collected for his biographies of the two famous Eastern mystics, Ramakrishna and Vivekananda. (4) I think that it is also fortuitous in respect of some of the connections I am making here with psychoanalytic and developmental

theory that Parson's comprehensive and balanced analysis should investigate the various psychoanalytic perspectives on mysticism that 'integrates cultural studies, developmental perspectives, and the deep epistemological and transcendent claims of the mystics.' (5)

Earlier, I have already referred to Rolland's *The Life of Ramakrishna* and the account he gives of the mystic's oceanic experience. (6) Ramakrishna's deep psychological encounter with the 'Divine Mother' is inevitably the sort of personal, indescribable, ineffable episode that provokes a lifelong religious worldview. Romain Rolland himself had a number of early personal mystical experiences, between the ages of 15 and 20 years, 'that had a profound and formative impact on his life.' Parsons recounts how even at the age of 63years, Rolland still continually stressed the 'importance of his early mystical experiences for the course of his life.' (7)

In his *Memoires*, written in 1939, Rolland gives an account of an early experience at the age of 23 years in 1889, whilst hiking in the Alps, when 'For a moment my soul left me to melt into the luminous mass of the Breithorn…Yes, extravagant as it may sound, for some moments I *was* the Breithorn.' Parsons points out that Rolland had further 'contact with Unity' and cites his letter to Louis Beirnaert in which Rolland talks of 'several brief and staggering' mystical experiences. (8) Again, as Parson notes, Rolland emphasised that the first precondition for 'knowing, judging…and condemning a religion' was, as Parsons puts it 'to have experimented with mystical experiences.' (9) In this says Parsons, 'Rolland also followed James's "modern" approach to mysticism, which stressed the personal, subjective, and experiential over and against "secondhand" institutional religion and its accoutrements.' (10)

In the context of his discussion of the Freud-Rolland dialogue and of the history of the psychoanalytic theory of mysticism, Parsons makes reference to many other 'saints' and mystics, whose conversion experiences prefigured a lifelong research and investigation and set of beliefs. For my own part here, I would like to cite two other examples of what could be called 'conversion experiences' of a kind which are more closely associated with the world of art.

In his acclaimed and influential 1908 thesis: *Abstraction and Empathy-A Contribution to the Psychology of Style*, Wilhelm Worringer makes connections between the experiences of both art and religion. He says at one point that 'To transcendentalism of religion there always corresponds a transcendentalism of art…' (11) In another context I have made a more lengthy reference to Worringer. (12) However, what is of interest here is the 'Foreword to the New Impression, 1948,' in which forty years after the publication of the original thesis, Worringer talks of a kind of conversion experience that he had as a young student in Paris, at the Trocadero Museum. (13)

Worringer was completely alone in the Trocadero, when joined by the powerful 'spiritual personality' of the Berlin philosopher Georg Simmel. He then describes how 'it was the ensuing hours spent in the halls of the Trocadero with Simmel, in a contact consisting solely in the atmosphere created by his presence, that produced in a sudden, explosive act of birth the world of ideas which then found its way into my thesis…' (14) He then goes on to talk of the 'state of spiritual intoxication in which those hours of conception left me' and 'the solitude of the Trocadero Museum in that

crucial hour, with no other contact than that of an atmospheric aura unknown to both of us.' He further talks of the 'birth of my inspiration.' (15)

The second reference that I want to make also involves a type of conversion experience and is related to the first account in that the event again took place in Paris, in the Trocadero Museum. It also would have happened around the same time as Worringer's visit, in 1905 or 1906. On this occasion it concerns the young painter Pablo Picasso, an artist as I stressed at the outset of this work that was very much 'at-one' with his painting. Although never a pure abstract painter, I think it is generally accepted that Picasso's Cubist paintings of the early twentieth century initiated the move towards the absolute excavation of the 'manic-oceanic' creative core undertaken by the abstract expressionists in the 1940s, and the 1950s

One key factor common to both the Worringer episode in the Trocadero and to the account of Picasso that I am about to relate, is the presence of African tribal sculpture which no doubt in part contributed to the 'aura' of the museum that Worringer refers to. Picasso's conversion experience was directly related to these tribal sculptures and artefacts, that in the beginning of the last century must indeed have seemed utterly alien and mysterious.

Patrick O'Brian recounts Picasso's own version of his visit to the museum in his biography of the artist, how out of curiosity he walked into the Musee d'Ethno-graphie, where 'African Sculpture was first revealed to him.' O'Brian lays stress on the fact that Picasso used the word 'revealed' in his own account, pointing out that although other modern artists such as Braque and Matisse 'and the whole advanced artistic world of Paris took to admiring and collecting what they called fetishes, they admired them as sculpture, whereas Picasso alone saw then for what they were.' (16)

O'Brian then quotes Picasso:

When I went to the Trocadero, it was revolting. Like a flea-market. The smell. I was all by myself. I wanted to get out. I didn't go: I stayed. It came to me that this was very important: something was happening to me, right?

Those masks were not just pieces of sculpture like the rest. Not in the least. They were magic...We hadn't understood what it was really about: we had seen primitive *sculpture*, not magic...I understood what their sculpture meant to the blacks, what it was really for...If you give spirits a shape, you break free from them. Spirits and the subconscious (in those days we weren't yet talking about the subconscious much) and emotion – they're all the same thing. I grasped why I was a painter. All alone in that museum surrounded by masks...The 'Demoiselles' must have come that day: not at all because of their forms, no; but because it was my first exorcising picture – that's the point. (17)

I have discussed Picasso's Trocadero encounter in an essay entitled *The Politics and Psychoanalysis of Primitivism* first published in 1996. (18) In the context of that work I also referred to the landmark and controversial exhibition: *Primitivism in 20th. Century Art, Affinity of the Tribal and the Modern*, held at the Museum of Modern Art, New York, in 1984. The show drew a direct comparison between tribal sculpture and modern art and was fiercely criticised for so doing. (19) However, the Director of the Exhibition and editor of the exhibition catalogue, William Rubin, had some key insights into the inner motivation of Picasso.

In relation to Picasso's revolutionary painting the *Demoiselles d'Avignon*, completed in 1907, which Picasso suggests was inspired by his visit to the Trocadero, Rubin writes:

> The various metamorphoses of Picasso's *Demoiselles d'Avignon* were but the visible symbols of the artist's search within his own psyche. This self-analysis, this peeling away of layers of consciousness, became associated with a search into the origins of man's way of picturing himself. That Picasso would call the *Demoiselles d'Avignon* his first 'exorcism picture' suggests that he understood the very making of it as analogous to the kind of psycho-spiritual experiences or rites of passage for which he assumed the works in the Trocadero (museum of ethnic arts) were used. The particular kind of personal freedom he experienced in realising the *Demoiselles d'Avignon*, a liberating power that he associated with the original function of the tribal objects he saw, would have been meaningless – as anthropologists would be the first to insist – to tribal man. Yet there *is* a link, for what Picasso recognised in those sculptures was ultimately a part of himself, of his own psyche, and therefore a witness to the humanity he shared with their carvers. He also realised that the Western artistic tradition had lost much of the power either to address or to change the inner man revealed in those sculptures. (20)

Rubin's highly perceptive commentary is important for the key connections it makes. I will again refer to this passage in the subsequent sections dealing with ritual, because Rubin astutely identifies the analogous relationship between the modernist creative process and the process forming rites of passage. He further understands Picasso's recognition of this fact: that the psychic processes implicated in the 'very making' of the *Demoiselles d'Avignon* were the same as the 'psycho-spiritual' core of the ritual process. The fact that Picasso in a conversation with Andre Malraux compares his role as a painter with that of a 'witch doctor' would further indicate his realisation of the ultimate shamanistic role of the modern painter.

Consistent with the 'psycho-spiritual' and shamanistic connections Picasso makes in respect of the painterly creative process is his reference to the exorcistic dimension of paintings such as the *Demoiselles*. That such painting involves 'exorcism' is clearly consonant with the references made earlier to the psychoanalytic theory of 'splitting' and 'projection' in the developmental phases and their counterparts in the creative process.

The type of process described in 'encounter with psychoanalysis,' in which the artist projects alienated split-off parts of the subjective psyche during the initial creative phase and then effects a restitution and a reparation as they are integrated, underpins the cultural dimension of expiation which ritual exorcism would appear to serve. Such comparisons between subjective, individual experience and wider cultural experience have been drawn before: In *Totem and Taboo*, Freud makes a direct correspondence between the irrational compulsions and obsessional symptoms of individual neurosis and the equally motiveless and apparently pointless tribal taboo prohibitions. Both individual neurotic compulsive rituals and obsessive cultural taboos appear to lack any motivation, because as Freud points out, their original source stimulus has been banished and repressed into unconsciousness. (21)

Picasso also associated such psychic purging with the 'personal freedom' and 'liberating power' of the creative process as its 'manic-oceanic' dynamic potential serves to neutralise intolerable threat and anxiety, so negating guilt in what W.R.Bion has described as 'at-one-ment.' (22) This is the key connection between the power of the creative process and mysticism: the personal liberation of the 'soul' in an ecstatic union with the creative core, or in the perception of some Eastern mystics, the 'Divine Mother.' In the context of the painterly creative process, this liberating potential is also held out for the receptive viewer, who can be enmeshed within the matrix of form. It is significant that Leo Steinberg, in an article written in 1972, argues that the distortion of figuration and condensation of space in Picasso's *Demoiselles* generates a power that completely envelops the engaged spectator in 'the orgiastic immersion' of 'Dionysian release.' (23)

What Picasso ultimately describes here is a force initiated by subjective creative engagement, but which has a universal, cross-cultural dimension rooted within the structure of the human psyche. What may appear to be regressive and subjective in the individualistic experience is reconstituted in the cultural dimension of ritual and religion and in systems of mysticism and spirituality. Both Picasso and Worringer in their different ways give credence to the idea expressed by Rolland, that conversion experience is a personal experience that forms the foundations for and generates religions and mysticisms as their 'true subterranean source' and which need not be exclusive to these more formalised ideas of inner spirituality.

Furthermore, the related experiences of Picasso, Wilhelm Worringer and Romain Rolland, give clear credibility to the claim that personal, idiosyncratic 'mystical' or creative revelation can form a justifiable foundation and motivation for the development of research and argument. In the case of Worringer, I have cited his 'sudden, explosive act of birth…' that produced the 'world of ideas which then found its way' into his thesis. Indeed, one can read his famous tract 'Abstraction and Empathy' as an exposition of personal transcendental experience and its source of the connections Worringer makes between the transcendentalism of art and religion. Again, as I have noted, even at the age of 63 years, Rolland was still striving to come to terms with the essence of personal mystical experience.

In the context of this work, dealing with the essential relationship between the creative process and ritual and mysticism, Picasso's deep empathy with the ritual creative process, which was to revolutionise and change art forever, is of key significance. Through what I think is fair to describe as a personal mystical conversion experience, the fundamental purpose of tribal sculpture is imparted to Picasso in a revelation. I have quoted Patrick O'Brian's argument that although African sculptures and 'fetishes' were admired by other artists, only Picasso was really able to see them for what they were.

From this revelatory encounter in the Trocadero, Picasso extracted the essence of the creative process itself, which is embedded within the tribal artefact through its intense association with the transformative ritual process originally giving rise to it. That is to say, Picasso experienced a creative communion with the exotic and deformed structure of these uncharted objects, objects that embody and encode the creative process as it is defined by ritual enactment. Picasso actually internalised the essence of the creative structure through tribal sculpture as a cipher of the trans-

formational and developmental sequences constituting the ritual process. Tribal sculpture revealed the skeleton of its inner creative frame, just as Cubist and abstract painting was about to do.

Picasso's realisation that these artefacts were not just sculptures, but in fact what he calls 'magic,' is crucial. As I have related, he then goes on to talk of giving 'spirits a shape' and suggests that what he means by spirits is the 'subconscious,' or in fact, the unconscious. This revelation enabled him to ultimately grasp why he was a painter and indeed, what it really meant to be an artist.

My claims for Picasso's creative and psychological experience are in some measure inevitably made through my own eyes as a painter and through personal transcendental creative encounters and the intuition and insight accrued in my own practice. As I have related earlier, I vowed to recreate the uncanny experience of envelopment within my own painting and experimented instinctively and empirically until I was able to reformulate the conditions for an *ekstasis*. This creative essence can then in turn be encoded and transmitted onwards so fulfilling a primal directive of the painter in the most fundamental shamanistic role.

This is not so uncommon as might be supposed and was tacitly recognised by those twentieth century abstract painters who were charged with the recovery of painting's creative core. Dore Ashton appears to believe that this was certainly the case with Mark Rothko, despite his dislike of 'overheated responses' to his work and his apparent denial. She says: 'Although his paintings progressed from metamorphosis to transfiguration, he adamantly denied in public that they represented for him (and now for many others) a kind of *ekstasis* (*ex:* out of; *histanai:* to set, to stand). Yet he was most affectionate with those who sensed the depth of his passion, and who knew that his protestations were somehow ritualistic.' (24)

To the extent that some of my views on Picasso and the *Demoiselles d'Avignon* are filtered through my own subjective creative perception, they cannot be validated or proved. However, from the painting's inception to the present day there has been ongoing debate and argument about its influences, sources and intentions. In respect of the unverifiable claims that I am making for Picasso's shamanistic artistic power, it is important to point out that much of the contemporary debate supports the contention that the *Demoiselles*, at least in part, was inspired by tribal sculpture that had a deep psychological impact on the artist, an impact that Rubin describes as an 'epiphany.' (25)

In turn, I think that Picasso was determined to reconstitute and transmit this true creative essence, an essence gradually forfeited in academic and mannered painting since the Renaissance. Christopher Green recently argued: 'Despite Picasso's later denials of any influence from "Art negre" in the *Demoiselles*, the changes to the heads of the nudes on the right are now agreed to relate to immensely powerful but generalised recent memories of West African and Oceanic sculpture in the Musee d'Ethnographie du Trocadero in Paris, which it is assumed he first visited just before he launched into his final campaign on the canvas.' He further talks of 'the two Africanised nudes on the right.' (26) To a degree, both the denials of Rothko and of Picasso would appear to support Freud's contention in 'Negation' (1925), that denial is often in truth an affirmation. (27)

Green further explains how in the *Demoiselles*, Picasso reformulates the precedents both in Ingres and in orientalism 'in terms of a harshly antidecorative approach, and in terms of a figuration that is explicitly primitivising, combining echoes of European archaism with the strongest possible invocation of African tribal sculpture.' (28) As far back as 1912, Andre Salmon had described Picasso as 'The apprentice sorcerer …still seeking answers to his questions among the enchantments of Oceania and Africa.' (29) In relation to my own arguments about the universal, cross-cultural, developmental dynamic at play here, Green concludes that Picasso's engagement with primitivism in 1907-8 could be read in 'cross-cultural, humanist terms' and 'in terms of the theme of sameness in difference, the essentialist theme of the unity of humankind…it is an appropriation of the African founded on the most positive revaluations, one compelled by the search for similarity in difference at the deepest level.' (30)

Whether in terms of the shaman, the sorcerer, or, as Picasso suggested, the 'witch doctor,' it is the individual experience of *ekstasis* that isolates the oceanic core of the creative process and in turn forms the foundation of mysticism and religion. It is in this mystical encounter that the initiate is somehow radically enlightened and propelled into a search for symbols to express its meaning. This is certainly the case in respect of Rolland, Worringer, or Picasso. Similarly, in my own experience as a painter, I came to understand that since the abstract monochromes there has been a subsequent evolution of a personal iconography, which on one level serves to embody and symbolise mystical creative engagement.

As in the workings of ritual, this process parallels the *structure* of the dream: that is, just as unconscious emotion formulates symbols of representation in the dream, so do unconscious states or altered states of consciousness, ultimately precipitate *trance-formations* and the artefacts that embody them, and unconscious creative painterly engagement distil an iconography, the function of the original religious icon paintings. (31)

From what I have said so far, it is clear that I subscribe to Romain Rolland's conviction that the oceanic feeling is the wellspring of religions. Such a viewpoint has been criticised for its stress on the 'little ego' and on subjective, individual psychology and regressive developmental concerns at the expense of deeper and wider universal mystical and religious meaning. I would hope in some degree here, however, to explain that both are reflective of the other and are interdependent. Just as in a painter's development, such as my own, those works which seem to deal exclusively with the regressive and subjective in fact lay down a template for a far deeper exploration and expression of transformative and healing processes, so can individual spiritual experience formulate deeper canons of mysticism.

William Parsons, as I have indicated, is sensitive to this whole debate and his work: *The Enigma of the Oceanic Feeling*, already referred to, is highly relevant here because a central concern in his argument is to address the historical relationship between psychoanalysis and mysticism, or the oceanic feeling. That is to say, the essential connections between individual psychoanalytic developmental models of transformation and their extension into a more general cultural context, where social functioning can channel such experience to help shape and integrate human society. In

essence, initiation rites in a communal context incorporate the individual and the cultural in one transformative procedure.

In respect of the relationships between the individual and the cultural, Parsons does define the two poles of debate in the analysis of mysticism, represented by the 'perennialists' (or 'essentialists') and the 'constructivists' (or 'contextualists'). The perennialist position is based on the view that all mysticism rests on a common-core transcendent unity. Different traditions might influence the perception of mysticism, but diversity of concept comes into play only subsequent to the individual mystical encounter. The constructivists, however, assume mysticism to be diverse and irreducible to a common-core. Mediation by differing cultures and contexts inevitably leads to different types of mystical experience not necessarily emanating from a universal, cross-cultural, essence.

Parsons also notes the further debate about whether mysticism should be viewed primarily in terms of experience or of process. That is to say, whether the accent should be placed on 'singular epiphanies' or on a broader context of life that may influence dispositions and states of consciousness. However, the key question still remains: 'whether there exists an underlying common-core of development.' (32)

If we briefly look at this essential debate in an anthropological context rather than in terms exclusively of mysticism, similarly opposing poles can be discerned perhaps with greater clarity. I.M.Lewis in *Ecstatic Religion: A Study of Shamanism and Spirit Possession* delineates differing perceptions of trance and mystical experience. On the one hand trance is viewed as possession by an external spirit, on the other it is predominantly attributed to what is referred to in anthropology as 'soul-loss.' Lewis further makes reference to the Belgian anthropologist Luc de Heusch, who argues that both explanations of trance phenomena are mutually indispensable. That is to say spirit possession is only possible if the self has been vacated, as in the theory of 'soul-loss.'

Lewis gives a full account of the complexity of these issues, recognising the very diverse cultural determinations and constraints placed upon conceptions of mystical experiences and trance. He says: 'The altered state of consciousness (which may vary considerably in degree) and which for convenience we call trance is, in the circumstances in which it occurs, open to different cultural controls and to various cultural interpretations.' (33) He further suggests that 'soul-loss' trance can involve a 'culturally determined emphasis on soul-loss, rather than on spirit possession...' (34)

In terms of ritual trance, therefore, Lewis takes a constructivist position, seeing cultural context as the major determining factor. However, I think that this misses a crucial component of mystical experience or ritual trance phenomena, that 'ecstatic religion,' to use Lewis' own title, is inevitably founded upon *ekstasis*, a Greek word with a root meaning 'to stand outside of or transcend *oneself*.' I emphasise the 'oneself' because this ecstatic phenomenon relates to an individual epiphany beyond cultural context. (35) The events or ceremonies that may eventually surround the process within the cultural context are developed after the singular experience has been isolated. This is, of course, the perennialist position, where 'Although it is acknowledged that the description of mystical experiences differ from tradition to tradition, such variety is attributed to a mystic's set of beliefs and concepts coming into play only after the initial, immediate encounter with the divine.' (36)

Although, as I.M.Lewis suggests, tribal emphasis on 'soul-loss' trance may be culturally determined, it is really the belief in spirit possession that lends itself most readily to constructivist ideas of cultural determination. Cultural context would seem to have more influence in respect of animism and the selection of spirits to represent tribal taboos or mythology. For this reason, in 'Ecstatic Religion,' Lewis concentrates predominantly on spirit possession. (37)

The perennialist position inevitably lays stress on the individual experience and on what William Rubin recognised as the cross-cultural psychic consonances expressed in a diversity of cultures. I have stressed earlier that a psychoanalytic interpretation of such phenomena can be very productive in defining these elemental structural parallels. However, as Parsons points out at length, the credibility of such psychoanalytic approaches has with good reason been seriously undermined by those exponents who have relied upon crude explanations based exclusively on regressive infantile developmental states. This criticism is levelled not only at classical psychoanalytic interpretation, but also in respect of some more recent and contemporary analysis. (38)

Early psychologists such as William James in his classic text *Varieties of Religious Experience* defined religious experience as solitary individual experience. The traditions and organisations that follow on from it he saw as secondary phenomena derived from what Parsons describes as the 'primary experiential matrix.' (39) The Latin origin of the word 'matrix' is 'womb' or 'mother' and the word evokes strong connotations of maternal and nurturing psychic space. Such a primary psychic element will inevitably attract a psychoanalytic definition.

As Parsons outlines, Freud's engagement with the oceanic feeling had definite ramifications on approaches to mysticism. Freud's basically perennialist position perceived of a common core psychoanalytic template underpinning mystical experience, but contrary to this essentialist perspective, psychoanalytic interpretation stressed developmental modes exclusively at the expense of transcendental sources. In its most reductive manifestations, the universality of experience is explained away as the unity of the infant with the mother's nurturing breast. The sense of oneness in mystical union is interpreted by Freud 'as a regression to immediately postnatal experience. (40)

It is true that psychoanalytic interpretive method, whether in the context of artistic creative processes or of religious experience, is more often than not culpable in its oft-perceived objective to project psychoanalytic models and structures on to external cultural events and situations. (41) In part, Romain Rolland's correspondence with Freud can be seen as an attempt to redress this imbalance. Rolland was ultimately concerned in all of his writings that Western interpretation of Eastern mysticism failed in general to appreciate its deeper transcendental esoteric dimension alien to the more rational and philosophical prescriptions of Western analysis and so beyond its parameters of understanding.

It will be recognised that my own objective here is to contribute to this debate through the insights gained in my own experience as a painter attempting to come to terms theoretically with the uncanny dimension of mystical creative experience. From what I have already said in respect of developmental templates forming a basic level of the creative process, it might appear contradictory that I also agree with

those criticisms of reductive psychoanalytic interpretation of mysticism. My reliance on psychoanalytic models and belief in psychoanalysis as a subtle hermeneutic is evident and although it is clear that psychoanalytic interpretation of cultural phenomena can be reductive and crude, I hope to show that whilst developmental models and structures are indeed intrinsic to creative and religious processes, they only form a fundamental level at which a dynamic template is installed as a blueprint from which a deeper and more mature engagement with creative and mystic processes can be developed.

Obviously in respect of my comments on the painting *Promised Land*, (Fig. 11) I have made the claim that such a work *can* somehow connect with events as early as the intrauterine and the postnatal, as Freud argues in respect of the oceanic feeling. As I have emphasised, this inner constitution of the painterly creative process provides a parallel dimension within which real developmental life events are re-enacted with perhaps a greater degree of control being exerted over them. In relation to the evolution of my own late painterly iconography, I will give a clearer exposition of how the initial formation of developmental structures leads to a deeper appraisal of reality and also, paradoxically of the unconscious and mystical processes in part defining that reality.

The reductive models initiated by Freudian psychoanalytic interpretation are of the classical school. Parsons points out that other more sophisticated approaches have developed, as in the 'adaptive school' that employs greater knowledge of ego psychology and object-relations theory and emphasises 'the healing, adaptive dimension of mystical experiences.' (42) There is also the 'transformational school,' the studies of which 'display a cross-cultural sensitivity and, in calling upon theorists like Bion and Lacan, displays a marked sympathy with the transcendent, religious claims of the mystics.' (43)

So Freud's analysis of the oceanic feeling, initiated in *Civilisation and its Discontents*, although a pereniallist version of events, was assumed to basically involve the intermittent regression to the preverbal and pre-Oedipal recollections of unity 'motivated by the need to withdraw from a harsh and unforgiving reality.' (44) This view had a strong impact on psychoanalytic interpretation of mysticism. What it misses is that spontaneous and induced recourse to transient, altered states of consciousness and mystical union are by no means exclusively escapist attempts to deny the harshness of the real world, but can ultimately be attempts to replicate primary sequences in order to confront again an original severity of conditions and transform them. This transformative effect of the process redesigns psychic structures for a more durable and stable relationship with external reality, an objective that is quite the opposite of escapism.

In my earlier comments on Melanie Klein's object-relations schema I did acknowledge the fact that the oceanic phase can provide a fallback or failsafe position against unsuccessful attempts to negotiate a transition through to the depressive stage. In other words, the oceanic dimension forming a connecting corridor between the paranoid-schizoid and the depressive, does in fact offer respite from a harsh reality, but effectively only a temporary recourse before further attempts to confront and engage with the depressive position. The oceanic phase, with its element of omni-

potence and freedom, can enhance ego strength through an increased toleration of anxiety and ability to cope with depression, as I explained earlier.

Although Freud's analysis of the oceanic feeling was generally *perceived* to be reductive in its apparent reliance on regression to infantile states, Parsons points out that the situation is really more complex and that Freud's interpretation is influenced largely in reference to letters from Romain Rolland. In fact, key contributions from *Civilisations and its Discontents*, when analysed against the letters, reveal that 'Freud offered two models for the interpretation of two different mystical states, neither of which corresponds to the received view of Freud's take on the oceanic feeling.' (45)

The synthesis by Freud of a more subtle and profound form of oceanic feeling is of interest here in the correspondences he draws between this refined oceanic feeling and mystic states and religion – and so ultimately with the creative process. In many ways, the references he makes in response to the writings of Rolland, support some of my own contentions in respect of the abstract creative dimension isolated in the monochrome collages.

Parsons examines how Freud extended his original reductive view of the oceanic feeling as simply a regressive 'common-man's mysticism' into something far more complex and with a greater acknowledgement of the cryptic nature of mysticism. From a view of the unitive oceanic feeling that demanded regression to a pre-Oedipal developmental model, Freud subsequently 'speaks of mystical practices (Yoga), of ecstasies and trances, and of regressive descent into "primordial states" for the purpose of achieving a particular kind of wisdom.' (46) So here Freud makes a link between the oceanic feeling and *ekstasis* and trance and so between mysticism and ritual and the creative process.

In the chapter 'The Enigma of the Oceanic Feeling,' Parsons outlines the development of Freud's more profound appreciation of the oceanic feeling and mystical experience. In reference to Freud's correspondence with Romain Rolland and the 'Goetz Letters,' he records how in *Civilisation and its Discontents* Freud characterises the oceanic mystical experiences with words from Schiller's *The Diver* and how he draws the term 'whirlpool' from the poem. Significantly, as Parsons points out, Freud here uses the term 'whirlpool' to designate the unconscious. (47)

Parsons goes on to explain how in Schiller's poem, Oedipal and oceanic imagery are effectively condensed. That is to say, the hero of the poem grapples with the forces of a feared 'whirlpool' portrayed as an 'oceanic womb' in order to recover a king's goblet. Parsons suggests that the poem '…can be read as a metaphor for the psychoanalytic task. One "dives" into the "whirlpool" of the unconscious, a whirlpool inhabited by powerful and potentially dangerous powers. Furthermore, the theme of *The Diver* is an Oedipal one: winning the favor of the king and gaining his daughter's hand in marriage, only to eventually displace the king himself. Freud's citation of *The Diver* in the passage in question suggests that, far from retreating from psychic reality, the mystic diver goes where few fear to tread.' (48)

In the context of a work that, as the title suggests, is 'revisioning' psychoanalytic theory of mysticism, it is understandable that Parsons would draw attention to the poem's structural analogy with psychoanalytic procedure. However, what such a poem really does in fact is to embody the creative process, upon which psychoanalysis is in any case originally based, in both terms of form and content.

Early in chapter 3 I pointed out that *Oedipus Rex*, by Sophocles embodies within its intrinsic structure an alliance of form and content in that the narrative in essence describes the creative process itself. That is to say, in terms of the painterly creative process, the Father, in the guise of ordered, discernible, logical shape, is eliminated or neutralised and there follows a 'communion' with the maternal matrix derived from the original maternal nurturing space of the Mother. I have also remarked in the present chapter that tribal sculpture similarly embodies and encodes the creative process as it is defined in ritual performance. Here again, in terms of Schiller's *The Diver*, the whirpool signifies the deeper manic-oceanic phase, enacted in purely formal terms within the form of the poem. Similarly, the appeasement and eventual negation of the king symbolically represents the structural creative dynamic I have outlined in which shapes representative of conscious order and constraint can be neutralised in the central manic-oceanic creative phase. As I also explained, their symbolic loading of guilt and conscience is likewise momentarily eradicated.

Parsons describes how Freud goes on to praise the artist for having the power to connect with profound truth not readily accessible to others and for having anti-cipated the metapsychology of psychoanalysis. Although in the 'Goetz Letters' it is clear that Freud is very wary and apprehensive of the oceanic depths encountered in the classic Eastern text on mysticism, the *Bhagavad Gita*, 'where everything melts into everything else,' and where you are 'confronted by nothingness,' it is nevertheless the case that despite Freud's lifelong trust in reason and logic, he does here acknowledge a deeper dimension of oceanic feeling. (49) Parsons indicates that: 'Freud's reference to the "ultimate in human understanding" suggests that the mystic... succeeds in gaining insight into the deepest recesses of his Oedipal distress.' (50)

Freud recognised that in the 'awful depths' of the *Bhagavad Gita* the mys-tic undertakes a 'psychic surgery.' (51) Again, it is evident, as Parsons suggests, that Freud unquestionably believed that 'mystical practices unearthed psychological in-sight' and in a letter to Rolland conceded that the intuition of mystics could be 'valuable for an embryology of the soul.' (52)

Significantly, as Parsons records, Freud further recognised the key relation-ship between psychoanalysis, art, and religion. He says that for Freud:

> Artists, moreover, existing at the margins of culture, seemed to have an unusual access to the unconscious and the talent to represent unconscious pro-cesses in symbolic, experience-distant ways. Art could be therapeutic in providing an outlet for instinctual gratification and edifying when it stirred the imagination and ignited introspection. Thus conceived, art had a special relationship to psychoanalysis. (53)

For my own investigations here, it is important to appreciate that Freud's more complex model of the oceanic feeling makes the connection with art. Parsons refers to the relationship between 'transient mystical experiences and the oceanic feel-ing,' which, for my purposes, effectively represents that between ritual and religion and the creative process.

As we have seen, Freud's reappraisal of the oceanic dimension was in part provoked by his correspondence with Romain Rolland. By his own admission, Freud was perplexed and unsettled by Rolland's accounts of the oceanic experience. (54) Up

to a point this is to be anticipated in light of the dependence of classical Freudian psychoanalysis on the Oedipal level of theoretical interpretation, which is concerned predominantly with the patriarchal and the Father. It is also logical, therefore, that when Freud attempts to locate the source of religion or religious practice, as he does in *Totem and Taboo*, he traces its genesis back to an original 'primal crime' against the patriarch and dominant male of the 'primal horde.' That is to say, the seeds of religious ceremony were sown when the sons and brothers of the horde band together to murder and devour the jealously protective primal father, who controlled the females exclusively for himself. (55)

Freud further conjectures that this deed induced guilt and remorse in the group:

> They revoked their deed by forbidding the killing of the totem, the substitute for their father; and they renounced its fruits by resigning their claim to the women who had now been set free. They thus created out of their filial sense of guilt the two fundamental taboos of totemism, which for that very reason inevitably corresponded to the two repressed wishes of the Oedipus complex. Whoever contravened those taboos became guilty of the only two crimes with which primitive society concerned itself. (56)

Freud, therefore, offers an explanation for totemism, taboo, the 'horror of incest' and the resultant practice of exogamy. The tribal totem animal, as a substitute for the primal father, is designated sacred and taboo in an expression of remorse and attempt at atonement. The institution of the memorial festival of the totem meal celebrates the original triumph by temporarily deferring the strict adherence to prohibition. In addition, the communal repetition of the original patricide also served to alleviate the guilt through association: all partook of the memorial sacrifice.

Totem and Taboo has in recent times been widely criticised and perhaps as a piece of historical speculation been discredited. However, I am not concerned here with the accuracy or otherwise of Freud's anthropological investigations; to apply scientific critique to a text in part allegorical anyway seems to miss the point. (57) What is of concern here is that for Freud it is primarily the father-complex that persists in totemism and so in religion generally. Furthermore, as I have indicated, what Freud is describing in *Totem and Taboo* ultimately comes down to a narrative of the creative process. This is to be expected, as the developmental phases forming the core of the creative structure will also inevitably be mirrored in religious and social rituals. But *Totem and Taboo* in its investigations of the origins of religious practice appears somewhat simplistic because it stops short at the patriarchal and Oedipal, so missing the essence of mysticism and clearly of a worldwide religion such as Roman Catholicism.

I have referred to Freud's dependence on the Oedipal earlier. However, in the context of religion such a relatively narrow perspective does severely limit the interpretation of religious motivations. The only reference he makes to other possibilities occurs in one significant aside: 'I cannot suggest at what point in this process of development a place is to be found for the great mother-goddess, who may perhaps in general have preceded the father-gods.' (58) In his concluding remarks in *Totem*

and Taboo Freud emphatically declares that: '...I should like to insist...that the beginnings of religion, morals, society and art converge in the Oedipus complex.' (59)

It is this factor that effectively divides Romain Rolland from Freud in their approaches to religion and is responsible for Freud's instinctive apprehension when confronted by the oceanic feeling. For the oceanic and mysticism functions within the maternal realm: a pre-Oedipal and pre-symbolic dimension. I have debated these issues at greater length in *Painting, Psychoanalysis, and Spirituality* (2001) and suggested that the crux of religious argument surrounding Protestantism, Catholicism, iconoclasm and the bitter struggles of the Reformation, was in essence transubstantiation. I draw a parallel between the ethos and ceremony of transubstantiation and the reincarnation of psychic structures, or the embodiment of the mind, within the core of the creative process. The ruthless and puritanical purges of iconoclasm against the visual image in effect target this parallel transubstantiation enacted in the central manic-oceanic phase.

Effectively, the only essential point of divergence in Protestant and Catholic belief is centred on transubstantiation. The fact that Catholicism embraces the pre-Oedipal and maternal psychic dimension inevitably confers a deeper or more all-embracing nature and access to a real transubstantiation, if only in ceremony. Up to a point this must validate Catholic counter-Reformation claims to be the 'true faith,' although the Christian concept of the Virgin Mother reflects the maternal in the possibility of a creative rebirth.

Parsons offers similar arguments in his discussion of 'Mysticism and the Mother' explaining how Freud's patriarchal model was at odds with Eastern religions. This reliance on the Oedipal level is called into question by 'revisionists' who endorse the alternative 'adaptive' and 'developmental' models of analysis, amongst other approaches. Significantly, Parsons states that such critics would: '...understand why the adherents of Catholicism and Hinduism, who have internalised a more maternal worldview, seem to favor mysticism and object-relations theory.' (60) Rolland, in his biography of Vivekananda, identifies this connection noting of the mystic that: 'At every instant he was struck by the similarity between the Catholic Liturgy and Hindu ceremonies...' (61)

Clearly, from the evidence gained through my own empirical analysis of the creative process in pure abstract painting, it will be recognised that an authentic transformative experience, or conversion, can only take place during the manic-oceanic creative phase which affords the conditions for a complete breakdown of conscious functioning and a reformulation of psychic structure as the mind is externalised and reconstituted or embodied within the evolving artwork or artefact. (62) As I have explained, this creative phase is pre-verbal, pre-symbolic and pre-Oedipal. It follows that a religion without access to this psychic dimension cannot offer genuine conversion. Similarly, as Ehrenzweig basically proposes, an artwork that cannot connect with this abstract oceanic level, the 'minimum content of art,' is not really art in this sense at all. (63) It is further transparent why Freud struggled to develop a real empathy with the oceanic: it was fundamentally beyond his sphere of consideration and analysis.

On the other hand, Rolland was drawn to mysticism for the very reason that his staunch Catholic background and personal, subjective religious credo were centred on the Mother and evolved from a 'deep maternal matrix.' (64) Rolland was suspicious

of organised, institutionalised religion, preferring a mystical philosophy, initiated by his own transformative, conversion experiences and informed predominantly by a 'ubiquitous maternal presence.' (65) As Parsons notes, Rolland's instincts 'predisposed him to pre-Oedipal issues, to mysticism, perenialism, and,...a maternally based psychology.' (66)

This is why Parsons' analysis of Rolland's dialogue with Freud is of such interest here. Rolland is very much like the artist, who through mystical experience develops a line of personal religious thought related to psychoanalytic developmental models and other perspectives not dependent upon the strictures of pure theology or religious doctrine. Such an approach, of course, also frees the initiate to develop an empathy with Eastern religion and mysticism. In addition, Rolland considered mystical experience to be a universal constant, 'always and everywhere the same.' He concluded that there was an innate, profound, '...universal dimension of the human soul' which could be closely related to a 'mystical psychoanalysis.' (67)

As a painter who has investigated personal transformative experience and had recourse to psychoanalytic developmental models of interpretation, I feel that I have a deep rapport with Rolland, who must at some stage have encountered accusations of subjective idiosyncrasy. Of course, as Parsons points out, Rolland's universalistic, cross-cultural, perennialist perspective could have inevitably been criticised by the constructivists and contextualists as being 'coloured by personal and cultural projection' and because 'He attempted to universalise a mysticism which, in actuality, reflected his own.' (68) But Rolland continually advocated an approach to mysticism 'which stressed the personal, subjective, and experiential over and against "secondhand" institutional religion and its accoutrements.' (69) He further engaged avidly with psychoanalytic modes of investigation and attempted to relate them to other practices in which he detected a transformative and therapeutic objective, as in Yoga.

Importantly for my own analysis of the painterly manic-oceanic creative phase in chapter 3, Rolland identified the etymological root of Yoga as the meaning 'to join,' which as Parsons comments 'implied the union with the divine' where '...in the final analysis subject and object, inner and outer, were transcended and united in primal Being.' (70) Yoga was a path to inner transformation and freedom. It was not escapist or regressive, but rather as I have suggested in respect of creative and ritual recourse to the oceanic, rigorous in its determination to toughen the ego and to face threat, anxiety and 'hidden monsters' directly. (71)

Like the artist, Rolland understands that mystical experience in the rigorous and disciplined context of Yoga, was a complex process of inner transformation and intellectual control adaptive in the regeneration of ties with reality. It is not surprising, despite his subscription to a mystical psychoanalysis and trust in psychoanalytic models of interpretation, that Rolland should be critical of those exponents who employed a narrow and reductive psychoanalytic interpretation. Rolland recognised that the developmental *and* transcendental must coexist within the mystical experience if it is to have real meaning and to be profound and effect a liberating conversion and new adaptation to the real world.

Rolland targeted Ferdinand Morel, a contemporary theorist, for his perceived deficiencies in this respect whilst at the same time criticising Western psychoanalytic and psychological 'science' for failing to understand 'The intuitive workings of the

"religious" spirit – in the wide sense in which I have consistently used the word....' He criticises those observers like Morel who are '...prone to depreciate an inner sense they do not themselves possess.' (72)

Morel dismissed the transcendentalist claims of the mystics in favour of reductive psychobiographical method that laid stress on psychosexual developmental theory and pathology. He concluded in his study that all mystics were introverted in the sense of the 'characteristic tendency of neurotics and psychotics to turn away from reality, regress to earlier developmental stages...divorced from the common social reality of everyday life.' (73) Parsons further comments that for Morel, mystics were 'sexually maladjusted' repressed introverts, who 'regressed to narcissistic and auto-erotic stages of development...Deep ecstatic experiences...were interpreted as a long-ing for the security and quietude of the intrauterine state.' (74)

My earlier remarks in this chapter have acknowledged that the ecstatic mystical experience in the context of the creative process can indeed involve a regres-sion to the solitude of the intrauterine state. I have described how the abstract mono-chrome *Promised Land* was imbued with the colouring and general characteristics that might be associated with such a state. But again I emphasise, that under-pinning the apparently regressive, infantile, 'nostalgic desire for the mother' there is the determin-ation to reconstruct the inner self from the original psychic building block and to begin anew. (75)

Furthermore, in making the assumption that the structural psychic parallels between the mystic and the introverted neurotic or psychotic reflected a real equiv-alence, Morel falls into the same trap as those who have equated the artist with the neurotic. Again, as I have explained, the complete breakdown of *conscious* faculty at the core of the creative process can all too readily be misinterpreted as an actual 'men-tal breakdown.' The crucial difference in the creative dissolution of the mind is that the artist is able to a point to be objective and to orchestrate events and so to guide a psychic reconstruction.

In my argument so far, I have plainly drawn mystical, ecstatic experience in the creative process within the same frame of reference as mystical experience encoun-tered in pure mysticism. I am also making detailed references to Romain Rolland and to the analysis of his views on mysticism by William Parsons. So at this point I should mention that Rolland's rebuttal of Morel's psychopathology of mysticism does en-croach indirectly on the artistic creative process.

As Parsons points out, in order to contest Morel's reductive use of introver-sion, Rolland divides it into two types. In effect, therefore, he defines two categories of regression. (76) Put simply, one type of introversion was defined as being more in the normal course of events and dealing with imagination, fantasy and reverie. The other type referred to the deeper 'unitive encounters of religious mystics.' (77)

Rolland criticised Morel's idea of both of these forms of introversion. Morel had defined the introversion of the mystics as a pathological regression and the fantas-ies and reveries described by them as a withdrawal from reality in a regression to a more primitive state. In order to divorce the higher mystical form of regression from the pathology of neurosis and psychosis, Rolland distinguished 'regression' from 'introversion.' 'Regression' was a pathological retreat with no real possibility of a

subsequent psychic reconstruction; 'introversion' would delineate the process that I have discussed in the context of the creative process whereby the regression is a prerequisite of the development of a deeper and stronger hold on reality. (78)

Unfortunately, Parsons assumes that the division of introversion that deals with the more usual contents of reverie and fantasy and which is also the category inevitably connected with the pathological regression of the neurotic and the psychotic in a total withdrawal from reality, also includes art and the creative process. To be fair to Parsons, such a conclusion is understandable and easy to arrive at because it is often the case that art appears to deal predominantly on the level of dream imagery, reverie and fantasy. From Freud onwards analysts have tended to ignore the deeper structural implications of the creative process at which level there can be a pure psychic 'unitive' experience arguably parallel to that of the profound mystical encounter. Of course, I am not only claiming that this deepest creative level parallels the depths of mysticism, but that the creative structure through its agencies in ritual and religion, is the original template for such experience.

I think that it should also be made clear that in his redefinition of regression Rolland does not appear to draw a similar conclusion about art and the creative process as does Parsons. In fact it is worth pointing out that his principal distinction between pathological regression and a positive introversion is that in the latter there is a retention of consciousness absent in the former. As I have said, in effect this means that the initiate or artist, can at least subliminally orchestrate the process in order to ensure a psychic reconstitution and renewal. Rolland also cites Morel as in fact subscribing to this key point. In commenting upon the 'complete introversion' of the mystic Denis the Areopagite, Morel states that: '...there is no loss of consciousness, but a displacement of attention...Ecstatic experiences remain deeply engraven upon those who experience them...Consciousness is in fact something intensely mobile.' (79)

Rolland was up to a point sympathetic with the idea that deep mystical introversion was interconnected with a regression to the maternal space and the intrauterine state. It was clear from the pervasiveness of maternal imagery in mystical and religious texts that there must be an underlying psychic universal of union with the maternal. But Rolland considered this to be only on one rudimentary level of mystical experience and recognised a much deeper and intuitive dimension. He consequently posited a new, wider conception of the unconscious, based predominantly on archaic unity and intuition clearly beyond the narrow scope of definitions of the unconscious formulated by classical psychoanalysis.

In relation to the parallels between the creative process and mysticism, it is significant that Rolland's proposal for an expanded notion of the unconscious is uncannily consistent with Anton Ehrenzweig's selfsame objective in terms of the creative process. That is to say, just as Rolland's response to mysticism led him to conclude that the unconscious domain accessed during mystical experience was in fact a far more profound and complex dimension than that defined by psychoanalysis, so too did Ehrenzweig's response to abstract painting and the modernist creative process bring about his realisation that the 'structural unconscious' evidenced in such art, was a far more subtle and all-embracing, intuitive instrument, which far from being 'primitive' or chaotic, did in fact have superior powers of organisation to the supposed rationality and logic of the conscious mind. (80)

So the correspondence in the relationships between psychoanalysis and mysticism, and psychoanalysis and the creative process are again highlighted. What Parsons says of Rolland could equally be said of Ehrenzweig, that: 'He proposed nothing less than the emendation of the psychoanalytic conception of the unconscious, a displacement of sexuality as a primary force in the motivation of individuals, a new developmental schema, and a new therapeutic technique.' (81) For Rolland, mystical experience can engage with the material and the intrauterine as a prelude to a deeper, unitive encounter. For Ehrenzweig, as we have seen, although the Kleinian, pre-Oedipal developmental schema forms the basic framework of the creative process, beyond this more rudimentary structure there exists the deepest stratum of the structural unconscious with its inherent paradox of dialectic, contradiction and ultimate unity. This is the structural manic-oceanic creative level Rolland detects within the mystical experience, which although coincidental with the pathological regression focussed on by classical psychoanalysis, further offers the potential for the 'transformational' healing and therapeutic engagement and for the ultimate transcendental claims of the mystics.

The excavation of the fundamental structural unconscious was a revolutionary achievement of modernist abstract painting, a factor discerned and monitored by those perceptive object-relations theorists such as Anton Ehrenzweig and Marion Milner. Milner recognised that the coherence and underlying structure of modern art indicated that the unconscious mind itself must have a reciprocal coherence way beyond its classical characterisation as primitive and chaotic. (82)

As I have explained, it was Ehrenzweig who transcribed the materialisation of unconscious psychic structure within the substance of the abstract painterly form and who understood the far-reaching ramifications of the discovery of a structured unconscious in which even the earliest and most original dynamic psychological and perceptual mechanisms could be manipulated and re-orientated. Although initially accessed through the portal of pre-Oedipal developmental sequences and framed by their processes, both Ehrenzweig and Rolland detected a further dimension where the very unconscious structure of the initiate's mind could be transformed and restructured in a conversion experience. Whether this psychic conversion takes place in the context of the creative process, religious mystical experience or ritual transformation, the constant connecting factor is that of oceanic unity. Parsons comments that 'The most significant existential fact of Rolland's mature mysticism was the emergence of the oceanic feeling,' a feeling distilled at the core of the creative process. (83)

Through my own personal, 'unchurched' creative experiences as a painter I have found these propositions to have validity. A painter like myself may well be initially propelled towards a re-engagement with early developmental sequences because of an unsatisfactory original transition, perhaps leading to a subsequent depression or other neurosis. As Anthony Storr demonstrates in *The Dynamics of Creation*, the artist may well be an individual more exposed than average to original psychological problems. (84) It stands to reason that such individuals will instinctively grope for methods to heal the self, whether through the creative process or through mystical conversion. But the artist or mystic who is able to access the fundamental psychic

oceanic level has the potential for a radical reprogramming of unconscious structures and the therapeutic transcendence of original deficiencies.

So the artist or mystic can objectively oversee a reorganisation and strengthening of the ego, as Rolland suggests in respect of Ramakrishna. In defiance of his traumatic developmental pathology and obsessive 'eroticism,' through mystical experience Ramakrishna transcended such factors in what Rolland describes as 'the spiritual voyage of this passionate artist.' (85) This is recognised by Parsons in his definition of the adaptive school of psychoanalysis, when he comments in reference to the theorist W.W.Meissner, that although Meissner basically employs a psychoanalytic developmental approach in his adaptive methodology, he perceives a wider religious dimension to mysticism. In respect of the saint Ignatius Loyola, Meissner points out that 'from a faith-based perspective, the remarkable ego strength displayed by Ignatius in overcoming and directing developmental vicissitudes is ultimately the work of grace.' (86) 'Grace' might perhaps involve that further oceanic psychic dimension of unity where the unconscious psychic structure is externalised and mirrored.

The conjunction of the original developmental template with a deeper potential for an actual reconstruction of the fragmented psychic structure is indeed a potent combination for an adaptive and therapeutic transformation that confers greater ego strength and a more mature relationship with reality and its vagaries. Rolland acknowledged such connections and Parsons emphasises the 'adaptive-transformational' in respect of his position. (87)

Parsons draws similar conclusions and recognises that ultimately mystical experience compounds the elements of the three classical, adaptive and transformational theoretical schools within its constitution. That is to say, the pathologically regressive along with the neurotic or psychotic symptoms of original developmental psychobiography emphasised by the classical school; the healing and therapeutic essences defined by the adaptive school; or the more profound mystical conversion and transcendence perceived by the transformational school, are all three interrelated and are contributory factors towards a complex mystical experience.

In his ultimate assessment of the composite nature of mystical experience, Parsons does make a comprehensive definition of the classical, adaptive and transformational schools and their contribution to the debate. He makes a further demarcation of subtypes such as the 'perennial invariant' asserting that 'all mystical experience' is composed of the same core characteristics and that their formal expression in mystical texts is so similar as to transcend religio-cultural influences.' A second 'variant' model similarly argues that the core of mystical experience is a universal, but acknowledges the influence of tradition on the characteristics of the experience. (88)

Significantly, from a perennial variant position, Rolland's dialogue on comparative Eastern and Western mysticism concluded that 'the ecstasies of the Greek, Christian, and Indian mystics were "identical experiences."' (89) Rolland recognised a 'universal dimension of the soul' and his ambitions for a 'mystical-psychoanalysis' and a 'science-religion' were instrumental to these claims. Parsons says that for Rolland 'Mysticism was thus everywhere the same, finding its source in an innate feature of man,' that is in the 'psychological notions of the workings of the unconscious.' (90)

Rolland was criticised for his comparativist and universalist conclusions by Indian mystics who rooted the true source of mysticism and Vedantic thought exclusively in India. Interestingly, he was accused by Yogi Sri Krishnaprem of 'debasing the currency' of mysticism by using the thought and expressions of mystics to 'lend a sort of borrowed grandeur to the pale experiences of "Art"...' In this he was thinking of the 'moderns' who saw religious experience as vague 'poetic intuitions' infusing all things. (91) The American Emerson-Whitman tradition of belief in the innate spirituality of nature might be a very appropriate target for such criticism. There was also the counter argument by the constructivists in their emphasis on context that there can be no pure, unmediated experiences or access to a constant noumenal dimension. Individual mystical intuition must inevitably be shaped by the religious and philosophical beliefs of the day.

Within this debate Parsons outlines the crude, reductive methodology of the classic school, through the more considered perspectives of the adaptive school and the development of a more all-encompassing transformational school that embraces ideas of the universality of mystical transcendence. As examples of the classic-school approach he refers to Jeffrey Masson's pathologising of Indian mysticism and to Narasingha Sil's psychobiography of Ramakrishna that has an unhealthy preoccupation with the mystic's psychosexual developmental issues, deemed 'necessary to understand the nature of Ramakrishna's psychosis...' (92) Sil builds on Masson's pathologising in categorising Ramakrishna as a pervert whose 'trances' were dismissed as delusion, hallucination, hypnotic evasion, manic denial and so on.

Parsons recognises that although classical approaches may be 'reductionistic,' they nevertheless 'illuminate common human foibles endemic to even the saint' and he notes Sil's 'convincing treatment of the developmental infrastructure' of Ramakrishna's psychobiography. (93) However, he is highly critical of such methodology for reducing all mysticism to pathology and missing the peculiarly unique mystical modes of knowing.

The adaptive school similarly grounds mystical experience in developmental models, but here the pre-Oedipal and object-relations predominate, with consequent definitions of mysticism as healing and therapeutic. Importantly, Parsons comments that the interpretative method here involves interactions between 'structural components of the psyche' with more diffuse and intuitive unconscious energies. Such structural elements extend beyond the more limited narrative of psychobiographical detail in the individual to a more common developmental template along the lines exposed in the creative structure. (94) In this context Parsons notes the work of Karen Horney, who aimed to integrate psychoanalytic thought with Zen and Morita therapy and to Daniel Merkur, who links mysticism with access to the superego. (95) Nevertheless, these models still fail to confront the transcendent sources of mysticism.

It is significant in respect of the connections I am making here, that Parsons draws attention to the fact that those theorists such as Sudhir Kakar, like Rolland, classified more in the 'adaptive-transformational' mode, have promoted a dialogue between psychoanalysis and anthropology. Their objective is for psychoanalysis to be characterised more as an ethnoscience with greater sensibility towards cultural diversity and as a 'theodicy-turned-poetics.' (96) Clearly, such a phrase connecting 'theodicy' with 'poetics' has a keen affinity with the objectives of my own argument. The

development of greater cross-cultural understanding, in particular between Western psychoanalytic therapies and Eastern mystical ones, is a project comparable to one that draws connections between core creative processes in the Western context along with their psychoanalytic counterparts and tribal ritual processes.

Furthermore, It is very relevant here that Kakar connects mysticism with the creative process and in 'creating a metapsychological space for linking mysticism with creativity' the intense experience of Hindu *Bhava* becomes, in Kakar's words, 'the ground for all creativity.' (97) In *The Analyst and the Mystic* Kakar argues that mystical experience is 'creative experiencing' and that 'Mystical experience, then, is one and – in some cultures and at certain historical periods – the pre-eminent way of uncovering the vein of creativity that runs deep in all of us.' (98)

Although he recognises the positive contribution of the adaptive school of theory, Parsons does question whether such models are adequate in any real understanding of 'higher forms of mystical encounters.' (99) However, the transformative school develops an interpretation of the authentic transcendent and mystical dimension of the personality that has its source in Rolland's 'mystical psychoanalysis.' Within this canon Parsons includes W.R.Bion, Jacques Lacan, Heinz Kohut, Jeffrey Kripal, among others. He notes the use of psychoanalytic models to form a non-reductive link between 'the developmental and transcendent dimensions of mysticism' in a cross-cultural religious context. (100)

In other words, the transformative school aspires to articulate the symbiotic relationship between original developmental templates and mysticism and their instrumental affect in transformative experience through a profound mystical dimension towards a deeper understanding. For example, Parsons cites the studies of Jack Engler who applies psychoanalytic metapsychology to the complex stages of Buddhist mystical subjectivity and 'proposes that psychoanalysis and Buddhist psychology map discrete states of a single developmental sequence, the former describing the lower stages of "conventional" development, the latter the more subtle, spiritual stage of "contemplative" development.' (101)

The clear objective of my own contribution in respect of these issues is to delineate the distinct parallels evident in the context of the pure creative process. In my own abstract collages, as I have shown, that 'single developmental sequence' was isolated and mapped out and I think it is fair to claim that later paintings evolved from this stage bear witness to the 'more subtle, spiritual stage of "contemplative" development.' I will describe later how these subsequent works evidence a personal iconography distilled through these transformative psychic processes and I believe embody a deeper understanding. This process may be driven by psychic disorder and explains why mystical forms of therapy – like art – can attract those desperate for some form of self-healing process. However, as Engler points out, such individuals are not suited for the demands of mystical practice, suggesting that they are best treated with 'psychodynamic or object-relational forms of therapy and not meditation. However, once a cohesive self is attained, the doors to meditation and Buddhist areas of health and maturity beckon.' (102)

This is a crucial point, for the exact parallel is true of deep painterly engagement. That is, once toleration and ego strength is put in place in a re-engagement with the original developmental phases through the externalisation and materialisation of

inner psychodynamics within the creative nucleus, the 'doors' to a more profound contemplation and maturity beckon.

Similarly, Jeffrey Kripal understands that this deeper dimension is accessed through developmental conflict and trauma, 'defensive trances' and 'fog of bliss' visions often associated with fundamental creative oceanic experience through to 'genuine religious experience.' He refers to Lacan, one of the 'mystics of psychoanalysis,' as recognising that mystical, ecstatic experience goes beyond reductive psychosexuality into a universal mystic domain. (103)

Along with Engler, Kripal bridges psychoanalytic developmental models and mystic vision. As Parsons outlines, he sums up the connection in relation to the anthropologist Gananath Obeyesekere's concept of 'personal symbols' when he writes:

> Sometimes, in exceptional cases, we find genuine two-way "symbols" that function *both* as symptoms, hearkening back to the original crisis, *and* as numinous symbols, pointing to a resolution of the crisis, greater meaning, and what Obeyeskere calls a "radical transformation of one's being."' Kripal further points out how Obeyeskere considered Ramakrishna was able to transform symptom into symbol and turned 'a crisis into an experience of the sacred: "Ramakrishna's Hinduism permits the progressive development of the personal symbol...To Ramakrishna his own mother is mother Kali who is *the* Mother and the guiding principle of cosmic creativity. Through Kali, Ramakrishna has achieved trance and knowledge of a radically different order from the others, and he can progress to the heart of a specifically Hindu reality that is essentially salvific. (104)

Exactly the same could be said of the painter's transition and evolution of a personal iconography and symbolism that embodies both the essence of the original crisis, its resolution in a radical transformation and a greater meaning and salvation. To this fact, I would hope that the paintings of my later years will testify.

The fundamental change posited by transformative mystic models is an 'alchemical transformation' opening 'psychophysiological structures.' However, Parsons nevertheless questions the transformative school's ability to specify the very inner psychic mystical process that transcends the limitations of the 'bliss of manic denial' into the realm of 'alchemical transformation' and real revelation. (105) I would argue that the investigation of the core painterly creative process is able in some measure to provide answers to this key question and add some unique insight. Of course it is a question that runs through the whole of Parsons' analysis and indeed that of mystical and oceanic experience generally. Indeed, it is similarly a recurring problematic question in relation to art also: is the cosmic bliss of oceanic union simply regressive, self-reflexive and self-indulgent and without any validity or real affect for others? It is exactly the same question that is asked of subjective, mystical experience. (106)

As I have already indicated, what the radical unearthing of the creative structure in modern abstract painting revealed, is that access to the transformative essence at the heart of the oceanic experience can only be gained through an engagement with the formal materiality of the painterly process. Again, I have used the

'creative blueprints' of my own collages to demonstrate in some degree how this psychic transformation occurs. I will expand on this further in the discussion of the third phase of my painterly development. However, as I have already suggested, the limitation of psychoanalysis in this context is the tendency of its interpretive models to rely on the psychobiography of individual developmental issues at the expense of the innate and universal abstract model underpinning them.

Unfortunately, this problem often still holds true in respect of those theorists dealing with object-relations and the pre-Oedipal. Parsons is therefore faced with the fact that even those more enlightened analysts of the adaptive-transformational perspective, perhaps applying the models of Klein or of Winnicott, still tend to reduce these to the pre-Oedipal individual narrative details. So when Parsons talks of 'developmental infrastructure' in relation to Ramakrishna, instead of referring to the abstract developmental processes innate within human evolution, the reference is instead to his unique childhood sexual trauma. Such factors may well be relevant, but cannot explain *how* the experience of transcendence and psychic conversion is engaged.

In some senses this is a similar argument to the controversy surrounding the acquisition of language in the human infant, where it is now generally assumed that there is a genetic or psychic mechanism that generates within the child a 'disposition' for an introjection of linguistic structures. The same might be said of developmental programmes that have a more elemental framework. In other words, as the creative structure reveals, a real transition and transcendence can only be effected in relation to abstract formulations, whether in the element of the material substance of art's form, or the pre-verbal poetic intuitions of the mystic.

As Parsons quite rightly stresses, what is at issue here is exactly how an authentic transformation is enacted and what really occurs during the inner psychic mystical process that engages with the oceanic as transcendental and potentially life regenerating. I think that it would be just for me to claim that in some measure I have attempted a formulation of these complex processes in *Painting, Psychoanalysis, and Spirituality* (2001) and certainly some reviews describing my 'neuropsychological' approach, would appear to support this contention. (107)

Despite his criticisms, Parsons nevertheless does discuss the ideas of those theorists who do try to address this difficult issue. In particular, he notes the observations of Heinz Kohut, who is squarely in the transformational school and who attempts to isolate a mode of consciousness rooted in both the developmental pre-Oedipal and in an archaic, universal dimension of communication activated during altered states of consciousness. This basic idea was first postulated by Freud, as an archaic or more primitive means of direct transference of psychic content and provides a basis for the universality of transcendental mystic experience. (108)

For Kohut, there exists an innate, empathetic facility for accessing the 'complex psychological configurations' of others that can be reactivated under certain conditions. Parsons cites the expansion of such ideas into the concepts of 'deautomisation' and of the 'undoing of ego functions during hypnosis,' both of which have clear consonances with the momentary suspension of consciousness in the creative oceanic trance state. (109)

In particular, Arthur Deikman proposed that during deautomisation the cognitive-perceptual functions acquired as second nature and automatic are 'deautomised'

restoring an earlier, archaic and universal mode of apprehension. His description of this process accurately reflects the 'peeling away' of layers of consciousness and the neutralisation of conscious faculty during the oceanic creative phase. Similarly, his recognition that there is a continual process of selection and elimination in cognitive processes echoes strongly Ehrenzweig's analysis of perception in the creative process. (110)

Indeed, the whole notion of a deeper unconscious dimension of awareness and perception has distinct consonances with Ehrenzweig's concept of a 'structural unconscious.' Like Ehrenzweig, theorists such as Rolland, Kohut and Deikman, were and are troubled by the devaluation of the archaic layers of unconsciousness associated with mysticism and failure to recognise the complexity and depth of 'empathetic' states and unitive consciousness 'pointing to a deeper layer of the unconscious and the existence of mystical intuition.' Parsons further considers that the dialogue initiated by such 'metapsychological formulations' suggests '…the possibility that deautomisation or deconditioned modes of consciousness and the operation of intuitive faculties and deep empathetic states are linked, and that the latter, once awakened and cultivated, grant one access to new modes of awareness.' (111)

The transformative school, whilst acknowledging the undeniable relevance of developmental and adaptive realities, tries to define that further, deeper dimension encountered during mystic conversion and transcendence, finding its original inspiration in Rolland's design for a 'mystical psychoanalysis.' Parsons views Kohut as bearing the most positive legacy of Rolland's mature mysticism. Kohut's concept of 'cosmic narcissism' lifts the condition of the subjective developmental into the realm of the universal. In so doing, he manages to combine the indispensable stage of fleeting regression, omnipotence and primary narcissism within the oceanic experience, with a mature, transcendental and universal concept beyond the limitations of the self into a '…supraindividual and timeless existence…' that he construes as a '…creative result of the steadfast activities of the autonomous ego, and only very few are able to attain it…' (112)

So, although Kohut accedes to the fundamental basis of the mother-infant space, he argues that cosmic narcissism goes much further in what Parsons describes as consisting of a '…gradual decathexis of the individual self' which cannot be 'branded as defensive.' But it actually demands a deep engagement with the 'transformation of archaic narcissistic structures into empathy…and creativity.' Critically, 'this shift, signified by the presence of the oceanic feeling, also indicates the type of ethical and existential achievement stressed by Kohut.' (113)

In this chapter I have made fairly extensive reference to the work of Parsons because his comprehensive investigation of the oceanic feeling and his overview of the psychoanalytic theory of mysticism, reveal essential parallels with creative experience and the core painterly creative process. The fusion of subjective developmental anomalies and defects, so instrumental in instigating the process, with adaptive, therapeutic transformation and potential for an oceanic, cosmic transcendence, is similarly embodied within the material substance of the authentic abstract painting that incorporates within its structure the tripartite developmental infrastructure characterised by

Ehrenzweig as 'the minimum content of art.' (114) Perhaps it should be borne in mind that 'trance' is often defined in dictionaries as 'abstraction.'

A decisive factor in respect of abstract painting is that the creative 'blueprint' for therapeutic transformation and for a more radical conversion experience as the conscious mind is momentarily decommissioned, is left in evidence for those engaging with it. Admittedly, this might more often than not involve an involuntary communion as psychic patterns in the unconscious mind of the spectator resonate with those parallel formations embedded within the mirrored formal arrangement and materiality of the artwork, so inducing a spontaneous synchronisation during which time the reformulated plastic contrasts and relationships are impressed and etched as through a mould upon the unconscious organisation of the receptive viewer. In the context of the mystic encounter, however, the individual oceanic experience, although universally powerful, is once removed in any attempt to communicate its essence.

This is why, earlier in this chapter, I referred to those fundamental life-changing experiences encountered by Worringer and Picasso. Indeed, prior to this, I also described how my own personal encounter with abstraction had somehow released repression and tension in a psychic conversion generating a radically altered 'world view.' As I stressed earlier, I think that it is valid to argue that Picasso's internalisation of an authentic creative template in the Trocadero, fundamentally altered the course of twentieth century art. In a way, therefore, I *am* making quite substantial claims for painterly oceanic experience in not only drawing a comparison with mystical experience, but also in respect of its potential to map out and record the tranformative process. The same thing could generally be said about music and poetry.

Irrespective of any need to validate such parallels, there *is* a general consensus about the essential function of the oceanic and its associated trance. As we have seen, the oceanic experience forms the very fulcrum of early developmental transitional phases, of the creative process, ritual and of mysticism. It may well differ in degree according to the nature of the experience, but is nevertheless the constant factor. Furthermore, the intrinsic interconnection between creativity and mysticism was clearly acknowledged by Eastern mystics, who often viewed themselves as creative artists and whose descriptions of mystical conversion uncannily reflect those of creative experience.

This factor is made manifestly evident in Romain Rolland's biographies of both Ramakrishna and Vivekananda. In his account of Vivekananda's first pilgrimage to America in 1893, Rolland notes the pervasive influence of the American idealist transcendentalists such as Walt Whitman and Ralph Waldo Emerson in a country where the 'predisposition to Vedantism' had existed long before the advent of Vivekananda. For Rolland: 'Indeed it is a universal disposition of the human soul in all countries and in all ages' and is not restricted to India. He further considers that '…this attitude of mind is latent in all who carry within themselves a spark of the creative fire, and particularly is it true of great artists, in whom the universe is not only reflected…but incarnate.' In this context he also makes reference to Beethoven and 'crises of Dionysiac union with the Mother' and further cites 'great European poetry' of the nineteenth century along with the poetry of Whitman as evidence of 'creative fire.' Rolland suggests that Vivekananda would have been struck by the parallels with an artistic faith such as Whitman's, with '…the sentiment, so strong in Whitman, so insis-

tent, so persistent, of the journey of his ego…and incessant "incarnations"…and loss of his previous existences…,' of Whitman as Brahman. (115)

In the 'Prelude' of *The Life of Vivekananda and the Universal Gospel*, Rolland compares Vivekananda's unitive oceanic experience of the Divine Mother with Beethoven's creative path, asserting that the 'sudden flights amid tempests' and heights attained by Vivekananda, reminded him 'over and over again of Beethoven.' (116) Beethoven's creative oceanic union with the maternal mirrors the communion of the mystic. Such parallels would not normally surprise artists. Indeed, a recent article in the *New Scientist* reporting on research into the 'Mozart Effect' describes how music connects with and inflects upon neural programmes that form the basic grammar of mental activity.

When researchers transposed simulations of neural patterns and rhythms into sounds, they were amazed to discover that '…the rhythmic patterns sounded like baroque, new age, or Eastern music.' In other words, they ascertained that 'brain activity can sound like music' and the possibility that '…patterns in music somehow prime the brain by activating similar firing patterns of nerve clusters.' An artist like Mozart could be accessing this 'inherent neural structure.' (117) The fact that rhythmic brain patterns reflect the structure of musical composition and that the musical patterns can 'prime the brain' would appear to support my argument that unconscious psychic structure is externalised and materialised in the creative process and that a subliminal dialogue is established in this parallel universe. This is a two-way communication: innate psychic structure, or 'inherent neural structure,' formulated in developmental phases, initially configure the creative template, which in turn serves as a vehicle for its transformation and reintrojection into a restructured unconscious.

As I have suggested, such a 'discovery' would not be such a surprise to the artist. In terms of painting, I have discussed how the complex manic-oceanic creative core sets up subtle interrelationships and conjunctions that serve as abstract analogues mirroring inner psychic composition. I have further argued that these dense plastic simulations, beyond the realm of logic or rational conscious determination, in turn, like a Mozart composition, induce changes effectively reprogramming the inner mind. Again, it is this process of replication, as I have said, that is responsible for the suspension of consciousness and the potential mystical experience of *ekstasis*, as other musicians have acknowledged. It was recently reported that the pianist, John Lill, '…has claimed to have had out-of-body experiences during recitals and to have communed with dead composers…' (118)

Vivekananda had described such a state thus: 'If we give up our attachments to this little universe of the senses, we shall be free immediately. The only way to come out of bondage is to go beyond the limitations of law, to go beyond causation. But it is a most difficult thing to give up the clinging to the universe: few ever attain to that…' (119) He further stressed that such a state of essential being ultimately '…consists in the stopping of all the functions of the mind…' (120)

Vivekananda's absolute essence of mind is the 'Raja-Yoga,' a way of knowing through knowledge and realisation described by Rolland as the 'experimental psycho-physiological method for its ultimate attainment' and he notes that Vivekanada labelled it a 'psychological Yoga.' For Rolland, such a concept can unite the West and East and he argues that: 'In all countries and at all times learned men, or artists …

have known and practised it instinctively each in his own way, either consciously or subconsciously…I have shown in the case of Beethoven, to what degree this can be achieved by a Western genius living in complete ignorance of Raja-Yoga…' In a footnote referring to his study on the *Deafness of Beethoven* Rolland records that mystics such as Vivekananda were well aware of this factor and quotes from the Raja-Yoga that 'All inspired persons' can stumble upon this 'superconscious state.' (121)

Significantly, Rolland draws attention to Vivekananda's own brother, Mohendra Nath Dutt, 'a profound thinker' who compares the artist and mystic in his *Dissertation on Painting* (1922), suggesting that they have essentially the same disposition. As Rolland puts it: 'The great Indian religious artist places himself face to face with the object he wishes to represent in the attitude of a Yogi in search of Truth…' He quotes Mohendra: 'In representing an ideal the painter really represents his own spirit, his dual self, through the medium of exterior objects. In a profound state of identification the inner and outer layers of the spirit are separated; the external layer or the variable part of the spirit is identified with the object observed, and the constant or unchanging part remains the serene observer…It is not astonishing that many great Indian artists, who have passed through this discipline, finally become saints.' (122) For Rolland, Vivekananda was ultimately a 'great artist' and Vivekanada himself concluded that 'I am first and foremost a poet.' (123)

The same parallels between artist and mystic had similarly been self-evident in the attitude of Ramakrishna. I have already quoted his account of immersion in the ecstatic oceanic flood. Rolland narrates Ramakrishna's apparent descent into insanity through his 'fits of unconsciousness, sudden collapses and petrifications, when he lost the control of the use of his joints and stiffened into a statue' and marvels at the fact that this 'necessary stage' didn't induce mental collapse and despair, but instead precipitated a rebirth of a strengthened ego and a spiritual resurrection. (124) Crucially, Rolland recognises that: 'There is no difficulty in proving the apparent destruction of his whole mental structure, and the disintegration of its elements,' but asks the critical question 'But how were they reassembled into a synthetic entity of the highest order? How was this ruined building restored to a still greater edifice and by nothing but will-power?' Rolland sees that 'Ramakrishna became master alike of his madness and his reason, of Gods and of men.' (125)

Rolland further recognises Ramakrishna's power to engage with the 'Savik-alpa Samadhi' in which the 'material world disappears' in a state of 'super-conscious ecstasy.' (126) Ramakrishna was 'forced to abandon the home of his heart and sink body and soul in the formless and the abstract!' (127) For Rolland, 'The complete surrender of himself to another realm of thought resulted as always in the spiritual voyage of this passionate artist' who 'sang the joy of the flying kite of the soul.' (128)

In my comments earlier in this work I compared the course of a psycho-analysis with the transition through early developmental phases and the dialogue between the analyst and analysand with that between the artist and the artwork. The function of the therapist as an objective blank screen offering the potential for an authentic engagement, simulates that of the blank canvas screen of the painter and confirms the foundations of psychoanalytic procedure in the creative process. The fact that Vivekananda talks of a 'psychological Yoga' and Rolland of a 'psycho-physio-

logical method' reveals the roots of psychoanalytic models in mystical and creative transformative processes.

Perhaps the psychoanalytic theorist and Kleinian W.R.Bion gave such correlations the strongest credibility. Indeed for Bion, the psychoanalyst must adopt the guise or attitude of the mystic and both are artists. He says: 'The psycho-analyst can employ silences; he, like the painter or musician, can communicate non-verbal material.' (129) Bion formulated the concept of 'O' to designate the pre-verbal, authentic, real essence of being at the core of mystical experience and indeed of the creative process: that is, the 'ultimate reality, absolute truth, the godhead, the infinite, the thing-in-itself.' It is beyond knowledge and is 'formlessness.' (130)

Bion's realm of O is important in respect of my arguments here because it is such a useful psychoanalytic model to describe in different terminology what I have referred to as the 'creative core.' Ehrenzweig's 'minimum content of art,' framed by Klein's developmental schema, *is* the creative core. In other words, when all of those factors, such as line, composition, colour, contrast and so on, apparently essential to the construction of a painting, are eradicated, all that remains if there has been unconscious creative engagement is the creative core. For me as a painter, the abstract monochrome collage *Promised Land* (Fig. 11) excavates that creative core, at once intrauterine, developmental in its embodiment of nascent projective and introjective dialogue, transitional and potentially transformative. Again, from my own perspective, this dark red collage *is* O.

For Bion, O can 'become' but cannot be 'known' until it evolves to a point where its existence can be 'conjectured phenomenologically.' This occurs in the domain denoted by Bion as 'K.' Of course, Bion is discussing such issues within the context of an analysis. But this is very relevant in its simulated reflection of inner transformative creative processes. Importantly, Bion strongly exhorts the analyst to focus all attention on O, 'the unknown and unknowable.' All other information is 'worthless.' Bion argues that analysis must maintain the point of view, or 'vertex' of O and insists that the analyst 'must be it.' For Bion: 'Every object known or unknowable by man, including himself, must be an evolution of O...In so far as the analyst becomes O he is able to know the events that are *evolutions* of O.' (131)

I think that this is really a fundamental perspective that the parallel dimension of the painterly creative process absolutely reinforces. The red monochrone is, of course, O because all of the false realities and constructions representing 'me' along with their plastic analogues in the parallel universe of painterly form have been stripped away and eliminated. What remains is an essence; a psychic core that represents only the self in a state of becoming. An absolute union, in which to use Vivekananda's terminology, 'causation' and 'law' are dissolved, where objectivity ceases and an authentic self is contacted but cannot be known. All subsequent attempts to understand and readily represent in terms of formulation and symbolism can only ever evolve from this point.

It is for this reason that Bion indicates that the transformations and formulations of the events of psychoanalytic experience have greater therapeutic value if 'they are conducive to transformations in O; less if they are conducive to transformation in K.' (132) I can reiterate that from my own empirical creative experiments, I believe that a real psychic transformation, or conversion, can *only* be effected at the

creative core (or O), at the point of psychic birth before the acquisition of knowledge. In so far as psychoanalysis *can* engage with the pre-verbal, it may well have this potential. But psychoanalysis is not poetry or music and cannot have the patterns that may be indispensable to a psychic reconfiguration.

I should perhaps mention at this point that Lacan has developed a very similar model to Bion in that his concept of the 'Real' has all of the critical characteristics of Bion's O. Similarly, all representation and symbolisation occurring in Lacan's subsequent orders of the Imaginary and the Symbolic, must be evolutions from the 'primordial reality' of the Real. In fact the prime directive of these two further registers is ultimately to visualise and represent the Real. Seeing as O and the Real may both be regarded as the ultimate objectives of mystical experience, it is understandable, as Parsons pointed out, that both Bion and Lacan should be regarded as 'mystics' of psychoanalysis. I will discuss further the connections of Lacanian theory in my discussion of gender and the creative process. As I have pointed out before, these theoretical models will also be measured against my later figurative paintings in the 'third phase' of my work, in which the iconography was precipitated from and represents the absolute O.

In Bion's interpretation, O stands for 'the absolute truth in and of any object.' Significantly, 'It is possible to be at one with it' in the essence of 'at-one-ment' and its clear associations with the omnipotent neutralisation of conscience and law (superego), reparation, mourning and atonement. In Bion's estimation, 'The religious mystics have probably approximated most closely to expression of experience of it.' (133) The correlations between Bion's formulation of the O domain and the oceanic core of the creative process and mystical experience are indeed seductive. Such connections are tacitly acknowledged by Bion in his many references to artists and mystics.

In Bion's view, mental space is vast and endless: 'the unknown, unknowable, "formless infinite."' In terms of psychoanalysis, the threat to the patient is that the 'capacity for emotion is felt to be lost because emotion itself is felt to drain away and be lost in the immensity. What may then appear to the observer as thoughts, visual images, and verbalisations must be regarded by him as debris, remnants or scraps of imitated speech and histrionic synthetic emotion, floating in a space so vast that its confines, temporal as well as spatial, are without definition.' (134) Although I hesitate to make too much of such similarities, it can be seen that there are characteristics of fragmentation and lack of conscious definition in both Bion's vast mental space and in the manic-oceanic unconscious depths exposed by abstract painting. Jackson Pollock's compelling need to transpose the easel painting on to the floor and to deny the existence of painterly edge or boundaries, was surely in order to express the infinity of the oceanic space and the loss of self in its dispersion beyond any rational limits.

This is manifested in O by the necessity to eliminate all memory and desire if a transformation here is to be achieved: Bion explains that all memory in view of its inescapable translation through the senses, must be suspect or 'fallacious.' But the analyst is concerned only with O and so must as far as possible neutralise the distortions of memory and desire. Bion advises that the analyst needs a 'positive act of refraining from memory and desire.' Only then can there be the 'evolution of ultimate reality' signified by O. Only such a reality can evolve a real awareness. The analyst

needs a 'frame of mind' in which he can be receptive to O. He needs the 'faith' to be 'at one with O.' (135)

Interestingly in this context, Bion does resort to the concept of abstraction in suggesting that a 'new formulation' of O 'has the quality of an abstraction only in so far as it is divorced from the sensuous background inherent in and essential to memory and desire. The abstract statement must not stimulate memory and desire though memory and desire have contributed elements to its formulation.' The discarding of memory and desire is an essential prerequisite to the state of mind in which O can evolve and the potential of 'at-one-ment.' For Bion, 'the act of faith' essential to engagement with O only becomes comprehensible 'when it can be represented in and by thought. It must "evolve" before it can be apprehended and it is apprehended when it is a thought just as the artist's O is apprehensible when it has been transformed into a work of art.' (136)

In this sense perhaps, I might have to agree that the creative 'blueprints' such as *Promised Land*, which effectively represent O, are not 'works of art' although they are apprehensible up to a point. They are rather transitional, subjective acts of faith and evocations of O, or the creative core, an essential transitory developmental stage prior to the evolution of artworks. What they *do* have, in line with Bion's postulation, is the quality of an abstraction devoid of memory and desire; as abstract statements they cannot stimulate the memory. In other words, as I have described, those representative elements that could record memory and desire have been expunged; the inherited formal painterly language embodying style and its antecedents along with the conventions of the time are negated in favour of a pure psychic space. 'At-one-ment' with O, or oceanic communion with the creative core are only possible when the narratives of memory and representations of conscious objectivity are removed. From this position, as Bion indicates, there can be an evolution of new thought and original iconography.

Bion's empathy with the artist and mystic is underlined by his argument that the analyst, like the artist of mystic, must undergo the same psychic evolution from O to K if he is to crucially engage with the patient's process of transformation. It is significant and to be expected that Bion considers the receptiveness engendered by the elimination of conscious memory and desire to be indispensable for access to O and the process of analysis and is 'essential for experiencing hallucination or the state of hallucinosis' where '...full depth and richness are accessible only to "acts of faith."' (137) I think that it is reasonable from Bion's own definition of hallucination to draw comparisons with the momentary trance state at the heart of the oceanic experience. It would certainly appear from Bion's analysis that hallucinosis is integral to experience of O and its characteristics of unique meaning, ungraspable outside of its conditions and altered under rational thought, would indicate similarities. Furthermore, he states that: 'The nearer the analyst comes to achieving suppression of desire, memory, and understanding, the more likely he is to slip into a sleep akin to stupor.' (138)

This reflects my own comments that in analysis the analyst must in effect reconstitute a dynamic developmental template in order to effect a transition from the paranoid-schizoid position to the depressive. But this should be undertaken in terms of an abstract essence of that dynamic and not in terms of the individual's psycho-biography. In general Bion appears to recognise this when he stresses that O is only manifested through the eradication of personal memory and desire, although it is the

109

case that some of his subsequent references to case studies do still seem to depend on individual narrative details. A real transformation, as I have stressed, can only be achieved on the abstract structural level of unconsciousness, beyond representation.

Bion does note, however, that if the analyst resorts to memory and understanding in the face of crisis or anxiety in the analytic situation, in order to acquire some security, '…he is proceeding in a direction calculated to preclude any possibility of union with O.' (139) In a corresponding manner, if the painter avoids the anxiety generated by the rise of inarticulate unconscious form with its innate threat to conscious order and clings on to surface representations of known understanding, then there can be no real, authentic creative engagement.

In respect of the joint participation in the process of transformation, Bion goes so far as to argue that: 'The analyst has to *become infinite* by the suspension of memory, desire, understanding.' He says that the suppression of these '…undermines sense-based experience which is the reality with which the individual is familiar' and a '…general obliteration of sensory perception.' In essence, this is a condition of trance and effectively the analyst is being instructed to adopt the blank infinity of the abstract monochrome. Bion compares this procedure to '…what occurs spontaneously in the severely regressed patient' and considers that real danger can be associated with it. He advises that the procedure should only be undertaken by the psychoanalyst 'whose own analysis has been carried at least far enough for the recognition of paranoid-schizoid and depressive positions.' (140)

The suppression of memory and understanding in Bion's estimation is to render oneself 'artificially blind' and he notes on more than one occasion Freud's method of 'blinding himself artificially' in order to achieve a particular state of mind. Bion's reference to this objective of artificial blindness in the analytic setting in which it serves to isolate a focus, is again an equation with great relevance for the creative process and mystical experience. Earlier, I described my own apparently irrational desire to blind myself, a blindness often interpreted by psychoanalysis as a castration in order to obliterate guilt and the threat of Oedipal reprisal, but also a clear analogy for the removal of those elements of conscious faculty impeding access to the transformative dimension of O.

In this context, artificial blinding is a prerequisite for contact with the ultimate reality of O. For Bion, '…the absence of memory and desire should free the analyst of those peculiarities that make him a creature of his circumstances and leave him with those functions that are invariant, the functions that make up the irreducible ultimate man.' In effect, Bion's 'irreducible ultimate man' in the analytic process is absolutely consonant with Ehrenzweig's 'minimum content of art' in the creative process: 'The further the analysis progresses the more the psychoanalyst and the analysand achieve a state in which both contemplate the irreducible minimum that is the patient. (This irreducible minimum is incurable because what is seen is that without which the patient would not be the patient.)' (141) Just as in the case of the creative process, the irreducible template of the abstract artwork is that without which the artwork would not be the artwork. Or indeed, even *an* artwork.

The close affinities and correspondences between the abstract creative process and the psychoanalytic dialogue, exposes the therapeutic foundation of both. Bion's analysis of the relationship between mysticism and psychoanalysis betrays

further structural parallels. Here Bion argues that there are certain inherent universals in the development of psychoanalysis and notes that, 'Homeric psychology indicates a stage of mental development in which the distinction between man and god is ill defined; in the individual psyche, little distinction between ego and super-ego is recognised.' (142) This stage corresponds to the manic-oceanic creative phase and Bion goes on to comment that in the development of institutions, whether in the religious or psychoanalytic sphere, there develops a gulf between man and god as man becomes conscious of separation. Such a development corresponds to the depressive position, where the autonomy of god, that is the Mother or Father, has to be reconciled.

Bion's remarks in respect of the development of 'Establishment' in this context are very reminiscent of Rolland's criticism of institutionalised religion as devoid of any spirituality. He says: 'The institution may flourish at the expense of the mystic or idea, or it may be so feeble that it fails to contain the mystical revelation.' He further talks of '...the need to control the messianic idea and make it available to ordinary people through dogmatic formulation.' (143)

However, Bion's outline of these developments generally reflects the structure of the creative process and of ritual. He says: 'in the first stage there is no real confrontation between the god and the man because there is really no such distinction. In the second stage the infinite and transcendent god is confronted by the finite man...In the third stage the individual, or at least a particular individual – the mystic – needs to reassert a direct experience of god which he has been, and is, deprived by the institutionalised group.' (144)

In regard to Ehrenzweig's three phases of the creative process the resemblances are patent. In the first stage there can be 'no real confrontation between the god and the man,' because the concept of god at this point has not yet been formulated. As Klein's developmental schema shows, the confrontation here is predicated on that between mother and infant and the concept of deity, as Freud expounded in *Totem and Taboo*, is established later through ritual. The correspondence in the second stage is clearer: in the oceanic phase, 'finite man' is in communion with an 'infinite and transcendent god.' A subsequent separation is inevitable in the depressive postion, but a reintrojection in the third stage can 'reassert a direct experience of god' as a new psychic oceanic organisation and sense of unitive experience is internalised as a rebirth.

The conflation of developmental and divine; of man and deity, is expressed by Bion when he asserts: 'The individuals show signs of their divine origin (just as the gods of the previous stage show signs of human origin). The individuals may be regarded as being incarnations of the deity; each individual retains an inalienable element which is a part of the deity himself that resides in the individual.' Bion further anticipates Lacan when he says, 'Finally, the individual strives for reunion with god from whom he feels consciously separated.' (145)

Bion recognises, again along with Freud's hypothesis in *Totem and Taboo*, that the 'similarities in the configurations' of institutionalised religion and of the Oedipus myth, 'suggest a common origin and common disorders associated with the problem of containing the mystic and institutionalising his work.' More importantly, he also perceives that 'formulated' and institutionalised ceremonies and dogmas of

religion, '…may represent the evolved aspect of an element which is represented also at its evolved stage by the Oedipus myth.' In other words, the narratives and symbolism of both are underpinned by the abstract, unconscious creative dynamic from which both are evolved. Crucially, Bion states: 'These myths are evolved states of O and *represent* the evolution of O. They represent the state of mind achieved by the human being at his intersection with the evolving O.' (146)

This aspect is again borne out by the experience of painting and in particular the religious icon painting. Here the surface narratives and symbolism, or iconography, similarly serve to describe the unconscious creative experience of the artist, in effect a mystical experience, in the unitive engagement with O in the painterly creative dynamic. Again Bion reinforces this point when he says: 'The configuration that represents the relationship between the mystic and the institution can be recognised in, and be the representation of, the relationship between the emotional experience and the representative formulation (words, music, painting, etc.) designed to contain it.' Bion puts this in terms of the creative process when he says: 'Direct access to the O of the mystic and the O of the Dionysian orgy is both contained and restrained by the religious dogmas substituted for them in the minds of ordinary people.' (147)

Bion gives an example of the essential relationship between the unconscious emotional experience and the symbolic formulation designed to contain it. Isaac Newton, generally perceived as a scientist, is considered by Bion to be a mystic: '…his mystical and religious preoccupations have been dismissed as an aberration when they should be considered as the matrix from which his mathematical formulations evolved.' (148) Such a comment bears witness to Bion's deep empathy with the creative process, whether in terms of science or of religion and echoes Parsons' description of the 'primary experiential matrix' mentioned earlier in this chapter. From this elemental matrix all other secondary phenomena are evolved.

In his concluding remarks in *Attention and Interpretation* Bion reiterates the fundamental canon that the psychoanalyst must reconstitute the prototypical developmental sequence and so with it the transformative potential of the creative process. He cautions the analyst to relate only to what is unknown to both him and the patient: 'Any attempt to cling to what he knows must be resisted for the sake of achieving a state of mind analogous to the paranoid-schizoid position.' Inarticulate form in the initial stage of the creative process represents the plastic analogue of what is unknown and beyond rational control. Fact and reason should be avoided until a 'pattern' evolves and the depressive position is attained. (149)

Bion's work is important because he extends the boundaries of psychoanalysis into art and mysticism. Although he may not specifically recognise the consistent role fulfilled by the creative process throughout, his descriptions of the necessary procedures to effect a transformation certainly parallel creative dynamics. He says: 'What is to be sought is an activity that is both the restoration of god (the Mother) and the evolution of god (the formless, infinite, ineffable, non-existent), which can only be found in the state in which there is NO memory, desire, understanding.' (150)

I have argued more than once that the oceanic core, with its inherent potential for *trance-formation*, forms the essence of the authentic creative process, of mystical experience and of religious conversion. Earlier I made a suggestion that the

monochrome abstract collages such as *Promised Land* were not 'works of art' in a real sense, but personal evocations of O. However, the important factor is that they create an authentic template for a future personal creative evolution.

In my own case, as I have described, the figurative paintings that preceded the abstract monochromes lacked the depth of engagement to generate original and personally unique iconography. Until the painterly 'slate is wiped clean' of memory and desire and so of time itself, the irreducible essence of the creative structure cannot be distilled and isolated. Bion understood that just as the artist must connect with this essence, so must the analyst engage solely with O to the exclusion of all else if a real transformation is to proceed. We shall see in the next chapter that just as the creative oceanic *trance-formation* forms the indispensable core of mysticism and religion, such trance experience further forms the foundation of ritual and initiation rite, a universal anthropological constant in human evolution worldwide.

I have emphasised the term '*trance-formation*' in order to convey the crucial idea that the conversion in transformation only takes place when a new psychic formation is internalised from some form of external analogous realignment, whether through induced trance experience in ritual or in the artistic creative process. In this chapter I further argued that transubstantiation formed the pivotal issue in religious argument around which so many conflicts developed along with the associated burning of those souls deemed heretic. In a recent work on the Reformation, the scholar Patrick Collinson defines the essence of reformist hostility to the Catholic Church as being the contradictory belief on transubstantiation. (151)

Reformists tended to believe that the Eucharist, Mass or Holy Communion, the ceremony of transubstantiation, was simply a commemoration and 'was all in the mind.' It was just that the spirit of the Eucharist ceremony was enhanced by the physical act of consumption of things that Christ had distributed at the Last Supper. These elements remained bread and wine and the reformists regarded it as ridiculous to claim that these substances were actually transformed into the body and blood of Christ, as the Catholics asserted. There was a great deal of very detailed, acrimonious and complex theological argument and huge treatises devoted to this subject. As Collinson recounts, Luther's craving for 'objective certainty' led him to reject transubstantiation as early as 1520.

As Worringer noted, such religious arguments would often appear to have parallels in the context of art. What gives a work of art 'soul' might well be described as a 'psychic transubstantiation.' Furthermore, in the final analysis, the essence of transubstantiation is *trance-substantiation*. That is to say, what is ultimately at issue is the confirmation of trance experience.

CHAPTER 5

RITUAL and the CREATIVE PROCESS

I quoted William Rubin early in the last chapter and indicated that I would refer back to his key comments. For Rubin astutely perceives that Picasso understood the parallel between the painterly creative process of his first 'exorcism picture' and the 'psycho-spiritual' experiences of the rites of passage that ultimately engender the sculptural objects and artefacts formulated to encode their arcane processes. In other words, Picasso crucially realised that the essence of rites of passage, or ritual, was effectively the creative process. Furthermore, it was this radical realisation that enabled Picasso to alter the course of art absolutely, for the *function* of art and the true operations of the creative process in its complex relationship with the art object were once again laid bare.

In this chapter I will put forward further evidence to support Picasso's insights in respect of the psycho-spirituality of the creative process and of its cross-cultural nature rooted as it is within the structure of the human psyche. But in respect of my claims for a consonance between the creative process and the ritual process, why is such a connection important? Why does the relationship between the creative process and ritual need to be underscored? What indeed is ritual?

I am sure it will no doubt be clear at this point that the questions being asked in this work are intimately connected to my own investigations into a personal creative process. In particular, my analysis of the abstract collages has explained that they expose a very rudimentary and irreducible creative core. I have noted how Anton Ehrenzweig recognised that this elemental creative schema formed the essence of an artwork, without which it ceased to function as such. I further related the connection he drew between this essential creative template and the Kleinian developmental model. As we shall see, these elements and relationships are also embodied within the structure of ritual procedures.

It was during my engagement with the abstract, monochromatic collages that my relationship with the creative process and its prototypical developmental sequences and ultimately with ritual was forged. Coming to these as I did, from a position of alienation, depression, isolation and complete and utter failure to relate to the real external world, I have since recognised their essential curative, integrative role as initiation rite and transformative ritual. That is to say, I was impelled, naively and automatically, into an intense psychic communion with a minimal creative process, that in all of its characteristics also represents the definitive ritual process.

It is my contention that in Western culture, at least, there is little if any social or communal provision for such initiation and so the individual must contrive personal devices to effect a genuine social reintegration or suffer social exclusion. Such individual experience is the core objective, but traditional tribal culture usually provided the ritual procedures for its manifestation. Romain Rolland understood this in arguing that it is *personal* mystical experience that is the true source of religion and that social ceremonials are but petrified facades utterly detached from their spiritual roots.

Indeed, I think that this is a critical point in any attempt to define ritual: the vast majority of anthropological research both historical and contemporary, apparently fails to clearly differentiate between ceremony and ritual, often treating the two as virtually synonymous. For example, R.A.Rappaport, a respected figure in recent anthropological study, suggests that the term 'ceremony' is a 'closely related if not synonymous term' to 'ritual.' (1) In my own reading of both traditional and contemporary anthropology, although I cannot claim this to be exhaustive, I have only come across one clear discussion of the relationship between ritual and ceremony. Even this is in the context of an analysis of the Indian Jain ritual, a complex ceremonial that is 'liturgy-centred' as opposed to 'performance-centred' ritual. (2)

It is this distinction by the authors, Humphrey and Laidlaw that designates the character of ceremony as separate from ritual. In a sense they really set out to justify the research into a ritual that has become perhaps little more than ceremony. They note that anthropology has placed such a great emphasis on performance-centred rituals as opposed to those immersed in liturgy, that they have become 'paradigmatic of ritual in general.' (3) However, in my opinion I think that there are very good reasons for this.

The authors consider performance-centred rituals to be 'commonly very weakly ritualised,' by which they mean such rituals are far less dependent upon the ceremonial accompanying ritual. In relation to their own analysis of liturgy-centred ceremonial, they describe the alternative performance rituals as providing 'only confusing clues, because their central concern, with the genuineness or truth of the supernatural quality of the event, is one that need not be demonstrated *ritually at all* – it may be revealed in quite other ways.' Examples of performance-centred rituals are given as 'inspirational shamanism and initiation ceremonies.' (4)

Significantly, in the same context Humphrey and Laidlaw quote Pierre Smith's analysis of initiation rite in which he concludes that 'the result of the rite as a whole' is wholly dependent on 'the crucial part' of the 'episode of trance' for its successful performance. (5) Although not acknowledged by the authors, this really gets to the crux of the matter, for as I have indicated in my remarks about the fundamental imperative in transubstantiation, it is the substantiation of trance that will ultimately define an authentic, transformative initiation rite. Again I might reiterate here that the sculptural artefact associated with the ritual, will also be inauthentic if the ritual has degenerated into surface ceremonial, just as the creative process is similarly inauthentic without the oceanic trance experience at its heart.

So although Humphrey and Laidlaw do try to get to grips with the distinction between ritual and ceremony, it is rather in an effort to justify their own emphasis on liturgical ceremonial. They acknowledge that Jain ritual is of a different order to performance-based rituals '…which predominate in the inspirational cults and life-cycle ceremonial of non-literate societies. There, where religion is not constituted as a separate domain from ritual, the response we are concerned with is bound to have a different nature.' (6) Of course here religion would not be deemed as separate from ritual, because it is understood that transformative initiation ritual is the source and essence of institutionalised religion that simply authorises ceremonial to symbolise the spiritual process of psychic conversion.

As I have indicated, this process of psychic conversion can only be genuinely attained if the necessary conditions are met. The conscious mind must somehow be distracted if a new psychic pattern is to be imprinted. The complete psychic metamorphosis can only be established if to some degree a momentary trance state can be induced. This may or may not occur during a particular initiation rite, but will have to at some point and in some manner if the individual is to be fully reintegrated into the social group. Trance experience constitutes the foundation of transubstantiation and it is interesting that Humphrey and Laidlaw make a comment on 'post-Reformation Protestant contexts where faith in the efficacy of ritual has been terminally undermined.' However, they fail to acknowledge the key factor here, which is the imperative of Protestantism to deny transubstantiation forming the core of the Mass and of the Eucharist. (7)

I think that any attempt to define ritual, therefore, must try to distinguish it from ceremony. Clearly, in my own view, ritual must be performance-based with the element of trance as its fulcrum. The transformative initiation rite is the essential, definitive ritual and depends upon trance experience for its effect. There is a weight of research and field evidence to justify such claims, some of which I will cite further in this chapter. I think also that the etymological roots of the terms 'ritual' and 'ceremony' further support my argument.

The word 'ritual' defined as 'of rites, done as a rite' originates from the Middle French *ritual* or from the Latin *ritualis* relating to rites from *ritus*. 'Rite' is cognate with Greek number and Old High German *rim,* meaning row, sequence. It has the same root as the word 'rhyme' or 'rime' again in the source of the Old High German or Old English *rim.* 'Rime' could be derived from the Latin *rhythmus* or rhythm, although this is uncertain. Significantly, the word 'ceremony,' although quite correctly used in some sense to describe rite or ritual, has of course a different source in the Medieval Latin *ceremonia* meaning 'show of reverence' and 'ceremonial practice.' But the fact that ritual has the same origin as rhyme would appear to point to its fundamentally poetic and creative derivation. (8)

So ritual here is viewed as having essential parallels with the creative process and with the prototypical developmental sequences (as evidenced in its root in sequence) that underpin its structure. Such connections are further corroborated elsewhere. To return again to R.A.Rappaport, for example, who subscribes to this thesis and should be quoted at length when he states:

> In light of the importance that psychiatric theory generally puts on learning taking place in the early years of life, it is of interest that rites of passage typically reduce the novice to a state of pseudo-infancy, or even to a pseudo-embryonic condition. The stages in which ritual learning is most concentrated, the second and third, are ones in which a variety of techniques are used to strip the subject of his everyday knowledge and to divest him of his previous identity. Between ritual death and ritual rebirth the novice may be held naked, nameless, silent. It may be suggested that whatever novices learn in this reduced or regressed condition they learn with a depth and a grasp approaching that with which they learn fundamentals in their earliest years. This grasp is strengthened, this depth made yet more profound, by becoming the focus of the ritually induced neurophysiological processes...That which is learned in ritual may thus override,

displace or radically transform understandings, habits, and even elements of personality and character laid down in early childhood. (9)

Earlier, Rappaport had cited further research on the 'neurophysiological effect of ritual behaviour' that had concluded: 'In essence ritual techniques neutralise...the functioning of the analytic conceptual mode, bringing to the fore developmentally earlier functioning...' (10)

It will be evident that Rappaport's description of the functioning of ritual is all but identical to my own account of the creative process involved in the abstract canvas collages. The restoration of the original developmental phases and even access to the intrauterine state that I have described is reflected in the potential for a ritual stage of 'pseudo-infancy' and for a 'pseudo-embryonic condition.' Similarly, the dissolution and negation of consciousness in the manic-oceanic creative phase I have described, is also the prerequisite in ritual for the elimination of all previous identity and for what Rappaport describes as the overriding, displacement and radical transformation of personality and character in the ritual process.

Rappaport further draws attention to the proposal that '...the pre-verbal infant's experience of its mother resembles that which Rudolph Otto attributes to the worshipper's experience of God: she is mysterious, tremendous, overpowering, loving, and frightening,' and that '...in the light of...the pseudo-infancy prevailing in some rituals, that ritual recaptures a state having its ontogenetic origin in the relationship of pre-verbal infants to their mothers. If this is the case the ground of the numinous precedes the development of any awareness of the sacred or the sanctified...' (11) I think that these references and connections lend support to my underlying thesis in respect of the correspondences between ritual, mystical experience and the creative process.

In chapter 3 I argued that the conditions of engagement within the creative process of the abstract monochrome collages, in both a synchronic and diachronic dimension also pertained to the ritual process. I also introduced the idea that the division of rites of passage as defined by Arnold van Gennep in *The Rites of Passage*, first published in 1908 and subsequently subscribed to by many others, revealed a very clear parallel between this universal ritual structure and the basic phases of the creative process. Rappaport's reference to the second and third stages of ritual learning does not directly refer to van Gennep's model, although he does acknowledge that van Gennep would have recognised them. (12)

Arnold van Gennep's unique discovery was that: 'The examination of any life-crisis ceremony will quickly establish the validity of the threefold classification of separation, transition, and incorporation.' That is to say, to one degree or another, in whatever cultural context, this basic tripartite schema would be evident in those rites of passage such as funeral ceremonies, rites of incorporation at marriage ceremonies, transition rites of pregnancy, betrothal and initiation, for example. (13) All fundamentally concern a regeneration of life expressed in rites of death and rebirth, and as van Gennep stresses: 'The underlying arrangement is always the same. Beneath a multiplicity of forms, either consciously expressed or, merely implied, a typical pattern always recurs: *the pattern of the rites of passage.*' (14)

When I say 'in whatever cultural context,' I must emphasis that this is a truly universal and cross-cultural phenomenon. Van Gennep's ideas expounded early in the twentieth century drew not only on African tribal ritual but also on global and historical sources. The word 'shaman,' often defined in part as 'medicine man' with its clear associations to the tribal witch doctor originates in the Siberian Tungus language. Shamanism in turn may well have been decisively determined through Asian Buddhist influence, again indicating a more archaic source in mystical experience. (15)

However, the fundamental ritual phenomenon, in whatever cultural manifestation, constituting a performance to achieve an altered state of consciousness, is a global phenomenon found in all cultures and times, whether in Siberia, North and South America, Africa and the Near East, India, Malaysia or Australia. Furthermore, magico-religious ritual performance stretches back to prehistory: recent research convincingly supports the contention that ancient rock and cave art was intrinsically linked to ritual performance. (16) Others concur with the idea of the universal nature of ritual performance and the consistency of altered states of consciousness. Douglas Davies notes that '...if physical death is the great fact of biological life, then ritual death is the great fact of cultural life.' (17) Perhaps even more emphatically, Rene Girard states that:

> The resemblances among the rites practiced in disparate cultures are striking, and the variations from one culture to another are never sufficient to disguise the basic similarities...The more one reflects on these structural similarities, the more one is tempted to qualify them as not merely surprising, but downright miraculous. (18)

Graham Cunningham in a recent overview of *Religion and Magic: Approaches and Theories*, recognises that for van Gennep there is no real distinction between ritual and religion: religion 'is a kind of theoretical adjunct to a wide range of techniques, all of which he regards as magical.' In other words, religion offers the narratives and ceremonials to represent the psycho-spiritual essence of ritual and conversion and that ritual is religion in a pure form. Like Fiona Bowie, Cunningham also stresses van Gennep's perception of 'rites of passage as having a common structure consisting of three stages: separation, transition and incorporation.' He explains that van Gennep 'thinks this three stage structure is most clearly shown in initiation ritual in which the individual is first removed from society in a separation ritual, transformed in a transition ritual, and then returned to society with a new social status in an incorporation ritual.' Such a description practically follows Ehrenzweig's three stages of the creative process to the letter.

Cunningham goes on to note that van Gennep 'interprets many ritual activities as symbolising one of these three stages' and concludes that in one respect his analysis has been particularly influential, that is 'in the importance attached to the transformative power of the transition stage in rites of passage. This power is now often referred to as liminality, from *limen*, the Latin word for threshold, indicating the status of the transition stage as outside the normal constraints of human time and space, and as having access to a different set of conditions that are both more powerful and more dangerous.' (19)

In respect of such overarching claims it should be noted that important anthropological studies of the time corroborated van Gennep's schema and that whereas the work on tribal religion of Emile Durkheim, for example, has since been discredited, 'the view presented by van Gennep has reputable currency.' (20)

Significantly in relation to the creative process as I have outlined it, van Gennep's analysis reveals both the synchronic and diachronic dimension of the stages of ritual. He recounts how stages of rites of passage can be further subdivided into rites of separation, rites of transition and rites of incorporation. That is to say, in all three stages of a rite of passage, further tripartite rites may take place, although they may not be 'developed to the same extent by all peoples or in every ceremonial pattern.' Van Gennep explains:

> Thus, although a complete scheme of rites of passage theoretically includes preliminal rites (rites of separation), liminal rites (rites of transition), and postliminal rites (rites of incorporation), in specific instances these three types are not always equally important or equally elaborated.
>
> Furthermore, in certain ceremonial patterns where the transitional period is sufficiently elaborated to constitute an independent state, the arrangement is reduplicated. A betrothal forms a liminal period between adolescence and marriage, but the passage from adolescence to marriage itself involves a special series of rites of separation, a transition, and incorporation into the betrothed condition; and the passage from the transitional period, which is betrothal, to marriage itself, is made through a series of rites of separation from the former, followed by rites consisting of transition, and rites of incorporation into marriage. (21)

So here it can be seen that within a far wider time-span a central transitional ritual will incorporate within its own form the threefold structure reduplicated. In other words, a central rite of transition forming a liminal phase between two more distant rites of passage in time will embody synchronically in its dynamic the tripartite schema. Arguably, it will be this focal initiation rite that exhibits the process of transition in its most concentrated and effective form involving the formal essence of performance and trance with its potential for real psychic transformation. This is why such pure manifestations of ritual would also be most closely associated with curative and healing magico-religious procedures. Although other rites of passage within the wider framework would still involve the threefold process, the emphasis might be more on the narrative and ceremonial of events.

What is important here is that a comparable overall picture holds true in respect of the creative process and of the artist's development in the parallel dimension which effectively re-enacts life in another medium. Indeed, it is this remarkable parallel that supports the contention that on at least one fundamental level, the artist is innately engaged in a universal rite of passage. Again, in the context of my own personal development as a painter, it is evident that the abstract collage paintings, within their own structure correspond with the pure liminal transitional phase and reduplicate this tripartite essence of the creative and ritual processes. Further, these are

in turn set within a far wider scheme of things that would again appear to reflect this wider dynamic. So there is the parallel synchronic and diachronic dimension.

In my account of the abstract monochromes, I outlined the three phases of their construction and the parallel with the psychoanalytic models of Klein and Ehrenzweig. The initial paranoid-schizoid phase is laden with an anxiety associated with the process of separation; it can be identified that the paranoid character of this initial stage is intimately connected with the primal separation of birth and passage through the intrauterine and with the subsequent stages of separation during weaning. It is no coincidence, therefore, that the parallel first stage in the ritual process is one of separation, during which time the initiate may be physically separated and isolated in the insecurity of a situation where all known and accepted customs and surroundings are eliminated. This induces a paranoid state of disorientation and anxiety, an essential prerequisite for a mental breakdown and that negation of consciousness indispensable to affect the objective of psychic transformation.

Similarly, the central manic-oceanic phase of the creative process corresponds exactly to the liminal sequence of ritual during which time the initiate may challenge through subversive action the whole social fabric of convention and law and of acceptable norms of behaviour. In the same way, as I have described in the painterly creative process, the manic-oceanic phase challenges those painterly conventions and their formal representatives of cohesive organisation and in so doing neutralises feelings of guilt and conscience induced internally to protect and support them.

Just as this dissolution of conscious deliberations and realities in the parallel painterly dimension can induce a temporary loss of consciousness in the painter, so too in ritual can a loss of consciousness be triggered by the ongoing process of anxious isolation and deprivation and removal from that which is perceived as the real world and subsequent complex and overwhelming intensity of drum rhythms and prolonged exhaustion of dance and sensory stimulation. This combined with the paradoxical abandonment of normal codes of behaviour and the possibility of those 'neurophysiological' effects contributing to the breakdown of conscious ties with reality, can give rise to a potential for an ecstatic trance state in which the psychic slate is wiped clean to be imprinted with new behavioural patterns.

In ritual, of course, there are narrative and symbolic actions designed to ultimately instigate a deeper connection with the transformative process. A classic example of this is to be found in the research of Levi-Strauss. In *Structural Anthropology* he discusses 'The Effectiveness of Symbols.' (22) He describes in detail how a physical sickness in the form of a difficult childbirth is affected and treated through a ritual, psychological manipulation in the creation of a symbolic and mythological uterine world. Through this mythic parallel of real events the patient can consciously materialise and re-enact a painful, fearful and largely incomprehensible and so unconscious condition: 'The cure would consist, therefore, in making explicit a situation originally existing on the emotional level and in rendering acceptable to the mind pains which the body refuses to tolerate.' (23)

It is by way of this analogous narrative that a sympathetic psychic initiative may be triggered. Levi-Strauss refers to this as a 'psychophysiological mythology.' This curative technique tends towards the narrative ceremonial and although it will assist in inducing a frame of mind more conducive to the cure of sickness, it could not

alone access the deepest trance state necessary for a psychic trance-formation. Such a technique in traditional tribal society can be compared with the religious ceremony of other cultures similarly designed to procure a state of mind more amenable to unconscious and spiritual connection. (24)

In a sense these function like icons on a computer screen, or indeed icons in religious icon painting, which also open access to a deeper dimension behind the surface. As I have said, in ritual separation there may be an actual physical separation, whereas in the creative process the separation is re-enacted through projection and exorcism. Similarly, in the liminal stage of transformation, narratives can both represent and be designed to trigger a real conversion. Some African tribal rituals might involve an actual physical burial underground or journey through an underground tunnel, both to simulate the obliteration of consciousness and negation of reality whilst at the same time creating those conditions conducive to exhaustion and mental breakdown. Ceremonials of baptism likewise simulate the mystical oceanic stage of psychic immersion and union.

A detailed account of such ritual involving public burial and resurrection can be found in E.E.Evans-Pritchard's classic analysis of Zande ritual made during his expeditions to the Sudan between 1926-36. After a lengthy narration of an initiation rite, Evans-Pritchard concludes that 'This ceremony bears the imprint of a typical initiation ceremony. The neophyte is in a tabooed state for two or three days before the rite takes place…He then goes through a ritual enactment of death and burial and resurrection, though a Zande would not describe it in this way.' (25) The 'tabooed state' corresponds with the alienation and dislocation of the paranoid-schizoid phase, whilst the burial and resurrection re-enacts the objective of dissociation of consciousness and psychic resurrection. An example of an underground tunnel to simulate the transformation of unconscious psychic structure can be found in the *Isoma* ritual of the Ndembu, a central African society observed in 1950-54 by Victor Turner. (26)

I have explained that in my own practice as a painter, I have engaged with these psychic experiences without, of course, any recourse to sensory deprivation, drugs or drums. But the parallels are there, it is just that they are negotiated purely in the manipulation of abstract forms and I explained the process whereby consciousness could be similarly 'worked to death.' The abstract nature of the creative process here might well indicate a more pure engagement with psychic transformation and it does surely expose the essence of ritual process, although in the context of a more personal dialogue.

It is nevertheless true that the receptive spectator can be carried through the whole of the artist's creative transformation vicariously. But ritual is clearly more of a public event and communal engagement intended in part to regenerate the whole of society through such transitional performances. Ritual performances, in either a personal or communal setting, can function within an isolated capsule withdrawn from real practical events and their affects and can challenge accepted codes and instigate change; recourse to the prototypes of transition and development can generate a curative conversion in which both individual psychic structure and the corresponding cultural dynamic can be absolutely altered. As I have stressed, the symbolic element of such ceremonials is designed to parallel the process of intrinsic psychic conversion and so initiate an authentic engagement. It is inevitably the case that over

time, ceremonials become more detached from the psychic and spiritual connections originally giving rise to them.

Van Gennep's isolation of the sequences of ritual reveals the dynamic liminal model in its parallels with the structure of the creative process. In the context of actual territorial passage, van Gennep draws attention to the 'magico-religious aspect of crossing frontiers' (27) and in so doing adds definition to the liminal:

> Whoever passes from one to the other finds himself physically and magico-religiously in a special situation for a certain length of time: he wavers between two worlds. It is this situation which I have designated a transition, and one of the purposes of this book (i.e. *The Rites of Passage*) is to demonstrate that this symbolic and spatial area of transition may be found in more or less pronounced form in all the ceremonies which accompany the passage from one social and magico-religious position to another. (28)

In other words, as a symbolist, van Gennep recognises to a point how physical manifestations in the real world, whether territorial, as in this case, or ceremonial, tend to mirror inner psychic dynamics such as the psychic transgression of frontiers in the liminal borderlands.

For van Gennep, the individual's transition through life crises is paramount and this brings into focus a somewhat complex issue that anthropology at times seems to struggle with. That is, who enters a trance, or magico-religious state and experiences a psycho-spiritual trance-formation. Is it the shaman or witchdoctor orchestrating the ritual? Or is it the communal group enmeshed in a type of mass hysteria? Or is it exclusively the initiate or a mixture of all three? In a slightly different sense my earlier reference to the apparently opposing poles of soul-loss or spirit possession touches on the same kind of question. At that point I did note that for a spirit to take possession, the soul must vacate the body.

This issue again encroaches upon the relationship between ceremonial and ritual. It is the case that the shaman or witchdoctor perceived as having a proven track record in accessing trance states is appointed by the society to conduct the ritual process and to procure a similar condition within the mind of the initiate. A comparable situation exists in Western culture in the case of the psychiatrist or priest. As I noted in chapter 4, W.R.Bion argued that the analyst must engage with what is in effect the absolute trance state 'O' if any real transformation is to be achieved in the analysis. The analyst's state of O can induce a mirrored reflection within the mind of the analysand. In a ceremonial sense, the shaman may well be charged with engaging in trance in order to make contact with spirits of one type or another in order to fulfil certain social obligations. However, the point is that the initiate may or may not enter a trance state, as is the case with the shaman.

In the context of painting, as I have tried to show, I might have a psycho-spiritual experience of oceanic union and envelopment before the image of an abstract painting. I cannot know whether the painter of that abstract work had a similar experience during the making of it, although I would assume, as it was the painter who put those formal constituents in that particular arrangement, that he did in fact have this experience. In turn, as I explained, I set about creating collage paintings able to induce

123

the same psychic effect, which in turn could engage the receptive spectator in the same psycho-spiritual sensation. But in the final analysis, whether the artist or spectator, or shaman or initiate, actually experience trance and *ekstasis* is not objectively possible to determine.

It is rather the function of the shaman or artist to put the conditions in place to offer the potential for such a psychic conversion. So ritual and ceremonial coexist in a symbiotic relationship of mutual interdependence. However, just as the liminal ritual of transition relegates ceremonial to an absolute minimum, so does an abstract monochrome operate on a comparable minimal level.

Van Gennep, as we have seen, identifies the sequences of initiation rites and the ceremonial that provides a framework for them. However, as in the case of anthropological research in general, he fails to give any real explanation of how such a transition is effected psychically in the liminal phase; that is to say, how a trance-formation is installed. He will relate, as in the case of Congo tribal society, how the initiate is: 'separated from his previous environment, in relation to which he is dead, in order to be incorporated into his new one. He is taken into the forest, where he is subjected to seclusion, lustration, flagellation, and intoxication with palm wine, resulting in anaesthesia.' Van Gennep notes that: 'The initiate's anaesthesia is an important factor in the rite of initiation...The purpose is to make the novice "die," to make him forget his former personality and his former world,' or in other words, to 'wipe the slate clean.' (29)

However, van Gennep does not identify the true objective of such anaesthesia: that is to induce a state of mind in which a real psychic negation of consciousness can be initiated. Only this unconscious psychic reorganisation can absolutely transform the personality. Although in reference to Australian tribal initiation rites he does recount how '...the novice is considered dead' and is so for the duration of the ritual which 'lasts for a long time and consists of physical and mental weakening which is undoubtedly intended to make him lose all recollection of his childhood existence.' (30) It can be seen that there is always the conflation of the external and the narrative with the psychic forces shaping them.

When van Gennep describes these transition rites he does so principally in terms of their narrative symbolism despite recognising that 'the novices are considered dead during their trial period,' or that a momentary trance death takes place. That is to say he does not stress that the metaphorical death is intended in part to symbolise death, but also to play a part in activating a real psychic death. Significantly in relation to the above initiation rite, van Gennep notes that the '...newly born (resurrected)... must relearn all the gestures of ordinary life,' as one would expect during a prototypical developmental sequence. He further records that before the relearning process can take place, the initiate must ceremonially bathe in a stream, so re-enacting the universal rite of baptism, actually signifying a psychic immersion in a manic-oceanic communion. (31)

I have already made a brief reference to the anthropologist Victor Turner, in the context of the ritual of the central African Ndembu people. As in the case of van Gennep, Turner's research is material to a close comparison of ritual and the creative process. Turner is usually classified alongside van Gennep in the school of anthro-

pology often described as 'symbolist.' Symbolist approaches, as we have seen, draw symbolic parallels between social structures and that of ritual and religion. It follows the ideas of the earlier school of anthropology known as 'structural-functionalism,' whose adherents included Evans-Pritchard, Emile Durkheim, Marcel Mauss and A.R. Radcliffe-Brown.

Symbolist approaches follow the structural-functionalists in stressing the function of ritual and religion in *implicitly* symbolising social structure, rather than any explicit function, such as addressing fertility deities, for example. (32) For van Gennep and others involved in symbolist approaches, such as Lucien Levy-Bruhl, Mary Douglas, H.M.Beattie, S.J.Tambiah and Turner, ritual develops symbolism that encodes human social and developmental structure. For Turner, who was influenced by van Gennep, elements of ritual symbolise basic human biological and psychological processes. Such approaches were inevitably coloured by the key French anthropologist Claude Levi-Strauss who argued through the ideas of structuralism that religion and social structure both reflected unconscious psychic structuring activity.

Graham Cunningham notes how Turner had analysed van Gennep's transition stage of ritual and closely compared this aspect of Ndembu ritual to those of other societies. Turner referred to this liminal stage as 'interstructural.' Cunningham records how Turner's analysis undertaken in *The Ritual Process* elaborates on van Gennep's tripartite ritual structure:

> He describes the first stage as separation of the ritual participant from everyday consciousness or social position; the second stage as a provision of a moment of liminality, a psychological and social state of transition in which sacred power is encountered; and the third stage a reintegration of the ritual participant into everyday life with a new status. He stresses the powerful nature of liminality: "Liminal situations and roles are almost everywhere attributed with magico-religious powers." (33)

Again, as I have stressed, this reflects Ehrenzweig's three creative stages of paranoid-schizoid separation, a momentary liminal, trance manic-oceanic state of psychic transition, and a reintegration.

Turner's further research in *The Ritual Process* discloses deeper consonances with the creative structure. He discovered that '...very often decisions to perform ritual were connected with crises in the social life of villages.' This again is a communal model of the individual's recourse to abstraction in times of personal crisis. Ehrenzweig has argued cogently that during transitional life crises, the individual resorts to an abstract mode of thought. The transitional rite of passage is nothing if not abstract, in its purest form devoid of literal references. Elsewhere I have expanded on these issues at greater length in order to show how the abstract structure of the creative process fulfils the self-same role, especially in its essential template as excavated in the abstract painting. (34)

Turner affirms the tripartite *diachronic* structure of Ndembu ritual and further inadvertently confirms its parallel dialectical core when he states that elements of Ndembu ritual convey '...the notion of the structured and ordered as against the unstructured and chaotic.' (35) As I have described, the dialectic at the core of the creative process comprises of just such an opposition between dislocated, inchoate

125

inarticulate forms and its relatively cohesive, compositional elements of conscious deliberation.

This characteristic of thesis and antithesis generates the emotional tension to precipitate a synthesis in an oceanic unity during which time opposites and contradictions can coexist in a state of equality and stability. Polyphonic diversity is subsumed in serial structures capable of encompassing disparate emotional and perceptual representations. In his analysis of the creative process, Ehrenzweig gave a detailed account of this complex process, noting, for example, how bisexual or hermaphrodite formulations at the deepest unconscious manic-oceanic level embody the total absence of opposites and differences between categories in a flux of free ambiguity. Ehrenzweig noted further how the roots of words, originating in the unconscious creative matrix, could accommodate absolute opposites: for example in the root of the words hostile and hospitable.

Again we can see evidence for the same processes active in the initiation rite. Although often appearing to be restricted to outward manifestations of narrative ceremonial and symbolism, these surface representations incorporate far deeper unconscious motivations. For example, Turner links liminality to bisexuality and explains that the initiate is inducted into a state of 'sexlessness and anonymity…highly characteristic of liminality.' In Ndembu ritual it is common for initiates or neophytes of both sexes to be dressed alike and referred to by the same term. He further notes that this is common in many African baptismal ceremonies and concludes that: 'Symbolically, all attributes that distinguish categories and groups in the structured social order are here in abeyance; the neophytes are merely entities in transition, as yet without place or position.' (36)

It has been substantially recorded how a type of role reversal is paradigmatic of the ritual process. Turner describes how in liminality 'the underling comes uppermost' and how the supreme tribal authority can be portrayed 'as a slave.' In *Violence and the Sacred* Rene Girard has similarly recorded the 'dissolving of distinctions' in ritual and how the authority figure of the king can be subjected to ritual violence and humiliation. Here again, the communal representative of an inner psychic superego is attacked and neutralised in order to assuage communal guilt and through acts of violence to establish 'the essential function of all myths and rituals: to disguise, divert, and to banish disorder from the community.' (37)

At other significant conjunctions, Turner prompts further close parallels: evidence of projective identification as the authority figure is reviled and insulted and phases or reaggregation enclosing the liminal. In terms of the structure of ritual Turner emphasises that the initiate must be a 'blank slate' during liminality and explains how the paranoid 'ordeals and humiliations, often of a grossly physiological character' are designed to initiate a 'destruction of the previous status'; the transitional sacred liminal rite imparts a wisdom that 'refashions the very being of the neophyte,' a comparable process to that potentially within the creative process. (38)

What is evident in the research of both Turner and van Gennep is their appreciation of the climactic role played by the transitional liminal phase of rites of passage; that is, of the transformative process encountered here that 'refashions the very being of the neophyte.' This holds true in whatever context: for the creative

process to authentically effect a psychic conversion, the artist must access the deepest manic-oceanic psychic level; for the analysand to experience a creative transformation, W.R,Bion's state of 'O' must be attained. Again, at least for me personally, the dark red abstract collage *Promised Land* is that state of 'O' and a materialisation of that condition of liminal space and time in which a 'blank state' is induced along with a real potential for a 'refashioning' of the very being, or as I have described it, a 'reprogramming.'

In effect the abstract monochromes create a blueprint for ritual procedure and embody within their substance the trance experience. That is to say, the liminal process of trance-formation is locked into the material dynamic, encoded as it were and fixed in a trance-substantiation. It is this materialisation of an essence, I think, that is re-enacted symbolically in religious ceremonials like the Eucharist, found in Eastern Orthodox religion as well as Catholicism, during which a spiritual essence is deemed to be reincarnated within the body of another substance. So transubstantiation essentially signifies the substantiation of trance, a 'mental abstraction,' through its materialisation and embodiment in another form; that it is fundamentally substantiated through evidence of its existence materially.

In the creative and ritual process, it is the mental abstraction of trance in its dissociation and fragmentation of consciousness that is the absolute prerequisite of a psychic reconstitution. Again, in my own circumstance, my contention is that having been denied a positive developmental transition within a dysfunctional context, I instinctively reconvened a blueprint for a rite of passage to effect the necessary change through trance.

That the trance experience is a constant in any rite of passage aspiring to effect a transformation cannot be seriously doubted; I think that the weight of evidence for its universal and cross-cultural manifestation is too strong. Mikkel Borch-Jacobsen, a psychoanalytic theorist responsible in part for a resurgence of interest in the curative potential of hypnotic trance within the process of an analysis, emphasises in his essay 'Mimetic Efficacity,' that:

> ...trance is considered extraordinary – that is, depending on which vocabulary is used, "sacred," "pathological," "prelogical," or "regressive" – since it transgresses both the symbolic order of societies and our scientific reason. And yet, as extraordinary as it may be, it appears really to be also a very ordinary phenomenon...since it is found everywhere, both in time and space, whether in cultures that make it the center of a cult or in those, like ours, that have a tendency to reject or marginalize it. *This is truly an anthropological constant, which obstinately defies historical and cultural differences*...Hence it seems that this universal invariant corresponds to an equally universal variation; each culture, each epoch, each theoretical setup emphasises one or another aspect of the phenomenon to the detriment of the others, in order to try to master its disconcerting ambiguity. (my emphasis) (39)

Borch-Jacobsen draws on the theory of the Belgian anthropologist Luc De Heusch, whose work I touched upon in chapter 4...in presenting a 'general classification of therapeutic rituals, conceived as a universal response to illness and ill in general,' (40) The debate again concerns something not strictly at issue here, that is the

apparently different categories of soul possession and soul loss. In this context Borch-Jacobsen confronts the resolutely social, as opposed to subjective setting, within which such illness appears to be negotiated. However, he does reaffirm the ultimately subjective nature of psychic disturbance and trance (41)

The important point here in respect or ritual is that trance is a 'ritually induced state' that 'regularly intervenes in the medico-religious response directed as much against illness in general as against the specific illness of spontaneous and mad "possession." In respect of de Heusch's argument Borch-Jacobsen concludes that "mental illness"…is the illness that traditional societies cure the most efficaciously. How so? By way of trance' and whether the ritual is one of exorcism or pure transformation in rites of passage, the salient point is that ritual passage '…operates *internally* in each of the medico-ritual situations he examines, and that, in each situation, the operator is the trance itself.' (42)

Again, the same issues arise in the contexts of the creative process and of mysticism. In both fields the trance experience is a subjective phenomenon subsequently transposed into the social setting of communal ritual and ceremony, which in turn service to reconnect with the original source. Whatever the cultural context of the ritual and whatever its various social obligations appear to be, it is the element of trance-formation at its core that is the generating force relegating all narratives and social ceremonials to the periphery.

Borch-Jacobsen is an influential member within a group of psychoanalytic theorists who recognise the radical and universal nature of trance experience. (43) He is critical of the approaches of structural anthropology and takes Levi-Strauss to task for his concentration on symbolism and narratives in the therapeutic ritual process at the expense of those non-symbolic elements mostly involving some kind of trance state. This is a critical omission because as ritual process shows, it is only at the level of trance that a transformation, conversion or cure can be truly attained. As Borch-Jacobsen has pointed out, this failure to fully comprehend the elemental function of mental abstraction beyond the scope of linguistics, discourse and the symbolic has seriously compromised much contemporary psychoanalytic though. (44)

Significantly, in the introduction to van Gennep's *The Rites of Passage,"* Solon Kimbali criticises psychoanalytic perspectives on ritual for failing to probe beyond symbolism. He notes that although psychoanalysis has paid some attention to initiation rites, 'This interest, however, is not in the internal structure or functions of rites of passage but in such data bearing upon psychoanalytic theory as they provide.' (45) As I have suggested, the self-same critique could reasonably be levelled at anthropological research in general and in a far more diverse context at art criticism.

Borch-Jacobsen criticises Levi-Strauss's concept of 'symbolic efficacity,' to which I referred earlier, on the grounds that it 'does not say a word about the nonetheless important and massive role of the trance…' This is a serious lacuna 'since the trance…always intervenes in one way or another in therapeutic rituals…and the "remedy"…is the trance.' (46)

So for Borch-Jacobsen the role of trance is crucial and his understanding of its function and operation provides further evidence of its close correspondence with the creative process. In place of 'symbolic efficacity' he astutely substitutes 'mimetic efficacity' for he sees that the essential difference in the role of trance is that it

'dramatises' rather than symbolises the psychic condition of the initiate. The word 'dramatises' certainly gets closer to what is really going on in the trance experience, although this might still be defined as 're-enacts' and be somewhat misleading. In fact the experience is far deeper that a re-enactment; it is as if the actual unconscious psychic operation is synchronised and then mimetically run in tandem until the real counterpart closes down as its functions are taken over elsewhere. This is a parallel of the abstract creative core where again the synchronisation of mental processes in turn leads to their actual externalisation leaving a void of consciousness and momentary trance state and sense of *ekstasis* in its wake.

The liminal trance state in ritual functions in the same way by intrinsically enveloping the initiate within the very process of transformation, an intense involvement not possible through symbols alone that are in effect once removed from the performance. This is fundamentally what Borch-Jacobsen means by 'mimetic efficacity.' It is the coterminous nature of the mimetic that underpins its effectiveness. 'Mimetic efficacity' has the same role as played by 'psychic mirroring' in the abstract creative process. Although as I have indicated Borch-Jacobsen's analysis following de Heusch basically addresses the ritual cure seen from the perspective of a witch doctor exorcising a possessing spirit, rather than the transformation of the pure initiation rite or rite of passage, the principle is essentially the same. That is to say 'whether the trance is induced in the patient for diagnostic ends, whether it is combined with the treatment, or whether the doctor puts himself into a trance to diagnose the ill, in the fashion of a true medium,' the underlying forces at work are constant and 'the trance *induced* by the doctor is continuous with the *possession* suffered by the patient.' (47)

Borch-Jacobsen's insights into the mimetic nature of transformation were gleaned partly from de Heusch's account of the possession trance of the Thongas of Mozambique. He sees that the trance remedy is initiated through a faithful modelling to the ill, 'being both illness and remedy' and says that 'the trance itself is never anything but the very ill that it exorcises through repetition and ritualisation…an astonishing sort of "go-between" that vaporises the instant we try to grasp it.' In other words the possession is dramatised and externalised and exorcised. But it dramatises a mental abstraction that is 'nonsymbolisable,' beyond language, 'outside of representation' and is only possible through trance. Only trance experience escapes from the symbolic: *all* other factors that may surface in ritual, such as sacrifice or search for a scapegoat and the various associated narratives, are ceremonial representations. Trance alone defines a ritual cure or conversion. (48)

The same holds true within the creative process: the trance induced mimetically by the painterly form within the parallel dynamic is continuous with the psychic condition or 'state of mind' and very psychic structure of the painter, who 'mimes' it through the abstract creative template. As I have argued, this sets up a reconstruction of original developmental programmes, as do rites of passage, in order to provide the framework for a transition to another life cycle, or to affect a cure through a psychic reorganisation. It should be borne in mind that it is often an individual suffering from a psychic disturbance and emotionally arrested who may be consequently denied transition to another life cycle. So the transitional rite and the ritual cure often function together in the same process.

Again, the exorcising nature of the paranoid-schizoid creative phase reflects the exorcism of a spirit possession in ritual. The effectiveness of a cure in ritual exorcism is supported by the fact that the ritual is attested to by the group. That is to say, the communal acknowledgement of the possession and exorcism in trance normalises the experience and enables the 'madness' to be dealt with. In the same manner, artworks can place into the public domain the essence of developmental cure and therapeutic transformation and so effect an individual psychic integration as well as the artist's social integration. At the core of ritual and the creative process is trance and for Borch-Jacobsen, trance is a universal cure and 'our true mirror.' (49)

It will be recognised from the discussion so far that ritual process operates on many levels and involves a complexity not necessarily conducive to straightforward definitions. Ritual can be predominantly curative, transformative, exorcist, ceremonial, or combinations of these objectives. Traditional, tribal societies throughout human development, whilst universally practising ritual, would have recourse to a wide variety of ritual formulations. However, I think that the general anthropological distinction between those rituals with the emphasis on exorcism and spirit possession, usually malefic, and those more concerned with soul loss, whereby the soul of the shaman or other entranced subject might travel to make contact with a deity, can be problematic and lead to confusing distinctions.

I think that it is the case that these categories have more aspects uniting them than dividing them and are predicated fundamentally on the same principles. As I have just noted in respect of the ritual cure and the rite of passage, these may well combine both objectives. As we can see from the evidence of the creative process, an exorcism is often a prerequisite for the 'loss of soul' or the 'standing outside of oneself' during the *ekstasis* of the oceanic stage. Whether the cure is to be effected by the apparent exorcism of an evil spirit, paranoia or depression, the expulsion of the patient's sick soul is accomplished through the 'mimetic efficacity' of trance experience. Or as I have said, the externalisation of inner psychic forces induces a type of mental breakdown or abstraction and subsequent trance during which time the psychic structure is reprogrammed.

So what Borch-Jacobsen stresses in his comments on the effectiveness of trance in the cure, is something that I discovered empirically in my own subjective creative endeavours: that the mimetic efficacity of trance is only attained in the course of mental abstraction at a psychic level beneath symbolism and narrative. Although legitimately criticising Levi-Strauss's structural anthropology for its neglect of this abstract trance, Borch-Jacobsen does acknowledge the fact of Levi-Strauss's recognition that even in the context of narrative, where a mythology is conjured to symbolise and negotiate the sickness, it is still the *form* and not necessarily the content of the narrative that is instrumental in the cure. Borch-Jacobsen suggests that 'the content is totally unimportant...any "zero symbol" would do the trick'; content is bracketed by structuralism in favour of 'pure symbolic form.' (50)

So even when there is a reliance on narrative, there is recognition that its effect is manifested through its formal structure and that up to a point it doesn't matter what the detail of the story is. The important factor, as Borch-Jacobsen perceives, is that a parallel dynamic is set up in order to facilitate a symbolic 'manipulation' of the

crisis. Similarly, when the shaman mimics the patient's possession or sickness through trance he manipulates its psychic orientation and in so doing instigates a sympathetic corresponding response within the patient, whose entranced state ensures that conscious resistance to the counter-transference is neutralised.

In all of its essentials this is the creative process in operation without an artwork. Just as mystical experience is the creative process without an art object, so is ritual transformative performance a distilled, isolated creative process. Both are in closer correspondence to music in their purity, ritual retaining the repetitive rhythms to synchronise brain patterns. Just as the artefact in ritual functions to encode the creative process on a particular level, so does the abstract monochrome in my own experience materialise and fix the trance phenomenon. Although I cannot claim this to be accessible by others, for me at least they embody the trance experience within their material dynamic. In a parallel process to ritual, the inner abstract psychic processes are removed, just as an organ might be during an operation, reintegrated and subsequently reintrojected within the altered state of consciousness. Just as the shaman's dramatisation is reflected back to the initiate, so is the mirrored psychic template reflected back to the artist or receptive viewer.

It is this very process that is imitated by psychoanalytic practice where the analyst, during counter-transference takes on the characteristics of the objects and persons that the analysand is attempting to deal with in the analysis. This instinctive mirroring of the analysand's projective identification means that the objective analyst, attaining Bion's O, can manipulate the relationships and in the counter-transference re-orientate the emotional condition of the patient. But the question remains as to what psychic level the 'talking cure' really operates on. As we have seen in ritual process, consciousness must be closed down to neutralise resistance and to generate the necessary receptivity through trance. As Borch-Jacobsen understands, it is the element of abstract trance that is missing in psychoanalytic procedure and that casts doubt over its ultimate 'mimetic efficacity.'

It is the mental abstraction of trance that forms the essence of Borch-Jacobsen's mimetic efficacity and of ritual cure and rites of passage and I think that there is much supporting evidence to validate this universal phenomenon. William Sargant's research carried out in the middle of the last century is very significant here in the context of ritual and the creative process, not least because his investigations cross the boundaries of ritual and anthropology, into mysticism and religious conversion and psychiatric treatment and the physiology of trance.

Sargant was physician in charge of the Department of Psychological Medicine at St.Thomas's hospital in London and had a long association with the Maudsley hospital. For many years he conducted first-hand, worldwide research into ritual trance states and religious conversion experiences. His own family background was rooted in revivalist Methodism. He was further unafraid to venture into contentious areas of physiology and behaviourism, drawing some fascinating parallels with the work of the Russian physiologist, I.V.Pavlov, which serve to reinforce the sequential parallels with the creative process.

In his work *Battle for the Mind – A Physiology of Conversion and Brainwashing,* originally published in 1957, Sargant first makes reference to those mystical

experiences and conversion, that result from excessive stress and overload of the nervous system and a 'displacement of psychic strata' leading to a 'change of personality.' (51) He confirms that the initial stage of what Ehrenzweig and Klein would describe as 'paranoid-schizoid' tension and breakdown of consciousness is a prerequisite of trance experience in whatever context, whether of tribal ritual, religious conversion, cure of depression in shock therapy, political brainwashing, or the experimental brainwashing of Pavlov's dogs.

Sargant had noted here that prejudice against Pavlov's thesis had blinded many to the fact that 'his viewpoint was irreproachably scientific.' He considers Pavlov's verifiable experiments in changing the brain patterns of animals to be highly relevant in respect of religious conversion, brainwashing and the inducement of altered states of consciousness. Pavlov's late work, neglected or suppressed, in fact compared the remarkable results of disturbances of brain functions in animals with those of human beings. (52)

A critical discovery of Pavlov was what exactly happened to conditioned behaviour patterns when the brain of a dog was subjected to stress and conflict beyond its capacity for normal response. Pavlov referred to this state as a 'transmarginal' phase during which a 'rupture of higher nervous activity' could be induced by imposing stresses. These varied in degree but would involve the disruption of conditioned responses. For example, Pavlov might greatly prolong the period between a signal for the arrival of food and its actual presentation, inducing unrest and abnormal behaviour, or breakdown through contradictory signals and consequent disorientation and uncertainty. (53)

The capacity of a dog to resist heavy stress depended on the state of its nervous system, but Pavlov noted that once 'transmarginal' inhibition was induced, brain function was inhibited and altered. These changes could be precisely monitored by the amounts of saliva secreted in response to conditioned food stimuli and were not liable to the subjective distortions in the context of a human being's analogous experiences. Pavlov further noted that there were three distinct and progressive stages of transmarginal inhibition. The first was designated as the 'equivalent' phase, during which time whatever the strength of the stimuli, the same response was produced. The second phase was termed the 'paradoxical' stage of behaviour where a type of inversion takes place, weaker stimuli instigating greater responses than stronger stimuli. However, what is of greatest significance here is Pavlov's third designated stage of behaviour he termed the 'ultraparadoxical,' for at this degree of breakdown, positive conditioned responses suddenly switch to negative ones and vice versa. In this state a dog may become attached to an attendant previously disliked, or attack a loved master, or enjoy food previously found distasteful. Its behaviour is exactly opposed to all of its previous conditioning.

Sargant draws attention to a particular incident reported by Pavlov in 1924 after he had been working for many years, since 1897, on the conditioned reflexes of experimental animals. His laboratory dogs were almost drowned in the Leningrad flood. They were trapped in their cages by the rising water and confined to swimming in the narrow space near the cage roof, a terrifying experience. When these animals were rescued, Pavlov discovered that the extreme state of stupor and collapse had obliterated conditioned behaviour patterns recently imprinted upon them. Although

over many years Pavlov had refined exactly how to implant such conditioned patterns, it had been less clear how to absolutely eliminate them. (54)

In a much later work, Sargant referred again to this defining moment in Pavlov's research, stressing that emotional collapse stripped away all recently conditioned reflexes: 'It was as if the recently printed brain-slate had suddenly been wiped clean, and Pavlov was able to imprint on it new conditioned patterns of behaviour.' (55) Significantly, he further comments, 'And we shall also frequently encounter the final inhibitory collapse phase, with its wiping clean of the brain slate as regards recent happenings: *this* is often called the 'little death,' preceding rebirth to a new life, in primitive tribal rituals.' (56)

The correspondences with the creative process as I have defined it are self-evident. The instigation of contradiction and confusion through increased stress, effectively 'working consciousness to death,' although here actively experimentally stimulated, equates with the paranoid-schizoid phase of development, with its anxiety, insecurity and uncertainty and with those subsequent periods of alienation in the depressive wilderness that may propel the individual into a creative curative transition. Similarly, the 'ultraparadoxical' condition, with its associated emotional collapse, eradication of preconditioned resistances and 'dispersal of abnormal brain patterns,' opens pathways to the acquisition of new psychic programmes.

In his references to 'techniques of religious conversion' Sargant argues that if brain patterns are to be transformed, success is more likely if it is possible to first induce:

> ...some degree of nervous tension , or stir up sufficient feelings of anger or anxiety to secure the person's undivided attention and possibly increase his suggestibility. By increasing or prolonging stresses in various ways, or inducing physical debilitation, a more thorough alteration of the person's thinking processes may be achieved...If the stress or the physical debilitation, or both, are carried one stage further, it may happen that patterns of thought and behaviour, especially those of recent acquisition, become disrupted. New patterns can then be substituted, or suppressed patterns allowed to reassert themselves; or the subject may begin to think and act in ways that precisely contradict his former ones. (57)

In effect what Sargant describes here is the original developmental sequence reconstituted in another setting in order to instigate the nascent process of transformation and conversion.

In *The Unquiet Mind* (1967), Sargant recounts his discovery of the precise same effects of collapse and conversion to be found in revivalist religions where the threats of hellfire and damnation, absolutely believed by the congregation, in some could induce a 'transmarginal' breakdown. Sargant notes that he '...observed how often conversions to beliefs dramatically opposed to those of previous habit would follow long periods of accumulated anxiety, doubt, physical debilitation, or a sudden overwhelming emotional crisis.' (58) He further records how some 'Bible-Belt' religious sects employ snake handling to generate the levels of stress and fear essential to induce a mental breakdown, where mounting fear, hypnotic tension and acute hysteria are followed by stupor and collapse, 'an effect deliberately induced by the preacher and in some sects called *wiping the slate clean for God*.' (59)

Sargant consistently makes the connection between religious conversion and tribal ritual and through these to the creative process. He also emphasises the function of repetitive rhythm and drumming to increase the effects of stress, breakdown consciousness and induce trance states in which the brain is receptive to the imprinting of new patterns. He says 'Rhythmic drumming is found in the ceremonies of many primitive religions all over the world. An accompanying state of mounting excitement and dancing is also maintained until the same point of physical and emotional collapse has been reached.' (60) He describes how the voodoo cult in Haitii subjects the brain to severe physiological stresses and works up the subject into a state of suggestibility by voodoo drumming. He says that:

> A voodoo priest increases excitement and suggestibility by altering the loudness and rhythms of the drums, just as in a religious snake-handling cult, which I observed myself in the United States, the preacher used the tempo and volume of singing and handclapping to intensify the religious enthusiasm, and emotional disruption was finally induced by thrusting live poisonous snakes into their hands. After a terminal collapse into stupor, both groups of participants may awake with a sense of spiritual rebirth. (61)

Sargant studied the effects of prolonged drumming and dancing in the actuation of trance states. For example, in his research on the nomadic Samburu tribe of Northern Kenya he records how their dancing was often carried to the point of trance and collapse. He notes how in part the effect of the ritual dance is to neutralise the social and cultural superego of convention and tradition imposed upon the new generation. In a different context I described how the abstract painterly process simulates this very process within its own parallel dimension.

Sargant further draws attention to the parallels between the 'intensive rhythmic over-breathing' of the Samburu and that encountered in trance states induced by 'religious pocomania' and notes the uncanny correspondences between the techniques and mental states in 'both a primitive tribal and a Christian religious setting.' In effect mystical experience and *ekstasis* forms the spiritual essence of both. (62) Again, he also recounts how trance states in Kung Bushmen of the Kalahari are instigated through rhythmic dancing and heavy breathing. These are curative rituals to both heal the sick and to provide mystical protection for the group. Sargant mentions that the state of collapsed trance is known in such societies as the 'little death.' (63) Significantly, more recent observations of the Kalahari Kung describe in detail the repetitive dancing inducing a '...type of death, in which the healer's soul leaves the body and ascends into the sky in order to confront the gods and spirits who are attempting the lure the souls of the living into their realm of death.' (64)

Throughout his extensive travel and research, Sargant was able to confidently proclaim that 'Over and over again I found that milder forms of nervous and mental illness can be helped by traditional methods of healing, by dancing and repeatedly going into trance...' (65) He witnessed the cure of depression in Sudanese Zar healing ritual and observed that 'The tempo and rhythm recorded at the Khartoum drumming ceremony were also found to be effective in putting ordinary people into trance when tested out later in England.' (66) Again he underlines how new patterns of behaviour are implanted during states of hypnotic trance. (67)

Numerous other anthropologists and field researchers confirm Sargant's observations. E.G.Parrinder's study *African Traditional Religion* (1954) details the function of repetitive, rhythmic drumming to induce an ecstatic trance state and records how the 'diviner' enters into an 'abstracted state' during the 'special rhythmical dances of the possessed' (68) Significantly, Parrinder also argued that new religions developing out of missionary, colonial Africa, retained their connections to ancient ritual with its innate developmental sequences. New African Christian sects still '…give great place to ritual and dancing…spiritual needs seem to be neglected by the orthodox churches, but it will be seen that they have their roots in the ancient religious beliefs.' He cites Placide Tempels: 'African paganism, the ancient African wisdom, aspires from the root of its soul towards the very soul of Christian spirituality.' (69)

Similarly, Evans-Pritchard had observed the pivotal role of drums and dance, often ongoing for hours on end, in ritual performance. In relation to his research on the Azande to which I have already referred, he states that: 'In the first place, they dance themselves into a condition bordering on dissociation. They are intoxicated with music created by themselves and others and are physically prostrated.' (70) He analyses the entry into trance states and describes its characteristics of omnipotence, again clearly associated with early developmental transitions and with their manifestations in the creative process. (71) Similar accounts can be found in many other works, for example, V.W.Turner's *The Drums of Affliction.* (72)

More recently, Margaret Stutley's examination of shamanism stresses that 'Frenzied dancing also causes trance accompanied by increased suggestibility' and compares this to the heavy drumming and violent dancing indulged in by the Greek Maenads to achieve transformation. She notes that 'The rhythmical drumming, apart from the singing, is enough to cause changes in the electrical activity of the brain in ordinary people' and that 'When a chant unites with the vibrations of a drum it is the classic shaman's power chant that frees the superconscious from ordinary consciousness.' (73) Stutley acknowledges Sargant's contribution in his emphasis on the alteration of brain states during trance experience and describes how trance '…dissolves the limiting boundary between the individual ego and the world,' just as we encountered in the manic-oceanic phase of the creative process. She further stresses that: 'It has been shown that if drum rhythm is synchronised with brainwave frequencies, an altered state of consciousness is more easily achieved. Essentially there is no distinction between trance and deep hypnosis.' (74)

I think that it is also relevant here that J.M.Chernoff's recent study of *African Rhythm and Sensibility* (1979) recognises the fundamental role of music and rhythm in African culture and the 'functional integration' of music and culture. He draws the essential developmental connection between the drum and the heartbeat, noting further how drums might often be ascribed familial roles such as mother or brother within traditional cultures.

Chernoff recounts how some ritual performance, such as in the Zhem dance of the Dagomba, develops a complexity of rhythmic combinations and counterpoint which effectively functions to induce a dissociation and breakdown consciousness, a process consistent with the abstract creative process whereby a build up of a polyphonic complexity of superimposition overloads consciousness so releasing uncon-

135

scious modes of psychic operation. He explains how '...the conflicting rhythmic patterns and accents...diverse rhythms establish themselves in intricate and changing relationships to each other...it is not easy to find any constant beat at all.' (75) It is the 'clash and conflict of rhythms' that is the essence of African performance: 'Several rhythms, each with shifting metric potentials, create an instability in combination... There is a rhythmic movement which is perhaps too complex to be grasped in its individual parts.' (76)

Naturally it is the case that music and rhythm expose the creative process in pure abstract form and it is significant, as Chernoff points out, that in African music the listener or dancer must supply the beat to 'the real rhythmic tension and conflict in the music.' (77) What he says of African ritual and drums has often been said of modern art, that the 'listener,' or spectator in the case of painting, 'must be *actively engaged* in making sense of the music' and that African music cannot be divorced from its context. 'Misaccentuation' and a dislocation of parts are made sense of through the ritual dance and the art object associated with it. (78) Chernoff's descriptions of the 'sets of balances,' 'establishment of multiple cross-rhythms' and importance of improvisation in African culture could all be as equally pertinently applied to the serial polyphony of all-over abstract painting.

Chernoff's analysis of the complexity of drumbeat and rhythm in ritual performance reveals those correspondences with the essence of the creative process. Having quoted Chernoff, however, it should be acknowledged that despite his empathy with the ritual creative process, he does not subscribe to the idea of its ecstatic nature, which I have argued forms its core. He states that: 'Our word "ecstatic," which some people like to apply to African music, means literally from its Greek origins, "extended out of the state one was in," and the word could not be more inappropriate to describe African music in general.' However, Chernoff here is referring principally to the performance of contemporary African music. In relation to ritual, contemporary approaches can only access the ceremonial vestige of the original spiritual source, whereas the immersion of African culture in the complexity of drum rhythm can be to a degree transposed into some contemporary music. In any event, I think that it is clear from the overwhelming anthropological evidence, that ritual performance and rites of passage in particular, do have as a central objective the transcendental, mystical experience of *ekstasis*. (79)

The arguments I have so far put forward should reveal that in a number of key areas there are close affinities between what is going on in ritual transformation and in the creative process. Both involve an initial schizoid alienation and dislocation, with its associated projective identification and exorcism. Both aspire to a liminal or unconscious oceanic trance state during which time new psychic patterns can be imprinted, constituting a type of rebirth, to be followed by a reintegration. Borch-Jacobsen continually emphasises the radical nature of this trance state and regrets its neglect in Western culture, just as Rolland lamented the demise of mystical experience in Western institutionalised religions. Sargant fully appreciates the curative potential of ritual trance, especially in the treatment of depression and psychic illness. His critical reassessment of Pavlov's findings was especially timely and it is interesting to compare his exposition of the 'ultraparadoxical' phase with Rappaport's description of

rites of passage, quoted earlier in this chapter, when he says: 'That which is learned in ritual may thus override, displace or radically transform understandings, habits, and even elements of personality and character laid down in early childhood.'

This, as I have stressed, is a key factor in my argument: that the individual, through the potential afforded by engagement with the creative process, can adjust and correct conditioned patterns of development that may be inadequate or debilitating. By accessing childhood sequences through the portal of the prototypical developmental framework, a psychic reorganisation and healing can be procured. This is at the most basic level of the creative process and in no sense need be restricted as regressive. Traditional tribal culture universally incorporated provision for this transformative process, but in Western society its decline compels the resort to individualistic resolutions.

In traditional society, the curative, transformative ritual was indistinct from the religion of the culture. The two were one and the same, whereas in the Western context the Church became a separate institution from art practice and so in actuality from the creative and mystical source originally forming its spiritual roots and giving it sustenance. In traditional tribal culture the shaman is both healer and priest, in Western culture the priest and artist are separate entities and both are now arguably secular, institutionalised, ceremonial figures ruptured from their ecstatic, transcendental origins that they were meant to embody.

It has often been suggested today that psychotherapy and psychoanalysis can fill the vacuum left by the demise of art and religion. I have already addressed some of the questions that this poses and it is worth noting that few of those involved in the anthropological research relevant here, have much faith in the power of psychotherapy to fulfil the obligations once met by ritual performance or by the essence of the creative process. For example, Sargant is critical of much psychoanalytic practice, noting that patients will often develop and produce symptoms according to the school of thought of a particular analyst and that '…if they change psychiatrists, they change symptoms.' (80) One of his conclusions is that the trance and hypnotic techniques used for centuries in African religions are far more powerful in breaking down the nervous system and developing states of suggestibility than are modern techniques. He says:

> The Power of these methods to produce new attitudes and new happiness in living is very great indeed, far greater than most of our modern methods of psychotherapy, or the use of intellectual arguments and persuasion alone. I could not help being again forcibly impressed by the deep and certain faith which this age-old pattern of brain-washing creates. (81)

Similarly, Andreas Laszlo, by profession a specialist in internal medicine in Connecticut, who travelled extensively in Portuguese Angola in the first half of the last century, witnessed first-hand rites of passage and intense ritual performance, noted that:

> How fortunate it is for him that a native can express so much through his music and dance! Sorrow and happiness, birth and death, initiation and marriage – and they will always dance. It is an outlet for human emotions and a perfect way to prevent frustration. I am sure we, too, could function better and require less

psychoanalysis in our own society if we would learn to dance with our children on our backs. (82)

Laszlo comments on traditional African tribal society that: 'This skilful and perfectly balanced system, like a smooth and compact ball with its inherent cohesive qualities, enabled the native by his own standard to exist on a fine ethical and moral level.' (83) Few, I think, would venture to make such a comment about our Western society. In the African context, the cohesive and integrative factor was the critical ritual performance, along with the associated art object encoding its form and content.

This is indeed a conclusion in respect of ritual and the creative process that ultimately has far-reaching consequences: that a society devoid of the provision for the cohesive and integrative force of ritual, which is essentially the creative structure and the artwork that embodies it, is liable to fragmentation, breakdown, decadence and violence.

In today's cultural climate to offer perspectives on traditional tribal cultures, or 'small-scale societies,' as they are on occasion described, is sometimes viewed disparagingly as Eurocentric or ethnocentric. In fact in many examples, especially in early anthropological research, such criticisms are justified. Again, it has often been generally considered inappropriate or untenable to compare Western art practice, a fundamentally intra-subjective experience, with the communal inter-subjective experience within the tribal context. (84) Nevertheless, despite these factors and also in full awareness of the fact that Western colonial influence often stretches back many more centuries than is usually supposed, the traditional tribal context still offered probably the purest example available of a relatively pristine microcosm revealing the innate natural organisation of human society and its responses to and interrelationships with the natural environment.

In particular, what such relatively isolated and autonomous societies display in their natural evolution over many centuries is the pivotal role played by the art object and the ritual creative process as the very 'glue' that holds the fabric of society together. Much current anthropological research confirms the pervasive and vital role played by art in tribal culture. Robert Layton's *The Anthropology of Art*, for example, gives an excellent account of this. (85) Anthropology generally has defined how the ritual process serves to integrate the individual into the community as a cohesive force. R.A.Rappaport, to whom I have already alluded, analyses this potential of ritual in his discussion of 'coordination, communitas, and neurophysiology.' (86) Rappaport cites the English anthropologist A.R.Radcliffe-Brown's research into the ritual of the Andaman Islanders:

As the dancer loses himself in the dance, as he becomes absorbed in the unified community, he reaches a state of elation in which he feels himself filled with an energy beyond his ordinary state...at the same time finding himself in complete ecstatic harmony with all the fellow members of the community. (87)

Ultimately, how this 'state of elation' and 'complete ecstatic harmony' is achieved from a neural or neurophysiological perspective is a complex question that is being addressed by a substantial amount of contemporary research. I referred earlier in

this chapter to the research on the 'neurophysiological effect of ritual behaviour' cited by Rappaport. (note 10) Such research monitors the alterations in cerebral activity and in this instance, as I quoted, it was concluded that 'In essence ritual techniques neutral-ise...the functioning of the analytic conceptual mode, bringing to the fore develop-mentally earlier functioning.' Biological effects of participation in ritual include the nervous system as a whole, as well as brain function. The interesting research into neural activity during altered states of consciousness is tangential to my main argu-ments here. However, what is relevant is the underlying mirroring effect of the synchronisation of brain patterns and the alteration in the electrical activity of the brain brought about by rhythmical drumming.

Rappaport stresses that 'The repetitive and rhythmical nature of many rituals seems to be of basic importance, for the rhythms of the order entrain the biological rhythms of the performers. That is, "The external rhythm becomes the synchroniser to set the internal clocks of these fast rhythms."' (88) In essence this is the abstract, *structural* synchronised parallel that induces a reciprocal, sympathetic response within psychic organisation. It is this structural dimension that can only be accessed through the manic-oceanic stage of the creative process and which must underpin the mytho-logical narratives of the healer if a psychic transformation is to be effective.

As Rappaport describes, much research seems to point to the idea that during ritual performance and trance experience, the analytic, logical left-hand hemisphere of the brain appears to close down in favour of the more intuitive, a-temporal, right-hand hemisphere, with its spatial and tonal perception, enhanced receptivity to emotion and the infinite. He says:

> The non dominant (usually the right) cerebral hemisphere seems to become predominant in the ritual condition. Indeed, the mechanisms of ritual – rhythmicity, repetition, drug ingestion, overbreathing, pain, and so on – seem na-turally to engage the right hemisphere, or to "carry" or "drive" the state of mind toward it... (89)

Irrespective of the complexities of neurophysiological research into the ritual phenomenon, it can be seen that it is in the 'mimetic efficacity' of the synchronisation of brain patterns, whether in the form of the contrapuntal pulsation of drumming which in effect restages the intense relationship between the maternal and infant heartbeat in the womb, or of the multi-layered superimposition of abstract shape connected through a serialised, polyphonic rhythm, that this psychic mirror generates an inner transforma-tion. Recent re-evaluation of the 'depth psychology' of William James casts some light on this 'dissociation of consciousness' in the trance experience, defining the personali-ty as 'an ultimate plurality of internal states...running from the psychopathic to the transcendent...' In respect of ritual transition, the key aspect of dissociation is that it posits a 'growth-orientated dimension to personality...the highest and ultimate exper-ience of which James would associate...with the transcendent, or mystical experience.' (90) It is this plurality of internal states that is mirrored and manipulated in ritual trance.

However little understood these issues may be, they do again support the notion of the universal and cross-cultural nature of ritual experience, because in the final analysis such experience is rooted in the elemental psychic developmental activ-

ity common to us all. It is this psychic source that links the creative process with ritual and ritual with mystical experience and in turn with a wide diversity of religions. Again, the universality of ritual performance, founded as it is on the constant factor of human psychic transition, points to its pivotal cultural role as an integrative and galvanising force.

Arnold van Gennep, who as we have seen defined the tripartite structure of ritual that effectively parallels that of the creative process, was fully aware of the universal nature of this phenomenon. He detected the rites of separation, transition and incorporation in research extending throughout the diverse cultures of Africa, Oceania, Melanesia and Polynesia, in Fiji, the Banks islands, the New Hebrides and so on. However, he likens further the connection of such rites with the universality of baptism ceremonies in initiation, for example in the Gabon, and ultimately in the ritual undergone by the Sabians whose religion is 'a mixture of Mazdaism, Judaism, Christianity, Islam, etc..' (91)

In other words van Gennep perceives the evidence of archaic ritual that permeates Christianity and that the order of rites is a 'magico-religious element in itself of fundamental significance.' Van Gennep makes clear that his objective was to determine the universal nature of initiation rites in reaction against much anthropological procedure which insisted upon 'extracting various rites…from a set of ceremonies and considering them in isolation, thus removing them from a context which gives them meaning and reveals their position in a dynamic whole.' (92) Furthermore, he traces their antecedents as far back as the ancient mysteries and the initiation rites at Eleusis and in the cult of Attis. Gnosticism, a critical influence on both Christian and Catholic Religion, similarly had degrees and successive rites of initiation that fit the pattern of rites of passage. (93) Throughout, the elemental theme of separation or 'lamentation' and a transitional period followed by a resurrection, is a constant.

Significantly for my argument here and in respect of those references to transubstantiation, van Gennep further identifies this universal tripartite ritual sequence within the ritual of the Catholic Mass: 'The only theoretical distinction between initiation and the Mass is that the latter is an initiation which is periodically reviewed.' (94) Likewise and importantly for my references to mystical experience in chapter 4, the same structure is evident in Hindu ritual and within the sacred world inhabited by the Brahman from birth. (95) Although these constant stages tend to be depicted in Christian catechism and in ceremonial or liturgical procedure, they remain symbolic narratives of inner psychic transition both serving to represent and encode, whilst simultaneously holding the potential to generate a framework more amenable to real psychic transformation.

Van Gennep, having noted the archaic antecedents of rites of passage, further draws correspondences between classical religious ritual and those of the shaman or witchdoctor. The stages of separation in its 'various privations with psychological and neuropathic consequences,' the trance death during which the novice is made to dance until 'exhausted and brought to a state of abnormally high sensitivity,' whereupon 'his soul rises to the sky' in an *ekstasis*, and of the ultimate rebirth or resurrection, are reflected in classical religious narrative of the wilderness, death and reunion with God, and resurrection. He cites Henri Hubert and Marcel Mauss in their conclusion that 'the

idea of a momentary death is a general theme of magical as well as religious initiation.' (96)

In a similar manner, Sargant likewise lays stress on the universal and cross-cultural nature of this psychic phenomenon. His wide research into religious conversion and trance experience demonstrates how religions are rooted in ritual experience despite the fact that their dogma may have lost sight of this. The cycle from the source in ritual trance through to 'respectable' religious procedure can be seen all the more clearly in his analysis of more recent religions such as Methodism and Quakerism. Emotion was progressively expunged from their ritual. Quakers, who once 'shook and trembled' in the course of attaining 'transmarginal' and 'ultraparadoxical' states, later lost this spiritual dynamism and repudiated the original conversion techniques. (97) In more established religions, the connections to archaic ritual conversion is virtually lost in time.

The cross-cultural nature of these phenomena can be seen in the parallels between these relatively recent Western revivalist religious sects and more traditional tribal rituals. Comparable evidence of shaking and trembling is abundant in violent tribal ritual. For example, I.M.Lewis draws a direct comparison between the shaking of 'uncontrollable bodily agitation and trance states achieved in emotionally charged church services' in the revivalist 'Bible Belt' sects of the USA, with the ritual shaking of the Samburu tribe of Kenya, also discussed by Sargant. (98)

Sargant references those epidemics in the Middle Ages associated with the 'hysterical dancing mania' occurring in Europe. Such manias in effect parallel tribal ritual trance. (99) He further traces the early Christian's use of dance and the fact that they were described as 'shakers' and have a direct line of descent through post-medieval Shakers and Quakers. (100) G.R.Taylor is cited by Sargant in his assessment that '...this dancing "is actually the mechanism through which theolepsy is brought about!" The words of an incantatory dance in honour of the Gnostic Ogdoad are then ascribed to Christ in an early Egyptian papyrus.' (101)

Again, Lewis confirms the archaic antecedents of ritual dance and performance. He notes the use of trance in the medieval dancing mania called tarantism, associated with the plague. The malady was connected with the names of St. Vitus and St. John the Baptist because it was at the shrines of these saints that dancers sought relief from their affliction. Whatever the context, however, Lewis states of the mania that:

> ...its symptoms, and the circumstances in which it occurred, were generally the same. In times of privation and misery, the most abused members of society felt themselves seized by an irresistible urge to dance wildly until they reached a state of trance and collapsed exhausted – and usually cured, if only temporarily. (102)

Once again we can see the evidence of the three stages of ritual – the paranoid-schizoid phase of privation and misery, followed by an oceanic trance and a psychic reintegration and cure. As Lewis argues, such trance states were curative with a 'non-mystical interpretation.' However, the underlying procedure, whether perceived as a mystical experience, a transformational initiation rite, or a purely therapeutic process, is a constant. Lewis further describes how the 'dancing mania...was remarkably

141

uniform in its incidence and character' despite that fact that it might be interpreted in vastly different ways according to the cultural context. He notes that:

> ...those suffering from the disease showed extreme sensitivity to music and, at the sound of the appropriate air, would dance themselves into a state of trance after which they would collapse exhausted and, for the time being at least, cured. Once the tune to which the patient responded had been discovered, a single application of this dance and music therapy was often sufficient to lift the affliction for a whole year. (103)

The underlying relationship between ritual trance and the creative process, is again clearly evident.

Sargant traces the source of ritual dancing and this 'same abreactive phenomena' as far back as the Stone Age and Nomadic dancing concluding that 'The brain of man has apparently not altered in thousands and thousands of years, and we are often using similar basic methods of psychological healing and indoctrination in modern men as were used by our earliest tribal ancestors.' (104) In this Sargant displayed remarkable foresight in anticipating much later research convincingly supporting the intrinsic connection between rock art and the ritual context in which it was produced. I have already briefly referred to this important point earlier in this chapter. (see note 16)

The innate relationship between the art object, ritual artefact or cave painting is fundamental to my arguments about the cultural *function* of art, to which I have referred, and the ultimate conjunction between the ritual trance performance and the artefact materialising and encoding it. That is to say basically, the relationship between ritual and the creative process. The fact that even in the very earliest cultural setting the artwork is now perceived to be dependent upon the ritual performance associated with it is highly significant. Again, it confirms the essential role of the isolated creative ritual structure in generating the imagery and iconography to symbolise it.

James L.Pearson in *Shamanism and the Ancient Mind – a Cognitive Approach to Archaeology*, argues cogently and persuasively that ritual practice is in fact the real genesis of much prehistoric art. He outlines the evolution of the various historical interpretations that have attempted to account for the production of cave painting and puts forward a strong case suggesting that such theories alone are inadequate. He dismisses the earlier archaeological and anthropological hypotheses surrounding décoration and ornamentation, totemism and hunting and fertility magic on a number of highly plausible grounds. For example, he cites Clottes and Lewis-Williams in his dismantling of the idea originating in the nineteenth century that prehistoric art had a decorative function: how could this explanation account for paintings and engravings to be found in deep cave chambers far from any dwellings? (105) He further shows how claims that paintings represented clan emblems were unsustainable. Similarly, the subsequent argument that prehistoric imagery represented sympathetic hunting magic was likewise shown to be untenable in that the animal iconography is not consistent with such hunting objectives. (106)

However, Pearson is more sympathetic to the structuralist approach to the interpretation of Paleolithic art. He describes the research of Andre Leroi-Gourhan,

142

who perceived that the relationship between objects and animals in the general composition of much prehistoric art was laid out to a preconceived blueprint and constant underlying structure '...or set of structured principles that generated the resultant imagery.' (107) Leroi-Gourhan concluded that the positioning and combination of animals such as bison, mammoths, ibex or deer, for example, followed a strict pattern. The most dangerous beasts were hidden in the cave depths. Although there was much criticism of such structuralist approaches, it nevertheless confirmed and extended '...the universal foundation of fully human thought back into the Upper Paleolithic Era.' Leroi-Gourhan further recognised that the cave's imagery formed '...a framework within which something magically or mythically unfolds.' (108)

Pearson finally examines the anthropological research of the proponents of research suggesting that Paleolithic cave art referred directly to 'supernatural visions' and experiences undergone by shaman in altered states of consciousness. Most notable is the work of the cultural anthropologist David Lewis-Williams at the University of Witwatersrand, who has researched the origin of painted forms in hallucinatory trance states through the investigation of the neuropsychological effects of altered states of consciousness on visual and graphic imagery. Pearson describes how the research experiments of Lewis-Williams on altered states of consciousness reveal that the neuropsychological effects are a constant cross-culturally and through the antiquity of human evolution. Furthermore, the research on trance abstracted a series of fundamental visual forms or 'entoptic phenomena' universally recurring in altered states and reflected in a wide diversity of trans-continental cave systems. The research draws the conclusion that the structure and composition of cave art was fundamentally predicated on '...the universal functioning of the human nervous system and in particular, how it behaves in altered states.' (109)

It is further significant that 'a set of principles of perception' were detected through which the forms were seen, as well as three distinct stages through which visual hallucinations proceeded in the trance subject's mind. Pearson records how scientific laboratory experiments reveal that in the first stage of trance only abstract or geometric entoptic images derived from the universal human nervous system are seen. These most often take the form of flecks, zigzags, spirals, grids and so on. In the second stage of trance there is a type of metamorphosis of these abstractions into discernible figurative images; in the third, the subject focuses on 'iconic' hallucinations surrounding animal and human figures and the 'emotionally charged events in which they participate.' Pearson describes how these two elements become interconnected: the geometric entoptic images distilled from the universal nervous system integrate with the iconic images derived from the specific culture to form composites of abstraction and figuration. (110)

Such a conclusion is entirely consistent with psychoanalytic analysis of the creative process, especially in relation to the physiology of perception. I have discussed in some detail how recourse to abstraction and the unconscious creative process ultimately precipitates original iconography and symbolism similarly formed of compounds of abstraction and figuration. (111) Pearson records how the research of Lewis-Williams and Dowson shows how depicted figurative representations were used as symbols of the power used to access trance states and spiritual dimensions. In other

words, the icon functions both as a key to a deeper transcendental dimension and to encode the 'tumultuous events experienced in deep trance.' (112)

Lewis-Williams and Dowson tested their 'neuropsychological model' across two continents on cave art known to have been created by shamans. They found a close correspondence between recurring entoptic forms and the geometric forms of cave art. The was also a correlation between their experimental predictions and Paleolithic art in terms of the combinations of geometric and iconic figurative images, compositional style and principles of perception and stages of trance. (113)

As Pearson acknowledges, this relatively recent idea that there is a symbiotic relationship between the image and ritual developed only in the last thirty years or so, has generated more controversy and scrutiny than any of the preceding theories. Although this interpretation has been applied to cave art previously, for example by the German ethnologist Leo Frobenius in the 1930s, there was little commitment to a framework taking into account religion and ritual before the 1980s (114) Clearly, when an examination of cave art reveals that in cultures evolving in different continents with probably remote possibility of any contact, the same figural groupings and order of depiction can be discerned, something of major underlying significance is taking place. The explanations arrived at through the scientific experiments of Lewis-Williams and others tend to subscribe to the interpretation that such cave art of both geometric and iconic imagery reflected the hallucinatory visions of shamans encountered during trance states. In the light of the experiments, such an interpretation may well be sustainable up to a point. However, I think that this explanation alone misses a subtle but crucial difference made evident in the analysis of the excavated creative process.

In my comments so far I have been at pains to stress this apparently finer point. In relation to research into the genesis of cave art, I think that it is appropriate here to again raise this issue and clarify it further. As I have said, such anthropological investigation tends to view images associated with ritual as having been *seen* by the shaman during the trance experience. Pearson cites Reichel-Dolmatoff's observation that 'everything we would designate as *art* is inspired and based upon the hallucinatory experience.' (115) Although of course many subconscious images are perceived by the shaman in trance and may well be at some point illustrated, it would be hard to sustain the notion that the many diverse artefacts and art objects directly connected to ritual performance were experienced or dreamt in a trance state. It is rather that the African tribal sculpture, or the Pre-Columbian figure to take a further example, evolved to fix and encode the ritual creative experience: that is the emotional intensity and psychic tension necessary to instigate the conditions for trance states.

It is this seemingly insignificant point that is largely missed by anthropology, as indeed it is by psychoanalysis. Just as anthropology tends to dwell on the idea that imagery is something hallucinated, so does psychoanalysis tend to depend on the interpretation of images perceived in dreams. Both really miss the key point that the hallucinated or dream image is probably in itself of relatively minor significance and may even be to all intents and purposes meaningless. Both actually serve a purpose: to contain, organise and exorcise extreme emotion. The tribal sculpture is separate from the creative process that originally gives rise to it and is instinctively carved to embody the emotional creative experience.

144

The investigation of art and the creative process discloses what is *really* going on in respect of images associated with ritual performance. It is not the task of the artist in any scenario to simply illustrate the dream image. Again, this is something completely misunderstood by much contemporary African art or Australian aboriginal art, for example, that often does just this in the misguided belief that such work is authentic. It is, as I have said, the role of ritual art to evolve and generate a repre-sentation to symbolise and materialise the ritual creative structure and to pinpoint the depth of the emotional experience. The dream image, as with the daydream or hallu-cination, does fulfil this role on a more primitive psychic level without the artist's conscious and considered contributions. Such imagery might on this more primitive level and in some degree be compared to a musical score or notation: it represents and encodes creative emotion, but in isolation, divorced from the creative context, is meaningless. The musical score is more sophisticated in intention and creative organ-isation but still functions structurally in the same manner.

To emphasise this point just a little further, this in fact is the answer to the question posed by William Rubin in relation to the exhibition *Primitivism in 20th. Century Art, Affinity of the Tribal and the Modern*, that I referred to early in chapter 4, Rubin asks the cardinal question as to why it is that a Fang mask made in the 1950s, even if executed by a tribal sculptor for cult activities, is a 'lesser object' than a Fang mask made in the 1930s Rubin gives the answer that the mask of the 1930s is more authentic and preferred because the religious faith and confidence of the Fang people remained unshaken at that time. He goes on to suggest that Fang masks antedating colonial influence would inevitably be more vital and stronger.

Rubin further criticises anthropologists for accepting as authentic tribal art produced under Western influence and so 'aesthetically sterile.' He recognises that more recent tribal art is vastly inferior to older examples, suggesting that those who respond directly to these objects as art find them 'dead.' More recent objects are di-luted and weakened, devoid of the vitality and emotional force imbued by the faith of the earlier culture. Rubin rightly attributes this to the disintegration of the cohesion of tribal culture due to colonial influence and other factors. However, the essential point is that the parallel decline in authentic ritual performance effectively divorces the art object from the creative process, so rendering it simply craft. In effect the Fang mask of the 1950s in its removal from genuine ritual experience, is also removed from Ehrenzweig's 'minimum content of art' as it is embodied in the essence of ritual, with-out which it ceases to be authentic art.

It is this critical factor that is verified in the analysis of the painterly creative process. In the context of my own painting, as I have described, the abstract mono-chrome collages extract the essence of the creative structure and isolates it in order to redefine and entrench it within the medium, or within its own area of competence as the art critic Clement Greenberg once put it. It is only when this irreducible creative core is confirmed, as in the ritual performance, that a real and intrinsically connected iconography is free to evolve. Or in the case of ritual, only when the authentic transi-tional creative structure is in place will genuine sculpture be produced. The inter-relationships between such factors, although varying in degree, reinforce the parallels I am drawing here. As we have seen, a close inspection of cave art reveals that the juxtaposition of figures and objects and their relationships can often be recurring

across diverse cave networks and continental divides, again indicating their connections with ritual and human psychic transformation.

In the same process, a cultural style defines a particular culture. Stylistic changes in traditional tribal culture often evolved very gradually over many centuries as they transformed to register the subtle changes in the dimension of ritual conversion at the heart of the society. It is the ritual process that determines the style and format of the artefact. Robert Layton recounts the experience of the anthropologist J.A.W.Forge, who carried out an interesting experiment with the Abelam people of New Guinea involving their placing cult house paintings in order of preference. Significantly, to the Abelam people, the 'best' paintings were those that were 'most effective in ritual.' (116) Richard Kuhns in his *Psychoanalytic Theory of Art* comments on cultural style. He defines culture as a tradition of interrelated art objects, 'whose functions and meanings depend on one another as well as their individual structures.' He says that they 'share and induce affective force that finds deeply sympathetic responses in the audience trained in the tradition. Coordinate with the affective force is the formal structure of each object that can be learned, acquired and passed on from generation to generation.' This formal structure he defines as style. (117)

This same argument pertains to religious icon painting, as it does to any authentic art. Religious icon painting was articulated over very long historical periods, with apparently little or no discernible change evident to the uninitiated. But again, it is through the interrelationship between iconic figures and objects and architectural spaces at one with psychic spaces that the creative and spiritual power of the artwork is instilled. It is in the gradual evolution of such artwork that subtle psychological cultural change is monitored and registered; minor alterations in style have deep ramifications and can effect a massive impact on the culture. So whether in the context of tribal ritual, religious icon painting, or cave painting, we can detect those inner structural affinities. Over lengthy historical periods they all evolve styles in which subtle changes in objects and figures and their relationships resonate with great cultural significance in a developing iconography. Again, this does also hold true for the dream, where it might often be the case that recurring symbols, condensations and displacements may subtly alter their relationship to one another, reflecting nuances in change of emotion. In the discussion of my own late painting I will further show how such developments are manifested in more contemporary painterly iconography.

Having said this about the apparent reliance of anthropological research on the importance of the hallucinated image, it is nevertheless a very significant development that recent research in this field does acknowledge that there is a fundamental connection between cave art and ritual trance experience. Pearson's view should also be expressed when he argues that: 'If we accept the notion that images perceived during altered states exert a profound influence on iconography, we should expect to find evidence of this not only in rock art but in other aspects of the material record as well,' for here he makes a fine distinction in respect of images perceived during trance states. That is to the effect that such images 'exert a profound influence' on iconography, rather than simply invoke an illustrative rendition. This is closer to the notion that unconscious emotion abreacted in ritual performance impinges strongly upon both the stylistic form and content of the image and indicates Pearson's acknowledgement of a deeper significance beyond simple illustration. (118)

146

So Pearson supports the case for the relationship between cave art and shamanism and in so doing confirms the tripartite ritual structure first recognised by van Gennep. He notes how 'The essential elements of shamanic initiation show remarkable similarities in a variety of cultures.' He describes the initial paranoid-schizoid 'ordeal' of isolation and physical and psychological stress as a prerequisite of the 'appropriate spiritual disposition' and to induce a 'shamanic state of consciousness.' He confirms the experience of ritual death and rebirth, recognising that the 'trance state is the gateway to a singular introspective experience.' He further quotes Reichel-Dolmatoff's phrase that the entire process represents 'an ecstatic metamorphosis' and importantly Eliade's conclusion that *It is only this initiatory death and resurrection that consecrates a shaman.*' (emphasis in the original). Pearson describes the individual's development of shamanic power over a period through continued access to transcendent states of consciousness and concludes that 'The common route is trance.' He says: 'Thus the shaman is, by definition, one who attains an ecstatic state. Most specialists, therefore, consider trance to be a prerequisite for any kind of true shamanism.' He finally confirms the essence of trance as *ekstasis*, during which the soul ascends from the body and that it is reached only through personal inner crisis. (119)

Pearson ultimately brings some powerful evidence to support his arguments. He cites Mircea Eliade in discussing the universality of trance states: 'We have termed the ecstatic experience a 'primary phenomenon' because we see no reason whatever for regarding it as the result of a particular historic movement. Rather, we would consider it fundamental in the human condition, known to the whole of archaic humanity.' (120) He also refers to the research of Erika Bourguignon furnishing empirical support for this proposition. She discovered that an overwhelming 90 percent of a sample of 488 societies worldwide had some form of institutionalised altered states. (121) He goes on to recount that current neurophysiological research would indicate that the human brain has a basic propensity towards altered states suggesting common neurological, biological and psychological origins. Critically, for Pearson:

Interpreting rock art from a cognitive perspective, whether the art of the Ice Age caves, paintings of the San bushman of South Africa, or the engravings of the western Great Basin, leads to the phenomenon of shamanism. The study of rock art, and the resulting evidence that the creation of much of the art found around the world can be attributed to shamanistic practices, has opened a new research direction that can be extremely valuable for the study of ancient cultures. (122)

Although other contemporary research validates the central role of ritual trance and shamanism in cave painting, Pearson does acknowledge that such a viewpoint has its detractors. For example, he notes the ambivalence of Paul G.Bahn in his *The Cambridge Illustrated History of Prehistoric Art.* This text might accurately be described as a work of deconstruction in its attempt to debunk all of those theories that Bahn considers may have grandiose claims of validity. For example, he gives the structuralist ideas of Leroi-Gourhan short shrift and his treatment of the proposed shamanistic connections is similarly dismissive. (123) He even suggests that the

cognitive approach investigating altered states of consciousness is flawed in that 'it does not require a shamanic trance to see entoptics.' In his preferred literalist interpretation he suggests that geometric forms such as the zigzag motif 'could easily be inspired by lightning' or circles 'can be inspired by ripples in water.' He also finds it difficult to accept that a geometric grid perceived in trance can be other than a hunting net. (124)

Bahn is overly sceptical of any mystical explanation, preferring the literalist reading. He bemoans the fact that much contemporary research has adopted 'a rather patronising view…of the literal interpretation of representations.' (125) Pearson notes Bahn's complaint but dismantles his faith in the idea that 'literal interpretations of prehistoric art are far safer' quite comprehensively. (126) Pearson's riposte to Bahn is that the cognitive approach and research into the neuropsychological model is firmly based upon the universality of entoptic phenomena. Furthermore, the shamanistic hypothesis is verified through the 'universal and irrefutable fact' that 'all human beings have equivalent neuropsychological systems' and 'the stages of trance are universal and hard-wired into the human nervous system.' (127) I think that Pearson is correct in his assessment that 'Bahn quite obviously does not understand what shamanism is all about; nor does he seem to comprehend the pervasive and multidimensional social role played by the shaman in prehistoric societies.' (128)

The debate surrounding the true objective of cave painting will no doubt go on. However, I think that ultimately the evidence linking it to some form of ritual is fairly conclusive. Even beyond the immediate context of purely anthropological argument we can find strong evidence supporting the thesis in respect of shamanism and ritual. For example, A. David Napier in *Masks, Transformation, and Paradox*, not only connects masks worldwide with rites of passage and curative ceremonies, but also traces the origins of Greek drama in ritual and in conjunction with religious shrines. (129) Napier refers to the work of T.L.Webster: 'Drawing on different and frequently new historical and iconographical evidence, he maintained that the study of preclassical Greek ritual was viable and necessary in describing the preconditions of Greek drama.' (130) Napier argues that '…there is everything to suggest that the structure of early theatre practice is a direct extension of the periodic inversion characteristic of rites of passage…' and connects early drama and mythology with '… intoxicated revelry that takes place when points of transformation are marked by the ritual inversion of what is normal.' (131)

What this confirms of course is the symbiotic relationship between ritual, mystical experience and the creative process and its transposition into religious narratives and ceremony. Further to this, however, Napier's analysis and processes of transformation embedded in carnival traditions reveals the archaic antecedents of animal symbolism as icons of transformative ritual and shamanism, just as they functioned in cave painting. (132)

For my own part, however, I must concede that my personal perspective on the relationship between the imagery found in cave painting and shamanic ritual is inevitably coloured by my own subjective creative experience as a painter. That is to say, the ritual processes that were invoked in the course of my abstract, monochromatic canvas collages are ultimately intrinsically linked with the iconography that

evolve from them. As I have argued, I think that the progressive elimination of all connection to reality and its representations and in the end with the very dimension of consciousness unquestionably sets up a parallel between the abstract creative process and ritual process. I reiterate the point that an individual desperate for personal conversion in a society largely deaf to such needs will be compelled to fall back on and take recourse in a personally reconstituted ritual procedure. I have drawn on a number of diverse sources in order to mitigate the subjective and idiosyncratic dimension of my own experience. Some reviewers have criticised my views of art as being fundamentally concerned with therapeutic transformation and for taking an anthropological perspective on art's social *function*. (133) However, as I described earlier, the depth of my own personal conversion experience was such that it must inevitably influence my views, as any life changing experience tends to do.

My contention that the ubiquitous ritual performance and rite of passage are in essence framed upon the structure of the creative process is important for two main reasons. Firstly, because so many traditional societies clearly relied upon these radical processes in order to achieve psychic transformation and healing, there is manifestly something of deep human significance going on here. Secondly, it might not be generally recognised for many reasons, but anthropological perspectives reveal that societies with ritual performance at their centre fared much better; were finely balanced and structured for survival in times when the unknown was a truly awe-full reality. J.M. Chernoff stresses that a common factor in African musical traditions is the 'depth of their integration into the various patterns of social, economic and political life.' He cites the eminent African musicologist J.H.Kwabena Nketia: 'A village that has no organised music or neglects community singing, drumming or dancing is said to be dead.' (134)

In light of these arguments, however, I am not suggesting that we should take up dancing and drumming in the streets, although this is done on other levels of pop music and so on. What I am suggesting, in a contemporary culture often apparently obsessed with counselling, psychotherapy and psychoanalysis, is that the phenomena of ritual curative processes should be closely examined, as Sargant recognised, in order to discover how they become effective. There is no doubt in my own case that I transformed and healed myself from what was certainly experienced as a desperate condition. This was carried forward purely through the ritual process of abstract painting whereby over time I managed to toughen up the ego and survive. I am sure that those who knew me through this intense period would bear witness to this fact.

In the final chapter of this book, I am going to look at how the art object or painted iconic image is intrinsically linked to the creative process forming its foundation. This will include the third phase of my own painterly evolution that I have designated the 'late years.' But also in this context I will include some references to tribal sculpture as well as some perspectives on drama, because they are very germane to my whole argument.

On more than one occasion in this chapter I have referred to art's *function* and I think that this is a key factor in the whole debate. Throughout the evolution of human culture in general, art essentially served a function: to embody the spiritual and psychic element of the indigenous culture and further to encode the essence of ritual

performance for subsequent generations. This is of course a sweeping generalisation, but I think as a basic tenet of human art production it can be shown to hold true up until the Italian Renaissance in the fifteenth century. Before the Italian Renaissance only the period of Greek classicism with its pursuit of naturalism in art neglected this central role of art.

Just as the more primitive and authentic religious icon painting prior to the Renaissance genuinely developed original iconography and narratives to register the painter's creative experience and psychic death and rebirth in the manic-oceanic engagement with pure painterly form, so too did the authentic tribal sculpture fulfil the self-same role. To varying degrees and at different times, art during and after the Renaissance, in its objective to revive Greek Classicism became more concerned with naturalism and the pursuit of more 'scientific' methods of representation. The associated preoccupation with craftsmanship, aesthetics and beauty, further served only to dilute the primary imperative of art.

This is, of course, why African tribal sculpture had no reference to the concept of aesthetic beauty. Boris de Rachewiltz underlines this factor in his *Introduction to African Art*. In chapter 4, 'The Creative Process,' he refers to 'the unsatisfactory nature of the word "art" in the phrase "African Art" where an aesthetic analysis based on the Kantian definition of beauty is inapplicable.' He notes that this is equally true of archaic Egyptian art which has the same magico-religious function as African tribal art, in which artefacts 'all serve a specific end, their creation being based on rules belonging to the world of magic.' He goes on to say that, 'There are thus close points of contact between Egyptian artistic conceptions and those proper to Black Africa. Above all, they both lack a word for "the Beautiful."' (135)

De Rachewiltz traces the '…roots of a common heritage of thought' in which beauty is 'not an end in itself,' but rather 'capable of an integrative function.' In tracing back this idea of integration and tribal communion he further ties in earliest African 'rock painting' with initiation ceremonies and rites of passage. He states:

> In Africa, integration effects communion with the clan, and participation on a hyper-physical plane, in the drama of creation. The purpose of the highest African initiation rituals is to experience the forces that preside over every tangible manifestation and, in so doing, achieve a state of psychic fusion with the generative processes. The precise means of doing this will vary from tribe to tribe; but analogous objects such as masks, statues and ritual instruments, are used everywhere. (136)

To question whether such artefacts are beautiful or ugly is pointless. What we should be doing suggests de Rachewiltz is to ask whether or not the object can fulfil the purpose for which it was made. He says 'Here we have a species of functionalism, the search for an adequate relation between an object and its end, between potency and act, or between the tangible reality and the transcendent manifestation which it serves. This is the essence of so-called "artistic" work.' (137) He really answers Rubin's question about Fang masks when he concludes that 'From what has been said it will be plain that such an art will exist only as long as the faith which gave it birth.' (138)

150

For de Rachewiltz, the artwork is intrinsically linked to the creative process, which is conjoined with 'the faith' as it is re-enacted in the rite of passage; such initiation rituals 'constitute the *sine qua non* of tribal life...' and he recognises their genetic bond with the 'generative' creative process and its art object. (139)

In my final comments at this point, it might be worth mentioning that today both academics and dealers continue to search for a definition of authenticity in African art. Christopher B.Steiner in his *African Art in Transit* examines 'the quest for authenticity and the invention of African art.' He cites the dealer Henri Kamer in defining 'an authentic piece of African art' as 'by definition a sculpture executed by an artist of a primitive tribe and destined for the use of this tribe in a ritual or functional way.' He further quotes the 'African art connoisseur' Raoul Lehuard in saying that 'In order for a sculpture to be authentic, it must not only be derived from a formal truth, but its language must also be derived from a sacred truth.' (140) As I indicated in my opening remarks of this chapter, these are the fundamental factors that were intuitively transmitted to Picasso and other modern artists in a type of revelation. For Picasso understood, as I have said, that the 'psycho-spiritual' essence of rites of passage was exactly analogous to the very creative process of making a painting.

CHAPTER 6

RITUAL and ICONOGRAPHY: The LATER YEARS

In the first paragraph of chapter 1 I began this work by outlining the three general periods forming my lifelong journey as a painter. From the late 1980s, onwards and into the later years, the third phase of my painting followed the pure abstract monochromes. The defining characteristic of these late paintings is their development of an iconography of interrelated objects and spaces generating a language both peculiar to my own evolving subjective creative dialogue and further rooted in a common psychic source. Generally speaking, the first two phases of my painting could not claim to have similar aspirations towards a more common or universal cultural context.

That these three general periods stretch over nearly a whole lifetime and incorporate within their dynamics the synchronic and diachronic dimensions that I have discussed might appear to be somewhat implausible. However, it is not uncommon for rituals in the tribal context to extend over many years, seeming not only to control aspects of human psychology and of the natural environment, but also of time itself. For example, some Dogon rituals concerned with the souls of the deceased take place several years after the actual funeral. There is a further ritual *sigi* occurring every sixty years. The last Dogon *sigi* took place from 1966-1974; the next *sigi* ritual, therefore, would be scheduled for the year 2034 and in this manner the Dogon have laid claim to the future as well as to the past and have given temporal definition to their culture. (1)

The wide timespan of these paintings in their delineation of what is basically a lifelong ritual transition is, of course, connected in much the same way as ritual phases are linked together. For example, it should be emphasised that the abstract framework installed within the monochromes is, in fact, transposed into the materiality and formal structure of these later iconographic paintings. The intrinsic relationship between the abstract paintings and their figurative counterparts was keenly recognised by Donald Kuspit in his catalogue essay title: *The Post-Modern Icon – Stephen Newton's Post-Abstract Paintings.* (2) So the paintings here absorb all that the analysis of the abstract creative process reveals and further make a connection to elements drawn from external realities. I use the word 'drawn' because the imagery in no sense represents or illustrates the external world, or acts as symbols or signs in the accepted sense. The objects and elements employed are rather registers of the tensions and emotions of creative engagement, in turn analogous to human emotion and the wider human condition. (3)

Towards the end of chapter 2 I discussed the painting *Path* (Fig. 16) painted in 1987 as one of those works forming a bridge between the pure abstract paintings and those subsequently to employ 'figuration.' The path and the trees in this image are clearly not illustrations of such elements found in reality, or even symbols of them, but act as tokens or artefacts which function to register a ritual transition from the abstract monochromatic oceanic backdrop towards a distilled icon embodying the process. The

painting *Armchair before a Mirror* (Fig. 18) painted some sixteen years later in 2003 intrinsically incorporates the same procedure.

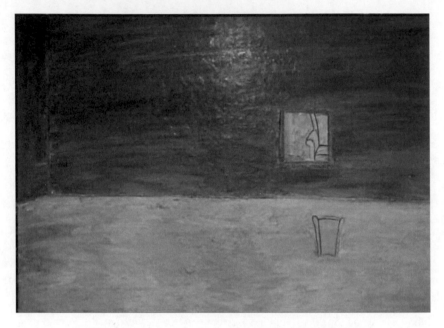

Fig. 18 *Armchair before a Mirror* (76 x 110 in) 2003

Objects such as the mirror or the armchair set in psychic spaces appeared unconsciously in my painting many years ago. I stress *unconsciously* because these elements and objects and how they relate to one another and to the space enclosing them develops through intuitive and spontaneous drawings bearing little significance at the point of production. It is only much later that the somewhat curious juxtapositions begin to give up their intentions and meanings. The motif of an armchair in front of a mirror evolved some years ago and it was only after the event that its significance, although obvious now, became clear.

Of course, as much psychoanalytic theory reveals, objects can be substituted for individuals and it is evident that the armchair in this painting represents myself as the painter before the canvas and the 'psychic mirror' of the abstract creative process. In other words, as I engage the abstract monochromes as a materialisation of unconscious psychic processes, there is a subsequent transition and so an icon is precipitated as a surface counter to encode the event. The materialised psychic structure of the monochromes is, as I have stressed, inbuilt into the impasto and painterly dialogue embedded within the painting's facture.

So the 'figurative' elements of the armchair and mirror are neither some sort of dream symbolism or representations of hallucinated or dreamt imagery, nor are they in

154

any way illustrative of mirrors or armchairs encountered in external reality. It is rather that they function as a sort of cipher of creative and ritual processes. As with ceremonial liturgy, or indeed the 'psychophysiological mythology' of Levi-Strauss, they can serve on a more conscious level to indicate a psychic direction and to trigger a deeper, unconscious engagement on the part of the viewer. Or as I suggested in the context of tribal ritual, such narrative or ceremonial adjuncts operate to instigate and induce the frame of mind in the initiate more amenable to a real transitional psychic event.

Again, this is how the original religious icon painting actually functioned, with the surface icon providing a key to open the portal of transcendental engagement. As I have argued, this was also the critical factor driving iconoclasm that ultimately aspired to arrogate to its own puritanical religious control this access to another dimension.

Perhaps this somewhat finer point is not always well received in the contemporary post-modern context, where notions of authenticity seem very outdated indeed. However, what I am saying here is not meant as a criticism of today's conceptual painting and conceptual art. It is just that I am discussing an authentic creative engagement as defined by the transformational, therapeutic creative and ritual processes now practically extinct. Such issues are of little concern in the contemporary art world often dealing with a totally opposed set of principles. Nevertheless, as I have noted, the comments of Christopher Steiner emphasise the continuing 'quest for authenticity' as far as African tribal sculpture is concerned. Here, the issue of authenticity is always paramount and is intrinsically linked to the objects' role and function in ritual psychic transformation.

The same factors hold true in respect of painting and it is really only post-Renaissance painting that ultimately gave rise to academic, illustrative and vacuous impressionistic works. But I am not claiming any right of way in describing my own subjective concerns and transition. Many other artists and painters from all epochs wrestle with such questions and it can be mentioned here that at the time of writing my planned two-man tour with the English painter Basil Beattie has focussed such issues and connections.

Beattie, at 70 years of age, has evolved a personal iconography over a lifetime and his use of objects, spaces and imagery is often deeply related to my own. His recurrent use of windows, staircases, doorways, empty rooms and so on, appear to have developed in parallel to the development of such objects and spaces in my own painting. What is of greatest significance here, however, is his clear struggle to convey that these 'figurative' elements, despite frequently being read as such, are neither signs, symbols or illustrative representations, but function in an altogether different manner. In this matter he has endured the difficulties of explication that would appear to accompany such a method.

In a recent exhibition catalogue Beattie noted that 'It's not me being fascinated by windows, doors and gates and then thinking that's a great idea for a painting. It's a state of mind to begin with, that has no form, no visibility and I resort to using things that look as if I've looked outside the painting when in fact I haven't.' John McEwen, in the same catalogue text comments, 'Inspired by the example of Guston and the late work of Picasso, where process and gesture are inseparable from the making of the image, Beattie had found a way of re-introducing a 'sort of symbolism'

into his painting. This concern for process and symbolic content makes his art an interesting bridge between the work of the post-abstract expressionist generation, which he represents, and the younger Goldsmiths' artists he taught.' (4)

What Beattie says here I have said of my own painting. The 'state of mind' with 'no form' and 'no visibility' is represented in my own situation by the abstract monochrome paintings, as it is in W.R.Bion's state of 'O.' Subsequently, the 'sort of symbolism' that is precipitated in a work such as *Armchair before a Mirror*, although not directly concerned with external reality, nevertheless does reflect an acknowledgement of the real external world essential to navigate the Kleinian 'depressive position.' So the third phase of my painting is underpinned by this essential transitional developmental stage, whilst at the same time I trust accessing other potentially more arcane depths. Again, in the other context of mystical experience and its associated psychoanalytic models, I would suggest that such works could be considered in terms of the 'adaptive-transformational' school, that I discussed in chapter 4.

The painting *Chest of Drawers* (Fig. 19) painted in 1995 incorporates many of these connections. It was once said of my work as a painter that I 'make icons out of everyday objects' and it must be the case that in this parallel painterly universe the process of materialisation of the object from the underlying matrix revisits the original psychological models of perception through which we isolate and formulate the essential character and shape of objects. The depiction of this parallel process lends credibility to the object (or artefact) and confirms an authenticity upon the iconic pictorial space, for although the chest of drawers depicted is a real object, or an icon, it is clearly set in an ambiguous psychic space.

In an essay on my painting, the critic and theorist Mel Gooding describes the 'inescapable consequences for the spectator' of being 'confronted by objects characterised by a material density, a richness of texture that is so overwhelmingly physical in its effects that such imagery as we may perceive with the eye, and all the questions that may arise in the mind relating to it, are delayed; the optical-tactile precedes the perceptual-conceptual.' In a description uncannily similar to my own, he goes on to say:

> This haptic experience, a matter of intense involuntary involvement with the medium itself, corresponding to that of the artist in the making of the work, is a crucial affective aspect of the process of reception. Working on at least two closely related levels, it initiates a necessarily complex (and complicated) response to the painting. In the first place it embroils us immediately in the process of image generation: we must work (or dream) through this experience, differentiating the image out of the matrix, allowing it to emerge from what may be thought of as a correlative to Bachelard's 'shadow.' (The vagaries of tonal indistinctness are functional to this aspect of the work.) Secondly, it declares the work as object, the material outcome of a struggle with substance, a real thing in our world, conjured out of formless matter; an object whose meanings have to do with more than the signs, or the image it carries. This is something other than a matter of Greenbergian (or Kantian) reflexive self-definition, a bid for 'modernist' authenticity: it constitutes nothing less than an assertion that the material itself may act as a signifier of psychic processes. It is a signifier that works not through

156

pure sign, but through aesthesis, its direct impact upon the sense as well as its signals to the organising mind. (5)

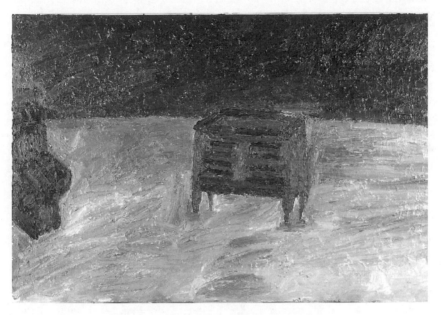

Fig. 19 *Chest of Drawers* (57 x 87in) 1995
Collection: Amadeo Amedesi, Milan

I think that *Chest of Drawers* is a concrete realisation of these concerns. The object here was certainly differentiated 'out of the matrix' and a 'material outcome of a struggle with substance,' for I remember vividly being so close to the painting during the single session orchestrating the image, that I was absorbed by the dense materiality of substance and quite unable to be objective about the work until I was disentangled from its creative process. That the object is somehow suspended or caught in an ambiguous space is evident. Of the 'background' space of this painting, Gooding notes: '...neither can the bituminous 'background' of *Chest of Drawers* be read as a wall, being rather an impenetrable darkness contradistinct to the light that illumines the floor and the furniture in the room.' Of this space he further comments '...the unbounded darkness that takes the place of the wall of the room ... an indeterminate space, as of darkness out of doors at night, or of the merging of marine air and seawater in heavy weather, invades the room...In *Chest of Drawers* the floor itself takes on the curvature of the marine horizon, and oceanic infinity merges with the finitude of domestic enclosure.' This sense of ambiguity is enhanced by a title that 'ignores the cosmic to fix upon the domestic particular.'

Gooding comments further that 'the conventional representations of "objects in space," or the visual play with "figure/ground" relations...are matters of no great concern to Newton. He is rather, concerned with the realisation, in plastic terms, of phenomenological experience: with our internal sense of the world in its relation to our apprehension of external facts; with memory and its internal "dissolving and distributing" of past events and the objects associated with them into scattered "fragmentary forms." These paintings are an attempt at the representation of psychic reality, which does not acknowledge a separation of the external and the internal, of the world "out there" and the world within.' (6)

Chest of Drawers functions to materialise an inner state of emotion and its coexistence in elements of external reality, much in the same form as D.W.Winnicott's conception of 'transitional phenomena,' on a cultural plane. It functions in part to distil the object in recovering original dynamic psychological and perceptual sequences and recording the oceanic transitional event – a fundamental process of the rite of passage.

Repeatedly, I have stressed the notion of *function* in art and in an apparent sweeping generalisation, I would argue that from the dawn of human cultural activity right up until the fifteenth century and the Italian Renaissance, the overwhelming incidence of art and artefact worldwide did serve a cultural function: that is, to register the ritual dynamic with its inherent negotiation of original developmental sequences; transcendental oceanic metamorphosis and conversion experience, along with the spiritual dimension of such psychic transition and the inevitable religious ceremonial associations. Furthermore, as I have suggested, the ritual dimension along with its intrinsically connected art object, fulfils on one level comparable objectives to D.W. Winnicott's 'transitional phenomena': like the transitional object, it is neither wholly external or internal, but provides a space incorporating both whilst remaining free of the constraints of either. This is why, in a cultural context, the ritual process furnishes an arena where all of the social mores and laws of the culture can be challenged, free of real threat and reconstituted, just as the individual initiate can challenge, disintegrate and refashion psychological programming.

Unfortunately, this fundamental role of art, spanning the epochs of human cultural evolution, is all too often subject to misrepresentation. Because historically painting in particular has frequently been sequestered by religious authority to fulfil the subservient role of simply illustrating religious narratives such as the Passion, usually under the guise of visual service for the illiterate masses, this mannered and ceremonial function came to be perceived as painting's real duty and objective. In fact, it was rather the case that the aspiration of powerful religious forces in this matter was to emasculate and neuter painting's transcendental potential. Illustrative narrative religious painting in truth really reflected the bankruptcy of authentic religious experience: the liturgy of religious ceremonial and the 'iconography' of academic religious narrative painting, were both severed from their spiritual roots in mystical experience and the oceanic core of the creative process.

As I have said, art's real function has a far more all-embracing objective in the cultural context, serving as a force of communal integration and ritual transition. At the end of chapter 5 I cited the excellent analysis of Boris de Rachewiltz and his convincing arguments about the *purpose* of the creative process and its interconnected

art object. I similarly referred to Robert Layton's discussion of art's pivotal tribal role in *The Anthropology of Art*. However, in order to underline this point, so critical to my argument, I think that it is worth briefly looking at a case study closer to home – or at least to my home: that is to say Britain and more specifically, the Orkney Isles, located at the extreme northerly tip of Scotland.

I have already put forward a case supporting the connections between ritual performances and the most archaic cave paintings and have examined how the ritual creative process informs the artefact. What is of great significance in respect of the sites still extant in the Orkney Islands is that they provide 'the best preserved Neolithic dwellings in Europe' in which to piece together the original function of the cultural creative network. In their remote and isolated setting, to a large degree removed from cross-cultural contamination, these suspended time capsules and microcosms of Neolithic life reveal the essential role of art throughout the social complex and the intrinsic and complicated relationship between artefact, architectural space and landscape. In other words they show how the materialised iconography of sacred creative processes becomes enshrined in the formal quality of the artefact and in related psychic architectural space and their ultimate integration with the environment.

In his project, *Lines on the Landscape – Circles from the Sky – Monuments of Neolithic Orkney*, Trevor Garnham elucidates the Neolithic cosmic view that embraces a network of complex relationships between artefacts, dwellings, tombs (cairns), ceremonial monuments and sites, all shown to be of a piece and interconnected in a psychological universe sourced in sacred ceremony and ritual, involving creative transformative processes that in effect formulate their characteristics and innate bonds. In this relatively isolated microcosmic context, Garnham lays bare the symbiotic relationship between ritual and artefact, a relationship parallel to that of the creative process and art object or iconography. Within this intrinsic correspondence Garnham suggests that 'By looking at how one thing might resemble another despite being assigned to a very different category of use, we can detect processes of transformation that offer suggestions of what things might have meant from within the world view of a cosmos.' (7)

From an anthropological perspective Garnham draws heavily on the approach of Mircea Eliade towards myth and religion and in particular on Eliade's 'homology' of '...essential patterns which bear comparison with others often from very different parts of the world' through which a 'framework, or mythical structure emerges...This framework can be useful in attempting to interpret evidence of ritual activity....' (8) What his research essentially reveals is the underlying psychic and ritual foundations of artefacts and structures in the material culture, responsible for the formal conjunctions and cosmic connections. For example, he analyses how the curious pair of linked dwellings at the Knap of Howar, overlooking the sea on the tiny northernmost island of Papa Westray, reflect and reiterate symbols of shelter and salvation found elsewhere. This site is important not least because it is the oldest in Orkney and the houses are the oldest still standing in Europe.

The shapes and forms of these two houses and connected chambers represent far more than simply dwelling areas, but are materialisations of psychic spaces encoding cosmic relationships along with associated transformative and regenerative processes essential to human existence. They further echo other artefacts and cultural forms.

Garnham notes how the houses reflect vestiges of boat forms and the Neolithic 'circular archetype' and how the ship itself became a symbol of shelter and salvation: the Latin word for ship *navis* is adopted in the main space of the nave, the body of the church. He refers to Eliades's realisation that primitive peoples commonly viewed the house as a 'kind of body, the homology house – body – cosmos emerging as a powerful and persistent framework in primitive belief systems.' (9) Garnham cites the example of a symbolic relationship established between house and cosmos as provided by the Kogi people whose ancestry was of pre-Columbian origin and the anthropological research of Parker-Pearson and Richards which shows that in prehistoric culture, spatial ordering of the house was both 'shaped by, and a shaper of, symbolic meanings embodied in ritualised practice.' (10) He says of his own research: 'From this extended discussion on baskets boats and buildings we can see how processes of transformation are embedded in the mental world of meaning.' (11)

Interestingly, from the point of view here, he makes reference to Aldo van Eyck's recognition of the 'linked meaning of things' in his study of the Dogon:

> His cities, villages and houses – even his baskets – were persuaded by means of symbolic form and complex ritual to contain within their measurable confines that which exists beyond and is immeasurable: to represent it symbolically. The artefact – whether small or large, basket or city – was identified with the universe or the power of the deity representing the cosmic order. (12)

As I have argued earlier in this work, it is often the case that anthropological studies would fail to distinguish between the terms ritual and ceremony and I claimed that there is in effect a critical difference. It must too often be the case, however, that in referring to the connections between ritual and artefact, anthropologists may be alluding to superficial ceremony. However, I think that Aldo van Eyck's references to 'complex ritual' in its relationship to what is beyond and immeasurable would indicate his intentions in dealing with rites of passage and transformative processes at the creative core.

This is clearly an important distinction to make in respect of the correspondences I am drawing. For the case I am putting here argues that the art object, artefact or icon, are of course generated by the creative process along with its cultural counterpart, the ritual process. This holds true in whatever setting: whether in the remote Orkney Isles, Africa or Siberia. In respect of my own painting I came to see that the evolving connections between objects and spaces fixes the nuances of creative and transformative emotion, expressing in icons an underlying creative tension rooted in a creative rite of passage. I think that the painting *Shelter* (Fig. 20) painted in 1997 seems appropriately related to some of these claims and would certainly seem to manifest the architectural structure as a psychic space, not only intrinsically connected to the oceanic and infinite backdrop, but also as an object extracted from it.

In respect of ritual activity in the culture of Neolithic Orkney, Garnham develops a cogent and guarded case. He examines evidence of shamanism and priesthood associated with rites of death and burial in the so-called 'Tomb of Eagles,' the Isbister chambered cairn in the cliffs on the island of South Ronaldsay. In particular, the curious wall paintings of vultures drawn with human legs and feet are symbolic ritual motifs that have occurred cross-culturally in diverse contexts such as Southern Turkey

around 6000BC and in 19th century Tibet and Siberia, suggesting a common source in ritual activity. (13)

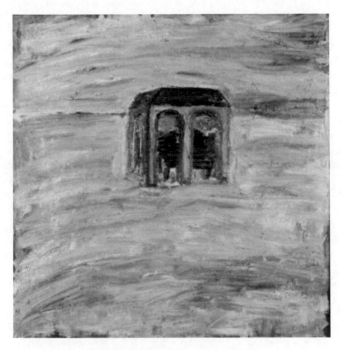

Fig. 20 *Shelter* (76 x 72 in) 1997

Garnham relates how Eliade's record of the ritual of the Tungus of Manchuria reveals 'strikingly similar elements and structure described in this ritual to the archaeological remains found at Isbister and elsewhere in Orkney.' (14) In relation to the Stones of Stenness, an important henge monument, he also refers to M.Edmonds' review of the complex problems of interpretation in such sites: 'In the course of this review Edmonds summarises the typically tripartite structure of ritual; one of "separation," "liminality, which in turn is followed by one of reincorporation."' (15)

At the centre of the circular ring of standing stones at Stenness there is a 'hearth' and Garnham argues: 'That the fundamental role of this hearth was a ritual one there can be little doubt...' (16) Such monuments cannot realistically be considered outside of the context of the ritual activity giving them meaning and Garnham also believes that dance played a key role in the Neolithic culture. He draws on the research of the American anthropologist Paul Radin to support his case in respect of the Orkneys; similarly he explains that several of the factors considered by the researcher Colin Renfrew as necessary to provide evidence for religion or religious activity are

161

present at the Stones of Stenness, not least what he calls a 'liminal zone' with direction towards 'non-terrestrial and therefore transcendental forces.' (17)

Garnham concludes that ritual activity and the transformational forces invoked to step outside the passage of time, link all cultural artefacts by 'embedding them in a complex web of visual and material relationships they had with other things and phenomena.' (18) In reference to archaic man's 'constant recourse to ritual' he quotes Eliade: 'every territory occupied for the purpose of being inhabited…is first of all transformed from chaos into cosmos; that is, through the effect of ritual it is given a 'form' [that] makes it become real.' From his long research, Eliade came to realise that 'ritual activity underlies all religion and myth.' (19)

The significance of this is clear: in the microcosm of an archaic setting, ritual transformation forms the framework for all cultural development and through its psychic experience of the oceanic creative process, new and original forms are generated. Or as Garnham puts it, the primitive mind '…develops mental structures that take the form of "a system of concepts embedded in images" .' (20) As I have argued, in my own subjective creative research, I can detect this process at work. I could not produce what I would consider to be imagery with a real, innate connection to my inner emotion, until the ritual creative process of the abstract monochromes had been isolated and defined. The abstract works can be equated with the ritual process as separate from the art object it serves to develop. In the ritual setting, the creative process is separated from the artefact, which nevertheless still embodies and encodes the process.

It becomes transparent in the more primitive and condensed archaic setting how a set of forms, material objects and artefacts are evolved into the network of a psychological universe intrinsically and genetically linked to the psychic trance-formative processes of ritual. In my own naïve and primitive way, I unconsciously evolved a parallel psychological universe furnished with sets of objects: mirrors, brick walls, empty rooms, enclosures, staircases, windows, plinths, pulpits, armchairs, tables and so on. The placing and relationships between these things is of paramount importance to register the emotion, whether a 'stultifying indifference' or a conflicted, ambiguous, confrontation with 'real' objects and what they may represent. (21)

In my own painting a brick wall or enclosed space or remote site come to intuitively register psychic and cosmic events. Staircases may lead to infinite points of contact with oceanic infinity, or to doorways and spaces signifying psychological rather than physical transition. In *Staircase leading to a Doorway* we can see that the flight of stairs leads to an open door set in a monochromatic grey oceanic space. It is very much an iconic space registering a creative transformation. (Fig. 21) In a catalogue essay on this subject, Mike von Joel has noted:

> These "situations" have taken on totemic (or iconic) status and are at once familiar to those with experience of Newton's work. The Empty Room; the Empty Chair; the Doorway; the Mirror; the Flight of Stairs; and the ever present possibility of transference between one pictorial space – one area of consciousness – and another, via a half open door or window or even Alice-like – via a reflection.
>
> These spaces, these two *realities*, are often divided by a line which could represent an horizon, might possibly represent the traditional yin/yang dichotomy

of good/evil; conscious/subconscious; light/dark. A perpetual Manichaean conflict.

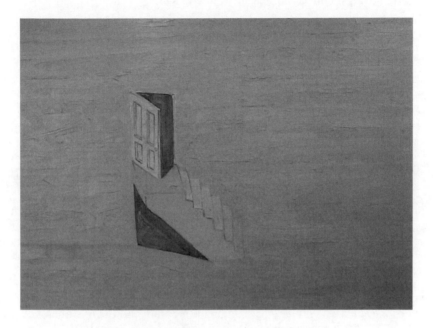

Fig. 21 *Stairway to a Door* (76 x 110in) 2001

What is apparently always suggested however, is the inherent possibility of a redemption – undefined, but certainly reminiscent of that spiritual essence contained within traditional icon painting, or Byzantine and Coptic art, with its hidden protocols. The resultant image disturbs. It disturbs because it is suggesting an idea which resonates somewhere in the psyche of the spectator, appealing directly to ancient, inherited, memories that can seemingly be triggered by the correct application of certain visual stimuli and suggestion. (22)

Von Joel concludes this piece by noting that: 'As with all Newton's works, the title of an individual piece is fundamental to the understanding of it, a consistent formalised metonymy. They are a first clue to the understanding of the *other world* which Newton's works attempt to reveal and which, on closer-inspection, appears to contain sinister elements common to us all. (23)

Like the form and style of the tribal artefact, the iconography and form of these paintings evolve gradually according to the nuances of the psychic register. In chapter 5 I referred at length to how the actual ritual process operates in conjunction with the creative process. But how does the artefact or art object in this context come to materialise the mystic oceanic experience?

Suzanne Blier, in *African Vodun – Art, Psychology and Power*, analyses how the art object becomes a vehicle for transcendental psychic forces. She recognises the true function of art and in her introductory remarks states:

> In southern Benin and Togo…art assumes a critical role in psychotherapeutic practice. In this feature and in other ways, psychotherapies display a multifocality rarely evidenced in the West, involving not only words (talk), medicines…and in some cases hypnosis (here trance) but also a full range of sensate experiences. Integrated into the therapeutic process as well are important religious components…and individual metaphoric journeys. In general, aggressive response in contexts of personal difficulty is widely promoted, worked out at the level of ritual and psyche rather than through interpersonal means. And, while transference is seen to be critical in this part of Africa it is often an object (in this case a *bocio or bo*) rather than (or in addition to) the intervening therapist that is the primary medium of this transference process. (24)

In other words, Blier detects the original and primary role of the art object in the transference or therapeutic transformative process, prior to the advent of the therapist.

Blier pieces together the complex relationship in West African voudou culture encompassing the art object and crucially, the materials incorporated in its manufacture and their connections with the 'religious and therapeutic ceremonies in which such objects played a part,' including the 'critical importance' of the 'diviners and divination sessions … for not only were the former extraordinarily knowledgeable, but the latter functioned as a primary psychotherapeutic frame in which not only personal anxieties and difficulties but also *bocio* commissions were brought up.' (25) That is to say, the concept of the art object was directly related to the ritual frame. She notes that 'sculpture of the *bocio* type function in conjunction with these *vodun* energies both in protecting humans and in offering avenues of individual empowerment and change.' (26) Blier stresses that such sculptural ritual objects are obscure and cannot be understood in any normal sense and are grounded in 'the highly personal psychodynamic roles these objects play in local communities…' (27)

Blier's field research was carried out in the 1980s and perhaps many of the ritual contexts and related objects are possibly relatively recent or contemporary, having been collected in the 1960s and later. It is not always clear in such a setting how much of the authentic ritual process remains and how far removed the object has become from its original creative and spiritual roots. However, Blier does trace the antecedents of this West African tribal sculpture back to the 18th. century and her analysis certainly reveals the inherent relationship between artefact and ritual process even if we might argue that in the contemporary context this relationship has become largely ceremonial.

Many of these sculptures are characterised by their continually unfinished or ongoing process in the reflection of ritual change and their surface may well be adorned by a range of suturing forms – 'cords, beads, iron chains, and cloth and leather wrappers.' In many examples, overlaid on the figure's head and torso, 'a thick patina of blood, oil, and feathers serves as a visceral signifier of the work's ritual history.'

164

(28) An example from the 19th or 20th century is the Agonli-style *bocio* shown in Fig. 22.

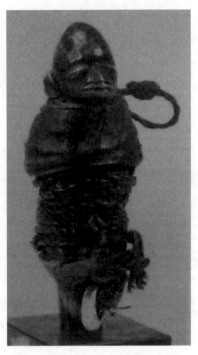

Fig. 22 Agonli-style *bocio*,
Republic of Benin
Wood, fabric, cord, cowrie,
and miscellaneous materials
H: 4in — 19th or 20th C.
Former collection of J.Muller,
Musee Barbier-Muller, Geneva
Catalogue no. 1011-43

Blier significantly states that: 'Cords (*kan*), the first and in many respects most prominent of these *bo* and *bocio* suturing means, represent at once a vital transformative state...' (29) Such elements, and Blier describes many, serve to act as indicators that the objects are in fact tied to the ritual process, both metaphorically and innately in their intrinsic and intuitive formal development. Often in their overt apparent ugliness and 'In their variated massing on the surface they emanate qualities of tension, anxiety, and danger. In this work a range of emotions seem to explode from within, the sculpture almost outgrowing itself and transgressing its own limits.' (30) She quotes M.M.Bakhtin's writings and his arguments that the grotesque instigates ideas of 'displeasure, disequilibrium, and change.' (31) We can infer that such an object incorporates primary paranoid-schizoid projection to help trigger the 'mental breakdown' as a prerequisite of psychic transition.

From her own observations Blier records the inarticulate nature within the 'counteraesthetics' of these objects which are 'spoiled, corrupted, inutile, wasted, or negated' and yet resistant and forceful. (32) Such aspects locate these tribal artefacts within a dynamic psychic developmental framework and it is significant that Blier connects them closer to ritual through their associations with drum rhythms: 'Serving both to protect humans and to offer avenues of individual empowerment and change,

these works, like the beating drum rhythms which bring on *vodun* possession, promote ideas of individual empowerment and response.' (33)

As I have implied, a critical feature of ritual tribal sculpture is its excavation and exposure of the very *process* of its creative manufacture and involvement in ritual transition. Blier states:

> It is as if they intentionally insert into their works evidence of each step undertaken in the course of artistic production. Not only are the sculptural planes heavily faceted , thereby enabling viewers to locate each cut of the adze, but many of the variant empowering materials also are displayed in full view on the surface of the figure itself. Every work accordingly carries essential qualities of the force and actions with which it was created ...Within the *bocio* tradition, it is this "production" primacy, this concern with the *process* of creation, this aesthetic of raw energy which is such a critical part of both artistic intent and audience response. (34)

This exposure of the *process*, of course, reveals the developmental and creative dynamic forming the essence of ritual encoded within the object. This is the structure of the creative process laid bare that was to have such a powerful effect on Picasso. What Blier has said here of the Benin and Fon *Bocio* sculpture could just as easily be said of modern art and in particular of abstract painting.

Blier stresses the power of the objects conferred by their 'interactive properties' of psychic transference. She outlines a variety of means through which the object is ritually 'activated,' 'energised' or 'cathected,' such as in one example the pronouncement of 'incantatory words.' Such ceremonial actions, however, may serve only as surface indicators of a potentially deep psychic power and Blier underlines the fact that the very first action within this objective is 'the dynamic of material assembly itself.' (35) This is true, as in the case of painting: the dynamic form induces cathartic effect through the mirroring of psychic processes embedded within its substance. What

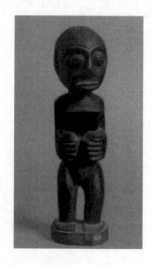

Fig. 23 Fon *bocio* (wife of deity, from a shrine, collected by Melville and Francis Herskovits in 1931), Republic of Benin
Wood — H: 16in
Indiana University Art Museum, Bloomington. Cat. No. IUAM 78.63.
Gift of Roy and Sophia Sieber
Photo: M.Cavanagh and K. Montague
Published in M.and F.Herskovits 1967
(p101)

166

the narrative ceremonials surrounding the consecration of such objects ultimately pay homage to is the supernatural vitality and force contained within their form. At some length Blier describes the 'activation' of sculptures, to endow the work with effective power; but in the final analysis it is within the object's potential for 'mimetic efficacity' of ritual psychic transition that its power resides.

Ritual *bocio* sculpture is intended to 'address the full range of human senses ... at the rawest sensorial levels' and significantly, 'They supply the unconscious with its raw signifying material.' (36) Blier stresses the 'strength of certain supernatural energies or powers which convey to each object its unique vitality and force.' (37) Underpinning this transcendental dimension is always the therapeutic – or developmental frame and Blier records how the designated deities associated with ritual therapy offer insight into a range of psychological issues identified with the commissioning of *bocio* sculptures. Although this is witnessed in a ceremonial residual practice, the innate connection between psychic transition and the ritual artefact is nevertheless enshrined within it.

This psychic transition at the heart of the initiation rite and the rite of passage is fundamentally concerned with the birth of a new self. In ritual process as with the radical creative process, the essence of conversion is founded on the 'psychic death' to be followed by a 'psychic resurrection' as preordained mental programmes are disintegrated and reintegrated in the creative process. It is this idea that the artist or initiate communes with a deity to give birth to a new self that is often registered or signified in associated female ritual figures. The Fon female figure in Fig. 23 is an example, as Blier points out, of the connections that such figures make between the stomach and pregnancy as an aesthetic signifier of psychic transition, along with other correspondences between 'stomachs and the psyche.' (38)

It is material to this that the Fon female figure is the wife of a deity, perhaps indicating on one level that her concern in holding on to the stomach, a concern depicted in other similar examples, reflects a creative tension: the union with a deity and potential for issue become metaphors encoding a potential ritual transition. As with the majority of these objects, whose slight stylistic variations from group to group reflect subtle differences of ritual procedure, the tension in the ambiguity of stance, facial expression and execution, records the ambiguity and tension of the ritual event: the accession to a dimension where contrasts, dialectics and diversity are harmonised in an oceanic unity prior to a reincorporation.

As we have seen, however, in relation to the fascinating example provided by Neolithic Orkney culture, ritual activity draws into its complexity a whole variety of apparently more mundane objects: baskets, pots, boats, shelters and so on. In the African tribal context this is similarly the case. Seemingly less vaunted objects such as stools take on particular significance. In the Luba chieftain's stool shown in Fig. 24, the ritual tension and creative process are key determining factors in its materialisation, as is reflected ceremonially in the object's cultural significance and usage and figuratively in the facial expression of tension in the weight of support.

It has been noted how the figures in Luba sculpture 'are generally finely rounded in form with a round face in which the large half-closed eyes seem to gaze into another world' and how the human figure 'often forms part of a larger piece. For instance there are chiefs' stools, neck supports, bowls, three-pronged spear-holders

and so forth.' (39) In respect of this apparently relatively banal list of objects, however, there is a significant point: that Luba style is 'probably the one and only example' from which an individual style can be distilled and then classified or grouped within a cultural style. (40)

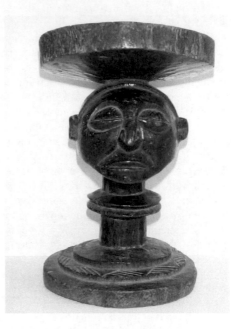

Fig. 24 Luba stool,
Zaire
Wood — H: 11in
19th or 20th C.
Collection of the author.

In Luba culture the chief's stool represents a material expression of power, laying 'impressive emphasis in their symbolic decorations on the connection between the sacred power of the original ancestors and that of their earthly representatives.' (41) Stools still function in this way, but 'they are also places of memory, situating power and memory in the past and present, and their subtle iconography can be read as sculptural narrative.' (42) The first Luba king was elevated through 'the clairvoyance of the first diviner.' (43) Diviners represent the mediators of all crises and conflicts that threaten individual and communal well being and use 'baskets, gourds and sculptures as mnemonic devices to remind them of certain general rubrics of Luba culture.' One of the most important of their instruments is the sculpted image of a woman holding a bowl: 'Among its diverse powers, the bowl figure is known to have curative capacities.' (44)

here is an almost holistic cultural capacity fulfilled by functional objects all interrelated and each in its own way embracing the ritual and creative dynamic of the culture. Evidence from further afield again supports the argument that artefacts are predicated upon an underlying common psychodynamic. For example, Alfred Gell's pertinent research on the Trobiand Islanders of Papua New Guinea in the context of 'technology and enchantment' is worth noting.

Gell regrets that modern social anthropology neglects art and is even 'constitutionally anti-art.' This state of affairs has really arisen from the problems associated with an ethnocentric, culture-bound attitude of 'universal aestheticism' and he examines the consequences of this through drawing analogies between the anthropological study of art and the anthropological study of religion. (45) He makes the important point that although art as a central anthropological study diminishes under the rise of structural functionalism in the last century, the same thing did not occur in respect of the study of ritual and of religious belief. In effect, Gell implicitly makes the key connection between religion in ritual procedure and the creative process, recognising the innate bond between the art object and ritual.

Significantly, Gell further takes the example of a seemingly mundane, functional object, the Trobiand canoe-board to illustrate some basic kernels involved in its manufacture. Firstly, as has been stressed, the carver is not concerned with what we might conceive of as aesthetic beauty:

> He must exercise a faculty of aesthetic judgement, one might suppose, but this is not actually how it appears to the artist in the Trobiands who carves within a cultural context in which originality is not valued for its own sake, and who is supposed by his audience, and himself, to follow an ideal template for a canoe-board, the most magically efficacious one, the one belonging to his school of carving and its associated magical spells and rites. The Trobiand carver does not set out to create a new type of canoe-board, but a new token of an existing type; so he is not seeking to be original, but, on the other hand, he does not approach the task of carving as merely a challenge to his skill with the materials, seeing it, instead, primarily as a challenge to his mental powers. Perhaps the closest analogy would be with a musician in our culture getting technically prepared to give a perfect performance of an already existing composition, such as the 'Moonlight' Sonata. (46)

Gell goes on to explain that these carvers 'undergo magical procedures which open up the channels of their minds so that the forms to be inscribed on the canoe-board will flow freely both in and out.' He refers to a study of Trobiand carving and the 'final rite of carving initiation' where throughout 'the emphasis is placed on ensuring free flow (of magical knowledge, forms, lines, and so on) by means of the metaphoric use of water and other liquids...' (47) We can perhaps assume that the metaphor implied must be associated with the oceanic dimension of the creative process within which a free flow of ideas is possible. As we have seen, this dimension forms such a pivotal factor in the orchestration and performance of the creative process and the ability to 'internalise the carving style' and in effect to develop the abstract mental template for its free expression.

In effect, therefore, the manufacture of the canoe-board is intimately connected to the ritual procedures of 'unimpeded flow' and a 'complex series of homologies ... between the process of overcoming the technical obstacles which stand in the way of the achievement of a perfect 'performance' of the canoe-board carving and the overcoming of the technical obstacles, as much psychic as physical, which stand in the way of the achievement of a successful Kula expedition.' (48) Gell elucidates the relationship between technical processes, or carving techniques and magical, or ritual

169

processes, in the creation of an object. He explains that canoes ultimately destined 'to be sailed hazardously, laboriously, and slowly, between islands … are evaluated against the standard set by the mythical flying canoe, which achieves the same results instantly, effortlessly, and without any of the normal hazards.' Ultimately, art objects will 'transcend the technical schemas of the spectator, his normal sense of self-possession, then we can see that there is a convergence between the characteristics of objects produced through the enchanted technology of art and objects produced via the enchanted technology of magic, and that, in fact, these categories tend to coincide. It is often the case that art objects are regarded as transcending the technical schemas of their creators, as well as those of mere spectators, as when the art object is considered to arise, not from the activities of the individual physically responsible for it, but from the divine inspiration or ancestral spirit with which he is filled' (49)

It is surely not accidental that in terms of painting and 'the artist as occult technician' Gell refers to 'the technical miracle which achieves the transubstantiation of oily pigments' into other agencies. (50)

Attempts to really get to grips with exactly how such diverse objects come to encode a creative orchestration and an unconscious psychodynamic within their very material substance often come to grief in their reliance on narrative and on a literalisation of a process demanding a much deeper understanding. It is certainly more accessible and simpler to describe the ritual ceremonials involved. For example to recount that blood smeared on a ritual sculpture represents ancestors' blood or snake oil and feathers represent something else. It is, however, somewhat more complicated to excavate the inner dynamic of psychic mirroring and the intrinsic parallels that such objects set up, something I have at least attempted to do.

I have said that psychoanalytic models can be very useful in their analogous interpretation of these objects and their inner structure. Suzanne Blier's research into African *vodun* has, as we have seen, revealed some acute insights into the relationship between artefact and ritual. Whilst she may on occasion fall back upon a literal interpretation, her analysis does nevertheless take into account the role of surface ceremonials as surface icons of underlying forces. For example, whilst recounting the narrative of *bocio* statues functioning to keep at bay malevolent forces, she stresses the psychic framework of emotional transference through which such forces are played out.

Blier notes how *bocio* figural sculptures in a literal sense 'comprise any activating object (*bo*) taking the shape of a human body, more accurately a "cadaver" (*cio*).' (51) The art object here serves a fundamental role as defined by object-relations. For example, Blier refers to the argument in respect of the statue erected outside of a house with the objective to ward off malevolent forces. It does this by both reproducing in a deceptive way the traits or characteristics of an inhabitant of the house and being in turn exposed to the mercy of the powers directed against it. Effectively, the innate linguistic root of *bocio* relates to 'dirt, disgust, or debilitation' and 'corpse' as its exposure of the paranoid-schizoid position would suggest. As a result, the intention is that the malevolent force, on perceiving the statue, will take on the implicit suggestion that the individual to whom the malevolence is directed is

already dead. In a sense, this pre-emptive defence already pulls the sting from a potential aggression. (52)

In this manner, a transference relationship is set up within the object-relations dynamic of the art object. Blier recognises the role transference plays within the cathartic and expiatory process. She stresses that 'Transference (the passing on, displacing, or transferring of emotion from a person onto another person or object) is an often overlooked but vital feature of art's overall psychological functioning, affecting, yet standing apart from interpretation, the principal object of most psychologically grounded art studies.' She further appropriately quotes Jacques Lacan in his paraphrasing of Freud that: 'Transference is the enactment of the reality of the unconscious.' (53) Crucially for my thesis here, Blier reiterates that:

> While Freud, Lacan, Obeyesekere (to whom I referred in chapter 4) identify the analyst (individual) as the primary support for the transference process, in the African settings discussed here, this role is split between the therapist (here principally the *bocio* activator or diviner) and the empowered object (here the *bocio* figure). (54)

Blier's recognition of these factors of course reflects my own arguments, especially in relation to the abstract monochrome paintings. I stressed in my comments at that point that such works incorporate the connection to ritual and developmental foundations and function as analyst in their embodiment of object-relations in terms of projection and projective identification, as transitional phenomena and vehicles of transference and countertransference to the audience. In general they serve as models of displacement of emotion and psychic structure. Transference is sourced in object relations and 'a successful work of art can restore to its perceiver aspects of experience that were previously unavailable, invisible.' (55)

Furthermore, Blier's references to Jacques Lacan are appropriate because his ideas do shed further light on the workings of the creative process and importantly for the relationship between ritual and iconography, his schemas do provide a mechanism supporting the potential for the transformation of abstract form and emotion into various representations and ultimately into icons. Freud, of course, did have the original formulations for this process as Lacan clearly acknowledges in his whole project to revisit Freud. However, Lacan develops a structural basis through his psychoanalytic models for the characterisation of the creative process that I have proposed here.

As I mentioned in chapter 4, Lacan, along with W.R.Bion and others, was perceived by many as one of the mystics of psychoanalysis, squarely positioned in the 'adaptive-transformational' school. It is recorded that Lacan was conversant with the work of Bion and greatly admired it and as I have said, I think it is evident that Lacan was greatly influenced by Bion's thinking. (56) Further to this, Lacan's mystical credentials are supported through his manifest interest in mystical experience and the ecstasies of mystics such as Saint Theresa. (57)

In chapter 3 I outlined those psychoanalytic models of Klein, Ehrenzweig and Winnicott that go such a long way towards illuminating the inner mechanics of the creative process. However, as I have indicated, Lacan is relevant at this point specifically because his analysis not only places an emphasis on the role of the pre-Oedipal

mother, but also points a way through the 'minimum content of art' of Ehrenzweig and beyond abstraction. This is why Lacan is more firmly entrenched in the transformational school as he develops a structure evolving through the essential ritual process.

It is not my intention to deal with Lacan's contribution here except in very general terms. It would be beyond the scope of this work to deal in any great depth with such a controversial psychoanalytic thinker, who is not without stern detractors. It is well recognised that his dense and tortuous prose often deliberately sets out to obfuscate meaning and coherence. Malcolm Bowie notes that within the general psychoanalytic tradition, 'Lacan is quite alone in placing a continous positive evaluation upon ambiguity, and in suggesting that students of the unconscious mind, when they become writers, are somehow morally obliged to be difficult.' (58) Lacan's fascination with modern art and with the 'stream of consciousness' techniques of modern writers such as James Joyce, led him to emulate modernist style in his own texts, an arguably misconceived fancy that I have commented on in greater detail elsewhere. (59) Having said this, however, it is nevertheless the case that Lacan's three essential psychoanalytic registers: the Real, the Symbolic and the Imaginary and the relationships between them would appear to have discernible correspondences with ritual and creative processes.

I have mentioned in passing that Lacan's psychic register of the Real arguably has many of the characteristics of the creative nucleus as exemplified by the three phases of the creative process and of rites of passage. I commented upon this in particular in respect of the dark red abstract monochrome *Promised Land* (Fig. 11), a work that I considered to have many of the attributes of the Real register and consequently Lacan's ideas insofar as they are relevant to my arguments, will be briefly addressed.

The three registers of orders defined by Lacan, are slippery, overlapping and multivalent concepts and are frequently misinterpreted and are certainly not open to straightforward definitions. Some analysts have drawn very tenuous links between Freud's concepts of the Id, Ego and Superego and Lacan's Symbolic, Imaginary and Real. (60). However, they are not in any real sense compatible although Lacan has drawn heavily on Freud's ideas in effect to transpose them into the realm of language and signification. He compares the structure of a sentence to that of a dream and ultimately translates the dream's constructions of condensation and displacement into the metaphor and metonymy of signifiers in linguistic discourse. This is of course a very simplified and necessarily truncated account. However, the Symbolic Order can be recognised generally as the register of language and the linguistic signifier and of symbolism. For Lacan, it has a correspondence with the Freudian unconscious because the unconscious, through metaphor and trope and so on, is structured like a language. The Symbolic Order is the domain of otherness and so is implicated in Lacan's critical view of the constitutional human condition of the divided self, so important in relation to all I have said in this work so far.

Lacan's Imaginary Order is really rooted in his ideas on the 'mirror-stage' of human development, during which time the infant first perceives its own image in a mirror. (61) Lacan postulates that the perceived unity of the reflection and apparent omnipotent control exercised by the infant over its counterpart in the mirror confers an illusory and false sense of unity and whole being not to be matched in reality. The Imaginary continually seeks this confirmation in identification and in reciprocation

and aspires to repeat those experiences originally serving to formulate the ego of the individual, along with all of the associated exaggerations and fantasies. In this sense the Imaginary bridges internal elements with the external.

The Real Order is absolutely alienated from any dimension of symbolism or signification. It is not to be confused with 'reality' as it is commonly understood in psychoanalysis, but is rather found in both the mental and material world: the essence of the Real emerges '...against a background of a primitive, undifferentiated All...' (61) It is an 'ineffable' and an 'impossible' register but has an important contribution in its role as a 'practical analytic tool.' (62) In this potential the Real must be in closely associated with Bion's dimension of 'O,' which as we have seen is similarly indispensable to the psychoanalytic dialogue.

As the Symbolic Order contains only symbols, so the Real is totally outside of the symbolic process, of fantasy and the 'phantasmatic constructions' comprising the Imaginary order. (63) The Real, in its pre-symbolic, pre-verbal position, is inevitably to be conflated with the real of the body, with bodily trauma and pain and anxiety. In this sense perhaps it accords with Klein's pre-Oedipal developmental positions and in particular the paranoid-schizoid. Organs and other material physical elements endemic to the Real, like any other physical objects can only access a place in the Symbolic through being symbolised.

Irrespective of the individual characteristics of the three orders, however, it is in the ways in which they are implicated within one another and in their range of interactions that the relevance to the creative process is revealed. The basis of this interaction is to be found in Freud's *Studies on Hysteria*. Freud's theoretical insights were predominantly founded on the dialogue with hysterical patients and on the analysis of neurotic symptoms. Just as the analysis of psychotic art, or indeed children's art, can help to isolate those particular characteristics defining what culture at a given time perceives to be 'healthy' or mainstream art, so can the examination of neurosis serve by comparison to distil the defining aspects of normal or healthy behaviour. However, it is also the case that such psychoanalytic investigations were undertaken on the understanding, as Paul Verhaeghe notes that '...the hysterical position is the necessary position of every speaking being.' (64)

What is significant about Freud's studies of hysteria is his fundamental discovery of the relationship between symptoms and their unconscious determinations and that this relationship was structured in three layers of 'psychical material' grouped around a pathogenic traumatic nucleus. It was Freud who therefore first recognised that the unconscious had a stratified structure, an idea that he had originally proposed in a letter to Wilhelm Fliess written in 1896. In *Painting, Psychoanalysis, and Spirituality* I give a more detailed account of this process of stratification inherent in the unconscious, and in particular showed how Anton Ehrenzweig had developed the concept in his work on unconscious perception and the creative process. (65)

Freud made this discovery through the analysis of patients such as Anna O, who under hypnosis recalled all of the events leading up to her symptoms in exact reversed order. Paul Verhaeghe, who discusses Freud's stratified unconscious in relation to the Lacanian Real, explains that this chronological sequence comprises the first layer. The second layer is a 'concentric stratification of the pathogenic material around the pathogenic nucleus.' The third layer 'is a dynamic one, crossing through the other

two and producing the logical connections; it is a complex system of connections with nodal points, in which the multiple determination of symptoms becomes apparent.' He goes on to say: 'In other words, the Unconscious is *ordered* ; the representations are linked to each other in a precise manner …the Unconscious is structured like a language. The first layer is the diachronic one; the second gives the synchrony of all signifiers; but the most difficult point in his theory is the third layer which is, for Freud, the signified …' (66).

These are the three layers surrounding the nucleus; Freud described the nucleus as the 'core of our being,' or the 'primal scene.' Its essence is that it cannot be verbalised, hence its pre-verbal isolation. Freud's hysteric patients could never verbalise this core. As Verhaeghe concludes, this is obviously the Lacanian Real.

The Real is traumatic and connected to infantile primal anxiety and to the primal scene. Freud developed the idea that the hysteric generates fantasies to disguise and to screen memories of the sexual primal scene, witnessed but not understood by the infant. However, there is always an element not translatable in this way that must remain behind in the Real from where it will exert traumatic force. The key factor in respect of my own argument is that infantile and neurotic primary anxieties, often sexual in nature, are psychically elaborated through fantasies arranged defensively in relation to the original impulse. This is a type of creative complex surrounding the nucleus of the process. Freud further extended this phenomenon and established the triple structure of this construct and '…the diachronic and synchronic level of signifiers, and the signified linked to the nucleus as the most repressed element.' (67)

What Freud uncovered in relation to the psychic condition of the hysteric is arguably an elemental framework to be found in essential original developmental phases, dream works and transposed into the creative structure and the transformative ritual process. Again, Freud had examined this fundamental process in relation to his famous case of Little Hans, who evolved a type of creative discourse in order to process and make sense of the dread of an Oedipal castration threat. In *Painting, Psychoanalysis, and Spirituality* I compared this construct with the type of creative network generated in many art forms. Lacan recognised that the Real dimension, which accords in many respects with the liminal phase of the rite of passage or with the inaccessible unconscious emotions that are translated into dream symbolism, is the source of traumatic emotion that has to be synthesised somehow by the other two orders.

It is of consequence that Lacan's schema here incorporates a first diachronic layer, initiating a narrative, whilst the second layer installs the synchronic dimension evident in the central phase of both the creative and ritual process. Whilst I do not want to give the impression that I am trying to force exact parallels between models where there are probably as many characteristics dividing as uniting them, I do think that there are discernible consonances. What Freud and Lacan are saying is that the driving emotion emanating from the inaccessible primal core unconscious, or Real, needs to be constantly negotiated through symbolic representations whether in dream condensations, hysterical symptoms or through the fantasies of the Imaginary. The unique capacity inherent in ritual and the creative process is for a degree of control to be exercised and brought to bear on the whole procedure, thereby enhancing and strengthening the therapeutic and transformative potential.

Ultimately, the symbolic representations generated in the more original context of tribal or Neolithic culture are tied to the ritual core and interact through stylistic and iconographic resonance. The same thing could be said of an individual's dream representations, which function in a similar manner to ritual artefacts and ceremonial practices. Returning again to my own subjective creative endeavours, I can say that the evolution of my own painterly iconography has proceeded in the same vein and the individual elements within the whole network are inevitably interconnected within their pictorial spaces and stylistic character and originate from the creative core.

The abstract monochrome collages represent that creative core and source of traumatic energy from which the iconography evolves to process and symbolise it. These works in all of their facets demonstrate the Lacanian Real. They are, of course, pre-verbal and pre-symbolic and are in essence feminine in character. As we shall see, for Lacan the feminine is excluded from the Symbolic Order and hence is left behind in the Real, which as a result acquires feminine attributes. I have discussed how the red monochrome *Promised Land* (Fig. 11) coincides at certain points with the intra-uterine and with what effectively is the materialised mother's body and how that encounter further evolves the parallel developmental psychic structure. Again, I specified that all representations of symbolism and in effect the Symbolic Order had to be expunged before the dimension of the monochromes could be accessed. Again, these works, in their very format encode the synchronic constituent also echoed in the Lacanian schema.

The abstract monochrome collage *Untitled* (*White*), Fig. 10, again reveals the oceanic fragile skeins of the pre-symbolic whilst further highlighting another key factor in Lacanian thought. I have already remarked upon Lacan's discussion of the mirror stage and it is interesting that in many of these abstract paintings I was often left with a central shape that I could never eliminate. The remnants of this can be seen in the shape resting above the centre of the painting. It is interesting to note that a number of subsequent figurative paintings unconsciously developing elements representative of these factors comprised of isolated central mirrors incorporating a reflected object, presumably myself. It is inevitable in the retrogressive passage of such abstract paintings that the mirror stage of development would be encountered at some point and with it the impossibility of eliminating the omnipotent mirror image. Just as the mirror stage in human infancy helps develop physical motor functions and control, so does the 'psychic mirror' of abstract painting contribute towards greater psychic control. (68)

The painting *Unearthed Foundations*, 2002, (Fig. 24), even so long after the original event seems to hark back to original experiences encountered in the abstract monochromes and in particular in *Promised Land*. It also appears now with the benefit of hindsight to be a clear example of how a creative communion on an abstract level will irresistibly displace representations to record the event even over a timescale of many years. Again, the same process is evident in the hysterical symptom, which similarly can be retrogressively unravelled, or in the dream condensation, or in the ritual's symbolism in the artefact. It is just that here, as in the case of the ritual artwork, there is the potential for a greater degree of objectivity and so, as I have stressed, of control over the process.

Fig. 25 *Unearthed Foundations* (76 x 110 in) 2002

The excavated foundations in the centre of the painting seem to incorporate those excavated parallel foundations of the creative nucleus and further provide a basis to literally and figuratively build on and develop an extended iconography. In other words this painting would appear to pinpoint one particular scene in the reference to an overall painterly evolution. The building bricks of the unearthed foundations are set within a dark red sea evidently transposed from the flux of the canvas collage of *Promised Land*. I stress that such a work represents some elements of one particular scene, just as another painting might on one level make a reference to the mirror stage. I would, of course suggest that these paintings go much further in their whole range of expression, but nevertheless think it is important irrespective of the risk of seeming to be overly reductive, that such connections are made.

That the excavated foundations serve as a metaphor for an excavated creative structure is conspicuous. The abstract manic-oceanic sea in the unconscious colour of dark red will precipitate the essence of creative foundations. But other associations will inevitably permeate such an image: the isolation of the human condition, especially in the depressive struggle to surface; alienation and loss in the ruins of an existence. These references did lead on to a series of subsequent paintings dealing with ruins of buildings and with exposed walls, often with their wallpaper still virtually intact and with the skeletons of derelict churches and shrines.

In more recent paintings, the dark red colour with its psychic overtones might still surface, although in a different setting. In the painting *Doll's House in a Room*, 2004, (Fig. 26), the red of the original monochrome has metamorphosed into the psychic space of a room, where the walls form a mental enclosure. As with many current works, the brushstrokes often extend the whole length of the canvas, which in this case is 114 inches, in their own take on endlessness and infinity. In turn, the yellow ceiling, suggestive of electric light, returns the viewer to a more conventional scenario.

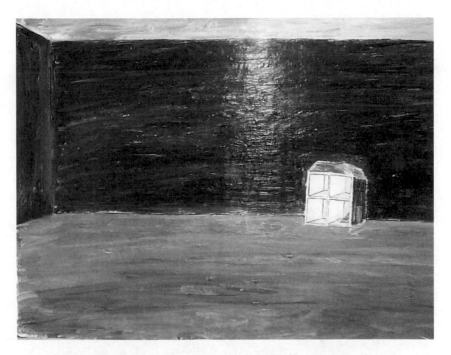

Fig. 26 *Doll's House in a Room* (80 x 114 in) 2004

The image of the empty doll's house is one that has crept into some other works. It is perhaps strange that this appears to become an icon of emptiness itself; not just a spatial emptiness, but rather of a spiritual emptiness. Possibly the staircase in the house, however, could be read as not only a token of content and of inner objects, but as the microscopic remains of the potential for transcendence. Nevertheless, the empty doll's house does serve as an icon; an emblem of creative experience in its empty lack of boundaries and definition and possibilities of both timeless infinity and for a retrogressive passage in time. But it is an icon in the strong sense that over a number of years such images are gradually displaced in those ongoing efforts to clarify and

make sense of the arcane issues confronting not just me personally but all transient beings caught up in the human condition.

In his catalogue essay on my painting, already referred to, Donald Kuspit describes vividly the sense of loss and 'stultifying indifference' he detects:

> Newton's pictures give us a view of an inhospitable, indeed, inhuman space, which diminishes whatever is in it. Everything becomes smaller in it, as it becomes too big to bear. His pictorial space is essentially deserted – the epitome of an emotional desert. Human reciprocity is impossible in it – altogether extinguished, as though it had never existed. Indeed, the radical emptiness of the space embodies the impossibility of being intimate in it. Newton's space has an air of remoteness about it, conveying feelings of separation and isolation – radical loneliness. Crucified by the surrounding emptiness much as Christ was crucified on Golgotha, Newton conveys the martyrdom – living death – of the unloved, unwished for, abandoned child. Implicitly it must be himself. The space must be his inner space, projected into the picture – given pictorial form. (Fig. 27).

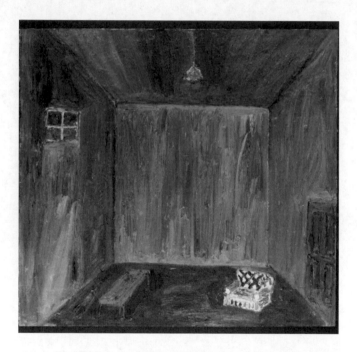

Fig. 27 *Room with Red Carpet* (76 x 80in) 1998

He goes on to suggest that these pictures are: '... personal icons, and that these are the only kind of icons that can be legitimately made in this age of doubt, indeed, of abysmal self-doubt. The self is reconsecrated in them, recovering its sense of itself as sacred by working through its wretched past – the past in which its growth

was stunted rather than encouraged. In a sense, we all grow ourselves, despite our emotionally impoverished childhood environments – and there is an air of genteel poverty to Newton's rooms – and Newton is trying to regrow himself in his pictures by exploring the miserable world in which he seemed to have no chance to grow – a world in fact in which nothing grows, nothing lives, except now and then a flower. Thus his self-analytic pictures show the process by which an emotionally wounded person heals himself with the help of his spiritual unconscious – his unconscious creativity.' (69)

Kuspit astutely recognises here the vital effort to heal the divided self and to effect a psychic rebirth; to once again become real and with a whole sense of self. It is against this creative imperative that Lacan's guise as mystic of psychoanalysis makes sense, for Lacan charts the ultimate human condition of the divided self, divorced from the opposite sex and from a divine communion and sees how the creative process, especially in respect of modern art, aspires to bridge the divide. I think that in this whole context my own painting has relevance in its depiction of works with a paranoid division and those abstract paintings aspiring for communion and a rebirth of a whole self. But how does this division of the self, which as Kuspit suggests is so keenly felt in the imagery of my own painting, come about?

I have indicated that for Lacan the feminine is excluded from any dimension of symbolism and is marooned in the Real Order. In effect this is a key factor in the inauguration of that radical division and lack that is such a critical aspect of Lacan's thinking. In a paper recently published in *Art Criticism* I discuss some of the background of Freud's late ideas on this subject, late ideas that fundamentally altered his earlier convictions and which impinge so strongly upon Lacan's analysis. (70)

In this paper I again make the point that it was in Freud's general inclination to deal with the Oedipal or symbolic level of development, although as I have shown in relation to his correspondence with Romain Rolland, Freud was very aware of the oceanic level of mystical experience. Similarly, as with Klein, Freud recognised that it is pre-Oedipal infantile anxiety and fear that initiates the creative urge and drive to symbolise. However, it was through his research in cases such as that of 'Little Hans' in *Analysis of a Phobia in a Five-Year-Old Boy* that Freud identified the ultimate threat of castration as the root cause of persecution anxiety and the motivating factor for his displacement of this threat into a defensive ambiguous abstract verbal construction, in some ways serving a similar function to a myth or fantasy.

Freud also understood that it was within the *materiality* of the word and distortion of the language that Hans mediated his phobia; that is in sound, or homophony and in a type of ambiguous nonsense language, rather than in the narrative or meaning of the dialogue. That is to say, the displacement of untenable anxiety was carried out in the purely formal and pre-symbolic dimension in order to circumvent any possibility of a re-conceptualisation by a conscious mind not structurally equipped to handle such depth of emotion. Only the abstract material level, as illustrated by my own monochromes, can suffice to radically re-programme psychic structure and initiate that ritual transition towards a new self. The point is that the male child like Hans, suffering the greatest threat of ultimate castration, is more likely to seek a resolution in the abstract.

In a paper written in 1925 entitled: *Some Psychical Consequences of the Anatomical Distinction Between the Sexes*, Freud recognised for the first time that there was no parallel between the sexes in terms of psychology and sexual development. (71) In fact there were fundamental differences in relation to the castration and Oedipus complexes and, importantly, in the make-up of the inner conscience, or super-ego. Crucially, whereas in the male infant the threat of castration destroys the Oedipus complex, in the female this threat actually initiates and consolidates it. That is to say the male obliterates the Oedipus complex under the threat of castration, and sublimates it, and incorporates the severity of this threat within a severe superego and conscience. Accompanying this development is the displacement into the *anaesthetic* defence of abstract aesthetic form. It can be seen how the abstract monochromes fulfilled all of these obligations.

In the case of the female, the urgent demand for the elimination of the Oedipus complex is lacking; there is no castration threat, as this is perceived to have been carried out already. The female is rather locked into the Oedipal situation by her desire for compensation in the form of a baby, a desire initially associated with the father. Furthermore, as Freud points out: 'The fear of castration being thus excluded in the little girl, a powerful motive also drops out for the setting up of a superego...' (72) Again in relation to women: 'Their superego is never so inexorable, so impersonal, so independent of its emotional origins as we require it to be in men.' (73)

In my paper I go on to explain that the overly severe restraints of conscience imposed upon the male can lead to violent measures to break free from such paralysing restriction. I go on to say that:

> Just as a severely repressive political regime can often foment a revolutionary insurrection within its subjects, so too can a strongly repressive conscience and superego engender a violent ambition to eliminate it altogether. It has been an archaic role of art and ritual to mediate such issues. For centuries the tribal ritual facilitated the transition of the initiate through to adulthood. I have argued that within the manic trance, which forms the creative core of the ritual process and the essence of a *trance-formation*, the residues of parental control and conditioning internalised as guilt and conscience can be neutralised and overthrown, in a psychic rebirth into a more adult frame of mind. (74)

I have probably laboured the point, but it is important that in the abstract monochromes I mediated these factors personally. It is of great importance, because as I mentioned in chapter 1, my brother shot my father with a shotgun, whereas as I eliminated the severity of guilt and oppression in an altogether different medium. However, as Freud pointed out, in the case of the female infant, the urgent demand to eradicate the Oedipus complex is absent. The intolerable conscience that in reality may lead to murder or patricide, in the creative process can be the catalyst for great art.

What these apparently tangential points lead up to is the fact that the female does not have the urgent imperative to displace the castration threat into symbolism of one sort or another and is one reason why the feminine is excluded from Lacan's Symbolic Order. I further argue in the paper that as a result women are less likely to need a last resort to the sort of ruthless abstract painting where all is obliterated. Indeed the feminine in general has less potential to retrogressively move through the

symbolic in order to access the oceanic creative dimension as the underlying drive to gain respite from an oppressive conscience is weaker. Hence the seeds of division between the Symbolic order as the realm of language and the feminine are planted.

Lacan extends these original ideas of Freud into the realm of the Mother beyond Freud's Oedipal analysis. He not only gives a plausible account of how the feminine becomes excluded and the subject divided but also provides a framework for the translation of these conditions into fantasy, symbolism and iconography. As I have said, the original agency for this recognition was the hysteric who uses the Imaginary Order to deal with the traumatic Real and in particular as we shall see, those aspects beyond signification in the Symbolic.

For Lacan, the fundamental loss of unity in the human condition is an ongoing force driving the individual to heal the breach through endless repetitions of attempts through networks of signifiers to recover lost unity. The constitutionally divided subject will further seek a discharge through 'la petite mort,' or the 'little death' we have already encountered in the ritual context and which is essence is the momentary ecstatic trance 'death' prior to a total communion. Lacan sees that the 'hysteric longs for the unity of paradise lost' and will elaborate in fantasy a mythical wholeness. It is acknowledged that the human child wishes to continue living as a component part of the mother-child unit. (75) The reasons for this are more complex than a simple yearning for security. Underlying other motives, however, remains the innate objective to affect a communion with the mother and give birth to a new psychic self.

In relation to this Paul Verhaeghe refers to a paper on psychotic episodes discussing a certain transference phenomenon and quotes the author, A.Peto: 'The phenomena consisted of recurrent states of deepest regression over periods of weeks or months. In these states the patient perceived himself and the analyst as being fused into a more or less amorphous mass of vague and indefinable character, (...) Soon this stage developed into a phase in which the two bodies became one mass of flesh.' (76) Clearly we can see here in fantasy, or perhaps more accurately in delusion, the compulsion to access that oceanic unity in which it is instinctively understood that an authentic healing rebirth can be achieved. The innate imperative to heal the split is undeniable.

Freud had also recognised this fundamental split in his concept of primary repression, a repression beyond verbalisation and prior to the constitution of the subject. Lacan knows that the subject aims always to restore this original, primal unity, commonly by way of fantasy: 'Every human being begins life as a satisfying unity with the mother, a unity which is lost and sought for later on in the figure of the partner. Freud specified later on that the same is true for the woman as it is for the hysteric, even her masculine partner can be contaminated by the mother-imago.' (77) Freud's connection of the woman with the psychotic is reflected of course in much classical literature. The figure of the madwoman in the attic, to be found in plays and novels such as Charlotte Bronte's *Jane Eyre*, is effectively excluded from the symbolic and from the means to retrogressively transit the symbolic to an oceanic rebirth. Similarly, the psychotic is effectively isolated in the paranoid-schizoid phase of development and in the fantasy and delusional systems precluding proper access to the symbolic. Furthermore, As Ehrenzweig had noted, the psychotic literalises the trance

death of creative communion and so fears and avoids it and in so doing forgoes the opportunity for a psychic renewal.

Following Freud, Lacan's explanation for the failure of the feminine to enter the Symbolic Order is complicated and on the face of it somewhat tenuous. However, there are correlations with the creative process and it does give more information as to how the subject becomes ineluctably divided so instigating that lifelong search for creative resolutions. Also it should be borne in mind that Lacan's ideas are consistent with previous thought.

In effect for Lacan, once the subject is inducted into the realm of language and symbolism, he is implacably severed from the paradise of union with the primal Mother and that oceanic ecstatic bliss apparently so often the objective of mystics and artists alike. But as with Freud, he also realised that aspects of an elemental truth had to be left behind in the Real condition. Again, for Lacan, a key elemental truth was the pre-Oedipal threat of castration engendered when the infant perceives that the mother is already castrated. As Lacan points out, the infant will crucially fantasise the existence of a mother's penis and that this fantasy is often undertaken with the collusion of the mother herself. Again, the case of 'Little Hans' furnishes a clearcut example of this and was used as an example by Lacan. (78) This primal truth of traumatic anxiety is irretrievably repressed in the Real domain because its implications are too fearful for the infant mind to process. As a result, the infant's inaugural introduction into the realm of the symbolism or the Symbolic Order is through the idea of a fantasised phallus.

A rather appropriate example of this type of screen fantasy or embryonic signifier is to be found in Freud's short essay on Goethe's childhood memories in *A Childhood Recollection from Dichtung und Wahrheit* (1917). (79) Freud gives an account here of a patient who had harboured murderous intentions towards his younger brother and who had actually attacked him in his cradle. The patient upon attending Freud for treatment had absolutely no memory of the attack on the hated baby brother, but only of a screen memory in which he had thrown all of his mother's crockery out of the window. This turned out to be the very same memory recorded by Goethe in his own childhood recollections. Paul Verhaeghe draws upon Freud's study as a lucid example of a signifier referring to another much more important content. He makes the point that in cases such as these a fantasy substitutes for the memory of a real trauma: 'Freud was beginning to make a differentiation between a reality which was already linked with signifiers and a Real that stayed completely beyond this realm.' (80)

This is the basic mechanism for how the original or primal signifier, the phallus, as illustrated by the case of 'Little Hans,' introduces the Symbolic and becomes for Lacan the primal and pre-eminent signifier. Of course we do not have to look very far back into human evolution to see that the phallus is the 'ancient emblem' of human culture and the signifier *par excellence* against which all others are measured. The history of African tribal sculpture alone bears witness to the paramount role of the phallus. The ritual figure from the Republic of Benin shown in Fig. 22 is a very good example of the phallic nature of tribal sculpture.

Malcolm Bowie notes that a key difference between Freud and Lacan is that Lacan positions the 'primacy of the phallus' at the very point of culmination of sexual development, whereas for Freud, the phallic phase supersedes the other phases of

infantile eroticism. Bowie is critical of 'Lacan's portrayal of the phallus as the signifier that holds all signifieds in thrall' as simply regressive. But he does nevertheless acknowledge the 'antiquity of this symbolic device' and that: 'Moreover in the successive phases of libidinal organisation that Freud had outlined, the penis was the only bodily part to receive this accolade...' and for other organs, including the vagina, 'no nimbus of cultural or historical value surrounded them.' (81) For Lacan, in the Symbolic Order, only the phallus has the strength to 'stand up for itself' and designate the order of other signifiers. Ultimately, as Bowie points out: 'The sexuality of women is to be understood, therefore, from within the phallic dimension...' (82) I think that we only have to look at the 'I' in the symbolic chain to see its phallic significance and also to underline the lack of such a signifier for the woman. The 'I' of course serves both sexes and it is the case that the written version, with its commonly looped head, can be read as an even stronger manifestation of the phallic.

Again, contiguous with the propensity to signify the phallic, is the notion of the *passivity* of the feminine also contributing further to the fundamental split in the human subject. The human condition is not only divided from real truths and confined to an order of endless discourse and inevitably condemned to skirt around this truth, but is also separated from the feminine. Lacan felt that this gap was impossible to transcend. The association of the feminine with passivity is, of course, essentially sexual and has given rise to much controversy. However, for Freud, from a psychological point of view, femininity can only be represented by passivity. (83) Freud had also argued that the core of the individual, a core that cannot be 'psychically elaborated,' is inaugurated by a disturbing, traumatic primal scene. This scene must inevitably be passively acknowledged by an infant unable to understand the event. Freud further said that 'It is to be suspected that what is essentially repressed is always what is feminine.' (84) Freud had associated the passivity of the feminine with the passive nature of the traumatic scene. As Paul Verhaeghe puts it: 'In other words, the traumatic Real, for which there is no signifier in the Symbolic, is feminity. *Freud had discovered the lack in the Symbolic system: there is no signifier for The Woman.*' (85)

Perhaps these assertions may seem to stretch a point. However, essentially the general argument is reasonable. It is always the case that in the position of the feminine 'The child is the passive object of the mother's enjoyment...' and feminity involves a relationship between the lack of a signifier for a woman and passivity. Throughout, I have referred psychoanalytic hypotheses back to my own creative experience for comparison. Again, in relation to the abstract monochrome collages, their essentially feminine and passive character, in keeping with that of the manic-oceanic creative phase, accords with Lacan's ideas and their sources in Freud.

The white diaphanous veils of *Untitled (White)*, already cited in respect of Lacan's ideas on the 'mirror stage' of development, are conspicuously feminine in their passive aspect. As I have said, during *ekstasis* these paintings 'painted themselves,' a factor recognised in the icon's *acheiropoietic* function being 'not made by human hand.' This essentially acquiescent stance with regard to the creative process is engendered by the elimination of those elements representative of deliberation and definite action and order, as I have explained. The concomitant experiences of oceanic envelopment and absolute union are very much characterised by the passive enjoyment of the Mother.

Likewise, in my references to the dark red monochrome *Promised Land* (Fig. 11), I have claimed that such a work not only stands for the intrauterine and the mother's body and pointed out how some aspects indicating organs endorse this, but also for the core structure of the unconscious. Although, as I have noted Lacan's Symbolic Order is connected with the unconscious through its linguistic analogies, the Real is the driving factor and must form the unconscious core. Paul Verhaeghe states that: 'The inevitable conclusion is *that the nucleus of the unconscious is the Real.*' (86) He further says: 'The primary mother and child relationship begins as a continuation of the intra-uterine relationship, in which the child enjoys the Other of the body by forming a unity.' (87) Again: 'The mother's body is the order of the Real.' (88)

In the analysis of Freud and Lacan that I have briefly addressed, the subject is divided because essential elements in the genesis of psychic structure are exiled to the Real. We can see this happening in the parallel painterly dimension, where in the dark red monochrome all aspects of signification; of symbolism and iconography; of discernible or legible shape and line – and along with them of dynamic perceptual process – are expunged. What is left cannot be elaborated in any recognisable terms, but nevertheless intrinsically embodies structural psychic truths. In effect, such works are composed exclusively of Ehrenzweig's 'inarticulate form,' a form that cannot be consciously re-conceptualised and the only substance in which primal anxiety can be embedded, as in the essence of the Lacanian Real.

In relation to these issues Verhaeghe considers the place of Freud's myth *Totem and Taboo*. In so doing he accentuates the three phases of the creative process and of the tripartite structure of ritual. In fact, as I have said, the myth of *Totem and Taboo* is a myth of the creative process in which the primal father is eliminated making way for a matriarchy or feminine phase. This is followed by a transition again into the symbolic or the father-patriarchy through the agency of the son-hero. In other words, by the son who gives rebirth to the self through union with the creative feminine:

> The first stage is the most unequivocal ... There is no language, only the Real "is." It is only in the second stage that the first one receives a meaning and this is due to the way in which it disappears: the murdered male animal becomes a primal father whose vanished authority permits the eruption of a power previously bridled by him: matriarchy. Just as one has to be read from two, the second stage – matriarchy – only receives meaning and weight by the way it disappears in the third ... The disappearance of paternal authority sets free a previously chained power – matriarchy – which calls for countermeasures to bridle it once again. According to Freud, this happens thanks to the intervention of the son-hero who re-installs the functions of the father. (89)

Here is the creative process in Freudian myth with the Real as initiator of the unconscious and heralding the passive feminine oceanic phase and the resultant communion of artist and mother generating a psychic rebirth along with new symbolism and iconography as the symbolic paternal function.

As I indicated in my earlier comments on Lacan, his theories have provoked fierce controversy and criticism. I have discussed how the dependence of Freud and classical psychoanalysis on narrative and symbolism tends to preclude a deeper

184

understanding of how a real therapeutic transition can only be effected at the psychic structural level of abstract form beyond representation or interpretation. As we have seen, Freud's investigations were inclined to halt at the primal father in the myth of *Totem and Taboo* and although Lacan did address the feminine in a far more rigorous fashion, the Symbolic Order for him was really the only meaningful domain.

Lacan recognised that it is the primal anxiety induced by the mother's castration complex and 'lack' that initiates the primary signifier and the symbolic. Furthermore, he acknowledges the diachronic and synchronic structure of the creative layers surrounding the pathogenic nucleus of the Real. However, as with Freud, he relies on symbolism and signification in his fundamental tenet that the Real is absolutely inaccessible. In this work, of course, I have argued that the artist and mystic can at least have access to a creative parallel of the Real, reconvening it in its every essential characteristic.

In chapter 5 I discussed Mikkel Borch-Jacobsen's endorsement of trance and of 'mimetic efficacity' as the essence of the therapeutic transition effective at a psychic structural level beyond symbolism and the 'symbolic efficacity' of Levi-Strauss that exerted such a strong influence on Lacan. He similarly criticises Lacan for his opposition to trance states in the analytic procedure and for his reliance on the symbolism and for holding the view that 'human experience is exclusively that of discourse, language and the symbolic' and that 'we can therefore simply not have a direct experience of what is beyond representation.' (90)

As I have said, it is the case that Lacanian ideas would seem to offer little possibility of psychic engagement with the core of the Real to affect a communion and conversion experience. Lacan's thesis recognises the 'function of the fantasy... as a basic structure attempting to answer a basic lack' in its therapeutic role, but does not accede to the deeper structural potential of unconscious trance states embedded in abstract form. (91) To again give an example, Lacan understood that the fantasies of Little Hans were in many ways comparable to the functions of myths for a people. That is to say, the myth developed around the horse phobia of Hans where he transferred feelings about his father onto an animal, parallels the tribal context where the people transfer emotion and anxiety onto the totem. (92) What Lacan misses, however, is that the real effective cure for Hans was enacted at the level of abstract form in his distortion of a language and development of an abstract creative complex beyond narrative and more to do with poetic construction. (93)

Nevertheless, irrespective of this what is recognisable in the Lacanian schema is a mechanism capable of displacing primal emotion into a realm beyond dream condensations, fantasies, parapraxes and so forth into the Symbolic Order. In terms of painting, where the Real or unconscious core is structured in abstract form such a model of transposition seems clearly applicable. In respect of the abstract monochromes, I have explained how these works develop the elemental creative template and have indicated that this template is still embodied in the later figurative works, within the materiality of the paintings. In other words, the core ritual potential for transition and for psychic transformation is still integral to the work, although in this figurative context it might be less evident.

In the painting *Announcement* (Fig. 28) painted in 1999, it can be seen that the isolated iconographic elements of the house and tree sit upon a swathe of oceanic sea painted in off-white impasto and set against a black sky. I would not draw any exact relationship, but again it is clear that the manic-oceanic substance of the figurative ground and backdrop once again evoke memories of the abstract *Untitled (White)* Fig.10, painted many years before. The off-white paint is dragged across the whole width of the canvas in an immediate integration of the many superimposed films of paint forming the foundations of the painting's structure. The final orchestration also embeds and fixes the figurative elements within the flux of the pictorial space.

I had used the relationship between a house and a tree in much earlier paintings, but I think it must be significant that against such a white abstract space the objects here take on an almost religious aura. Such effects are entirely unconscious for the title suggested itself after the work's completion when the deeper connections between two apparently mundane figurative elements seem to be revealed. As I have said earlier, the abstract paintings such as *Untitled (White)* were in essence types of annunciations heralding psychic conversion and it is only much later that the iconography is displaced to register such events.

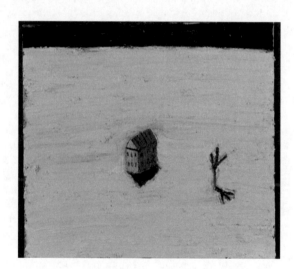

Fig. 28
Announcement
(38 x 40in)
1999

The infinite horizon against the empty black sky records the infinity of the oceanic experience. The suggestion of endlessness is in the empty brushstrokes painted without a break in their line and in their implicit perpetuation beyond the canvas edge. This is both the creative core and the Lacanian Real: the divided self is signified in the alienation alongside the potential for psychic communion and redemption intrinsic to the substance. Donald Kuspit suggests that:

> 'Newton's pictorial space, then, is the self's new as well as old home. His furniture represents both the destructive loss of selfhood and creative self-dis-

covery – self-recovery. The insular little house that recurs again and again – like all of Newton's standing motifs, it seems naively real as well as profoundly symbolic – is both prison and sanctuary. It is clearly an image of privacy become estrangement, and the site of self-estrangement. Newton's very personal icons convey the dark night of the soul the saint must experience before he finds his salvation – recovers his sense of self – by investing his creativity – all that he has left after suffering has stripped him of every shred of selfhood – in God. Or, in Newton's case, investing himself in his creativity – in the spiritual unconscious, Newton's paint especially conveys what Frankl calls the "defiant power of the human spirit" (10) – the defiant power of creativity – while the poignant emptiness of his scenes conveys its defeat.' (94)

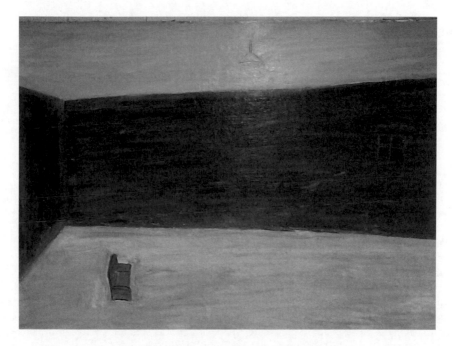

Fig. 29 *Room at Night* (76 x 110in) 2003

Kuspit further says that:

The dense matrix of gestures…that form the ground in which the figure is embedded – is undifferentiated manic-oceanic space. At the same time, it is the spiritual pictorial space in which every gesture is experienced as a spontaneous revelation of difference, subjective and objective simultaneously. If one regards it as completely objective – descriptive of the world – one misses its subjective import, and if one regards it as completely subjective – a subtle expression of the self (a self-taught dramatizing gesture) – one misses its objective import. The painterly unity of articulate, consciously constructed figure and inarticulate, un-

187

consciously – radically – expressive ground epitomizes this "oscillating" simultaneity. Indeed, it is the peculiar way they converge and merge – "mystically" become one – that seems the "most right" aspect of the picture. If Newton's primitive, intense gestures can be understood as what Wilfred Bion calls "beta elements," then their containment in a figurative form – their use as the mortar and building blocks of the "homely" gestalt, whether it be an interior room with its few furnishings, seen up close, or the house as a whole, seen from the transcendental distance of a bird's eye point of view – indicates that for Newton painting performs the "alpha function." (14) That is, painting makes what is painfully – unbearably – real into an emblem that one can reflect upon with affection, thus making it tolerable, memorable, and personally sacred. (95)

It must be the case that the iconographic elements that exist within the painterly space are emblems. David Maclagan has said of my figuration:

> To be sure, here are "landscapes" or "interiors" (albeit with a striking absence of human figures); but you can tell at a glance that they are functioning as representational tokens. Tokens, indeed, not simply of "house" or "window," but of such things as "subjects" in themselves. They look like pictographic recipes or hieroglyphic shorthand (another Freudian trope); they make no reference to perception, but function like souvenirs – and perhaps they would be more like an object or setting remembered from a dream than anything in the external world. (96)

Indeed, in such works the ideas of Freud and Lacan that I have discussed in this chapter seem to resonate so strongly. Here, writ large, is the empty core Real, materialising or reincarnating primal anxiety that exerts force from its pathogenic nucleus and displaces images whose objective it is to process and make sense of inner trauma. They are never illustrations of real objects, or transcriptions of remembered dream images, but icons, in their innate encoding of psychic experience and its transposition into signification and the symbolic.

Similarly, in the more recent painting *Room at Night* (Fig. 29), the iconography registers the emotion of psychic space and of the material substance with its disturbed surface at points seeming almost to break or crack from inner force. Here the iconography is more isolated in a vaster space and the connections between the objects more tenuous and fragile. *Room at Night* again reveals the mechanisms whereby objects are precipitated from the unconscious creative matrix in the dark mental setting.

A connecting thread, running through this chapter and throughout the work as a whole, is the idea that representations of one sort or another, if they are to have any meaning or significance, emanate from a creative nucleus. Whether we recognise this nucleus as the core of the unconscious or Lacanian Real; or as the irreducible psychic manic-oceanic level, as in Ehrenzweig's 'minimum content of art'; or as the essential synchronic capsule at the fulcrum of the rite of passage, the fundamental mechanism in each context has distinct correlations. When I describe those representations connected or bonded with this core as having 'meaning' or 'significance,' I am referring to their *function* as ciphers of elemental creative and ritual transitional processes. Whether we are discussing cave paintings, Neolithic cultural objects, Afri-

can tribal artefact, or indeed the symbolism of symptoms as extensions of a pathogenic nucleus, the same basic tenets surrounding the generation of such representations would appear to apply.

I have argued that the same thing applies to my own artistic endeavours. The iconographic paintings of the later years are indelibly linked to the earlier abstract monochromes and the imagery and objects in them originally emanate from that core. Again, just as in the case of the network of related artefacts in a Neolithic setting, or of the connections in the iconography of cave paintings, the objects in my own painting have gradually evolved and are all interconnected. In respect of my painterly evolution over a lifetime, the pictorial register and the relationships between objects and symbols within it are far from arbitrary. The positioning of a chair against a window and a ceiling light, for example, as in *Room at Night* (Fig. 29), may seem innocuous enough, but for me at least, the placing of these things has deep psychic resonance and meaning and can express a wealth of emotion.

What I have been describing effectively is art that has fulfilled an indispensable cultural function in human evolution. In attempting to explicate the role and essential characteristics of such art I am not here commenting upon more recent art forms that do not engage with this function, a function that many may deem redundant in modern culture. I have made comparisons elsewhere and there are of course other excellent commentaries, most notably Donald Kuspit's recent work *The End of Art*. (97) Needless to say I think that painting can still offer elemental codes of psychic transition and there *are* those today who believe that ritual transitional processes should still form the core of contemporary art. Wole Soyinka, winner of the Nobel Prize for literature, is one such writer and I think that his work is very germane to the whole argument I have expounded here. His analysis of the interconnecting worlds of myth, ritual and literature in his *Myth, Literature and the African World*, deals with the ritual structure of art.

In this work Soyinka gives an account of the connections between African mythological deities and drama and their representations within dramatic rites of passage. He argues that the rite of passage is integral to drama and that the setting of ritual is the 'cosmic entirety,' a 'realm of infinity.' He also astutely comments on contemporary drama that has lost connection with these ritual sources and with the essence of what makes art a fundamental human activity:

> This brings us briefly to the question of art. The difficulty of today's agent of a would-be ritual communication (call him the producer) is that, where the drama of the gods is involved, his sensibility is more often than not of an enthusiastic promoter, very rarely that of a truly communicant medium in what is essentially a 'rite of passage.' To move from its natural habitat in the shrine of the deity, or a historic spot in the drama of a people's origin, or a symbolic patch of earth amidst grain stalks on the eve of harvest; to move from such charged spaces to a fenced arena at a Festival of Arts, or even to an authentic shelter of the god only lately adapted for tourists and anthropologists alike; this constitutes an unfair strain on the most even-tempered deity, and also on the artistic temperament he shares with humanity. This is not simply a question of truncation, such as the removal of the more sacred events from profane eyes. The essential problem is that the emotive progression which leads to a communal ecstasy or catharsis has

189

been destroyed in the process of re-staging. So this leads us intentionally to the perennial question of whether ritual can be called drama, at what moment a religious or mythic celebration can be considered transformed into drama, and whether the ultimate test of these questions does not lie in their capacity to transfer from habitual to alien environments. (98)

Similar things could easily have been said by Romain Rolland, who believed, as I have recounted, that personal mystical oceanic experience is the original lifeblood of religion and that its 're-staging' in institutionalised ceremonial only leads to its petrification. As Soyinka puts it, the 'emotive progression' or creative stages of ritual developing a personal or communal ecstasy and that form the very roots of art are severed and the artwork atrophied.

Soyinka discusses contemporary drama that he considers incorporates ritual processes. For example he makes reference to playwrights such as the Brazilian Zora Zeljan whose drama *Oxala* of 1974 has as a central character the Yoruba god Sango, who relates to a 'cosmic functionalist framework.' Soyinka considers that:

> Sango embodies in his person, in that culminating moment, the awesome essence of justice; nor is it disputable that the achievement of this is in large measure due to the ritualist mould of the play, where all action and all personae reach deeply through reserves of the collective memory of human rites of passage – ordeal, survival, social and individual purgation – into an end result which is the moral code of society. (99)

Ritual sequences and their counterparts in original developmental phases and structure of the creative process, frame the drama. As a result, the spectator is unconsciously and irresistibly drawn into the transition of the drama through the resonance of mirrored psychic essence and carried vicariously through the whole transformational creative process.

Soyinka makes lengthy references to Ogun, the god of creativity who is central to Yoruba cosmogony. Within the mythology of such a god we can clearly discern the structure of the creative process. Ogun's myth reveals him to have been sent 'hurtling into an abyss in a thousand and one fragments,' a fundamental element to:

> ...man's resolution of the experience of birth and the disintegration of consciousness in death. Ritualism itself is allied to these axial constants; in the gods' tragic drama the gods serve as media for this central experience, the conflicts and events are active contrivances for ease of entry into experience, dramatic motifs whose aesthetic formalism dissolves the barrier of individual distance. (100)

As the god of creativity, Soyinka recounts how Ogun formulates the *original* 'realm of transition.' Ogun alone 'experienced the process of being literally torn asunder in cosmic winds, of rescuing himself from the precarious edge of total dissolution by harnessing the untouched part of himself, the will.' (101)

Significantly, Soyinka transposes the original myth into drama:

> It is as a paradigm of this experience of dissolution and re-integration that the actor in the ritual of archetypes can be understood ...The actor in ritual drama operates in the same way. He prepares mentally and physically for his disintegration and re-assembly within the universal womb of origin, experiences the transitional yet inchoate matrix of death and being. Such an actor in the role of the protagonist becomes the unresisting mouthpiece of the god, uttering sounds which he barely comprehends but which are reflections of the awesome glimpse of that transitional gulf, the seething cauldron of the dark world-will and psyche. Tragic feeling in Yoruba drama stems from sympathetic knowledge of the protagonist's foray into this psychic abyss of re-creative energies. (102)

Here we have the creative process and the essence of mystical experience reflected in the intrinsic structure of the dramatic artwork. The paradigm of 'dissolution and re-integration' where the actor orchestrates a 'disintegration and reassembly within the universal womb of origin' is the paradigm of Ehrenzweig's 'three phases of creativity' in which the artist disintegrates the psychic self in order that the manic-oceanic 'universal womb of origin' can reconstitute a psychic rebirth. In so doing, the actor becomes the 'unresisting mouthpiece of the god' in the artist's authentic role as shaman.

Such cultural mythologies form the iconography of creative and mystical experience at the core of rites of passage. The iconography of 'ritual archetypes' registers the subtle psychic transitions of the culture and is determined by unconscious creative experience. As Soyinka puts it: 'When ritual archetypes acquire new aesthetic characteristics, we may expect re-adjustments of the moral imperatives that brought them into existence in the first place, at the centre of man's efforts to order the universe.' (103) In such drama '...a dynamic marriage unfolds of the aesthetics of ritualism and the moralities of control, balance, sacrifice, the protagonist spirit and the imperatives of cohesion, diffusing a spiritual tonality that enriches the individual being and the community' (104)

Soyinka quotes George Thompson from his *Aeschylus and Athens* when he states that 'Myth was created out of ritual.' In respect of what I have said about 'mimetic efficacy' it is pertinent that Thompson goes on to say: 'In the song and dance of the mimetic rite, each performer withdrew, under the hypnotic effect of rhythm, from the consciousness of reality, which was peculiar to himself, individual, into the subconscious world of fantasy, which was common to all, collective, and from that inner world they returned *charged with new strength for action*. Poetry and dancing, which grew out of the mimetic rite, are speech and gesture raised to a magical level of intensity. For a long time, in virtue of their common origin and function, they were inseparable.' (105)

Thompson goes on to explain how the 'divergence of poetry from dancing, of myth from ritual' came about as society became more complex.

Soyinka stresses here 'the recognition of the integral nature of poetry and dancing in the mimetic rite.' However, he criticises Thompson's definition of inner world as 'fantasy' in an argument supportive of my own contentions about the abstract

191

essence of the core creative process. Significantly he says of this unconscious ritual transitional space that 'We describe it as the primal reality, the hinterland of transition.' He endorses the notion that the 'protagonist' or artist, through access to the 'transitional realm' and by becoming 'immersed within it,' is 'enabled empathetically to transmit its essence to the choric participants of the rites – the community.' (106)

Effectively, Soyinka recognises here the fact that true psychic re-alignment in conversion experience can only transpire at the deepest abstract psychic levels, beyond fantasy or representation, in the realm of 'primal reality.' Primal reality is absolutely devoid of recognisable symbolism or representation, or of 'memory, desire or understanding' as in Bion's domain of 'O' or Lacan's Real Order.

Soyinka criticises the Eurocentric conditioning that projects ideas of fantasy and 'collective unconscious' onto the inner world of ritual transition. He underlines the important point, as I have argued throughout this work, that 'what is transmitted in ritual is essence' beyond representations of fantasy or of a collective unconscious. He further censures psychoanalysis for its reliance on this relatively superficial psychic level of operation: 'The profession of the psychoanalyst lies in the sorting out of the new discrete images from their hostile environment; he has no equipment (as an outsider) for the equation of such images themselves with the essence-reality of their origin.' (107) Rather, for Soyinka, this 'mythic inner world' is the 'psychic sub-structure' excavated in ritual procedure. (108)

It is this 'psychic substructure' that intrinsically activates the artwork in its elemental function. Soyinka examines this 'essential' nature of Yoruba art and the pure idiom of the ritual structure of Yoruba dramatic tragedy and its archaic roots in Yoruba Mysteries, which in many aspects parallel the European idiom of the Passion play. Fundamental to this is the relationship of music, ritual and drama. Furthermore 'The nature of Yoruba music is intensively the nature of its language and poetry, highly charged, symbolic, myth-embryonic.' In religious rites '...words are taken back to their roots, to their original poetic sources when fusion was total and the movement of words was the very passage of music and the dance of images.' (109) In effect, these roots are juxtaposed in Ehrenzweig's manic-oceanic depth where all opposites and conflicts are negated.

In his account of Yoruba Mysteries and drama, Soyinka defines its ritual structure and the iconography of imagery and narratives representing the transitional experiences. He recognises Yoruba myth as 'a recurrent exercise in the experience of disintegration' in its embodiment of the 'principle of creativity.' The ritual drama is framed by the transitional phases of ritual and '...is all essence: captivity, suffering and redemption.' Involved is the 'submission to a disintegrating process within the matrix of cosmic creativity, whence the Will performs the final reassemblage.' (110) Within this matrix of psychic rebirth are 'the activities of birth, death and resorption in phenomena' and the original sequences in 'the transition between the various stages of existence.' (111)

In a further reference to Ogun, the god of creativity, Soyinka says: 'Ogun is embodiment of Will, and the will is the paradoxical truth of destructiveness and creativeness in acting man. Only one who has himself undergone the experience of disintegration, whose spirit has been tested and whose psychic resources laid under stress by the forces most inimical to individual assertion, only he can understand and

be the force of fusion between the two contradictions. The resulting sensibility of the artist, and he is a profound artist only to the degree to which he comprehends and expresses this principle of destruction and re-creation.' (112)

Wole Soyinka has a deep empathy with the authentic and intrinsic relationship between ritual transition and the iconography of myths and drama ultimately expressing it. Although such an example is in the more likely setting of what Soyinka describes as 'ritual theatre,' it nevertheless reveals this elemental 'psychic substructure' of the creative process. Such theatre becomes a microcosm of 'ritual space'; an area of simulated events; a 'cosmic envelope' and 'paradigm for the cosmic human condition.' It functions 'to parallel...the experiences or intuitions of man in that far more disturbing environment which he defines variously as void, emptiness or infinity.' (113)

By comparison, for Soyinka, western art has lost its soul and he takes it to task for 'the abandonment of a belief in culture' and for the loss of ritual essence. Western art is severed from its ritual and spiritual roots and so its creative impulses are misdirected, unlike African culture '...whose very artefacts are evidence of a cohesive understanding of irreducible truths....' (114) In the primitive consciousness 'the element of creative form is never absent' and for the artist:

> Entering that *microcosmos* involves a loss of individuation, a self-submergence in universal essence. It is an act undertaken on behalf of the community, and the welfare of the protagonist is inseparable from that of the total community. (115)

In his general critique of western art, Soyinka draws in painting, what he describes as 'that essentially individualistic art':

> In surmounting the challenge of space and cosmos, a Turner, a Wyeth or a van Gogh utilises endless permutations of colour, shapes and lines to extract truly harrowing or consoling metaphysical statements from natural phenomena. There is, however, no engagement of the communal experience in this particular medium. The transmission is individual. It is no less essential to the sum of human experience but it is, even when viewed by a thousand people simultaneously, a mere sum of fragmented experiences, individual and vicarious. (116)

What Soyinka says of painting may to a degree be true. But he misses some crucial aspects of its nature. The ritual performance or drama of ritual theatre may well be more communal and collective in character, but the performance is transient and evaporates, although it might have fulfilled its primary function to induce psychic transformation. The painting on the other hand, although its 'transmission is individual,' encodes the transformative and cathartic essence within its material substance and like a genie from a bottle, this essence of mystical experience has the potential to forever break free from its flat plane and envelop the unsuspecting spectator, who is transfixed in an altered state of consciousness and in an indelible psychic conversion. This is the essence of the 'psycho-spiritual' experience structured within ritual performance and its associated artefact that had such a profound effect upon Picasso at the

beginning of the last century and who as a result determined to reinstall it within the core of western painting.

In my references to my own 'later years,' or 'third phase' of personal painterly evolution, I would hope that to some degree at least I have shown that a type of icon painting is still possible; that an absolute contact with inner ritual of psychic transition is still possible and that such access to the 'psycho-spiritual' essence of trance-formation is not the exclusive preserve of authentic tribal culture. I hope also that in some measure I have shed some light on the efforts of the individual artist to make some sense of the arcane, ineffable and untranslatable psychic experience that can drive the individual and further impact upon the wider culture as a whole.

CONCLUSIONS

The consistent implication underlying Wole Soyinka's urgent affirmation of authentic art and ritual is that any culture disconnected from its creative and spiritual roots will wither and die. What is true of the individual needing the sustenance of renewal in the creative rebirth of ritual trance-formation is also true of the wider culture. Many anthropologists and analysts of ritual and the creative process that I have referred to similarly subscribe to this basic tenet. Again we come back to that pervasive question addressed by William Rubin as to why more recent Fang masks seem 'sterile' and banal in comparison to earlier authentic examples when the 'religious faith and confidence of the Fang people remained unshaken.' Religious faith and confidence are generated through communal ritual with its potential for psychic transition and social regeneration. The crux of the ritual process represents the essence of mystical experience as the source of transcendental religion and the creative process with its therapeutic core. (1)

For Soyinka, in order for a society to live in harmony with Nature and maintain those ethical and moral imperatives seen as a guarantee of 'a parallel continuity of the species' the 'fundamental matrix' of ritual must provide the framework: 'We must try to understand this as operating within a framework which can conveniently be termed the metaphysics of the irreducible: the knowledge of birth and death as the human cycle.' Within this matrix the barometer of a culture's vitality is its art; a 'profound experience' distilled within the 'irreducible hermeticism' of ritual performance. (2)

Soyinka echoes Rubin's perception of the art object as the register of the vigour and faith of culture. Against the backdrop of the pernicious effects of colonialism on the authentic spirituality of African culture he laments the Western attitude that sees traditional ritual theatre as a 'village craft' or 'quaint ritual,' little better than the 'artefacts in any airport boutique.' Soyinka wrote this back in the 1970s and it is inevitably the case that since that time authentic ritual has all but dissipated into surface ceremonial sideshow. As a result, African 'tribal art' has more often than not degenerated into curios and 'airport carving.' (3)

In *The Politics and Psychoanalysis of Primitivism* I discussed at greater length this progressive debasement of authentic tribal art. I gave as an example the development of so-called 'Modern African Art' in Mozambique of the 1960s and 1970s, under the auspices of the Marxist Frelimo who set up subsidised workers' co-operatives with the express intention of manufacturing Makonde-type sculpture as its own national style specifically for Western consumption. This sculpture ranges on a spectrum from curio, souvenir or 'airport carving' to styles that do at least try to emulate their authentic antecedents. I also described how certain features were gratuitously interpolated into these commercial artefacts in order to appeal to the tourist looking for evidence of what was perceived to be the stamp of real tribal art. Giganticism and grotesqueness were two characteristics deemed to fit this bill, but also the sculptures were rendered more naturalistic in order to appeal to Western tastes. The

facet of naturalism was meant to reinforce 'the Western idyllic view of African life' and to make them 'easily accessible to non-indigenous buyers.' (4)

I further recounted in respect of this ominous development that at least some important Western curators and critics were confounded by such artefacts, or at best they considered it politic to embrace such benign and banal clichéd crafts. Either way there is no doubt that this Makonde style carving has found its way into major galleries and museums. This is a transparent example of the collusion of institutions and bureaucrats in the emasculation of authentic art. To those who might question whether this really matters I trust that I have shown to a degree here the importance of cultural or individual access to regenerative creative ritual as an antidote to dissociation from the unconscious heritage determining both. Without the potential for renewal held out by trance-formation there is an inevitable decline into entropy.

What the authentic tribal sculpture in all its glory reveals is how the creative process in the essence of the ritual dynamic served to generate its material form. Furthermore, over the last two centuries or so, microcosmic tribal societies provided anthropology with a lens through which the distilled cultural function of art could be perceived. Robert Layton has expressed the view that this is a prime directive of anthropology, to ask: 'What does art DO in a small-scale society?' (5)

Paradoxically, despite its often hostile, deformed, distorted and fragmented character, the cryptic nature of such ritual artefacts was more often than not deciphered to reveal a deep cohesive and integrative social function. Anthropology was able to disclose the fact that tribal art was often the very fabric of social structure and the glue that held it together. It is surely not coincidental that the downward slide of many post-colonial African regimes into tyranny and anarchy has occurred alongside the demise of authentic ritual and its associated art encoding the 'genetic' spiritual heritage of the culture. The most detrimental effect of colonial influence was not in the transplanting of economic or social organisation upon an ill-equipped community, but in the imposition of alien religious concepts that inevitably led to the loss of innate religious faith and confidence underpinning the survival of relatively isolated microcosmic cultures.

In a recent paper I commented:

> For many millennia prior to the Renaissance, art throughout Africa, ancient Egypt and elsewhere served a strictly functional role, to effect access to the purely psychic integrative communion of *ekstasis*, and so transport a participant on to a higher psychic plane. It has been said that 'to deprive a people of their inner motivation for producing works of art is to subject them to the severest psychological trauma.' This is exactly what colonial missionaries did in trying to transplant a Christian dogma, which had lost all connection with its original motivation, on to cultures that, in a supreme irony, still retained their intrinsic connection to real spiritual roots. (6)

The damning evidence of the degeneration of those societies whose peoples have been deprived of the motivation for access to the creative process through ritual transformation, must have acute ramifications for Western culture where the greater degree of complexity can obscure the dissociation from creative roots. The ultimately divided element within the human psyche can be transposed into the cultural arena and a key function of art and ritual throughout human history has been to monitor and

196

mediate this dissociation. What genuinely objective commentator could fail to acknowledge the decline of Western culture in terms of social cohesion and purpose? The massive increases in violent crime, drugs abuse, sexual offences and diseases accompanying the breakdown of traditional social structures and the alienation of the individual has led some critics to brand Western society and the art that represents it as 'decadent' and 'schizophrenic.' (7)

Again it is not surprising that these invidious circumstances have arguably been accompanied by the development of contemporary art forms that often appear to champion or vaunt the superficial, surface, mannered simulations intended as specific ideological critiques of 'high art' perceived as 'elitist' and to debunk notions of authenticity. This is certainly not intended as a blanket criticism of all contemporary art much of which is radical in its conceptual dimension. However, the type of painting that simply mimics originality by copying great works in a bland manner in order to extract its lifeblood completely misses the point of authentic art. Far from being 'elitist' radical modern art was exactly the opposite in its truly revolutionary and liberating power and its prime imperative to once again engage with the transcendental and therapeutic creative core.

In the tribal context, ritual performance provided an institutional and communal access to those psychic processes of trance-formation and rebirth through the essence of the creative process. I have said that in the Western context such provision is obsolete and that the individual is compelled to fall back on subjective strategies to fill this void. In effect this is what the solitary, solipsistic modern artist resorted to: the initiation of an individualistic communion with the authentic creative process and with the unconscious redemption it could hold out. (8)

Within the abstract nucleus of the creative process and its ritual counterpart, the potential for psychic transformation is encoded within the material form as trance-substantiation. In the final analysis it is ultimately the substantiation of trance that is at stake. It is the trance experience in *ekstasis* that verifies mystical experience, a mystical experience that in turn is the source of all religions. The vestiges of transubstantiation are in evidence in the sacraments and liturgies of most religions from Roman Catholicism to the archaic Greek Orthodox Church. In recently reading Carter Lindberg's detailed and exhaustive account of *The European Reformations*, I was again struck by the pervasive and resolutely pivotal role of transubstantiation throughout the whole of religious catechism. In whatever context, the arcane and abstruse wrangles and disputations over seemingly tangential and idiosyncratic minutiae of ecumenical procedure and liturgy in the end come down to whether or not transubstantiation is accepted to whatever degree.

The concept of transubstantiation was first advanced in the late 11th. century to define the transformation or transfiguration of the Eucharistic elements of bread and wine at the Last Supper into the body and blood of Christ. It relates to the direct statements made by Jesus whilst still alive, inaugurating the most important sacrament of the Catholic Church: the Eucharist. The various gospel traditions confirm Christ's statements at the Last Supper that 'this is my body' and 'my blood of the covenant.' (9)

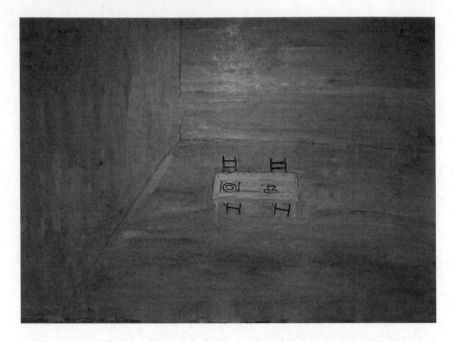

Fig. 30 *The Last Supper* (80 x 114in) 2004

Esoteric and complex reflection and disputation over what exactly it means for the substance of the bread and wine to be transformed into Christ's flesh and blood has continued throughout the two thousand years of history of the Catholic and Christian Church up to the present day. (10) Controversy over the nature of the change of substance has generated elaborate and finely nuanced debate in all of those centuries. In the first two hundred years of Christianity, for example, definitions of the Eucharist were developed by Justin, Ignatius, Irenaeus and Tertullian; in the third century by Origen; in the fourth by Athanasius, Gregory and John Chrysostom and so forth, a clear indication of the density and importance of this sacrament.

The debate essentially centred on whether or not Christ is actually present physically through a change of substance in the sacrament or whether the presence is simply spiritual, symbolic or metaphysical. By the 16th century, the Reformers generally opposed the idea of transubstantiation on the grounds of its alleged idolatrous nature. For example, the Swiss reformer Ulrich Zwingli argued that the Eucharistic elements actually underwent no change whatsoever and that the Last Supper is a mere memorial with a simple symbolic meaning. Zwingli had opposed Luther's reinterpretation of transubstantiation in the doctrine of 'consubstantiation' because the real presence of Christ was still conceded:

Unhappy with the perceived papist remnants in Luther's emphasis upon the real presence of Christ in the Lord's Supper, and aided by linguistic tools borrowed from the humanists, Zwingli insisted that the 'is' in 'this is my body' means 'signify.' Thus when Jesus says 'this is my body,' he means 'this signifies my body,' just as a wedding ring signifies a marriage but is not the relationship itself. (11)

Here we can see in a theological context of nearly five hundred years ago, the exact self-same argument that has surrounded the debate on post-modernism and post-modern art by comparison to modernism and modern art. Since Andy Warhol and the arrival of movements such as Pop Art, contemporary art has tended to elevate to prominence the superficial surface sign at the expense of authentic unconscious embodiment of emotion and ideas. Paradoxically, it was often theorists in the mould of Jacques Lacan who aided and abetted this development through the insistence that linguistic signs are self-defining chains removed from their unconscious referent. The hype of the clichéd sign was also intended to mirror the emotional sterility and alienation of Late Capitalism and the perceived death of notions of history, progress or redemption.

Whatever its ultimate intellectual or theoretical justification, much post-modern art has often been developed in collusion with institutions and theorists, in order to install forms of contemporary art fulfilling ideological directives as well as market forces. I have argued also that underlying this movement is a virulent strain of iconoclasm seeking to neuter the authentic creative process. This is not a new phe-nomenon by any means and just as we can trace back the arguments about signs and symbols and what they really might represent, so does the controversy over the paint-ed image stretch back throughout human history. The religious icon painting from the earliest centuries of the Christian and Catholic Church generated a real presence through its delicately orchestrated layers of superimposed impasto and a real incar-nation of psychic forces embodied and re-materialised in the paint substance in a transubstantiation. This is what the puritanical iconoclasts couldn't accept: that an authentic access to an unconscious spirituality was beyond their control. Today, the post-modern ideologues and theorists often appear likewise to desire the elimination of that which they cannot understand or control.

Post-modern art has not only often been characterised by its fetish for the superficial sign, but also for its over-reliance on text and narratives to explicate asso-ciated theories without which the artwork would make no sense. In another context I showed how this art is a type of mannerism and how in nearly all of its characteristics such art bears exact comparison with the Mannerism of the 16th. century following the Renaissance. (12) In the context of the Reformation it is significant to recognise that the only painted images that were eventually accepted were those heavily reliant upon text and narratives and expunged of any real unconscious presence.

The Reformation movement began by Martin Luther in Wittenberg in 1517 swiftly targeted the veneration of images as superstitious idolatry. Only the Word of God was to be listened to. The public destruction of images was to spread from the first instances of Reformation iconoclasm in Germany through northern Europe to England and Scotland and become a staple rite of purification. But Luther circum-spectly shifted his position when he became alarmed by the extremism of iconoclasm

and when he saw that some advantage might be served. His attitude to images softened to approval arguing that the human soul was a force that generated images. However, images could be acceptable only as long as they were never viewed as sacred in themselves – and this is the key point, of course. Paintings were to be signposts, acting only as signs to direct the believer's gaze to the invisible.

Eamon Duffy in a recent article reminds us that Lucas Cranach, a staunch Protestant painter fitted this bill and was prepared to produce images:

> ...which decisively shaped the official visual propaganda for the new movement, creating not only dozens of Bible illustrations or woodcuts idealising Luther and lampooning the old religion, but also a series of elaborate painted altarpieces designed to adorn and explain the worship of the flagship churches of the new movement. (13)

It is perhaps not surprising that such Lutheran altarpieces, although having superficial resemblances to their medieval antecedents, differed in the key respect that they relied upon a relentless didacticism and were 'often heavily encrusted with explanatory text and biblical quotations.' (14)

Duffy comments further on how Luther was blamed for debasing art into propaganda and refers to Hegel's view that the Reformation:

> ...had robbed art of its intrinsic holiness ...from that point onwards, however skilfully God, Christ or the Saints might be portrayed by painters ...Art was no longer sacred, immediate, an encounter with the ultimate: instead, it offered an alternative form of textuality, mere food for thought. (15)

What is that *intrinsic* holiness? It is the materialisation of psychic forces in the psychic mirror of the paint substance in a transubstantiation. This was the creative core, the 'minimum content of art' that had to be eradicated if the painting was to be acceptable. Throughout the Reformation and the subsequent Counter-Reformation when Catholic sacramental principles were reinstated, argument rages around the crux of transubstantiation. Was anything in actuality incarnated within the substance, embodied and materialised, or were the elements just simply surface signs?

Some Reformists argued that 'transubstantiation is an invented doctrine without biblical foundation.' (16) It was the very essence of reform to deny transubstantiation and to eradicate its sacrament in the mass. As Carter Lindberg states:

> This bedrock Reformation theology found public expression in rejection of the mass and the Roman doctrine of the Eucharist.
> To attack the mass was to attack the heart of medieval religion and therefore was believed not only to entail the eternal condemnation of the heretic but also to jeopardise the health and salvation of the whole community. (17)

To attack the mass *would* threaten the survival of the community, because what is attacked is the creative core, the essence of trance-formation. Just as when the tribal culture loses faith and confidence when the counterpart ritual core is debased, so does the community dependent upon the mass as its original variant of creative rebirth.

The penalty for heresy in respect of the doctrine of transubstantiation was burning at the stake. Whether the transgression was from a Reformist of Counter-Reformist perspective, that is either denial or acceptance of the doctrine as heresy against the prevailing credo of the moment warranted incineration. As Lindberg comments on Henry VIII of England, his title 'Defender of the Faith' and his defence of the seven sacraments of Catholicism:

> ...not only indicates his life-long zealousness for the Catholic faith, in particular the doctrine of transubstantiation, but also reminds us once again of the centrality of this issue to Reformation controversies. (18)

As I have stressed, this is the real contention in respect of the religious icon painting in which the embodiment and mirroring of creative psychic forces ensures an authentic bond between the iconography registering and encoding the deeper unconscious spiritual forces and emotion within the creative core dynamic generating the imagery. In other words there is an absolute harmony of form and content developed through the creative encounter with trance and embodied in the material substance as a transubstantiation.

Throughout this work I have never lost sight of the fact that on one fundamental level my perspective on these events has inevitably been filtered through the prism of my own painting and subjective creative experience. Wole Soyinka acknowledges the same situation in respect of his own deliberations and research. (19)

The painting *The Last Supper*, (Fig. 30) is an example of subjective creative experience being somehow transposed into a more communal arena. For me the work initially seemed to be about purely subjective issues and again referred back to the icon of the table that has had a number of reincarnations in my painting, most notably perhaps *Homecoming* painted in 1994. (20) But as with the case of the abstract painting *Promised Land* (Fig. 11) to which I have turned to on many occasions here, the religious overtone of the title suggested itself intuitively after completion of the work. Perhaps it is also significant that to me the table and chairs in this painting look like an archaic image scratched on to a rock surface in an innate remembrance of cave art's connection to ritual: in this case, the ritual of *The Last Supper*.

What the subjective creative experience can provide is an inner understanding of how an art object can become dissociated from the creative process and as a result degenerates into surface sign and cliché; into curio, 'airport carving,' or in another context, petrified religious ceremony. What it further ultimately reveals is the indissoluble link between the creative experience and mystical, religious experience, although as I have said on more than one occasion, I am certainly not claiming sainthood for the artist or special dispensation for the artist as mystic. It is rather that I have tried to focus on those positive and transformative elements of the creative process to which the artist-shaman is traditionally the cultural guardian. These elements inevitably become compounded within other discourses and as a result can lose their vital regenerative forces.

In my own personal analysis carried out in the abstract monochromes, In effect I isolated the creative process, just as it is isolated in ritual. Similarly, as ritual

informs the artefact, so did the distilled creative process in the monochromes determine the later iconographic paintings such as *The Last Supper*. What such an analysis revealed is the creative structure forming the substance of the artwork without which it loses depth and vitality. Aesthetic value has never been of concern to me in my painting just as it is of no concern to the tribal sculptor. What I *have* been concerned about is the *substance* of the painting. It's worth remembering that the word 'substantiate' is usually defined as 'embody.' Transubstantiation becomes the embodiment of trance and this is what I have argued that the monochromes achieved: the materialisation of trance experience within the very substance of the form; the psychic processes of trance-formation are fixed and preserved in a *trance-substantiation*.

It is clear from my references to a creative transubstantiation and to the constant Reformist iconoclastic concerns directed at the painted image, that the creative process always forms the very essence of religion and mystical experience. The ceremonial of the mass celebrates the incarnation of a saviour in another substance prior to a resurrection; through the creative process the individual can be psychically incarnated within the materiality of another substance – if trance is substantiated – and be initiated into a psychic resurrection. Romain Rolland understood and embraced this fact. In his biography: *The Life Of Vivekananda and the Universal Gospel* he quotes Ralph Waldo Emerson's consecration of art in his poem *Brahma*:

> Far or forgot to me is near;
> Shadow and sunlight are the same;
> The vanish'd gods to me appear;
> And one to me are shame and fame.
>
> They reckon ill who leave me out;
> When me they fly, I am the wings;
> I am the doubter and the doubt,
> And I the hymn the Brahmin sings.
>
> The strong gods pine for my abode,
> And pine in vain the sacred Seven;
> But thou, meek lover of the good!
> Find me and turn thy back on heaven.

NOTES

Chapter 1

1. Quoted in I.F.Walther, 1986, p.82.
2. Quoted in P.O'Brian, 1976, p.154.
3. P.O'Brian, 1976, p.27.
4. These are somewhat complex arguments that I have discussed in greater depth in *Painting, Psychoanalysis, and Spirituality*, Cambridge University Press, 2001. In particular on pp. 40 & 208, and in relation to Anton Ehrenzweig's 'theory of beauty and ugliness feelings' expounded in his *The Psychoanalysis of Artistic Vision and Hearing: An Introduction To a Theory of Unconscious Perception*, Routledge and Kegan Paul, London, 1953. Basically, this centres on the defensive and protective function of aesthetics, clearly denoted in the word 'anaesthetic.' For Ehrenzweig, the Oedipal child of 4 or 5 years of age must begin to concentrate on the purely formal characteristics of objects in order to deflect any deeper 'libidinous' or sexual interest, which could invoke an Oedipal threat. Freud also said that 'the motive force of defence is the castration complex,' and that 'ethical and aesthetic barriers' are created as a defence. See S.Freud, *Inhibitions, Symtoms and Anxiety*, 1926, Penguin Freud Library, Harmondsworth, 1993, p. 269.
5. See Anton Ehrenzweig's discussion of this in his section on 'Ego Dissociation' in *The Hidden Order of Art*, University of California Press, Berkeley and Los Angeles, 1967.
6. The 'mandylion' icon represents the original classical form of the image of Christ and is the prototypical painting made 'without the agency of human hands.' See Newton, 2001, pp. 115, 175, 176, 177.
7. Melanie Klein, a psychoanalyst whose clinical work was predominantly with children, developed seminal psychoanalytical theory around the idea of 'object-relations.' She argued that in early development the infant must pass through a 'paranoid-schizoid' phase of aggression and hostility in early relationships through to a 'depressive' position where a compromise is made with reality in all its contradictions and anomalies. I have also explicated this theory, in particular as it relates to the creative process, in greater depth in Newton, 2001, especially under the section 'Inarticulate Form and Anxiety,' pp. 56ff. It is also important to stress that although Klein defines this developmental template in relation to infancy, through the creative process it can be re-engaged at any point in later adult life.
8. D. Ashton, 1990, p. 61.
9. I am using the word 'dissemblance' in the sense of Georges Didi-Huberman's in *Fra Angelico: Dissemblance and Figuration*, University of Chicago Press, Chicago and London, 1995. In an investigation of medieval art Didi-Huberman shows how images can be disfigured or disguised in order to heighten the expression of complex religious ideas.
10. Freud published an essay on Leonardo in 1910 in which he interprets elements of Leonardo's iconography as corroboration of a preconceived psychobiography of Leonardo's psychosexual development. See Newton, 2001, 'Freud and Art,' pp. 2-6.
11. In Newton, 2001, I develop a case for the close correspondence between the creative process, the clinical format of psychoanalytical procedure, and indeed with the whole notion of psychic transformation embedded in mysticism and core religious ritual and practice. On p. 189 I comment that: 'At a very basic level, the painter can be

seen to indulge in a type of exorcism: symbolic fragments of hidden and repressed aspects of the self, represented by dislocated, uncontrolled, or inarticulate unconscious form, are expelled and projected into the painting. The painting can act as a vehicle to integrate, unify, and make sense of these elements; it becomes the structure within which such aspects can be re-presented to the artist in a form suitable for greater conscious apprehension. In a bluntly simplified scenario, this process is parallel to the setting and process of psychoanalysis, where the therapist, in the position of the artwork, might be expected, for example, to interpret and rationalise the incomprehensible fragments of intense emotions, or irrational hatreds.'

12. From Cesare Lombroso in the mid-nineteenth century through to Hans Prinzhorn in the first half of the twentieth century, psychotic art has been analysed and defined as a unique category of art. John MacGregor's *The Discovery of the Art of the Insane*, Princeton University Press, 1989, gives a detailed account of this.

13. See Newton, 2001, pp.206-12.

14. In the early 1920's, the art historian and psychotherapist Hans Prinzhorn assembled a collection of psychotic art at the University Psychiatric Hospital at Heidelberg. This collection was pictured and analysed by Prinzhorn in *The Artistry of the Mentally Ill*.

15. The seminal concept of 'inarticulate form' was defined by the theorist Anton Ehrenzweig in his two most prominent works, 1953 and 1967. Inarticulate form is the subconscious, accidental type of form which is a by-product of the deliberate and conscious engagement with the creative process. It cannot be preconceived, but can be procured by the artist keen to develop the emotional vitality embedded in such unconscious form.

16. See Newton, 2001, p. 21ff.

17. For an explanation of this in detail see Newton, 2001. Basically, this is a momentary trance state brought about by the mesmeric effect on the mind of the artist or viewer in sensing a parallel unconscious structure within the creative dynamic of the artwork. I discuss this further later in this work.

Chapter 2

1. The phrase 'distortions of articulate imagery' comes from the writing of Anton Ehrenzweig who criticises the classical Freudian psychoanalytic concept of 'primary process' and completely redefines the unconscious as a far more complex and subtle formation. I outline his ideas on this in Newton, 2001, in particular in the section 'Structural Repression in Perception,' p. 31ff. On p.33 I quote Ehrenzweig in his criticism that the neglect of the form and structure of the unconscious 'has been responsible for the deadlock which has held up the progress of psychoanalytic aesthetics for over half a century. What Freud calls primary process structures are merely *distortions of articulate surface imagery* (my emphasis) caused by the underlying undifferentiation of truly unconscious fantasy.'

2. There are, of course, endless references in psychoanalytic and philosophical literature attesting to the therapeutic and regenerative power of art and creativity. The paediatrician and psychoanalyst D.W.Winnicott developed the seminal concepts of 'transitional phenomena' and 'transitional objects' which in early infancy designate an intermediate area of universal experience where both inner reality and external life can coexist. He further extends this idea into an intermediate cultural space inherent in art and religion. In *Playing and Reality* he says in respect of 'Creative Activity and

the Search for the Self' that '…it is only in being creative that the individual discovers the self.' D.W.Winnicott, 1988, p.63.

3. In evolutionary history, the imperative to immediately discern the true nature of an object, whether it be predator or obstacle, is clearly biologically adaptive. It can be shown experimentally that our perception is in fact inherently programmed to eliminate or eradicate any vagueness or ambiguity which might impede this perceptual dynamic. The painter in particular can manipulate these unconscious processes by deliberately introducing visual anomalies and distortions, which in effect induce the viewer to discount them. This dynamic psychological reaction seduces the viewer into projecting a vivid and plastic image. See Newton, 2001, p.27ff.

4. The role and function of the sense of omnipotence in psychoanalytic developmental models varies according to the particularity of the context and to the differing perspectives of theorists. By some definitions it may be characterised as essentially regressive and defensive in its refusal to acknowledge the true ramifications of a real relationship with external reality. By other definitions it may be assigned a more positive role as a temporary fallback position promoting a more positive and meaningful relationship with reality. I discuss this in greater depth in Chapter 3.

5. This is why the amateur artist trying to copy a Rembrandt or a Titian can only ever produce a stilted and mannered rendition lacking the life and unconscious vitality of the original. Anton Ehrenzweig critically argues that 'It was thought that the structure of unconscious processes was unstructured and even totally chaotic. The evidence of artistic production proves otherwise. Art's substructure is shaped by deeply unconscious processes and may display a complex organisation that is superior to the logical structure of conscious thought.' Cited in Newton, 2001, p.19.

6. See for example *Kali's Child: The Mystical and the Erotic in the Life and Teachings of Ramakrishna* by Jeffrey J. Kripal, Chicago, 1995.

7. Cited in Newton, 2001, p.57

8. In her research, begun in 1935, the analyst Dr. Grace Pailthorpe, assisted by the artist Reuben Mednikoff, aimed to 'use art as a short cut to deeper levels of the unconscious.' The resultant pictures literally produced the experiences of early infancy, even including intra-uterine experiences. See *Making for Mother* by David Maclagan, 1998.

9. *Why Women Can't Paint* in *Art Criticism*, Vol.16, Number 2, 2001.

10. See Wilfred Bion's *A Memoir of the Future*, London: Karnac, 1991 and the comment made by Donald Kuspit in *Psychostrategies of Avant-Garde Art* that 'Bion regarded the mind as a digestive apparatus.' Kuspit, 2000, p.211.

11. The cannibalistic characteristics of these initial creative processes reflect the unrestrained artistic expression of the Dionysian and its ultimate objective of mystical ecstasy. See Robert A. Johnson's *Ecstasy-Understanding the Psychology of Joy*, Harper, San Francisco, 1987. The fragmentation is represented by the inclination of Dionysius to tear apart live animals and eat their bloody flesh.

12. In Goethe's 1799 poem *The Sorcerer's Apprentice* in which the apprentice over-reaches himself in the absence of his master, the magician, by using spells to complete his domestic duties. This soon gets out of hand as the brooms (or paintbrushes) continually multiply and sprout arms, acting autonomously and beyond the command of the apprentice. Likewise, the pails of water continually overflow, flooding the room in an 'oceanic' experience.

13. See Anton Ehrenzweig's *The Hidden Order of Art,* Weidenfeld and Nicholson, 1967. In this work Ehrenzweig has sections on 'The Three Phases of Creativity' and 'The Minimum Content of Art.'

14. See Jacques Lacan's *The Mirror Stage as formative of the function of the I as revealed in Psychoanalytic experience,* in *Ecrits-A Selection,* Routledge, 1993.

15. See Newton, 2001, p.69ff.

16. Quoted in Romain Rolland's *The Life of Ramakrishna,* Advaita Ashrama, 1997, p.15

17. Ibid., cover.

18. Ibid., p.14

19. Ibid., p.14

20. Newton, 2001, p.121ff.

Chapter 3

1. In his analysis of the art of children, Herbert Read delineates four different types of temperaments and expression: 1. hypomanic cycloid, 2. depressive cycloid, 3. hyper-aesthetic schizoid, 4. anaesthetic schizoid. He goes on to describe four 'perceptive types' and then in correspondence with Jungian archetypes to define four categories of child art: thinking, feeling, sensation and intuition. At one point in reference to brain physiology and 'traces,' he states: 'That the pattern into which the traces are integrated should tend towards fourfoldness or quaternity need not cause us any more surprise than such 'neat' facts as the periodicity of the elements or the mathematical regularity of the elements...' See H. Read, 1968, p.190.

2. For an interesting discussion of this, see Umberto Eco's *Art and Beauty in the Middle Ages,* Yale University Press, New Haven and London, 1986.

3. E. Kris, *Psychoanalytic Explorations in Art,* International Universities Press, Inc. Madison, Connecticut, 1988.

4. Newton, 2001, pp. 2-6.

5. In the course of the play, the tragic hero *Oedipus* unwittingly murders his father and marries his mother. This basic plot only actually serves to symbolise the unconscious creative process, in which the artist, in order to either create something new and original, or to recreate something anew, including giving rebirth to a reconstituted self, must at some point and to some degree destroy the constructions and conventions which represent accepted realities. For example, in the case of painting, clear, cohesive, legible abstract shapes, can represent order and composition associated with reason and law. The annihilation of these elements, as in the abstract expressionist 'all-over' painting, re-enacts the destruction of paternal authority and an engagement or union with the feminine and maternal dimension located prior to the Symbolic Order and the acquisition of language and symbolism. See my paper: *Guilt in Painting* in *Art Criticism,* vol.13, no.2. State University of New York (1998).

6. D.W.Winnicott, 1988, p.64.

7. Ibid., p.76.

8. Ibid., p.63.

9. Ibid., p.64.

10. S.Freud, *Creative Writers and Daydreaming* in *Art and Literature,* vol.14, Penguin Freud Library, Penguin, Harmondsworth, 1990.

11. D.W.Winnicott, 1988, p.64.

12. Newton, 2001, pp.59-60.

13. The head of fine art at Nottingham Trent University, David Horn, who was my tutor on a masters degree in fine art, remarked on the passage by Ehrenzweig that: 'it

could have been written about your work.' David had been very positive about the embryonic nature of my painted collages at that time, commenting that he considered them to be 'somehow radical and fundamental.'

14. See the section on 'Structural Repression in Perception' in Newton, 2001, p.31ff.
15. A. Ehrenzweig, 1967, p.102-3.
16. See the section on 'The Phenomena of Envelopment and the Oceanic Feeling' in Newton, 2001, p. 84ff.
17. A. Ehrenzweig, 1967, p.102.
18. See the essay: *The Post-Modern Icon – Stephen Newton's Post-Abstract Paintings* by Donald Kuspit, 2000, note 12, reproduced as an appendix in this volume.
19. I have made the case in other works that figuration, symbolism and narrative is actually precipitated and evolved from this abstract primordial space. My later figurative paintings, which constitute the third phase of my general overall development as a painter, clearly evidence how a personal and original set of objects and figures evolve from the matrix and come to embody the emotional undercurrents encountered in the creative process.
20. W.R.Bion, 1991, p. 34.
21. See 'The Abstract Structure of Creativity' in Newton, 2001, p.69ff.
22. A. Ehrenzweig, 1967, p.103.
23. *Guilt in Painting* in *Art Criticism*, Vol. 13, Number 2, 1998.
24. Newton, 2001, p.31ff.
25. A.Ehrenzweig, 1967, p.103.
26. F.Bowie, 2002, p.169.
27. A.Ehrenzweig, 1967, p.103.
28. Newton, 2001, p.134.
29. A.Ehrenzwcig, 1967, p.103.
30. Ibid., p.103.
31. Ibid., p.105.
32. D. Kuspit, 1993, p.11.
33. D.W.Winnicott, 1990, p.176.
34. F.Bowie, 2002, p.161.
35. Ibid., p.163.

Chapter 4

1. Quoted in W.B.Parsons, 1999, p. 4.
2. Ibid., p. 37
3. Ibid., p. 37
4. R.Rolland: *The Life of Ramakrishna* and *The Life of Vivekananda and the Universal Gospel.*
5. W.B.Parsons, 1999, cover.
6. See chapter 2.
7. Quoted in W.B.Parsons, 1999, p.90.
8. Ibid., p. 92.
9. Ibid., pp. 65-6.
10. Ibid., p.66.
11. W.Worringer, 1953, p.132.
12. Newton, 2001.
13. W.Worringer, 1953, pp. vii-xiii.
14. Ibid., p.xi.

15. Ibid., pp. x & xii.
16. P.O'Brian, 1976, p.153.
17. Ibid., p.154.
18. Newton, 1996.
19. I make further reference to this debate in *The Politics and Psychoanalysis of Primitivism* (1996). See, in particular the section on 'Contemporary viewpoints on primitivism,' p. 44ff.
20. W.Rubin, 1984, p.73.
21. S.Freud, 1983, p.26ff. and p.64-74.
22. W.R.Bion, 1970, p.33.
23. Cited in C.Green (ed.), 2001, p.10.
24. D.Ashton, 1996, *preface.*
25. Cited in C.Green (ed.), p.12.
26. Ibid., p.6.
27. S.Freud, 1984, pp. 435-442.
28. C.Green: *'Naked Problems'? 'Sub-African Caricatures'? 'Les Demoiselles D'Avignon,' Africa, and Cubism*, in C.Green (ed.), p.129.
29. Cited in C.Green (ed.), p.137.
30. Ibid., pp.143-4.
31. Interestingly, in the essay *Dream, Imagination, and Existence* (K.Hoeller, ed. 1993), Michel Foucault takes Freud to task for neglecting the *morphology* of the dream in favour of content and narratives. The unconscious structure of the dream inevitably has parallels with the unconscious structure of the creative process. The important difference, however, is that during the creative process, the artist is able, up to a point, to subliminally and intuitively direct and orchestrate events and so to enhance the depth of creative power. This has on occasion been described as the artist 'dreaming whilst awake.' Donald Kuspit, in an essay on my own painting (see appendix) puts it very succinctly when he says: 'To surrender to the flow of unconscious creativity without losing consciousness of its treacherous intricacies – the changing currents of dialectical interplay between resolved gestalt and unresolved gesture that constitute its drama – and with no sacrifice of self-possession is a rare feat, and it is Newton's.' In relation to the argument about the *structure* of the creative process and the dream, Surrealism poses some interesting questions. Surrealist painting by, for example, Salvador Dali or Rene Magritte, may *illustrate* the dream, imitate its symbolism in displacement and condensation, or recount or recreate dream narratives, but fails to engage with the dream structural processes which are ultimately responsible for the generation of appropriate symbolism and iconography. This is not to invalidate Surrealist painting that deals with its own curious and *surreal* characteristics and objectives. But it does nevertheless present an intriguing example of art that is almost academic and mannered in its reliance on the illustation of preconceived ideas, rather than on the essence of the modernist creative project, which is to initiate in some degree the evolution of pertinent vehicles of embodiment actually during the creative process itself. In the end, this is exactly what Picasso intuitively understood in his encounter with authentic tribal sculpture and when he talks of giving 'spirits' or the 'subconscious' a 'shape,' which I have quoted in this chapter.
32. W.B.Parsons, 1999, p.7.
33. I.M.Lewis, 2003, p. 38-9. Lewis goes on to say: 'Indeed, as with adolescence, trance is subject to both physiological and cultural definition. Some cultures follow our own medical practice in spirit if not in detail in seeing this condition as a state of mental aberration where no mystical factos are involved. Other cultures see trance as mys-

tically caused; and others again interpret the same physiological phenomenon in different ways in different contexts. The existence of rival and apparently mutually opposed interpretations of trance occurs of course today in our own society. With the advance of medical science, the incidence of trance states interpreted by the Church as signs of possession has progressively decreased since the Middle Ages. Yet outside this rigid framework of established religion, fringe cults have increasingly taken over a mystical interpretation of trance as the sign of divine inspiration. This is certainly the manner in which trance is overwhelmingly understood in revivalist movements like those of the 'Bible Belt' of the U.S.A., and seems also to be growing in significance in the newer protest cult groups which employ drugs such as LSD and other psychedelic stimulants.' (*Ecstatic religion* was first published in 1971).

34. Ibid., p.43.
35. The neglect of the Greek etymological root of *ekstasis*, leads Lewis to criticise the argument of the Greek scholar E.R.Dodds in *The Greeks and the Irrational* (Berkeley, University of California press, 1951), for taking soul-loss as the definitive characteristic of shamanism. He suggests (p.49) that '...it seems possible that the imposition of a misleading model may have skewed his interpretation.'
36. W.B.Parsons, 1999, p.7.
37. I.M.Lewis was Professor of Anthropology at the London School of Economics. *Ecstatic Religion* was first published in 1971. The emphasis on cultural context is, therefore, perhaps to be expected. Chapter One is actually titled: 'Towards a Sociology of Ecstasy.'
38. For example, Parsons cites Jeffrey M.Masson's *The Oceanic Feeling: The Origins of the Religious Sentiment in Ancient India* (Dordrecht, Netherlands: D.Reidel, 1980) and Narasingha Sil's *Ramakrishna Paramahamsa: A Psychological Profile* (Leiden, Netherlands: E.J.Brill, 1991), as '...more recent portrayals of Indian mysticism...in terms of regression, manic denial, depersonalisation, and derealisation.' W.B.Parsons, 1999, p.10.
39. Ibid., 1999, p.9.
40. Daniel Merkur, 'Unitive Experiences and the State of Trance,' in *Mystical Union and Monotheistic Faith*, pp. 129-30. Cited in W.B.Parsons, p.10.
41. Earlier in chapter 4 I referred to Freud's classic text: *Totem and Taboo* as an example of a work that draws comparisons between subjective, individual experience and its translation into wider cultural rituals and institutions. I made this reference in connection to my own projection of subjective creative exorcism into the cultural dimension of expiation and ritual exorcism. Whilst such correspondences can have deep psychological ties common to both arenas, *Totem and Taboo* has been criticised for its general projection of psychoanalytic theoretical models into the whole of human development and evolution and for its professed explanation of cultural structures. For example, Freud draws in psychoanalytic method used in the analysis of individual neurosis and transposes the investigated processes into animistic social systems. (Chapter 3: 'Animism, Magic and the Omnipotence of Thoughts.') In chapter 4: 'The Return of Totemism in Childhood,' Freud uses the interpretation of individual case studies such as that of 'Little Hans' in 'Analysis of a Phobia in a Five-Year-Old Boy' (Freud, 1909), to construct explanations of tribal totemism. That is to say, the individual displacement of Oedipal fears on to animal symbolic totems is compared with such displacement in tribal totemism. I have discussed the case of 'Little Hans' in greater depth in Newton, 2001. In 'The Politics and Psychoanalysis of Primitivism' (1996), I further outline how Freud's psychoanalytic mythology of primal impulses are projected into the cultural domain. Freud followed Darwin in the

assumption of a 'primal horde' dominated by a single powerful male and projects Oedipal theory and conflict into this primitive state as a basis for future religion. In relation to *Totem and Taboo*, Parsons comments: 'By 1913, with the publication of *Totem and Taboo* and the thesis of the "primal crime," Freud had pretty well ensured both the universality of the Oedipus complex and, with respect to other social sciences, the methodological primacy of psychoanalysis concerning self, culture, and society.' W.B.Parsons, p.54.

42. W.B.Parsons, 1999, p.11.
43. Ibid., p.11.
44. Ibid., p.36.
45. Ibid., p.36
46. S.Freud, *Civilisation and its Discontents*, vol. 12, Penguin Freud Library. Penguin, Harmondsworth, 1991, p.260. Cited in W.B.Parsons, 1999, p.44.
47. W.B.Parsons, 1999, p.47.
48. Ibid., p.47.
49. From the Goetz Letters: 'That is all I Have to Say About Freud: Bruno Goetz's Reminiscences of Sigmund Freud,' translated by Shirley E.Jones in *International Review of Psychoanalysis* 2, 1975: 139-43. Cited in W.B.Parsons, 1999, p.48.
50. W.B.Parsons, 1999, p.49.
51. Ibid., p.49.
52. Ibid., p.50.
53. Ibid., p.51.
54. Ibid., p.38.
55. S.Freud, 1983, pp.141-2.
56. Ibid., p.143.
57. I say this despite the fact that in *Totem and Taboo*, Freud exhorts the reader to '...beware of interpretations which seek to translate it in a two-dimensional fashion as though it were an allegory, and which in so doing forget its historical stratification.' S.Freud, 1983, p.149.
58. S.Freud, 1983, p.149.
59. Ibid., p.156.
60. W.B.Parsons, 1999, p.54.
61. R.Rolland, 1997a, p.100.
62. In his biography *The Life of Ramakrishna* Rolland suggests in respect of Ramakrishna's experiences that: 'There is no difficulty in proving the apparent destruction of his whole mental structure, and the disintegration of its elements.' R.Rolland, 1997b, p.19.
63. A.Ehrenzweig, 1967.
64. W.B.Parsons, 1999, p.55.
65. Ibid., p.57.
66. Ibid., p.58.
67. Ibid., pp.62-63.
68. Ibid., p.119.
69. Ibid., p.66.
70. Ibid., p.66.
71. Ibid., p.67.
72. R.Rolland, 1997a, p.333.
73. W.B.Parsons, 1999, pp.67-68.
74. Ibid., p.68.
75. Ibid., p.68.

76. Ibid., pp.68-69. M.Ferdinand Morel's work is titled *Essay on Mystic Introversion.* Cited in R.Rolland, 1997a, p.333.
77. Ibid., p.68.
78. As Parsons notes, Rolland's attempts to distinguish between introversion and regression deal with the same kind of problem that Ernst Kris tried to solve in his ideas of 'regression in service of the ego' formulated in *Psychoanalytic Explorations in Art.* W.B.Parsons, 1999, p.69.
79. Cited in R.Rolland, 1997a, p.339.
80. See Newton, 2001, p.19.
81. W.B.Parsons, 1999, p.73.
82. I discussed these issues at length with Marion Milner at her home in Hampstead in 1995. She was herself an artist and her struggles in that arena were of course recorded in the fascinating work *On Not Being Able to Paint*, (Heinemann, London) first published in 1950. She showed me her collages and paintings, which after her death were donated to the Wellcome Foundation.
83. W.B.Parsons, 1999, p.162.
84. In relation to a wide range of composers and authors, Storr describes how developmental and psychological issues can impinge upon artistic creation. A. Storr, 1983.
85. R.Rolland, 1997b, p.49.
86. W.B.Parsons, 1999, p.215.
87. Ibid., p.146.
88. Ibid., p.113.
89. Ibid., p.113.
90. Ibid., pp.115-116.
91. Cited in W.B.Parsons, 1999, p.117.
92. Ibid., p.126.
93. Ibid., p.127.
94. Ibid., p.129.
95. Ibid., p.129.
96. A phrase used by Suzanne Kirschner in *The Religious and Romantic Origins of Psychoanalysis* (Cambridge University Press, 1996), p.15. Cited in W.B.Parsons, 1999, p.130.
97. Cited in W.B.Parsons, 1999, p.133.
98. Cited in W.B.Parsons, 1999, p.133.
99. Ibid., p.133.
100. Ibid., p.134.
101. Ibid., p.134.
102. Ibid., p.135.
103. Ibid., p.136.
104. Ibid., p.137.
105. Ibid., pp.138-139.
106. Interestingly, Adrian Stokes defines a cultural context for this question I have discussed in greater detail in (2001) pp.86-89.
107. See the review *A Work of Cryptology* by Derek J.Smith, in the *Journal of Consciousness Studies*, Volume 9, No.3 (2002), pp.83-87.
108. W.B.Parsons, 1999, p.159.
109. Ibid., p.160.
110. Again I refer the reader to my analysis of this in (2001), in particular, pp.31-45.
111. W.B.Parsons, 1999, p.161.
112. Cited in W.B.Parsons, 1999, p.163.

113. Ibid., pp.163-164.
114. A.Ehrenzweig, 1967, p.171.
115. R.Rolland, 1997a, pp.62-63.
116. Ibid., p.4.
117. *New Scientist*, 6.11.2000.
118. *The Guardian*, 2.8.2000.
119. Cited in R.Rolland, 1997a, p.193.
120. Cited in R.Rolland, 1997a, p.275.
121. Cited in R.Rolland, 1997a, p.222.
122. Cited in R.Rolland, 1997a, pp.227-228.
123. Cited in R.Rolland, 1997a, p.271.
124. R.Rolland, 1997b, pp.17-18.
125. Ibid., p.19.
126. Ibid., p.27.
127. Ibid., p.30.
128. Ibid., pp.49,124. It is interesting to note that I discussed the oceanic feeling and the 'flying kite of the soul' at length with the painter Alan Davie during the dinner to mark his recent one-man show at Gimpel Fils Gallery, London. He remarked how the painter Peter Lanyon took to flying gliders in order to simulate the oceanic creative eperience.
129. W.R.Bion, *Attention and Interpretation*, Tavistock, London, 1970, p.15.
130. Ibid., p.26.
131. Ibid., pp.26-27.
132. Ibid., p.26.
133. Ibid., p.30.
134. Ibid., pp.12-13.
135. Ibid., pp.30-32.
136. Ibid., p.35.
137. Ibid., p.36.
138. Ibid., p.47.
139. Ibid., p.51.
140. Ibid., pp.46-47.
141. Ibid., pp.58-59.
142. Ibid., p.75.
143. Ibid., pp.81, 114.
144. Ibid., p.77.
145. Ibid., p.77.
146. Ibid., pp.84-85.
147. Ibid., p.85.
148. Ibid., p.64.
149. Ibid., p.124.
150. Ibid., p.129.
151. P.Collinson, *The Reformation*, Weidenfeld and Nicholson, London, 2003. See for example the description of the essence of Reformist Zwinglianism, pp.64-65. See also Newton, 2000.

Chapter 5

1. R.A.Rappaport, 2001, p.24.
2. C.Humphrey and J.Laidlaw, 1994, p.8.

3. Ibid.
4. Ibid.
5. Ibid., p.9.
6. Ibid., p.8.
7. Ibid. Interestingly, Humphrey and Laidlaw argue that a characteristic of liturgical ritual is that it searches for the 'true prototypical form' or original form and meaning of a rite. They argue that this characteristic is 'much weaker' or 'altogether absent' in performance-centred ritual. See pp.12-3. However, in my view the performance centred ritual should not need to search for a prototypical form as it must inevitably connect with and re-enact this original essence and spiritual root through the authentic trance experience, or mystical conversion. It is this psychic communion that is probably far weaker or absent in the liturgical ceremonial and hence its need to search for spiritual origins.
8. Word definitions are from *The Barnhart Dictionary of Etymology* edited by Robert K.Barnhart. H.W.Wilson Company, 1988.
9. R.A.Rappaport, 2001, pp. 389-90.
10. Ibid., p.226. The research cited is C.D.Laughlin, J.McManus and E.d'Aquili, *Brain, Symbol and Experience*, Columbia University Press, New York, 1990.
11. Ibid., p.390. Here Rappaport cites the work of Erik Erikson, 'Ontogeny of ritualisation in man,' in J.Huxley (convenor), *A Discussion of the Ritualisation of Behaviour in Animals and Man*. Philosophical Transactions of the Royal Society of London. Series B. Biological Sciences 251(772) and Rudolph Otto, *Naturalism and Religion*, Trans. J.Thompson and M.Thompson, Williams and Norgate, London, 1907.
12. Rappaport is referring to the ideas of A.F.C.Wallace, who argues that the 'cognitive and affective restructuring' or learning in ritual typically has five stages. Wallace's second stage of separation and third stage of 'suggestion' correspond to van Gennep's first and second phases of separation and transition, or separation and liminality. A.F.C.Wallace, *Religion: An Anthropological View*, Random House, New York, 1966, pp.239ff.
13. See Solon T.Kimball's introduction to Arnold van Gennep, *The Rites of Passage*, The University of Chicago Press, 1984, pp. vii-viii.
14. Ibid., p.191.
15. See Ronald Hutton's *Shamans-Siberian Spirituality and the Western Imagination*, Hambledon and London, London and New York, 2001, pp.113ff.
16. See James L.Pearson's *Shamanism and the Ancient Mind – A Cognitive Approach to Archaeology*, Altamira Press, Walnut Creek, Lanham, New York, Oxford, 2002, pp.47ff.
17. D.J.Davies, 2002, p.138.
18. R.Girard, 1995, p.90.
19. G.Cunningham, 1999, pp.58-9.
20. Solon T.Kimball, introduction to A.Van Gennep, 1984, p.xii. The two monographs are by A.D.Radcliffe-Brown, *The Andaman Islanders*, 1922, and W.Lloyd Warner, *A Black Civilisation*, 1937.
21. A.van Gennep, 1984, p.11.
22. C.Levi-Strauss, 1977, pp.186-206.
23. Ibid., p.197.
24. Ibid
25. This account is given in E.E.Evans-Pritchard, *Witchcraft, Oracles and Magic Among the Azande*, Clarendon Press, Oxford, 1937, pp.240-43. Evans-Pritchard's theoretical anthropological research is usually classified in the school of 'structural functional-

ism' the ideas of which basically draw parallels between social structure and the structure of ritual and religion and lays emphasis on their socially integrative function. In his observations Evans-Pritchard describes how a novice was buried in the earth with the lower half of his body sticking out of the ground where he remained for about half an hour while there was frenzied dancing over his body. Eventually he was raised from the ground exhausted and disorientated. The novice himself described the experience thus: 'Then they heaped earth around me and left me like that. The drums began to sound and they commenced to dance the dance of divination. They danced and danced and danced. They stood around the hole in a circle, and I heard the ringing of the bells in their hands. After a while one of them came and placed his head under the banana leaves into the hole and told me to arrange myself in a good position or I would die from suffocation, and he added that, when they uncovered me, I was to spring out of the hole with alacrity…I got out of the hole, and when I first opened my eyes people appeared to me like a mist, and I was quite weak with exhaustion, because it almost kills one in the earth.' pp. 241-2.

26. See Victor Turner, *The Ritual Process-Structure and Anti-Structure*, Aldine de Gruyter, New York, 1995. Turner discusses the 'curative process' of the *Isoma* ritual on pp.33-7.
27. A.van Gennep, 1984, p.15.
28. Ibid., p.18.
29. Ibid., note2, p.81.
30. Ibid., p.75.
31. Ibid., p.81.
32. See Graham Cunningham: *Religion and Magic-Approaches and Theories*, Edinburgh University Press, p.55.
33. Ibid., p.67.
34. See Newton, 2001, p.69f. I discuss Ehrenzweig's ideas on the individual's recourse to abstract modes of thought during periods of crisis on pp.89-90.
35. V.Turner, 1997, p.15.
36. Ibid., pp.95, 102-3.
37. R.Girard, *Violence and the Sacred*, The Athlone Press, London, p.111.
38. V.Turner, 1997, p.103.
39. Mikkel Borch-Jacobsen, 1992, pp.101-2.
40. Ibid., p.103.
41. Ibid.
42. Ibid., pp.104-5.
43. I have discussed this in Newton, 2001, pp.235-8, in particular in relation to an interview Borch-Jacobsen held with Chris Oakley in the journal *Free Associations*, 1995, Volume 5, Part 4, No.36 pp.423-452. Other members of the group include Leon Chertok and Francois Roustang.
44. See Newton, 2001, pp.235-8.
45. Solon T.Kimball, introduction to A.van Gennep, 1984, p.xiv.
46. Mikkel Borch-Jacobsen, 1992, p.108.
47. Ibid., p.105.
48. Ibid., p.110.
49. Ibid., p.120.
50. Ibid., p.107.
51. W.Sargant, 1975, pp.104-5.
52. Ibid., p.23.
53. Ibid., pp.35-8.

54. W.Sargant, 1967, p.113.
55. W.Sargant, 1973, p.9.
56. Ibid., p. 12-13.
57. W.Sargant, 1975, p.92.
58. W.Sargant, 1967, p.116.
59. Ibid., p.135.
60. W.Sargant, 1975, p.106.
61. Ibid., p.107.
62. W.Sargant, 1973, pp.115-7.
63. Ibid., p.119.
64. G.William Barnard, 'The Varieties of Religious Experience – Reflections on its Enduring Value,' *Journal of Consciousness Studies*, 2002, Volume 9, No.9-10. p. 73.
65. W.Sargant, 1973, p.130.
66. Ibid., p.138.
67. Ibid., pp.152-3.
68. G.Parrinder, 1954, p.104.
69. Ibid., pp.146-7.
70. E.E.Evans-Pritchard, 1937, p.175.
71. Ibid., p.169.
72. V.W.Turner, 1968, pp.164ff.
73. M.Stutely, 2003, p.33, 36.
74. Ibid., p.37.
75. J.M.Chernoff, 1984, pp.43, 46.
76. Ibid., pp.97-9.
77. Ibid., pp.50-1.
78. Ibid.
79. Ibid., p.141, 148-9.
80. W.Sargant, 1973, p.195.
81. Ibid., p.156.
82. A.Laszlo, 1955, p.233.
83. Ibid., p.210-11.
84. See Newton, 2001, p.232.
85. R.Layton, 1991. See in particular his discussion of the Bwami cult of the Lega tribe, in 'Art and Social Life, pp.42ff. I also deal with this issue in *The Politics and Psychoanalysis of Primitivism*, (1996) pp.53-4.
86. R.A.Rappaport, 2001, pp.226-30.
87. A.R.Radcliffe-Brown, *The Andaman Islanders*, 1964, Glencoe: The Free Press. First published, Cambridge: Cambridge University Press, 1922, p.252. Cited in Rappaport, 2001, p.226.
88. R.A.Rappaport, 2001, p.228.
89. Laughlin, Charles D., J.McManus, and E.d'Aquili, *Brain, Symbol and Experience.* New York: Columbia University Press, 1990. Cited in Rappaport, 2001, p.227.
90. Eugene Taylor, 'William James and Depth Psychology,' *Journal of Consciousness Studies*, 2002, Volume 9, No.9-10. p.22.
91. A.van Gennep, 1984, p.80.
92. Ibid., p.89.
93. Ibid., pp.89-96.
94. Ibid., p.96.
95. Ibid., p.105.

96. Henri Hubert and Marcel Mauss, "Essai sur la nature et la fonction du sacrifice," Annee sociologique, 11, 1897-8, pp.29-138. Cited in van Gennep, 1984, p.110.
97. W.Sargant, 1975, p.115.
98. I.M.Lewis, 2003, p.39.
99. W.Sargant, 1975, p.104.
100. Ibid., p.142.
101.G.R.Taylor, *Sex in History*, 1953, Thames and Hudson, London. Cited in Sargant, 1975, p.142.
102. I.M.Lewis, 2003, p.36.
103. Ibid., p.37.
104. W.Sargant, 1967, p.139.
105. J.L.Pearson, 2002, p.45.
106. Ibid., pp.45-6.
107. Ibid., p.47.
108. Ibid., pp.48-49.
109. Ibid., pp.49-51.
110. Ibid., p.50, p.120ff., pp.155-6.111. Newton, 2001.
111. Newton, 2001. The relationship between abstraction and figuration is discussed in the section on 'Abstraction and Modern Art,' pp.120-54.
112. J.L.Pearson, 2002, p.156.
113. Ibid., pp.50-1.
114. Reference in Paul G.Bahn, 1998, p.236.
115. J.L.Pearson, 2002, p.135.
116. R.Layton, 1992, p.16. See also Newton, 1996, p.52.
117. R.Kuhns, 1983, p.54. See also Newton, 2001, p.54.
118. J.L.Pearson, 2002, p.135.
119. Ibid., pp.72-5.
120. Ibid., pp.95-6.
121. Ibid., p.96.
122. Ibid.
123. P.G.Bahn, 1998.
124. Ibid., pp.240-2.
125. Ibid., p.221.
126. J.L.Pearson, 2002, pp.150-55.
127. Ibid., p.159.
128. Ibid., p.111.
129. A.David Napier, 1986, pp.24, 40.
130. Ibid., p.37.
131. Ibid., p.43.
132. Ibid., p.63ff.
133. See review by Gavin Parkinson, *Times Literary Supplement*, 18.5.2001.
134. J.M.Chernoff, 1984, p.36.
135. B. de Rachewiltz, 1966, p.45.
136. Ibid., pp.45-6.
137. Ibid., p.46.
138. Ibid., p.53.
139. Ibid., p.8.
140. C.B.Steiner, 2001, pp.100-1.

Chapter 6

1. See 'Dogon Religion and Cosmogony' in *Art of the Dogon –Selections from the Lester Wunderman Collection* by Kate Ezra, The Metropolitan Museum of Art, New York, 1988, p.18.
2. D.Kuspit, *The Post-Modern Icon – Stephen Newton's Post-Abstract Paintings* in *Stephen Newton – Paintings and Drawings 1997-2000*, Ziggurat, London, 2000, pp.i-ix.
3. In his essay: *The Silence of the Sirens – The Unconscious Aesthetic in Stephen Newton's Paintings*,
David Maclagan writes 'To be sure, here are 'landscapes' or 'interiors' (albeit with a striking absence of human figures); but you can tell at a glance that they are functioning as representational tokens. Tokens, indeed, not simply of 'house' or 'window,' but of such things as 'subjects' themselves. They look like pictographic recipes or hieroglyphic shorthand (another Freudian trope); they make no reference to perception, but function like souvenirs – and perhaps they would be more like an object or setting from a dream than anything in the real external world.' This essay is in the catalogue: *The SpiritualUnconscious - Stephen Newton, Paintings and Drawings 1975-1996*, Ziggurat, London, 1996, pp. 13-18.
4. J.McEwen, 'Basil Beattie in conversation with John McEwen,' Todd Gallery catalogue, London, 1998.
5. M.Gooding, *Reveries, Intimations, Ironies – The Recent Paintings of Stephen Newton*, pp.7-12, in *The Spiritual Unconscious – Stephen Newton, Paintings and Drawings 1975-1996*, Ziggurat, London, 1996, p. 8.
6. Ibid., p.9.
7. T.Garnham, 2004, p.13.
8. Ibid., pp.17-18.
9. Ibid., p.45.
10. Ibid., pp.45&51.
11. Ibid., pp.43-4.
12. Ibid., cited on p.41. Aldo van Eyck, 'The Interior of Time,' in G.Baird & C.Jencks (eds), *Meaning in Architecture*, p.183.
13. Ibid., p.110.
14. Ibid., p.113.
15. Ibid., p.147.
16. Ibid., p.157.
17. Ibid., p.184.
18. Ibid,' p.214
19. Ibid., cited on pp.190-1. Eliade, *The Myth of the Eternal Return*, p.11.
20. Ibid., p. 193.
21. Comments from Donald Kuspit's essay in Ziggurat, 2000, as above, pp.i-ix.
22. M.von Joel, *The Drawings of Stephen Newton* in *Stephen Newton – Paintings and Drawings 1975-1996*, Ziggurat, London, 2000, pp.48-9.
23. Ibid., p.49.
24. S.P.Blier, 1995, p.14.
25. Ibid., p.21.
26. Ibid., pp.4-5.
27. Ibid., p.20.
28. Ibid., pp.1-2.
29. Ibid., p.242.

30. Ibid., p.1.
31. Ibid., p.2.
32. Ibid., p.30.
33. Ibid., p.47.
34. Ibid., p.64.
35. Ibid., p.74.
36. Ibid., pp.76-7.
37. Ibid., p.83.
38. Ibid., p.139.
39. R.S.Wassing, *African Art – Its Background and Traditions*, Alpine Fine Arts, London, 1988, p.26.
40. Ibid., p.44.
41. Ibid., p.152.
42. T.Phillips (ed), *Africa – The Art of a Continent*, Prestel, Munich, New York, 1995, p.292.
43. Ibid., p.289.
44. Ibid.
45. A.Gell: 'The Technology of Enchantment and the Enchantment of Technology,' pp.40-63, in *Anthropology, Art and Aesthetics*, Jeremy Coote and Anthony Shelton (eds.), Clarendon Press, Oxford, 1992, pp.40-1.
46. Ibid., p.54.
47. Ibid.
48. Ibid., pp.55-6.
49. Ibid., pp.58-9.
50. Ibid., p.49.
51. S.P.Blier, 1995, p.95.
52. Ibid., p.101.
53. Ibid., p.95.
54. Ibid., p.383, note 5.
55. Ibid., p.383, note 7.
56. See for example Jean-Michel Rabate, *Jacques Lacan, Psychoanalysis and the Subject of Literature*, Palgrave, 2001, p.15.
57. See for example Bice Benvenuto and Roger Kennedy, *The Works of Jacques Lacan – An Introduction*, Free Association Books, London, 1986, p.192.
58. Malcolm Bowie, *Lacan*, Fontana Press, 1991, p.3.
59. Newton, 2001, pp.214-5.
60. For example, see Shoshana Felman, 'On Reading Poetry: Reflections on the Limits and Possibilities of Psychoanalytic Approaches, pp.133-156, in *The Purloined Poe – Lacan, Derrida, and Psychoanalytic reading*, John P.Muller and William J.Richardson, (eds.), The John Hopkins University Press, Baltimore and London, 1993, p.146.
61. J.Lacan, 1993, pp.1-7.
62. M.Bowie, 1991, p.95.
63. Ibid., p.99.
64. P.Verhaeghe, *Does the Woman Exist – From Freud's Hysteric to Lacan's Feminine*, translated by Marc du Ry, Rebus Press, 1997, p.144.
65. Newton, 2001, pp.33-4.
66. P.Verhaeghe, 1997, pp.22-3.
67. Ibid., p.34.
68. J.Lacan, 1993, pp.1-7. At the 2nd. annual conference of U.A.P.S. held in Sheffield I gave a paper 'The Unconscious Space of Art,' 1995. A Lacanian devotee came to

speak to me afterwards and clearly felt that my discussion of the abstract paintings of the American painter Philip Guston made sense in the light of Lacan's ideas and the mirror stage in particular was discussed. The paper is published in the catalogue: *The Spiritual Unconscious – Stephen Newton, Paintings and Drawings 1975-1976*, Ziggurat, London, 1996, pp.120-3.

69. D.Kuspit, 2000, pp.ii-iii.
70. S.J.Newton, 'Why Women Can't Paint,' in *Art Criticism*, volume 16, number 2, State University of New York at Stony Brook, 2001, pp.52-62.
71. S.Freud, 'Some Psychical Consequences of the Anatomical Distinction Between the Sexes,' *On Sexuality*, vol.7, Penguin Freud Library, Penguin, Harmondsworth, 1991, pp.331-343. (*SE* 19).
72. S.Freud, 'The Dissolution of the Oedipus Complex,' *On Sexuality*, vol.7, Penguin Freud Library, Penguin, Harmondsworth, 1991, p.321. (*SE* 19).
73. S.Freud, 1991a, p.342.
74. S.Newton, 2001b, p.59.
75. In his paper on 'primary object love' Michael Balint states that: 'The human child has the wish to continue living as a component part of the mother-child unit (a dual unit).' M.Balint, 'Early Developmental States of the Ego – Primary Object Love,' 1937, *International Journal of Psycho-Analysis*, 30, 1949, pp.269-72. Cited in P.Verhaeghe, 1997, pp.142-3.
76. A.Peto, 'Body Image and Archaic Thinking,' *International Journal of Psycho-Analysis*, 1959, 40, resp. p.223,6,8. Cited in P.Verhaeghe, 1997, p.143.
77. P.Verhaeghe, 1997, pp.146-7.
78. Ibid., p.155.
79. S.Freud, 'A Childhood Recollection from *Dichtung Und Wahrheit*,' *Art and Literature*, vol.14, Penguin Freud Library, Penguin, Harmondsworth, 1990, pp.321-33. (*SE* 17).
80. P.Verhaeghe, 1997, p.132.
81. M.Bowie, 1991, p.124.
82. Ibid., p.148.
83. See P.Verhaeghe, 1997, pp.38-9.
84. S.Freud, *Draft M,* SE 1, p.251. Cited in P.Verhaeghe, 1997, p.39.
85. P.Verhaeghe, 1997, p.39.
86. Ibid., p.153.
87. Ibid., p.243.
88. Ibid., p.212.
89. Ibid., p.223
90. See Newton, 2001, p.237.
91. P.Verhaeghe, 1997, p.166.
92. See Ibid., p.194.
93. See Newton, 2001, pp.65-8.
94. D.Kuspit, 2000, pp.iv-v.
95. Ibid., pp.vi-vii.
96. D.Maclagan, 1996, pp.13-14.
97. D.Kuspit, *The End of Art*, Cambridge University Press, New York, 2004.
98. W.Soyinka, 2000, pp.5-6.
99. Ibid., p.9.
100. Ibid., pp.27-8.
101. Ibid., p.30.
102. Ibid., p.30.

103. Ibid., p.25.
104. Ibid., p.32.
105. Cited in W.Soyinka, 2000, pp.32-3.
106. Ibid., p.33.
107. Ibid., p.34.
108. Ibid., p.35.
109. Ibid., p.147.
110. Ibid., pp.151-3.
111. Ibid., p.154.
112. Ibid., p.150.
113. Ibid., pp.40-1.
114. Ibid., p.38.
115. Ibid., p.42.
116. Ibid., p.42.

Conclusions

1. W.Rubin, 1984, note 68.
2. W.Soyinka, 2000, pp.52-3.
3. Ibid., p.7.
4. S.J.Newton, 1996, pp.48-9.
5. R.Layton, 1992, p.43.
6. Ibid.
7. The New York critic and theorist Donald Kuspit is the most astute exponent of
 this line of argument. I think that he was arguably the first thinker to analyse and
 isolate the defining characteristics of the two opposing poles of twentieth century art:
 mod-ernism and post-modernism. He was also the first to recognise the healing and
 thera-peutic essence of modern art. See for eg. *The Cult of the Avant-Garde Artist*,
 Cam-bridge University Press, 1993.
8. S.J.Newton, *Guilt in Painting* in *Art Criticism*, vol.13, no.2. State University of
 New York (1998), pp.23-4. I also discuss these issues in a paper I gave at the
 'Sculpture and the Divine' conference held at Winchester in 2000. The paper,
 Sculpture and Ritual: The Role of Art in Transformation is published in *Painting,
 Sculpture and the Spiritual Dimension – The Kingston and Winchester Papers*, (Co-
 eds. Stephen J.Newton and Brandon Taylor), Oneiros, 2003, pp.115-22.
9. See the paper, *Sculpture and Ritual: The Role of Art in Transformation* (2003).
10. G.O'Collins and M.Farrugia, *Catholicism – The Story of Catholic Christianity*,
 Oxford University Press, 2003, p.247.
11. The issue was prominent in the Second Vatican Council of 1963. See,
 G.O.Collins and M.Farrugia, 2003, pp.247-55.
12. C. Lindberg, 1996, p.189.
13. See Newton, 2001, pp.195-8.
14. E.Duffy, 'Brush for Hire,' *London Review of Books*, 19 August 2004, p.15.
15. Ibid.
16. Ibid.
17. C.Lindberg, 1996, p.278.
18. Ibid., p.280.
19. Ibid., p.316.
20. W.Soyinka, 2000, p.ix.
21. See the catalogue, Ziggurat, London, 1996, p.56.

BIBLIOGRAPHY

Ashton, Dore. *A Critical Study of Philip Guston*. University of California Press, Berkeley and Los Angeles (1990). *About Rothko*. Da Capo Press, New York (1996).

Bahn, Paul G. *The Cambridge Illustrated History of Prehistoric Art*. Cambridge University Press (1998).

Balint, Michael. 'Early Developmental States of the Ego – Primary Object love', in *International Journal of Psychoanalysis*, 30. pp.269-72, (1949).

Barnard, William G. 'The Varieties of Religious Experience – Reflections On its Enduring Value' in *Journal of Consciousness Studies*, Vol.9, No.9-10, p.73 (2002).

Benvenuto, Bice and Kennedy, Roger. *The Works of Jacques Lacan – An Introduction*. Free Association Books, London (1986).

Bion, Wilfred. *Attention and Interpretation*. Tavistock Publications, London, Sydney, Toronto, Wellington (1970). *A Memoir of the Future*. Karnac, London (1971). *Learning from Experience*. Maresfield Library, London (1991).

Blier, Suzanne P. *African Vodun – Art, Psychology, and Power*. The University of Chicago Press, Chicago and London (1995).

Borch-Jacobsen, Mikkel. *The Emotional Tie – Psychoanalysis, Mimesis, and Affect*. Stanford University Press, Stanford, California (1992).

Bowie, Fiona. *The Anthropology of Religion*. Blackwell, Oxford (2002).

Bowie, Malcolm. *Lacan*. Fontana Press (1991).

Chernoff, John M. *African Rhythm and African Sensibility – Aesthetics and Social Action in African Musical Idioms*. University of Chicago Press, Chicago and London (1984).

Collinson, Patrick. *The Reformation*. Weidenfeld and Nicholson, London (2003).

Cunningham, Graham. *Religion and Magic – Approaches and Theories*. Edinburgh University Press (1999).

Davies, Douglas. *Anthropology and Theology*. Berg, Oxford, New York (2002).

Deikman, Arthur. 'Deautomisation and the Mystic Experience', in *Understanding Mysticism*. R.Woods, ed. pp. 240-60. Image Books, Garden City, New York (1980).

De Rachewiltz, Boris. *Introduction to African Art*. Trans. P.Whigham, John Murray, London (1966).

Didi-Huberman, Georges. *Fra Angelico: Dissemblance and Figuration*.

Dodds, E.R. *The Greeks and the Irrational*. University of California Press, Berkeley (1951).

Eco, Umberto. *Art and Beauty in the Middle Ages*. Yale University Press, New Haven and London (1986). University of Chicago Press, Chicago and London (1995).

Ehrenzweig, Anton. *The Psycho-Analysis of Artistic Vision andHearing: An Introduction to a theory of Unconscious Perception*. Routledge and Kegan Paul, London (1953). *The Hidden Order of Art*. University of California Press, Berkeley and Los Angeles (1967).

Eliade, Mircea. *The Myth of the Eternal Return, or Cosmos and History*, Princeton University Press, Princeton (1971).

Erikson, Erik. 'Ontogeny of ritualisation in man', in J.Huxley (ed), *A Discussion of the Ritualisation of Behaviour in Animals and Man*. Philosophical Transactions of the Royal Society of London. Series B. Biological Sciences 251(772). (1966).

Evans-Pritchard, E.E. *Witchcraft, Oracles and Magic among the Azande*. Oxford University Press (1937).

Ezra, Kate. *Art of the Dogon – Selections from the Lester Wunderman Collection.* MoMA, New York (1988).

Felman, Shoshana. 'On Reading Poetry: Reflections on the Limits and Possibilities of Psychoanalytic Approaches', in *The Purloined Poe – Lacan, Derrida, and Psychoanalytic Reading.* J.P.Muller, W.J. Richardson, eds. pp.135-156, The John Hopkins University Press, Baltimore and London (1993).

Foucault, Michel, and Binswanger, Ludwig, Hoeller, Keith, ed. *Dream and Existence*, Humanities Press, Atlantic Highlands, New Jersey (1993).

Freud, Sigmund, *Totem and Taboo.* Routledge and Kegan Paul, London, Melbourne and Henley (1983). 'Negation', in *On Metapsychology*, Vol. 11, pp.435-42. Penguin Freud Library, Penguin, Harmondsworth (1984). *SE.* Vol.19. 'A Childhood Recollection from *Dichtung Und Wahrheit*', in *Art and Literature*, Vol.14, pp.321-33. Penguin Freud Library, Penguin Harmondsworth (1990). *SE.* Vol.17. 'Creative Writers and Daydreaming', in *Art and Literature*, Vol. 14, pp.129-141, Penguin Freud Library, Penguin, Harmondsworth (1990). *SE.* Vol.9. 'Leonardo Da Vinci and a Memory of his Childhood', in *Art and Literature*, Vol.14, pp.145-231, Penguin Freud Library, Penguin, Harmondsworth (1990). *Various SE.s.* 'Analysis of a Phobia in a Five-Year-Old Boy "Little Hans".' In *Case Histories 1*, Vol.8, pp.165-305. Penguin Freud Library, Penguin, Harmondsworth (1990). *SE.* Vol.10. 'Civilisation and its Discontents', in *Civilisation, Society and Religion* Vol.12, pp.243-340. Penguin Freud Library, Penguin Harmondsworth (1991). *SE.* Vol.21. 'Some Psychical Consequences of the Anatomical Distinction Between the Sexes', in *On Sexuality*, Vol.7, pp.331-43. Penguin Freud Library, Penguin Harmondsworth (1991). *SE.* Vol.19. 'The Dissolution of the Oedipus Complex', in *On Sexuality*, Vol.7, pp. 313-22. Penguin Freud Library, Penguin Harmondsworth (1991). *SE.* Vol.19. 'Inhibitions, Symptoms and Anxiety', in *On Psychopathology*, Vol. 10, pp.227-315, Penguin Freud Library, Harmondsworth (1993). *SE.* Vol.20.

Garnham, Trevor. *Lines on the Landscape – Circles from the Sky. Monuments of Neolithic Orkney.* Tempus (2004).

Gell, Alfred. 'The Technology of Enchantment and the Enchantment of Technology', in *Anthropology, Art and Aesthetics.* J.Coote, A.Shelton, (eds.), pp.40-63, Clarendon Press, Oxford (1992).

Girard, Rene. *Violence and the Sacred.* Trans. P.Gregory. The Athlone Press, London (1995).

Goetz, BruNo. 'That Is All I Have to Say About Freud: Bruno Goetz's Reminiscences of Sigmund Freud', translated by Shirley E.Jones, in *International Review of Psychoanalysis* 2, pp.139-43 (1975).

Gooding, Mel. 'Reveries, Intimations, Ironies: The Recent Paintings of Stephen Newton', in *The Spiritual Unconscious – Stephen Newton, Paintings and Drawings 1975-1996,* pp.7-12, Ziggurat, London (2000).

Green, Christopher. "'Naked Problems'? 'Sub-African Caricatures'? Les Demoiselles D'Avignon, Africa and Cubism", in *Picasso's Les Demoiselles d'Avignon*, C. Green (ed), Cambridge University Press (2001).

Hubert, Henri, Mauss, Marcel. 'Essai sur la nature et la fonction du sacrifice', In *Annee Sociologique*, 11, pp.29-138 (1897-8).

Humphrey C. and Laidlaw H. *The Archetypal Actions of Ritual.* Clarendon Press, Oxford (1994).

Hutton, Ronald. *Shamans – Siberian Spirituality and the Western Imagination.* Hambledon and London, London, New York. (2001).

James, William. *The Varieties of Religious Experience – A Study of Human Nature.* The Modern Library, New York (1994).

Johnson, Robert A. *Ecstasy – Understanding the Psychology of Joy.* Harper, San Francisco (1987).

Kakar, Sudhir. *The Analyst and the Mystic.* University of Chicago Press, Chicago (1991).

Kirschner, Suzanne. *The Religious and Romantic Origins of Psychoanalysis,* Cambridge University Press (1996).

Kohut, Heinz. *The Search for the Self: Selected Writings of Heinz Kohut, 1950-78.* P.Ornstein ed. International Universities Press (1978).

Kripal, Jeffrey J. *Kali's Child: The Mystical and the Erotic in the Life And Teachings of Ramakrishna.* University of Chicago Press, Chicago (1995).

Kris, Ernst. *Psychoanalytic Explorations in Art.* International Universities Press Inc., Madison, Connecticut (1988).

Kuhns, Richard. *Psychoanalytic Theory of Art: A Philosophy of Art on Developmental Principles.* Columbia University Press, New York (1983).

Kuspit, Donald. *The Cult of the Avante-Garde Artist.* Cambridge University Press, New York (1993). *Psychostrategies of Avant-Garde Art.* Cambridge University Press, New York (2000). 'The Post-Modern Icon – Stephen Newton's Post-Abstract Paintings' in *Stephen Newton – Paintings and Drawings 1997-2000,* pp. i-ix. Ziggurat, London (2000). *The End of Art.* Cambridge University Press, New York (2004).

Lacan, Jacques. 'The mirror stage as formative of the function of the I as Revealed in psychoanalytic experience', in *Ecrits – A Selection,* pp. 1-7, Tavistock, Routledge (1993).

Laszlo, Andreas E. *Doctors, Drums and Dances.* Hanover House, Garden City, New York (1955).

Laughlin, Charles D., McManus, J., d'Aquili E. *Brain, Symbol and Experience.* Columbia University Press, New York (1990).

Layton, Robert. *The Anthropology of Art.* Cambridge University Press, Cambridge (1992).

Lewis, I.M. *Ecstatic Religion – A Study of Shamanism and Spirit Possession,* Routledge, London and New York (2003).

Lindberg, Carter. *The European Reformations.* Blackwell, Cambridge Massachusetts (1996).

Macgregor, John M. *The Discovery of the Art of the Insane.* Princeton University Press, Princeton (1992).

Maclagan, David. 'Making for Mother', in N.Walsh (ed) *Sluicegates of TheMind* Leeds: Leeds City Art Gallery. 'The Silence of the Sirens – The Unconscious Aesthetic in Stephen Newton's Paintings', in *The Spiritual Unconscious – Stephen Newton – Paintings and Drawings 1997-2000,* pp.13-18. Ziggurat, London (2000).

McEwen, John. 'Basil Beattie in conversation with John McEwen', Todd Gallery catalogue, London (1998).

Masson, Jeffrey M. *The Oceanic Feeling: The Origins of the Religious Sentiment in Ancient India.* D. Reidel, Dordrecht, Netherlands (1980).

Merkur, Daniel. 'Unitive Experiences and the State of Trance', pp.125-57, Mystical Union and Monotheistic Faith, *M.Idel, B.McGuinn, eds.* Macmillan, New York (1989).

Milner, Marion. *On Not Being Able to Paint.* Heinemann, London (1984).

Morel, Ferdinand. *Essai sur l'introversion mystique.* Kundig, Geneva (1918).

Napier, A.David. *Masks, Transformations and Paradox.* University of California Press, Berkeley, Los Angleles, London (1986).

Newton, Stephen J. 'The Unconscious Space of Art', in *The Spiritual Unconscious –
Stephen Newton, Paintings and Drawings 1975-1996.* pp.120-3, Ziggurat, London
(1996). *The Politics and Psychoanalysis of Primitivism.* Ziggurat, London (1996).
'Guilt in Painting', pp.16-24 in *Art Criticism*, State University of New York, Vol.13,
No.2 (1998). 'Psychoanalysis and Iconoclasm', pp.48-63 in *Free Associations –
Psychoanalysis, Groups, Politics, Culture.* Process Press, Karnak Books, Vol.8, part 1,
(Number 45), (2000). *Painting, Psychoanalysis, and Spirituality.* Cambridge University
Press, New York (2001). 'Why Women Can't Paint', pp.52-62 in *Art Criticism*, State
Univer-sity of New York, Vol.16, No.2 (2001). '*Sculpture and Ritual: The Role of Art
in Transformation', pp.115-22 in* The Kingston and Winchester Papers – Painting,
Sculpture and the Spiritual Dimension. S.Newton, B.Taylor eds. Oneiros, London
(2003).

O'Brian, Patrick. *Pablo Ruiz Picasso, A Biography.* Collins, London (1976).

O'Collins, Gerald and Farrugia, Mario. *Catholicism – The Story of Catholic
Christianity.* Oxford University Press, Oxford (2003).

Otto, Rudolph. *Naturalism and Religion.* Trans. J.Thompson and M. Thompson.
Williams and Norgate, London (1907).

Parrinder, Geoffrey. *African Traditional Religion.* Hutchinson's University Library,
London (1954).

Parsons, William B. *The Enigma of the Oceanic Feeling – Revisioning the
Psychoanalytic Theory of Mysticism.* Oxford University Press, New York, Oxford
(1999).

Pearson, James L. *Shamanism and the Ancient Mind – A Cognitive Approach
To Archaeology*, Altamira Press, New York, Oxford (2002).

Peto, A. 'Body Image and Archaic Thinking', in *International Journal of
Psychoanalysis*, 40. pp.223-31 (1959).

Philips, T. (ed.), *Africa – The Art of a Continent.* Prestel, Munich, New York. (1995).

Prinzhorn, Hans. *Artistry of the Mentally Ill.* Berlin, Springer (1994).

Rabate, Jean-Michel. *Jacques Lacan, Psychoanalysis and the Subject of Literature.*
Palgrave (2001).

Radcliffe-Brown, A.R. *The Andaman Islanders.* The Free Press, Glencoe (1964).

Rappaport, *Ritual and Religion in the Making of Humanity.* Cambridge University
Press (2001).

Read, Herbert. *Education Through Art.* Faber and Faber, London (1968).

Rolland, Romain. *The Life of Ramakrishna.* Advaita Ashrama, Calcutta (1997).
The Life of Vivekananda and the Universal Gospel. Advaita Ashrama, Calcutta (1997).

Rubin, William. 'Modernist Primitivism, an Introduction', in *Primitivism in 20th
Century Art.* MoMA, New York (1984).

Sargant, William. *The Unquiet Mind.* Heinemann, London (1967). *The Mind
Possessed – A Physiology of Possession, Mysticism and Faith Healing.* Heinemann,
London (1973). *Battle for the Mind – A Physiology of Conversion and Brain-Washing.*
Greenwood Press, Westport, Connecticut (1975).

Sil, Narasingha. *Ramakrishna Paramahamsa: A Psychological Profile.* E.J.Brill,
Leiden, Netherlands (1991).

Smith, Derek J. 'A Work of Cryptology', in the *Journal of Consciousness Studies*,
Vol.9, No.3, pp.83-7 (2002).

Soyinka, Wole. *Myth, Literature and the African World.* Canto, Cambridge
University Press, Cambridge (2000).

Steiner, Christopher B. *African Art in Transit.* Cambridge University Press (2001).

Storr, Anthony. *The Dynamics of Creation.* Penguin, Harmondsworth (1983).

Stutley, Margaret. *Shamanism – An Introduction.* Routledge, London and New York (2003).

Taylor, Eugene. 'William James and Depth Psychology', in *Journal of Consciousness Studies*, Vol.9, No.9-10, p.22 (2002).

Taylor, G.R. *Sex in History.* Thames and Hudson, London (1953).

Thompson, George. *Aeschylus and Athens.* Lawrence and Wishart (1941).

Turner, Victor W. *The Drums of Affliction – A Study of Religious Processes Among the Ndembu of Zambia.* Oxford University Press, London (1968). *The Ritual Process – Structure and Anti-Structure.* Aldine de Gruyter, New York (1997).

Van Eyck, Aldo. 'The Interior of Time', in G.Baird, C.Jencks (eds) *Meaning In Architecture*, pp.170-212.

Van Gennep, Arnold. *The Rites of Passage.* Trans. M.Vizedom and G.Caffee. University of Chicago Press (1984).

Verhaeghe, Paul. *Does the Woman Exist – From Freud's Hysteric to Lacan's Feminine.* Trans. Marc du Ry. Rebus Press, London (1997).

Von Joel, M. 'The Drawings of Stephen Newton', in *Stephen Newton – Paintings and Drawings 1997-2000.* pp.48-9. Ziggurat, London (2000).

Wallace, A.F.C. *Religion: An Anthropological View.* Random House, New York (1966).

Walter, Ingo F. *Picasso – Genius of the Century.* Taschen Verlag, Cologne (1986).

Wassing, R.S. *African Art – Its Background and Traditions.* Alpine Fine Arts, London (1988).

Winnicott, Donald, W. *Playing and Reality.* Penguin, Harmondsworth (1988).

Worringer, Wilhelm. *Abstraction and Empathy: A Contribution to the Psychology of Style.* International Universities Press, Inc. New York (1953).